THE JAGUAR WITHIN

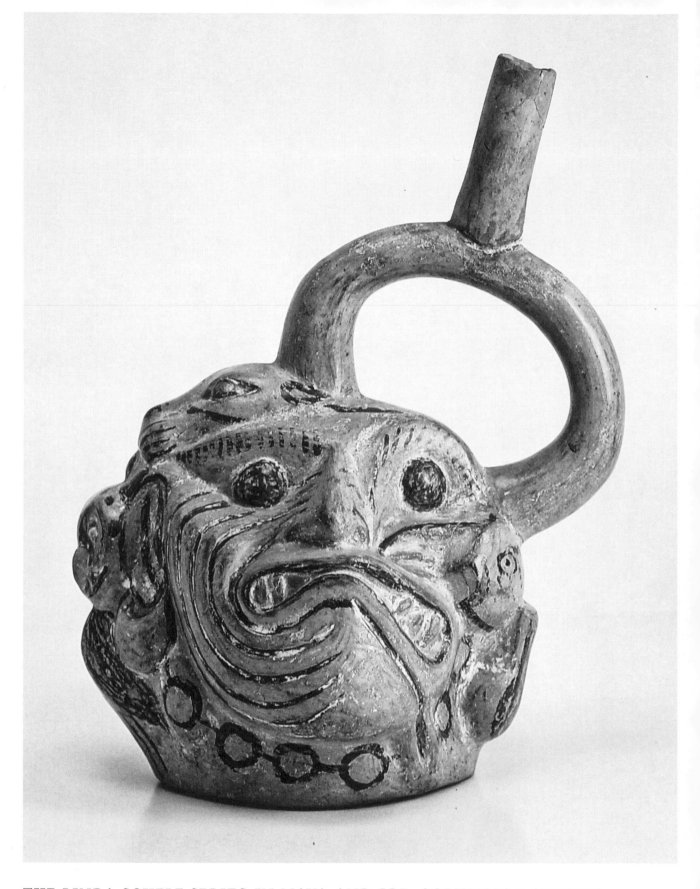

THE LINDA SCHELE SERIES IN MAYA AND PRE-COLUMBIAN STUDIES

REBECCA R. STONE

THE JAGUAR WITHIN
SHAMANIC TRANCE IN ANCIENT
CENTRAL AND SOUTH AMERICAN ART

University of Texas Press *Austin*

THIS SERIES WAS MADE POSSIBLE THROUGH THE GENEROSITY OF WILLIAM C. NOWLIN, JR., AND BETTYE H. NOWLIN, THE NATIONAL ENDOWMENT FOR THE HUMANITIES, AND VARIOUS INDIVIDUAL DONORS.

Requests for permission to reproduce material from this work should be sent to:
 Permissions
 University of Texas Press
 P.O. Box 7819
 Austin, TX 78713-7819
 www.utexas.edu/utpress/about/bpermission.html

♾ The paper used in this book meets the minimum requirements of ANSI/NISO Z39.48-1992 (R1997) (Permanence of Paper)

LIBRARY OF CONGRESS CATALOGING-IN-PUBLICATION DATA

Stone, Rebecca, 1958–
The jaguar within : shamanic trance in ancient Central and South American art / Rebecca R. Stone.
 p. cm. — (The Linda Schele series in Maya and Pre-Columbian studies)
Includes bibliographical references and index.
ISBN 978-0-292-72626-0 (cloth : alk. paper)
1. Indian art—Costa Rica. 2. Indian art—Andes Region.
3. Indians of Central America—Costa Rica—Rites and ceremonies. 4. Indians of South America—Andes Region—Rites and ceremonies. 5. Shamanism—Costa Rica. 6. Shamanism—Andes Region. 7. Shamanism in art. 8. Hallucinogenic drugs and religious experience—Costa Rica. 9. Hallucinogenic drugs and religious experience—Andes Region. I. Title.
F1545.3.A7S83 2011
709.01′1—dc22 2011002613

ISBN 978-0-292-73487-6 (E-book)

Frontispiece: Visionary portrait head with facial contortion. Central Andes, Moche. 200–600 CE. Museo Arqueológico Larco Herrera ML007256. Museo Larco–Lima, Peru.

To Rhiannon and Dylan

CONTENTS

ACKNOWLEDGMENTS

I am grateful to many people for their kind assistance in making this book possible. First and foremost, the Bill and Carol Fox Center for Humanistic Inquiry at Emory University Senior Fellowship for 2007–2008 allowed me the time to write, and I am very thankful to Martine Watson Brownley, Keith Anthony, Colette Barlow, and Amy Erbil. Support from and conversations with Laurie Patton, Judith Miller, Harvey Klehr, Polly Price, Mary Dzon, Robin Thomas, Cathy Ouelette, Lauren Rule, Anthony Mangieri, and Kent Brintnall were extremely helpful. A seminar in Disability Studies coordinated by Rosemarie Garland-Thomson and Nancy Eisland was very thought-provoking, encouraging me to focus on the shaman's body and consider how anomalousness in the physical as well as in the social and sensory realms played an important role in images of shamans in trance. My colleagues in art history at Emory have been supportive over the years, especially Walter Melion, James Meyer, Elizabeth Pastan, Sidney Kasfir, and Sarah McPhee, as have my colleagues in Spanish, Ricardo Gutierrez-Mouat, and in Religion, Gary Laderman. I want to thank Kathleen Carroll, Angie Brewer, and Frank Jackson for their help as well.

At the Michael C. Carlos Museum I want to thank Bonnie Speed, Catherine Howett Smith, Todd Lamkin, Stacey Gannon-Wright, Jessica Stephenson, and Elizabeth Hornor, as well as Nina West, who created the lovely drawings throughout the book (with one exception, begun by Gabrielle Cooper). Bill and Carol Thibadeau, who gave the wonderful collection I have been privileged to curate, are always in my heart. At Emory University's Oxford campus, colleagues Mike McQuaide, Stacy Bell, and Lucas Carpenter kindly introduced me to shamans Don Agustín Grefa and the Tamayo family in Ecuador, which has

been very influential in my work. The Institute for International and Comparative Studies and the Michael C. Carlos Museum at Emory University generously funded my second research trip to Ecuador. I am eternally grateful to the people of Bajo Ila for saving our motley crew on the first field trip to see Don Agustín.

Many students have contributed to the project along the way, especially Meghan Tierney, Sarahh Scher, Laura Wingfield, and Jennifer Siegler, as well as Gabrielle Cooper, Rebekah Cordeiro, Marie-Helene Gagnon, Ian Hennessee, Matthew Kerrigan, Michelle Kleinman, Laura Kochman, Kate Lyford, Katerina Marks, Jennifer Pawela, Alex Polk, Amanda Rogers, Alyson Small, Andrew Tate, and Elizabeth Westlake. Intern Tyler Crafton helped immensely as well.

Ulla Holmquist Pachas and Patricia Chirinos at the Museo Larco Herrera, Kara Schneiderman at the Lowe Museum of Art at the University of Miami, Leslie Freund and Alicja Egbert at the Phoebe Hearst Museum of Anthropology at the University of California–Berkeley, Patricia Nietfeld at the Smithsonian Institution–National Museum of the American Indian, Jeffrey Quilter, Julie Brown, and Jessica Desany at the Peabody Museum of Archaeology and Ethnology at Harvard University, Gertraud Remmers and Dorothee Schaefer at the Staatliches Museum fuer Völkerkunde Muenchen all generously contributed their time and/or access to their collections. The beautiful images were shot by photographers Bruce M. White and Mike McKelvey for Emory, as well as Alicja Egbert at the Hearst, Mark Craig at Harvard, and Tim McAfee for the Lowe Museum. I also appreciate the assistance with animal photographs from Michael Durham of the Oregon Zoo, Art Rilling at the Yellow River Game Ranch, and Andy Murch, Michael Smith, and Leroy McCarty. Joe Fabish's assistance with research in Peru is much appreciated, as well as comments made by Flavia Mercado and Randy Hall. Teresa and Tom Smith allowed me to include their figurine, for which I am grateful. My colleagues Dorie Reents-Budet, Sandra Noble, Barbara and Justin Kerr, Pat Knobloch, Eduardo Eizirik, John Polisar, Duncan Earle, and Bruce Carlson graciously assisted me with their expertise.

At the University of Texas Press, I wish to thank Theresa May, Victoria Davis, and Derek George for all their help as well as Tana Silva for thoughtful editing suggestions.

I always want to reiterate my continuing love for and thanks to my children, Dylan and Rhiannon, who put up with my disappearing to Latin America periodically and being glued to the computer at odd times of the day and night. I thank my parents for their ongoing support at all levels.

While it may be relatively new in scholarship to acknowledge one's own dreams (Tedlock 2003: 107–118), I feel one of mine is relevant. Before going to Ecuador for the first time in 2004 I had a dream in which it was night in a forest. I noticed a shadowy black-on-black silhouette in a tree outside my home, and then suddenly a male black jaguar appeared inside my house. Rather than the magnificent beast he might be in the wild, this one was smallish, moth-eaten, and painfully skinny. I communicated with him telepathically, and he told me that he was desperately hungry and beseeched me to feed him. I hesitated but decided to help him. After I fed him, he thanked me silently and disappeared. Instantly, his mate and their three black jaguar cubs materialized at the door. She, too, was underfed, and the cubs were lean and restless; they also silently asked me to feed them. This time I did so without vacillation, and they were likewise gratified and departed. The dream switched to a daylight scene outside the house featuring a swimming pool. A huge brown bear walked deliberately out of the woods and straight onto and across the surface of the water in the pool. At the center, he miraculously jumped thirty feet straight up in the air, landed again on the water, and walked proudly off.

Soon after having this dream I was invited as a guest lecturer on Michael McQuaide's and Lucas Carpenter's annual student field trip to the Amazon, where we met with several shamans, including Don Agustín Grefa. That year the rainy season was lingering, and our group hiked long in the pouring rain after our bus could not ford an unusually high river. We were ultimately saved by a hospitable group of people in the tiny settlement of Bajo Ila. Don Agustín made his way down to meet us the next day, when the rivers above subsided.

In shamanic cultures dreams are considered to be significant messages, if not actual occurrences in a parallel world, so I told my dream to

Don Agustín. He told us all dreams are significant and should be shared because they propel us forward in time and aid in our development. He saw the hungry male black jaguar as myself, in desperate need of spiritual energy. More along the lines of my own interpretation, he saw the female and the cubs as the people around me—my friends and students—who want to learn about shamanism. To him, the bear was also an aspect of myself and represented all the students on the field trip (shamanism values having many concurrent animal selves). To Don Agustín, the dream had predicted our soggy journey to meet with him and showed that we were willing to get wet in the river we had just crossed—the swimming pool in the dream—to be spiritually nourished by learning about shamanism. Indeed, the experiences and research that have gone into this book have nourished me and my students; I hope *The Jaguar Within* has value for other "jaguars" and "bears" as well.

THE JAGUAR WITHIN

INTRODUCTION

On a pragmatic level, certain experiences may be deemed basic to human existence: the pull of gravity on the body; the perceptibly stable appearance of different phenomena in nature (including a human always actually being human and not something else); and the apparent categories of animate and inanimate, of life and death, as mutually exclusive states. Each of these "normal" experiences, however, can be called into question by going beyond the pragmatic into other modes of perception, such as trance consciousness. Peter Stahl wrote, "Cosmographically coextant with an observable world of mundane events is a world of mythic time and space which is most consistently visited through ritually ecstatic alteration of body and spirit" (1986: 134). During trances, the corporeal is reported to fall away, and gravity's weight is replaced by a feeling of soaring flight. Plants, animals, and humans merge and exchange identities with one's human self in rapid flashes of transformation, and a shared animation pervades all things, even remaking death itself within the larger cosmic flux. The rules that govern vision in the quotidian realm do not apply when visiting this visionary one; it is where one sees with one's eyes closed, where geometric patterns and enormous snakes abound, where tiny spirit-beings advise, and the outsized human ego dissolves in the face of essential truths and interconnections.

This book considers how deep familiarity with and profound respect for such extraordinary visionary experiences deeply affected the artistic output of American indigenous cultures before the European invasions of the sixteenth century. Focusing here primarily on ancient Costa Rica and the Central Andes but including a few unavoidable references to the parallel Mesoamerican traditions, I propose that these cultures maintained a "visionary aesthetic" characterized by assump-

tions, choices, and values indelibly marked by how trance affects the body, mind, and spirit. This visionary aesthetic was born of shamanism, the religious complex pervading the Americas for many millennia and remaining a strong force today. Despite the weight of ponderous scholarly semantic debate, I am retaining the general term "shamanism" for lack of an equivalently encompassing Native American one. Recent scientific support for the ongoing relevance of this nomenclature comes from finding a close genetic connection between Native Americans and specifically the Siberian Tungus area where the term originates. In other words, the peopling of the Americas from the specific world homeland of shamanism continues to be upheld.[1]

For the present purposes, shamanism—a religious complex rather than an institutionalized religion—can be defined as a set of beliefs, ritual acts, and visionary experiences that seek to balance natural forces in order to cure bodily, social, and spiritual ills. The shaman acts as a skilled intermediary with the Beyond, having been called to serve through dreams, visions, miraculous self-healing, and/or anomalous physicality. She or he almost always completes a lengthy and arduous apprenticeship and ideally proves authoritative and efficacious as a healer and/or diviner. Through trances, shamans feel they directly communicate with spirits and often transform into other beings to acquire esoteric knowledge, songs, and information about herbal cures, the future, and distant situations. During these journeys out of the body their relationship to their corporeality is greatly altered, as their spirits are considered to travel elsewhere in the cosmos. (Throughout this study I will use the terms "Elsewhere," "Not-Here," "There," "the Beyond," and "the Other Side" interchangeably to communicate this shamanic understanding that many cosmic realms lie apart from the terrestrial—"Here" or "This Side.") For this reason, an art historical consideration of how the bodies of shamans in trance were characterized artistically serves as a first pass at the vast topic of how visions inspired ancient American art.

Since current Amerindian shamanism still relies heavily on trance states and the traditional means to induce them, I will mine the reports of those experiences found in the anthropological literature as well as original fieldwork and apply them

to the many ancient objects that directly commemorate that consciousness. If the artistic enterprise in the vitally creative areas of ancient Central and South America indeed embraced the fundamental characteristics and values instilled by visions, the artistic choices embedded in effigies that literally embody (or recorporealize) the shaman in trance should be conditioned by the trance experience itself. There are also a number of ancient images that directly and obviously depict the content of visions in some way, as seen in the frontispiece and illustrated in chapter 8.

The close interrelation of trance and art is not surprising: both are visual enterprises not necessarily bound by the terrestrial world and thus represent parallel phenomena. Alana Cordy-Collins finds, "Very often such people [shamans, mystics, visionaries, seers] are artists who can portray their solitary ecstatic encounters in forms accessible to everyone. Thus, mystical experience is brought into the mundane world; the gap between ordinary and non-ordinary reality is transcended by artistic symboling" (1989: 34). The paintings of the visions of a well-known contemporary Amazonian shaman in northeastern Peru, the late Don Pablo Amaringo, prove her point, and his comments provide important insights into the characteristics of visions. Amaringo's claim that "the spirits don't talk, but express themselves through images" (Luna and Amaringo 1993:30) provides an artist-shaman's confirmation of the basic link between spiritual visions and artistic objects: they are both based on images, not words. More specifically, he reports that during ayahuasca-induced visions he had been shown "how to combine colors correctly to create the most beautiful nuances" (ibid.: 17).[2] According to his biographer Eduardo Luna, Amaringo "acquired his ability to visualize so clearly and his knowledge about colors partly from the ayahuasca brew" (ibid.: 29). Thus, he saw his artistic ability as a gift from visionary consciousness.

Amaringo's personal and creative insights underscore that *The Jaguar Within* is at base not only an art historical but also a *phenomenological* study in which direct experience—both that of visionary consciousness and that of perceiving art—is primary evidence. Shamanism is an experiential religious complex in which an initiate is singled out by having experiences different from the ordinary and then learns to control non-

ordinary realities through repeated journeys to the Other Side, each one adding another layer of sensory—but primarily visual—revelation. Likewise, the traditional Amerindian curing ritual is a shared experience that brings There into contact with Here, the "patient" very often in trance with the shaman.

Furthermore, visionary experiences are, among other things, aesthetic ones. Therefore, a better understanding of the relationship between visions and art may be possible by considering current trance perceptions as relevant in the analysis of ancient artworks. In order to make this claim, human visionary and aesthetic perceptual experience must be linked to some degree across space and time. In other words, we must assume that what happens today in trances is similar to what happened in ancient times and that what we see in surviving works of ancient art can access in some way what those long-dead artists sought to convey. It is important to stress that I do not argue for specific similarities between individual trances across time or that the modern interpretations of ancient works, such as Grefa's experience of pre-Hispanic petroglyphs (Stone 2007b), directly reflect past cultural ones. Rather, at the level of general visionary propensities, such as losing touch with one's body and seeing geometric patterns, we can expect or at least confidently hypothesize continuities.

Core features of visions, as reported by modern Latin American shamans and others who have experienced them in traditional shamanic settings or participated in recent scientific experiments, are remarkably predictable across wide gulfs of culture. Because certain substances induce trance and have been staples of Amerindian shamanism for millennia, one of the explanations for such continuities would be their chemical/spiritual effects. Instead of using the loaded term "hallucinogens," I will refer to ingested substances that cause trance under the broad and neutral term "entheogens," meaning something that connects one to the divine. Many current researchers reject the term "hallucination" as well. Metzner avers that these substances "do not cause one to see hallucinations in the sense of illusions: rather one sees all the ordinary objects of the sense world plus another whole range of energies and phenomena not ordinarily seen" (2005: 4).[3]

Numerous ethnographic reports substantiate the repetitive nature of trance visions; for example, "regularities are found in *Banisteriopsis* drink experiences between tribes as widespread as the Chocó Indians west of the Andes in Colombia and the Tacana Indians east of the Andes in Bolivia" (Harner 1973a: 173). As Heinrich Klüver found in his pioneering early-twentieth-century experiments, mescaline "produces certain typical visual effects uninfluenced by the personality of the subject" (1966: 54). Ronald Siegel concludes, after conducting further experiments, "Even in our wildest and maddest hallucinations the mental landscape is the same for all of us," and "the drama of [the subjects'] hallucinations may have different actors and props, but everyone was reading from the same basic script" (1992: 3, 17). Stahl, among others, concurs that "a set of universally redundant sensory phenomena comprises the experiential basis of hallucination" (1986: 134). This comparable visionary perception seems to be basic to the human brain: Gerardo Reichel-Dolmatoff has tabulated the many common geometric patterns ("phosphenes") seen by both the Tukano of Colombia and scientific subjects whose brains were stimulated with electrical impulses (1975: 173–175, figs. 39, 40), as I will discuss further in chapter 2.

What are these recurring perceptual-revelatory characteristics? While this question will be elaborated in chapters 1 and 2, about 75 percent of the time visions will contain brilliant colors and geometric shapes; spinning, spiraling, and undulating movement; confrontations with predatory animals and transformation of the self into other beings; sensations of flying; communication with spirit-beings; and revelations concerning a universally shared life force. Besides ingesting substances, there are many ways to achieve such visions, yet the experiences remain strikingly similar. I will not venture into why this may be the case but rely on the redundant recounting of the trance experience as an intriguing body of evidence to apply to the visual arts. I postulate that this consistency makes it possible to pursue the matter further into the past, although the exact content may vary among individuals, cultures, and vision episodes (the kind of spirit-being with which one communicates, where one flies, and so forth). To assume that these general core trance features may prof-

itably be applied to images of the ancestors of contemporary shaman informants means to accept the premise that the human brain/mind/soul shares the same tendencies in altered consciousness then as now, especially within a common cultural trajectory, but even outside it. As a scholar, I am certainly not alone in pursuing this line of reasoning (Lewis-Williams 2002, among others); however, effigies from the Amerindian cultures of Costa Rica and the Central Andes provide another means to test how important core visionary features were in past aesthetic systems.

On the second count, the idea that it is possible to interpret art from vastly different eras and cultures also relies upon shared human sensory apparatus, allowing the original makers and ourselves to communicate at some level via the work of art. The basic trust in art to communicate broad messages across space and time underlies all art history and related fields, such as anthropology. In broad strokes, Roman art broadcasts masculine power and its discontents, Dutch paintings bask in the sensuous, and Australian Aboriginal bark paintings de- and re-materialize the Dream Time. Roman art eschews dreams as subject matter. Aboriginal creativity ignores the look of clouds. It is at that level that "style is inescapably culturally expressive" (Prown 1980: 199). My confidence in a certain amount of cross-temporal and -cultural aesthetic communication is grounded in training in perception theory, material culture studies, and formal analysis.[4] Cautiously adding ethnographic analogy to these stances seems warranted in analysis of such a long-standing religious complex as shamanism. The present study is not primarily a theoretical work, and so here I will only introduce fairly practical ways to reconstruct visionary content in ancient American art.

RECONSTRUCTING SHAMANIC MEANING

Certainly to find these bridges to past artistic meaning we must take great pains to be observant, find mutually reinforcing information (visual analysis, archaeological reports, and documentary sources such as the Spanish chroniclers and early dictionaries of indigenous languages), and often work multidisciplinarily, particularly in botany

and zoology (Stone-Miller 2002b: 254–258, catalogue no. 567), to avoid gross distortion of the original messages. By "observant" I mean not only attuned to the details of the work of art but also to the natural models with which ancient American artists were so intimately familiar, such as deer, jaguars, whale sharks, and ocelots, and to which shamanic art in particular is exquisitely sensitive due to the core trance experience of actually *becoming* animals and plants. Trained as an art historian, I cannot claim definitive botanical or zoological expertise, and some identification remains highly subjective, especially given the shamanic value placed on purposefully indescribable multiple beings and the ancient American artistic tendency toward abstraction. However, ambiguity as a positive and diagnostic characteristic of shamanic art will be explored beginning in chapter 4.

Yet we must earnestly seek to avoid identifying images frivolously and ethnocentrically, as has occurred in the past. Egregious examples of naming according to contemporary Western culture include "smiling" mouths and "coffee bean" eyes.[5] Likewise, we will fail to recognize shamanic subject matter if we continue to use overtly Christian terms like "angel" (Cook 1985), "catechism" (Cordy-Collins 1976), and "genuflect" (J. Rowe 1962: 18; Torres and Conklin 1995: 96) and European royal references like "crowns" and "scepters" (Llagostera 1995: 73). These terms inevitably reinforce a Christian European worldview and so stand in opposition to shamanic beliefs and practices. To name one key difference, the Western attitude of humans toward animals is one of distinction, superiority, and domination, as set forth in the first book of the Bible (Genesis 1: 26–28),[6] and this attitude is reflected in artistic representations (Stone-Miller 2004: 47n1). By contrast, shamans actively seek to become *other* animals—humans are, after all, primates, animals—reflecting an attitude of equality or even submission to animal power and wisdom (Cameron 1985). The Kogi express this lack of human dominance when they say they descend from the jaguar and that therefore "this is his land, from him we ask permission to live here" (Reichel-Dolmatoff 1985, 2: 46). In shamanic thought humans submit to the plant kingdom as well, yet in a catalogue a sculpture of a mushroom was positioned upside down so as to show the inverted human figure upright

(Calvo Mora, Bonilla Vargas, and Sánchez Pérez 1995; Stone-Miller 2004: 53n7). We so routinely favor the human over all other phenomena that we often misinterpret images. Saunders reminds us that a Guaman Poma drawing that appears to show a jaguar being hunted in fact represents a royal son who transformed into a jaguar to attack the lowland jungle peoples (1998b: 14–15, fig. 2.1). I have called the Amerindian attitude "human displacement," noting that "if a person *becomes* a jaguar, then the jaguar's point of view is equivalent to, if not dominant over, that person's own perspective. Clear distinctions between humans and animals are obliterated in shamanic visions, which displace the human from a central position in the cycles and food chains of the animal and plant world" (Stone-Miller 2002b: xvi). We have failed to notice that many ancient American effigies, as will be illustrated in chapters 3 through 8, display round eyes like those of most animals and thus communicate the animal self embedded in the human visage. We may also be lulled into thinking the figure is wholly human by the common artistic choice of a vertical bodily stance, despite a figure's many other animal features. Overcoming our natural anthropocentrism, avoiding Western terminology that encodes such a worldview, and recognizing the telltale signs of other animals in the mix are necessary first steps toward extracting the distinctive messages conditioned by shamanic trance states.

Having given pride of place to the animal, it becomes crucial to assiduously scrutinize the artistic image and correlate it carefully to zoological information. First, to be relevant to a given work of Amerindian art a species does have to be native to the continent and exist in the vicinity of the culture in question. Tigers and leopards definitely do not fit these criteria but are invoked nonetheless (Saunders 1998b: 20). Often "alligator" is used interchangeably with "crocodile" or "caiman" although alligators do not inhabit areas south of Florida (Abel-Vidor et al. 1981: 224–225; Legast 1998: 127; Luna and Amaringo 1999: 37).[7] Besides favoring animals more familiar to us, scholars tend to latch onto one native animal, especially the jaguar, and fail to recognize other animals such as the kinkajou (Legast 1998: 125) and the many other American felines (Saunders 1998a: 12, 17). The ocelot has been largely ignored but will figure

here in several instances, correcting my own previous misidentifications. Animals not previously identified as shamanic alter egos such as the deer (in chapter 5) and the whale shark (in chapter 7) must be considered as well. Accurate identification involves more than one trait matching a particular species; for instance, both jaguars and pumas have white bellies, so this feature alone does not distinguish them, as Ruege asserts (1991: catalogues 20, 51, n.p.). Care with individual traits such as spotting in cats is important—ocelot spots are long and wavy, jaguar ones concentric—but also especially tricky; for example, young pumas are spotted for up to two years (Tinsley 1987: 43, 48), and jaguars may appear unspotted when albino or melanistic (Wolfe and Sleeper 1995: 95). It is important to keep in mind that spotting is not limited to felines: boas and whale sharks, among many others, are likewise covered with circular markings.

Thus, it is important to acknowledge that Linnaean categories may stand in opposition to indigenous ones, especially if the latter are generated by visionary rather than terrestrial "reality." In other words, specific identification of species may be a Western preoccupation. There seems to be a place in shamanic art for purposefully vague categories like Spotted Predator when no other specific species traits can be discerned. Fangs added to a wide range of images could equally be feline, snake, crocodilian, or bat references. If the fangs cross, bend back, or only feature top teeth they may designate feline versus snake versus crocodile, but this is not always reliable; vampire bats have pointed upper teeth, too (Fenton 1983: 59). I argue that because they foreground the shaman's transformational state, certain effigies are more concerned with conveying the fantastical visionary human and multiple animal beings than with recording specific species, as in the famous Mesoamerican Feathered Serpent. The basic multiplicity inherent in shamanic imagery can frustrate Westerners. Regarding the San Agustín sculptures, Legast complains that "the combinations [of animals and humans] are so varied, and there are so many elements that can be combined that it is difficult, if not impossible, to deduce the rules or circumstances by or in which the associations originated" (1998: 136). It remains difficult to pin down works of art that may combine lizard,

boa, stingray, and hammerhead shark attributes (fig. 4.1; Stone-Miller 2002b: 164–169) or insect, rodent, and iguana elements (fig. 8.12, center). At the heart of the matter, flux characterizes the visionary experience and informs images at all levels. It becomes scholars' thorny task to decide what features of which beings apply and how the combinations reflect indigenous values. In a particularly apt comment, Jonathan Hill writes that shamanism among the Wakuénai "'embarrasses the categories' of Western scientific and artistic culture" because it is at once psychological, medical, musical, social, economic, and more (1992: 208).

Despite recognizing "the cognitive fusion or symbiosis of the animal and human worlds" (Legast 1998: 136), we remain confused as to what to call, and hence how to understand, the most basic multiple type of spiritual entity portrayed in ancient American art. When the same types of winged, animal-headed humans may be interchangeably called "mythical," "semi-gods," "gods," or "transfigured shamans" (Alva 2000: 30, 34), our ongoing struggle becomes clear. One might say that seemingly neutral terms such as feline, avian, ritual impersonator, and supernatural are preferable. Yet, neutral terminology can itself be problematically imprecise and ethnocentric, and it can miss overt shamanic content. At one extreme, a pejorative term such as "monstrous" perhaps unwittingly continues the sixteenth-century discourse of European vilification of Amerindian spirituality (Llagostera 1995: 69–76). Reichel-Dolmatoff resorts to the phrase "jaguar monster" to denote a general principle of creation and destruction, a natural life force (1972: 61). Terminology intended to draw attention to the supernatural can no longer reference the Western tendency of looking at the indigenous Americas and finding "there be monsters." I also have taken exception to the more seemingly innocuous term "ritual impersonator" for Paracas embroidered figures, meaning a person ceremonially donning the costume of another being, when quite often there are clearly nonhuman feet (Stone-Miller 2004: 54, 56–58). Even if other elements may be interpreted as costuming or masks (and no established criteria for determining this are currently in use),[8] nonhuman body parts appear to denote a shaman in transformation. Neutral terms and even apparently factual archaeological descriptions can actively obscure spiritual messages and actions (Staller 2001: 31). Unfortunately, we have few words to fall back on when even the word "supernatural" is problematic, assuming a Western split between nature and that which is beyond nature, while the spiritual *in* nature is fundamental to Native American thought and to shamanic consciousness cross-culturally (Abram 1996: 7–11). I cannot propose an entirely new vocabulary but will attempt to disclose how I am using existing terminology.

Importantly, I will qualify the idea of "images" throughout, arguing that these objects are conceived of as living receptacles for the shaman's spiritual essence, not superficial depictions of their appearance. There are some linguistic clues regarding indigenous conceptions of "images" and how nature, power, and flux manifest through them, though these relate to the latest Amerindian cultures alone. Richard Townsend explores the Nahuatl meanings of the terms *teotl* and *teixiptla* in his classic art-related exegesis *State and Cosmos in the Art of Tenochtitlan* (1979). It is teotl, or life force, that underlies the idea of objecthood captured in teixiptla:

> *Teotl* was universally translated by the Spanish as "god," "saint," or sometimes "demon," but its actual meaning more closely corresponds with that of the Polynesian term *mana*, signifying a numinous, impersonal force diffused throughout the universe. This force was preeminently manifested in the natural forces (earth, air, fire, and water) but was also to be found in persons of great distinction, or things and places of unusual or mysterious configuration. (28)

Teotl inheres in all levels of unmanifest to manifest phenomena, down to the clothing worn in rituals that invoke a given invisible spirit; as such, it obviously does not correspond to the term "god" in any useful sense, as Townsend's analysis clearly demonstrates, and it infuses life into the full spectrum of what we call aesthetic objects. A teixiptla was a memorial cult effigy of the deceased ruler in which he can "virtually interchange with the *teotl* of a natural phenomenon" (ibid.: 31). The ruler had impersonated that teotl during life and assimilated its being, so the teixiptla "was not a *personality* that was being commemorated but, rather, the *continuing office of leaders* in preserving a transcendental affinity between the

cosmic and the social orders" (ibid.). Thus, teotl was a dynamic quality or relationship embodied in a physical form, just as active as I argue shamans are in relation to their corporeality.

Closer to this book's cultural focus, Quechua concepts almost uncannily share teotl's pervasive nature and sacred energetic quality and likewise encourage us to see objects as verbs rather than nouns. Like teotl, the concept of *camay* encompasses the active, mutable, energized/energizing nature of seemingly physical phenomena, positing creation as a continuous infusion of specific life force uniting invisible/celestial with visible/earthly versions (Salomon and Urioste 1991: 16; Gérald Taylor 2000). The idea of infusion (camay) includes the infuser (*camac*) and the infused (*camasca*), the latter being the most physical manifestation. For instance, according to Inka thought, all living llamas were energized by the celestial llama constellation (Salomon and Urioste 1991: 16). The physical object is always in a dualistic relationship with something larger, more energy-rich, and less visible, as I argue for the shamanic effigy. For the Inka, the equivalent to teixiptla was *wawki*, a sculpted double or "brother," to be discussed in more depth in chapter 4.

A more general term for physical phenomena charged by spiritual force, *huaca* focuses on the sacred life energy found in dual-natured, anomalous entities such as double-yolked eggs, cleft boulders, odd facial features, and springs (Salomon and Urioste 1991: 16–19; Classen 1993: 2, 14–15, 67). I will explore how anomalousness as sacred applies to shamans as well. But in terms of objects, many if not most huacas were stones, and current shamanic uses of stones retain strong continuities with Inka concepts, not surprisingly since Quechua or Quichua continues to be spoken by current practitioners (Stone 2007b: 22–25; Stone n.d.a). Crucially, the Quechua words for stones act both as nouns and as verbs, communicating the transformational spiritual force inherent in uncarved and carved rocks (Howard 2006: 239–241; Stone 2007b: 21). Linguistics thus reflects this deeply rooted shamanic assumption that all things are in flux, that one thing becomes another, making a "verbal" approach to images more productive than does a search for fixed species and static gods.

In his attempt to convey what *pajé* or *payé*

(commonly glossed "shaman") signifies for the contemporary Wayapí in Brazil, Alan Campbell calls this inadequacy of our vocabulary in relation to shamanic thought "hobbling along with the language." He, too, argues that

> our language world is heavy with nouns . . . It becomes particularly obvious when we define ourselves. When people ask "What do you do?" inviting a verb, we answer with a noun. "I am an architect; I am a miner" . . . Because we cast *ourselves* in nouns constantly, endlessly, we go on to impose this . . . on everyone else we meet . . . "Shaman" we get wrong because we can't see beyond the specialized human role to *the quality from which the role is moulded*; a quality that inheres amongst many aspects of the world; that emerges from all sorts of places; and that envelopes us in all sorts of ways. (2003: 129, my italics)

Like teotl and huaca, Campbell was told that payé is a type of energy that can exist in a tree, an anaconda, a healer, and all around in nature, as well as being normally invisible, appearing in various degrees, and capable of being acquired, lost, and regained (ibid.: 134). In this study I retain the term "shaman" but reconceptualize it as actively as possible, with the shaman first and foremost as an intermediary, an anomalous experiential knowledge seeker, and an authoritative ritualist restoring dynamic balance to the system by going outside the norm, as discussed in chapter 3.

Excavating the experiential foundations of shamanic thought, I believe, uncovers some provocative links between the present and the past and in turn helps reveal how art has embodied the visionary worldview for millennia.

RELATING THE ANCIENT TO THE MODERN

There is no denying that continuities exist between pre- and post-Hispanic religious life in the Americas, just as it is obvious there are significant disjunctions due to five centuries of upheaval and vicious ongoing "extirpation" of indigenous beliefs and practices. These continuities and disjunctions coexist; for instance, the Inquisition condemned consumption of visions-inducing

plants in 1616 (Grob 2002b: 189), and so perforce it went underground, yet it has continued almost unabated into modern times. Perhaps ironically, the extirpators' vitriolic attacks on indigenous plant sacraments help us reconstruct the religious orientation so powerfully maintained even in the face of long, concerted campaigns to wipe it out. For example, Ruiz de Alarcón in 1629 reveals that colonial native Mexican women caught with the entheogenic morning glory (*ololiuhqui* in Nahuatl) staunchly denied it; this may not be surprising given the punishment they stood to receive for their "pagan" acts, but the reason they gave for it discloses an important indigenous value:

> Being asked why she had perversely denied it, she answered the usual: *Oninomauhtiaya*, which means "Out of fear I did not dare." And here it should be carefully noticed that this fear is not of the ministers of justice for the punishment they deserve but of the *ololiuhqui* or of the deity who they believe lives in it, and they have this respect and veneration for it so firmly rooted that indeed the help of God is needed to rip it out. (1984: 61)

Thus, we discover that the plant spirit—bypassing his imposed term "deity"—was considered divine and in this case vengeful to those who would expose it to enemy attention; in short, the plant spirit was believed to be more powerful than its formidable European adversaries. This underscores how firmly ancient values remained intact a century after the Spanish invasions, as they were in Peru as well (Mills 1997, Cobo 1990). I would also point out that ancient plant imagery was animated with faces (Cordy-Collins 1979: 53–54, figs. 3, 7–10; Knobloch 2000: 391), and contemporary shamans across Latin America continue to aver that entheogenic plants have spirit-beings within them or are spirits in essence.

On the other hand, Ruiz de Alarcón's conclusion that "indeed the help of God is needed to rip it out" represents how Spanish Catholicism has had inevitable distorting effects. The Europeans' violent distaste for the "pagan" recast indigenous beliefs as instruments of "the Devil" and lumped shamans into the European category of evil "witches," especially if they ingested plant substances (Harner 1973c; Glass-Coffin 1998: 41–46,

145). Friar Bernabé Cobo's *Inca Religion and Customs* begins:

> The Indians of Peru were so idolatrous that they worshiped as Gods almost every kind of thing created. Since they did not have supernatural insights, they fell into the same errors and folly as the other nations of pagans . . . Upon finding fertile ground in the simplemindedness and ignorance of these barbarians, he [the Devil] reigned over them for many centuries until the power of the Cross starting stripping him of his authority. (1990: 3)

Any religious tradition that has been so consistently vilified will have changed and cloaked itself to adapt to a hostile environment, and so absolute continuities with the past cannot be postulated. Indeed, the blending of shamanism and Catholicism creates fascinatingly complex, ambiguous, dualistic situations that point up both continuity and disjunction. For instance, in the *mesa* (a set of power objects usually arrayed on a cloth on the ground or on a table) of the late Don Eduardo Calderón, a shaman of north coastal Peru, the left or "evil" side, ruled by "Satan," contains the ancient American objects (Sharon 1972: 42; 1978: 62–63). The "good" side contains power objects with Christian imagery. The two sides are mediated, appropriately enough, by San Cipriano, a great magician whose devilish powers of love magic were thwarted by a girl who was protected by the Virgin Mary, Jesus, and the cross of Saint Bartholomy. The Devil conceded to Cipriano that God was more powerful, so Cipriano converted, was martyred, and finally canonized (Dobkin 1968/1969: 30). It is hard to miss the message that it is morally positive to give up the evil ways of the "magician"—that is, indigenous shaman—or at least hide them behind the cross. Certain shamans, such as Shipibo Don Guillermo Arrévalo, therefore reject Cipriano as anti-indigenous (Arrévalo 2005: 206). Yet to others like Don Eduardo who do not practice harmful magic, Cipriano was manipulative and thus a "black" magician, so they can embrace the Christian moral of conversion from evil to good. To all, Cipriano represents a liminal figure: Don Eduardo centrally places his San Cipriano image on his mesa so it can strike bargains with Satan (Sharon 1978: 71). The delicate

cultural position of a modern Catholic shaman is played out in his mesa, though the Christian overlay on a fundamentally shamanic curing ritual is abundantly clear.

In such a multilayered phenomenon, the emphasis on tracing continuities over time or focusing on post-Conquest disjunctions is subjective. It seems germane that shamans often point up continuities with the past. Don Pablo talks about the lineage connecting the Inkas, the traditional people, the mestizos, and now the Caucasians, each teaching the next (Wiese 2010: minute 23). Scholars tend to come down heavily on one or the other side of the issue; I will neither replay the debate here nor engage those who deny all shamanic terminology, objects, practices, and imagery.[9] A group of scholars from disparate backgrounds note basic continuities that allow us to look in the present for clues to the past, tempered with healthy caution. For Staller and Currie, ethnography provides "an informed framework . . . to construct an intelligible picture" of the past, and

> Andeanists, as well as those working in the Amazonian lowlands, . . . have the advantage of indigenous societies surviving in their regions which have, to a greater or lesser degree, maintained their cultural traditions and concepts about their universe, and their languages have survived largely intact. . . . A particularly important body of literature has been generated from ethnographic and ethnohistoric accounts surrounding indigenous folk practices of healing and curing and those relating to shamanic rituals. It is generally believed that such traditions have their roots deep in antiquity. . . . Recently, scholars of Pre-Columbian South America have turned increasingly to the rich ethnographic record for the interpretation of Andean symbolism. They have sought and applied widespread universal themes and common mythological elements in an approach to the analysis of symbols which encompasses new cognitive approaches to cultural anthropology. This focuses on ways that people from traditional societies have of perceiving themselves and their place in the universal scheme of things in contrast to a Western order and world view. All this attempts to go beyond mere culture description in order to gain a better understanding of the Native American perspective. (2001: 2)

Anthropologist Catherine Allen remarks, "Five hundred years after the Spanish Conquest I did not expect analogies to exist at the level of specific detail but in general ways of thinking . . . [However,] the mental shifts I had to make [as an ethnographer] to enter the discourse of my Andean acquaintances might help us 'interrogate' the pre-Columbian material" (1998: 25). Nicholas Saunders agrees:

> Ethnographic analogy should not be based on the assumption that human behavior is generically uniform, or that historically recent or contemporary indigenous societies will replicate an identical association of attributes or meanings distinctive of a prehistoric culture . . . Nevertheless, a careful consideration of ethnographic contexts can suggest generative principles and generalizations that can be tested against archaeological data. (1998b: 20–21)

Cordy-Collins notes that ethnography forms a good starting point because the "study of a substantial number of cases of ethnographic hallucinatory art can delimit parameters by which investigations of ancient art may be begun . . . Using ethnographic guidelines as points of reference and departure, it appears that at least some prehistoric art was also hallucinatory in origin" (1989: 39–41). Don Pablo Amaringo, Don Eduardo Calderón, and other modern shaman artists serve as valuable informants in such a process. With their views in mind and specifically concentrating on visions as the point of departure and a major source of continuity, in this study I consider ways in which the general framework of current shamanic trance experience suggests generative principles that are reflected in ancient artistic choices; for example, seeing visions better with eyes closed helps identify images of slit-eyed and closed-eye people as being in trance.

Yet, it is important to distinguish ethnographically based inquiry from other kinds of continuities, substitutions, and bridges between present and past with varying degrees of relevance to the topic at hand. Shamanism is a configuration of traits, and it cannot be reduced to any one of its component elements in isolation, such as taking entheogenic substances, communicating with animals, or predicting the future. It has certain sets of

practices (trances, sucking/blowing out disease, cleansing, chanting, and so on) guided by assumptions about how phenomena in the cosmos interact (for example, that spirits can be incorporated into the human intermediary and that songs and actions do not have to be perceptible to be effective) and with defined goals (curing ills, balancing forces, promoting fertility, bringing game). Furst makes the key point that visions were undertaken toward "individually and socially useful ends," not for their own sake (1990: xiii). A contemporary report of a visionary experience, therefore, may belong within the overall coherent cultural tradition of shamanism, or it may not. This is certainly subjective and potentially arbitrary, but I will propose what I consider a relevant visionary experience for present purposes.

I avoid including examples from the U.S. drug culture beginning in the mid-twentieth century, since recreational use of often synthetic "psychedelic" substances diverges from sacred traditions (with rare exceptions in which a reported independent experience with a natural substance closely echoes a shamanic one). While in the 1960s adherents to the so-called counterculture ingested some of the same substances as in ancient and contemporary traditional shamanic communities, at best the former gave only superficial "lip service to the 'teachings' of Native Americans" (ibid.: xii).[10] The infamous and tragic case of celebrities whose interaction with Oaxacan shaman Doña María Sabina and others destroyed the ancient spiritual tradition for her is apparent in her lament: "'What is terrible, listen, is that the divine mushroom no longer belongs to us. Its sacred language has been profaned. The language has been spoiled and it is indecipherable for us'" (in Rothenberg 2003: xvi; this case is covered in Sabina with Estrada 2003: 47–69). Shamanism and drug culture have again overlapped in the twenty-first century; there has been an alarming rise in a phenomenon variously called "whiteshamanism" (Rose 1992), plastic shamans (Aldred 2000), spiritual hucksterism (Churchill 2003), neoshamanic appropriation (Johnson 2003), drug tourism, and commercial shamanism (Arrévalo 2005). Margo Thunderbird expressed it succinctly: "'Now they want our pride, our history, our spiritual traditions. They want to rewrite and remake these things, to claim them for themselves. The lies and thefts just never

end'" (in Rose 1992: 403).[11] Profiteering, untrained, appropriative, and potentially dangerous, the propagators of this contemporary "borrowed mysticism" (Arrévalo 2005: 203) are not considered germane here, and native traditional shamans recognize the distinction between their practices and the "false shamans" around them.[12]

Though the "churches" that have fought for religious freedom to ingest ayahuasca or peyote are worthy of study on their own terms (Grob 2002b: 194–196, 206–210), they nevertheless likewise do not qualify as traditional expressions here.[13] The Santo Daime, Centro Espírita Beneficente União do Vegetal (UDV), and Native American churches may dispense entheogens and display some shamanistic elements in their rituals, but institutionalization is antithetical to traditional shamanism, and Christian as well as other religious and social orientations predominate over Native American elements (Grob 2002a; Fikes 1996; Metzner 2002: 167–169; Metzner with Darling 2005: 43).

THE PRESENT STUDY

In this thematic study I examine ways in which shamanistic visions inform, illuminate, and undergird the ancient artistic renditions of shamans and seek principles that link experience with aesthetics. For instance, a persistent theme in visionary reports is a feeling of corporeal suspension that relates to how bodies in ancient renditions of shamans in trance might appear light or floating. The extreme excitation of the senses also encouraged artists to emphasize the head over the body.

Because I consider the experiential aspects of visions highly influential, if not causative, in determining the character of Amerindian shamanism, its assumptions about reality, and what is encoded in images of shamans, I will begin with an in-depth consideration of what is reported to take place in trance consciousness. Chapter 1 covers the phenomenology of the visionary experience as reported by a wide range of shamans and traditional informants, exploring the overarching characteristics of altered states of consciousness, including the ineffable yet veracious character of the visionary world (distinct from this world but equally or more believable), dual con-

sciousness (as opposed to possession or unconsciousness), multiplicity and flux (reinforcing that transformation characterizes the more-than-human realms), and the common light and color effects that pervade the experience (especially brilliant illumination, enhanced color, and the hues blue and red).

Chapter 2 details the major perceptual experiences of the early stages of trance, featuring geometric patterns and spiraling and undulating movement, as well as the later, more narrative ones, principally entailing suspension and flying, animal interaction and transformation, and spiritual communication and revelation. Decorporealization, new perspectives, nocturnal and predatory animals, and shared life force are foregrounded.

Chapter 3 views the shamans' basic roles and uses of objects in modern healing as indebted to their experience in visions. Using as examples the better-studied ethnic groups, especially those of the Andes and Amazonian regions, four main themes emerge: the intermediary, anomalousness, attainment of authority, and dynamic balance. These themes again will be applied in the more in-depth consideration of artworks in subsequent chapters.

Turning to effigies in the second half of the book, chapter 4 concerns how these general shamanic and perceptual visionary concepts inform the artistic rendering of the shamanic body. Exploration of creative ambiguity, communication of authority, cephalocentrism, and the trance gaze will set the stage for the art historical crux of the study.

Applying the previous concepts to the artistic choices embedded in effigies, in chapters 5 and 6 I analyze a series of images of shamans from ancient Costa Rica and in chapters 7 and 8 a corresponding set from the Central Andes. These case-study objects are considered along a continuum of transformation from the apparently more human to the balanced human-animal to the more animal and finally to those that reach "beyond the continuum" into the highly abstract, patently fantastical, and therefore overtly visionary. Effigies of individuals with anomalous bodies, those who have historically been called disabled, are integrated into this continuum under the argument that the wounded-healer phenomenon is pervasive and to resemble an animal would be highly valued in shamanic societies. In addition, compositions will be highlighted that directly illustrate what is seen and how that is arrayed in visions, replete with partial, inverted, incoherent figures of animals, plants, and humans and combinations thereof.

I conclude the study with a comparison of three sets of pieces found in the earlier case studies to evaluate how Costa Rican and Andean examples treat a similar subject matter, technical, or design choice. Striking similarities in artistic patterns are postulated as evidence that a larger shamanic visionary worldview governed both cultural areas, but differences indicate the particular emphases that distinguish Central from South American expressions.

GENERAL RECURRENT THEMES IN THE PHENOMENOLOGY OF VISIONS

Historically, the great majority of those who have reported on their experiences of ingesting entheogenic substances describe very profound visionary experiences, and many achieve almost identical altered states of consciousness without any external catalysts.[1] Since these contemporary out-of-the-ordinary perceptual experiences follow certain patterns, I contend that we may relate their characteristics to other times, places, and visual modes of expression, including aesthetic objects. Before reviewing the typical stages of visions in chapter 2, discussing some overarching perceptual traits of altered states will help contextualize choices evident in ancient Costa Rican and Andean artistic embodiments. Four important general trance qualities are the distinctive, sometimes indescribable, yet veracious character of the visionary world; dual consciousness; multiplicity and flux; and brilliant light and color effects.

DISTINCTIVE VERACITY

Visionary reality obviously differs from the everyday in many profound ways. In some aspects this is a matter of degree; for instance, familiar colors appear much more saturated. However, there is often a difference in kind: colors, objects, and visual effects seem to the subject unprecedented, indescribable, even literally impossible to express. "The psychic changes and abnormal consciousness induced by hallucinogens are so far removed from similarity with ordinary life that it is impossible to describe them in the language of daily living" (Schultes and Hofmann 1992: 14). Grob calls this the "sense of the ineffable" (2002b: 198). Klüver quotes a subject's description of "'the display which for an enchanted two hours followed such

as I find it hopeless to describe in language which shall convey to others the beauty and splendour of what I saw'" (1966: 15). Amaringo's paintings avoid words, obviously, but the visionary images are similarly indescribable in many ways; they are replete with odd figures and impossible spaces and juxtapositions (figs. 1.1–1.8). Informants strain to describe unprecedented effects: "'My visual sense is enriched, but the colors lack "color"; they are nothing but . . . "shines"'" (ibid.: 25). Narby writes, "I relate this experience with words on paper. But at the time, language itself seemed inadequate. I tried to name what I was seeing, but mostly the words would not stick to the images . . . [I was a] 'poor little human being who has lost his language and feels sorry for himself'" (1998: 7).

Like language, certain perceptual effects taken for granted in everyday life do not "stick to" the world of visions. For example, porrhopsia, characteristic of mescaline-induced visions (peyote and San Pedro cactus),[2] paradoxically allows percepts to recede in depth but stay the same size as opposed to shrinking (Klüver 1966: 78). Siegel includes a drawing of a vision in which a scene that seemed far in the distance nevertheless was impossibly replete with detail (1977: 137, upper left). Amaringo shows detail at the same magnitude no matter where the images appear in space, for example, tiny but complete cities in the distance in two works (figs. 1.1, 1.2). Likewise dimensionality may be exaggerated, from seeing a line so thin and colorless that it approaches one-dimensionality to perceiving flat things like relief maps and three-dimensional things as hyperplastic, that is, extremely volumetric (Klüver 1966: 27, 66). Unlike objects' appearances under normal circumstances, visionary percepts' location in space may be either unclear or deemed irrelevant; they defy "an exact egocentric localization," at best described as "rather near but floating indefinitely in the air" (ibid.: 27). These profound differences from the everyday become difficult to convey in the language employed for ordinary spatial relationships. They are, however, aptly communicated by the Moche Visionary Scenes discussed in chapter 8.

Yet different does not necessarily mean unreal or unbelievable. There is a conceptual and/or affective component to the visual paradoxes presented in visions that counters necessarily judging them as imaginary. For instance, in the absence of the usual cues of diminishing object size, a person simply *knows* that the thing is receding. Emotional, psychological, and spiritual elements are inextricable from the perceptual as well, making them convincing on various levels to the individual. For instance, a person may completely identify with the geometric patterns being "seen," reporting: "'I am fretwork; I hear what I am seeing; I think what I am smelling; everything is fretwork . . . I am music, I am climbing in music; I am touching fretwork; everything is the same'" (ibid.: 22). The profound interpenetration of the various senses is an effect known as synaesthesia (described below), yet it carries no sense of paradox as one would expect under ordinary perceptual circumstances. This exemplifies a larger visionary phenomenon, described as the "dissolution of boundaries between self and others, world, universe" (Dobkin de Rios and Katz 1975: 66–67). Other, even more far-reaching distinctions, such as between the present and the future, the human and the animal, terrestrial and celestial or underworld perspective, are routinely elided as well during trance.

However, if what is perceived during visions did not seem as real as or more real than the quotidian world, visions would not likely be taken seriously as the basis of a spiritual system. While Westerners may tend to define visions as all that is unreal, hallucinatory, illusionary, imaginary, even psychotic (Narby 1998: 42n13), shamans, anthropologists, scientific subjects, and other visionaries agree that the percepts, as well as the feelings and revelations that infuse them, seem truer and more real than the objective world of normal waking consciousness.[3] An anonymous Huichol shaman summed up: "'There are no hallucinations with peyote. There are only truths'" (in Siegel 1992: 29). Citing the Siona, Shuar, and Yagua beliefs regarding *Banisteriopsis caapi* and other entheogens, Luna avers, "These plants reveal the 'real' world, while the normal world is often considered illusory" (Luna and Amaringo 1999: 13n4). In fact, the Shuar give a newborn baby entheogens "to help it enter the 'real' world" (Johnson 2003: 338). For the Aguaruna, "the hidden world is taken to be the true world which underlies and causes the visible world" (ibid.). The Ashininca "seemed to consider the visions produced by hallucinogenic plants to

be at least as real as the ordinary reality we all perceive" (Narby 1998: 20). According to Wasson,

> What we were seeing [under psilocybin mushrooms] was, we knew, the only reality, of which the counterparts of every day are mere imperfect adumbrations . . . The blunt and startling fact is that our visions were sensed more clearly, were superior in all their attributes, were more authoritative, for us who were experiencing them, than what passes for mundane reality. (1980: 16)

In sum, "in the province of the mind, the border between hallucinations and reality is easy to cross" (Siegel 1992: 9).

Yet merely believing in them is not what makes visions seem real (our placebo effect);[4] in certain ways the perceptual parameters of a visionary situation appropriate the rules of usual experience, making the reality of the vision easy to conclude. In other words, there are parallels between the normal perceptual rules and those governing visionary phenomena. There are also ways in which the visionary claims precedence over the mundane; it may appear more persuasive, even superior. For instance, when a mescaline subject's eyes are open, the objective world may appear colorless or all gray and its objects less solid than when the subject closes her eyes and reenters the colorful, three-dimensional, visionary world (Klüver 1966: 34). This "closed-eyes seeing" is key to shamanic vision and to the artistic record; one major category of what I am calling trance eyes are, in fact, closed. Shamans typically sing with their eyes closed as well, so that going into trance and being in trance likewise take place without looking outward (Wiese 2010: minute 5). The effects lent by both opening and closing the eyes add to the inherent believability of the vision in other ways. With open eyes the things of this world and those of the Other Side can be perceived simultaneously, overlaid in dual consciousness. With closed eyes many visionary objects still appear identical to everyday ones like cats, people, trees, and houses. Thus, the two worlds are equivalent, having many objects in common and even occupying a single space, and so the confidence in quotidian objects transfers to their counterparts in other realms. Yet wherever they may be, Here or Not-Here or both, familiar things tend to appear

hyperplastic, more intensely colorful, and their contours more sharply defined than usual. The Other Side charges everything with more energy; it magnifies, shifts, and expands all aspects as part of its *extra-real* character.

Perhaps most convincingly, the visionary percepts maintain constancy of location. For instance, a subject saw a disembodied head in one spot and then reported, "'I look in a different direction. After a short time there appear pale, sad looking human faces . . . I look back in the first direction and, frightened for a moment, see the same head at the same place'" (in Klüver 1966: 27). The disembodied head does not travel with the person's eyes when she looks away but stays in its location just as things do under ordinary circumstances. Visionary percepts also cause the same visual effects as the objects of everyday life, such as the occurrence of color afterimages that appear, for example, when one stares at a blue object, looks away, and then sees the complementary orange version of it (Arnheim 1974: 343). Visionary afterimages are very commonly reported, and because the colors are so heightened in visions, afterimages are more visually intense as well. These familiar effects help convince the visionary that the Other Side constitutes a parallel reality, not a fiction.

An even more persuasive truth is ascribable to visionary consciousness: knowledge gained while on the Other Side may be interpreted as more complete than pre-existing terrestrial wisdom. Klüver describes how a man first studied a regional map, then under the influence of mescaline saw it in minute detail, with the notable addition of a town that the actual map had been missing (1966: 37). Klüver attributes this to mescaline heightening memory for detail; conversely, a traditional shamanic viewpoint might consider that the spiritual realm possesses knowledge greater than that of the human. The miraculous, instantaneous ability of the unlettered Doña María Sabina to read what she called "The Book of Knowledge" during a vision is another example (Wasson 1980: 48). During trance, Saint Peter showed Doña Isabel, a shaman of north coastal Peru, the exact look and location of the sacred lagoons she had yet to visit, and when she did they were exactly as she had been shown (Glass-Coffin 1998: 65). Likewise, another shaman of north coastal Peru, Doña Flor, was shown the place where she

could find a pack of tarot cards to use for divination; she later walked there and found the actual deck (ibid.: 71). Don Pablo could speak Quechua only during trance (Weise 2010: minute 20). These experiences proved to them the omniscience of the spirit world.

Experiencing other realms as places that predict events Here certainly gives truth and reality, even superiority, to There. Indeed, accurately seeing the future is commonly described, such as a man who saw his not-yet-conceived daughter as a young girl and on another occasion found himself at the cave he had witnessed in visions months before (Metzner 2006: 125–127). Indigenous people report viewing distant current reality to which they have no physical access; an unidentified group on the Ucayali River of eastern Peru

> who frequently practice the use of *ayahuasca* sit at times together, and, drinking it, propose that they see something of the same subject, for example: "Let's see cities!" It so happens that the Indians have asked white men what those strange things [*aparatos*] are which run so swiftly along the street: they had seen automobiles, which of course, they were not acquainted with (Harner 1973a: 169).

Don José Campos, a shaman from southeastern Peru, told me he knew a ninety-year-old indigenous man who had never left the jungle physically but from his ayahuasca journeys could draw planes, boats, motors, and computers (personal communication 2003). Such incidents appear highly persuasive that the Other Side is a powerful place from which to accurately view mundane time and space.

Thus, from the outset the experience of strange yet believable visions naturally gives rise to a dualistic perspective, an overlapping perceptual interaction of this realm and others. Many cultures resort to the analogy of the vision as a journey, the Shuar and Siona among them (Harner 1973a: 158–160), as well as Western popular culture (Siegel 1992), underscoring the perception of the Other Side as a real place, space, time, and world(s) that one visits. A Tukano headman explained, "'I travel a lot when I drink *yagé* . . . Surely people must have seen me wherever I went. But one cannot harm others when one travels

that way'" (in Reichel-Dolmatoff 1975: 195). The Tukano, furthermore, conceptualize the world as having its double or mirror image in another dimension, a place where the Master of Game Animals lives, where spirit-beings dance, sing, drink yagé, and so on, just like humans do on This Side (ibid.: 192).

For present purposes, the visionary world's believability sets up the possibility for art to illustrate other realities in the same terms as those used to depict this world. It allows for a concrete image that may be a direct encapsulation of visions. If the visionary realms are deemed as real as the terrestrial, then the apparent paradox of a person who is both Here and on the Other Side—experiencing dual consciousness—can be bridged.

DUAL CONSCIOUSNESS

During this journey, "*without loss of consciousness*, the subject enters a dream world which often appears more real than the normal world" (Schultes and Hofmann 1992: 13–14, my italics). Having visions of other realities is not synonymous with being unconscious (except with datura),[5] being possessed, or losing all sense of self, but rather the opposite. Besides taking visionaries' word for it, there are several ways to verify that people remain conscious during altered states, such as seeing them dancing, singing, and performing other dramatic actions (Lizot, Curling, and Jillings 1996: minutes 10–14, 32–33; Mann 1999: minute 18). Visionaries can and usually do communicate during the experience, narrating the spiritual journey as it is taking place. For instance, under *Virola* the Yanomami expostulate (Mann 1999);[6] under San Pedro cactus, Don Eduardo produced long divinatory discourses on what he saw (Sharon 1972: 43); and Klüver describes mescaline subjects as talkative, narrating their experiences as they occurred (1966: 53, 90). Indeed, Munn calls psilocybin the "mushrooms of language" for the marked verbosity it engenders:

> Intoxicated by the mushrooms, the fluency, the ease, the aptness of expression one becomes capable of are such that one is astounded by the words that issue forth from the contact of the intention of articulation with the matter of experience. At times it is as

if one were being told what to say, for the words leap to mind, one after another, of themselves without having to be searched for. (1973: 88)

That a person can describe his ongoing perceptions, as a Yanomami shaman does on tape (Lizot, Curling, and Jillings 1996: minutes 10–14, 32–34), constitutes evidence that dual consciousness is apparent to and directed at others within shamanic societies. It provides veracity, like an announcer calling a baseball game on the radio.

As further evidence for consciousness during visions, they remain profoundly memorable over long periods of time and across different entheogens and other methods of inducement. Don Augustín Grefa, a highland Quichua shaman from south-central Ecuador, recounted in extreme detail a particular vision from years earlier despite having had other visionary experiences weekly since then (personal communication 2004). Amaringo painted specific renditions of his many shamanic visions well after the fact, saying of a painting completed in the late 1980s, "I had this vision in 1971" (Luna and Amaringo 1999: 106). Klüver, an occasional subject in his own experiments, avers, "One looks 'beyond the horizon' of the normal world, and this 'beyond' is often so impressive or even shocking that its after-effects linger for years in one's memory" (1966: 55). Wasson likewise finds that in his visions from ingesting sacred mushrooms, "all the impressions, visual and auditory, are graved as with a burin in the tablet of my memory . . . [which] is far richer and fuller than those notes" he took after the experience (1980: 27). One of Naranjo's subjects wrote a forty-page description of his six-hour ayahuasca experience and took more than an hour to talk about it, remembering a vast array of detailed experiences (1973: 178). Through the clear memory of the visions dual consciousness arguably can be relived at will, both for the visionary as a private act and for the community by recounting them publicly. Telling or painting the blow-by-blow of past visions resembles a traveler describing in detail her sojourns years later, recreating the reality of the experience for her and others.

There is an even more direct way past visions can infiltrate the present perceptibly. Well after a visionary experience, "striking visual effects" can

be replayed during normal consciousness, spontaneously recreating the dual state. For example, a man re-experienced becoming a lion a week after the vision and without any entheogenic intake (Metzner 2006: 152). Shamans can actively seek recurrences of visions, known colloquially as "reruns" or "flashbacks" (Siegel 1992: 65–80). Amaringo would purposefully sing his power songs and "then the visions come again, as clear as if he were having the experience again" (Luna and Amaringo 1999: 29). Some occur quickly, as a sort of aftershock: upon awakening the morning after a vision, Klüver again saw the brilliantly violet, kaleidoscopic patterns whether his eyes were open or closed (1966: 87). Siegel finds that visions

> might return as single fleeting images, like snapshots from a holiday trip, or they might appear as a rerun or flood of images depicting an entire sequence of events. The snapshots are almost always brief flashes lasting one or two seconds. Reruns have been known to go on for as long as one hour. As time passes, the flashbacks decrease in duration and frequency, eventually disappearing altogether. They tend to occur within the first few weeks after a trip, although flashbacks persisting for weeks or months after a particularly intense drug experience have been reported. (1992: 68)

In the case of natural entheogens taken often, the tapering-off effect may not apply; altered consciousness recurs often and is not considered unusual (Grefa, personal communication 2005). Reichel-Dolmatoff discusses how the phosphenes recur for six months and become permanently accessible after repeated visions (1975: 174).

Most intriguing for the present purposes, however, is that art can serve as a trigger for visionary recurrences. Siegel mentions the catalytic role of looking at a picture that either reminds the person of patterns seen during an altered state of consciousness or was seen during the experience itself (Siegel 1992: 69). Reichel-Dolmatoff discusses how visionary recurrences are triggered in the Tukano by the visual environment, including the geometric patterns of the house forms, baskets, and by implication all the visions-inspired, decorated works of art (1975: 174–175, figs. 41–53). Thus, the patterns, deliberately placed on art

objects to represent the phosphenes from visions, have the direct power to pull the visions into this realm, to bring the Other Side back. This dynamic and highly calculated relationship between the visionary experience and works of art serves as a key element in reconstructing the sacred nature of geometry in ancient shamanic art, as will be discussed in subsequent chapters.

MULTIPLICITY AND FLUX

Visions, whether geometric or narrative in content, are characterized by their fundamental multiplicity and flux. A very high number of percepts rapidly change into other things, just as the person can experience profound shifts in personal identity, as we shall see in chapter 2. Multiplicity also means seeing repeats of individual elements across the visual field, more than one sense being involved, and the overlapping of sensory modalities. Flux, or change, occurs in the scale of percepts (macropsia, micropsia) and in perspective (aerial, internal, underneath, and inverted views). Multiple transformations also take place with the body, ego, and soul losing connection to one another and reconfiguring in significant ways. Change encompasses the moving position of the body and what is seen, especially in three main directions: spiraling, undulating, and radiating. Most of these qualities are both visual and conceptual; for example, visionaries take different perspectives in both senses, literal and metaphorical.

Percepts "'in frantic motion which continued for such a long time as if it would never stop'" (in Klüver 1966: 41) are reported. For instance, one subject witnessed "'mathematical figures . . . chasing one another wildly across the roof,'" another "'animals in frantic motion, I see a crow and a black cat racing on'"; a third saw a cigarette moving in the dark room "'desperately fast, as fast as it cannot be performed by any human being'" (ibid.: 14–15, 30, 41). Because of how fast everything changed, subjects became aware of "motion per se," especially at the outset (ibid.: 18, 28). In Siegel's experiments subjects saw "as many as ten changes of image per second" (1977: 136). Under ayahuasca the person often feels a sensation of moving very quickly (Reichel-Dolmatoff 1969: 329) and of things changing suddenly:

"I went at a terrific speed . . . I suddenly saw a man running. He was a messenger. I had to slow down and placed myself next to him. That is, next to his face, since . . . only my soul participated. My soul is a sphere of some 7 cm. in diameter, pure energy, and it rotates on itself at such enormous speed that it would be the same if it didn't. It can displace itself in any direction at the speed it wishes." (In Naranjo 1973: 178–179)

Others recounted, "'Suddenly, a crucified Christ ascended moving his arms like wings. And then another . . . all these movements were at an incredible speed'" (ibid.: 181); "'at one point, riding on its [a giant serpent's] back, we were moving incredibly fast through the universe'" (in Metzner 2006: 209); "'I was flying with abandon through the jungle, speeding past lush vegetation, animals, jaguars, birds, snakes, and other luminous beings on a kaleidoscopic roller coaster'" (ibid.: 213). Amaringo's canvases capture this hectic pace by packing in so many images: I counted seventy-two figures in Vision 30 (Luna and Amaringo 1999: 107), excluding plants, architecture, and geometric patterns.

One example among hundreds, the rest of the experience of the woman with the "spherical soul" illustrates the sheer number of images displacing one another very quickly. She also saw a giant wearing leopard skin and threatening her with a whip, a black snake threatening to devour her, a funeral procession, many tiger faces, an ascending Virgin and Child, a tiger she rode, a fight between the tiger and a female snake, lizards and toads in a primeval swamp, dinosaurs, and a volcanic eruption into which she threw herself and ascended into the sky with the flames (Naranjo 1973: 183–185). The endless possibilities strike researchers and visionaries alike: "It seems as though there were no limit to the number of different shapes an object may assume in the visual experiences of different subjects. Every conceivable distortion has been reported" (Klüver 1966: 78).[7] Usually one percept melts seamlessly into the next; an effect termed "metamorphopsia" (ibid.: 72). For instance, "'suddenly a little man is standing there changing continually in appearance, sometimes he has a beard, sometimes not, the covering of his head is also changing'" (ibid.: 30). A taker of ayahuasca saw her guide turn into an old Indian sha-

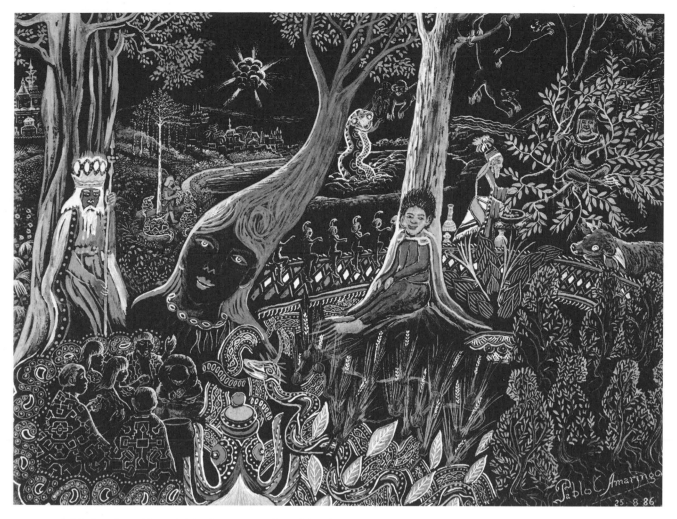

FIG. 1.1. Pablo Amaringo, Vision 4, *The Spirits or Mother of the Plants* (Luna and Amaringo 1999: 55). Permission of North Atlantic Books, Berkeley, California.

man; another first saw the Virgin Mary shape-shift into Jesus, then all the men in her life become one other and then the Devil (Metzner 2006: 163, 226). This effect applies equally to oneself: "'I see my face, my internal image, melt, flow, re-form, congeal. Repeatedly, a new face, a new persona, consolidates, steps forward, briefly, then fading, one followed by the next'" (ibid.: 234). Figures in Amaringo works are shown melting into trees (fig. 1.1), the sky, and the black background (figs. 1.2, 1.3) and shamans become wolves (fig. 1.4).

Not only do fast-moving and changing percepts and selves characterize the altered state of consciousness, but each percept may be repeated several to many times across the visual field. Double vision, or diplopia, a type of visual repeating, often occurs under the influence of mushrooms

(Wasson 1980: 48). Similarly, under mescaline the image of one person may become two mirror images (diplopia), then the two split off and run away from each other (Klüver 1966: 44). As with other transformational imagery, one image often becomes many (polyopia), such as a screw that becomes hundreds or a single cat face that gives way to many cat faces, then a field of repeated cat eyes (ibid.: 17, 30, 31), or a statue that multiplies ad infinitum (Metzner 2006: 143, 148). Many describe arrays of motifs that seem to go on forever, "a kaleidoscopic play of ornaments, patterns, crystals, and prisms which creates the impression of a never-ending uniformity" (Klüver 1966: 21–22). Amaringo's visions feature long series of snakes (figs. 1.2, 1.5) and spirals (fig. 1.6), especially a huge one with figures and flowers that does not

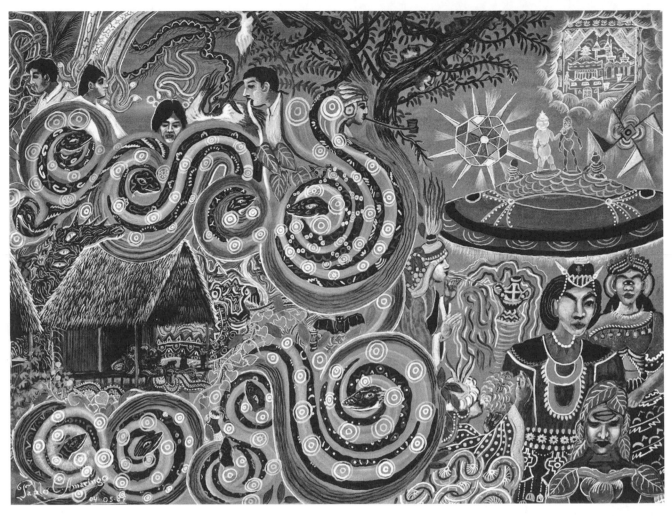

FIG. 1.2. Pablo Amaringo, Vision 42, *Lucero Ayahuasca* (Luna and Amaringo 1999: 131). Permission of North Atlantic Books, Berkeley, California.

end at the top of the painting but seems to go on forever (fig. 1.7). Often the repeated images line up in rows. One image may beget or emit another and another: "'at first the [black metal pipe] organ was stationary; then out of the upper pipes there developed smaller and smaller pipes moving upwards continually followed by new pipes'" (in Klüver 1966: 31). One may watch more and more fingers grow on one's hands, an effect Klüver calls polymelia (73). With eyes open, the visionary sees objects in the mundane world also multiply freely (30). The actual room may feel as if it is filled with the presence of many people (73); Don Agustín recounts seeing the spiritual presences of all his deceased relatives in the room with him (personal communication 2005).

A further striking aspect of the multiplicity

of visions is their multisensory nature, not only visual but also auditory, tactile, olfactory, and gustatory (Schultes and Hofmann 1992: 12). The initial indication of the entheogens taking effect is often auditory: Grefa describes the sound of a loud buzzing insect or an oncoming train as the first percept under ayahuasca (personal communication 2005). The Tukano report that "when one takes *yajé*, first one hears something like a heavy shower" (Reichel-Dolmatoff 1975: 171). Another made this analogy: "'Like the Santa Ana winds winding their way trough the mountain passes before their window-rattling, tree-shaking descent, I could sense the *ayahuasca* coming before it arrived'" (in Metzner 2006: 182). Grefa has mentioned hearing drumming as a prelude to communication with his counterparts in Africa (Stone

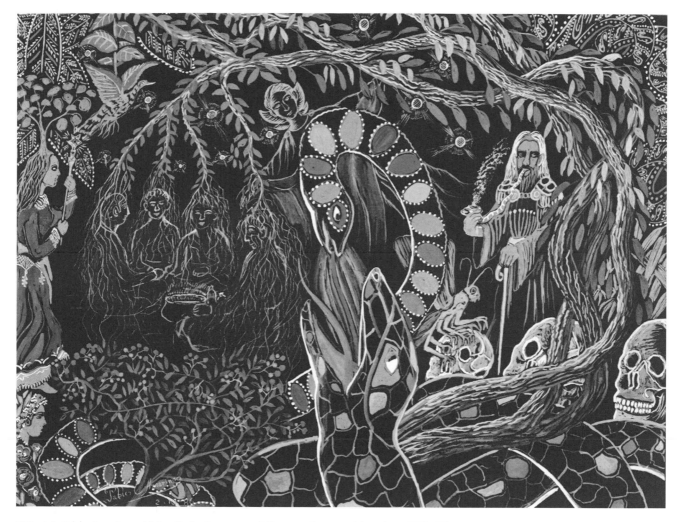

FIG. 1.3 Pablo Amaringo, Vision 3, *Ayahuasca and Chacruna* (Luna and Amaringo 1999: 53). Permission of North Atlantic Books, Berkeley, California.

2007b: 16). One ayahuasca visionary heard the roar of a red dragon as it flew through his body (Metzner 2006: 218), while another heard a voice answer his questions about his scientific research (Narby 2002: 160–161).

Among the six types of ayahuasca identified by the Tukano, the strongest creates marked auditory as well as visual effects (Schultes and Hofmann 1992: 121). Under the effect of sacred mushrooms one hears the sound of thumping beats "as though it was the rhythmic pulse of the universe" although no one is playing a drum (Wasson 1980: 30). Auditory effects include sounds coming from all different places, first close then far, louder then softer as if moving locations (ibid.: 23, 34–35, 48). Under mescaline, sounds may seem either preternaturally loud or noticeably muted, and one can

hear and be aware of subtle undertones in voices. Smell is affected as well; many perceive strong odors or have no sense of smell at all (Klüver 1966: 47–48). Don José Campos' first indications of trance are strong smell as well as clear and amplified hearing (personal communication 2003).

It is worth noting that traditional shamanic rituals heighten all sensory modalities, induce sensory overload with the use of bright bird feathers, hours of chanting and dancing, colorful body paint, and strong smells like perfume, alcohol, and orange water mixed with the brew (Dobkin de Rios and Katz 1975: 71). The visions and the ritual in which they are contextualized obviously echo each other's multiple sensory enhancement. I will argue that works of art from many different ancient American cultures exhibit intentional

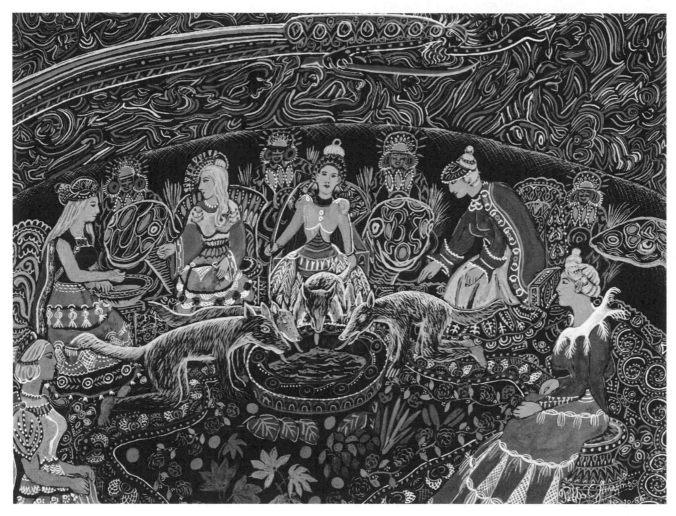

FIG. 1.4. Pablo Amaringo, Vision 45, *Vegetalistas Transforming Themselves into Wolves to Hide from a Sorcerer* (Luna and Amaringo 1999: 137). Permission of North Atlantic Books, Berkeley, California.

exaggeration of all the sensory organs to convey the trance state.

Perhaps the most extreme and pervasive multisensory aspect of visions is the common experience of synaesthesia, Greek for "union of sensation" (Paulesu et al. 1995: 661). This inter-penetration of the usually distinct senses was first recorded with blind people who heard a tone for the name of a color, namely a trumpet blast for the word "scarlet" (ibid.). Various sensory crossovers may be induced by a number of entheogenic sub-stances. Under mescaline, subjects experienced rhythmic sounds as gray circles, sounds or visual movements as sensations on the skin, touching as seeing lights, and a dog barking as vibrations in the right foot (Klüver 1966: 49–50). One per-son saw himself from the waist down as a spiral-

wound green cone that sounded like an accordion (ibid.: 24). More sensory modes may be involved: "'It seemed to me as if tones, optical phantasms, body sensations, and a certain . . . taste formed a unity'" (ibid.: 22, 71–72). "Synesthetic experiences under the effects of ayahuasca are common: the visions are simultaneously seen, heard, and even smelled" (Luna and Amaringo 1999: 38), as others have observed (Grob 2002b: 198; Ludwig 1969). Amaringo illustrates a vision in which a spider web created music (fig. 1.8) and had another vision in which an angel's vibrantly colored clothes pro-duced extraordinarily beautiful notes (Luna and Amaringo 1999: 26). Similarly, Wasson has found,

the bemushroomed person . . . is the five senses dis-embodied, all of them keyed to the height of sensi-

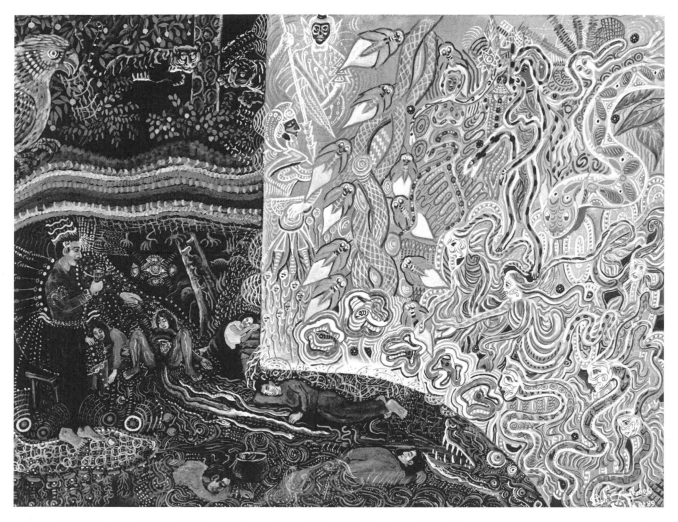

FIG. 1.5. Pablo Amaringo, Vision 32, *Pregnant by an Anaconda* (Luna and Amaringo 1999: 111). Permission of North Atlantic Books, Berkeley, California.

tivity and awareness, all of them blending into one another most strangely . . . what you are seeing and what you are hearing appear as one: singing and percussive beat assume harmonious shapes, giving visual form to their harmonies, and what you are seeing takes on the modalities of music—the music of the spheres. Likewise with your sense of touch, of taste, or odor: all your senses seem to function as one . . . the world of odors, delicate iridescent harmonies. (1980: 17)

There are other aspects of naturally occurring synaesthesia that relate to the visionary, perhaps reinforcing the possibility of synaesthetes being called to be shamans. First, "visual perception without external input to the visual system" defines both actual and visionary synaesthesia, at least the eyes-closed type of the latter (Paulesu et al. 1995: 662). Two adjacent parts of the brain seem to interconnect in synaesthetes; an unusually dually or cross-connected brain works well as an analogy to the shaman who is capable of perceptually inhabiting two worlds at once, crossing from one modality to another, from present to future, and so forth. Furthermore, in both natural and visionary synaesthesia, the percepts appear as real perceptual phenomenon, not metaphorical (not "That sound is like blue" or "It reminds me of the color blue"). Contemporary artist Carol Steen says that when she feels physical pain the color orange suffuses everything (2005); painter Marcia Smilack hears specific instruments play when she witnesses rippling waves of water (2005).[8] These are very like visionary experiences in the direct overlay of

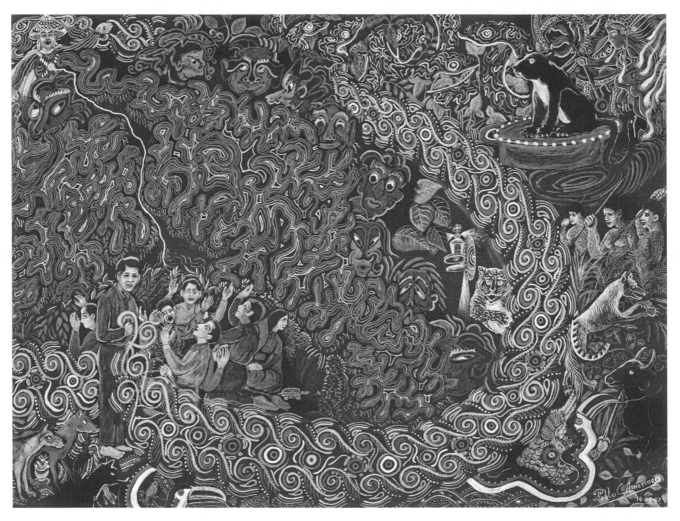

FIG. 1.6. Pablo Amaringo, Vision 44, *Fighting through Tingunas* (Luna and Amaringo 1999: 135). Permission of North Atlantic Books, Berkeley, California.

another sensory reality on the objective world, the flux in senses, and the oddity of the resulting perceptions in relation to everyday ones. Furthermore, "Synaesthetic percepts are not confused with events in the outside visual world" (Paulesu et al.: 673); thus, there is a dual consciousness despite the striking nature of the sensory effects. Like shamans-to-be, synaesthetes often experience their distinctive perceptions from an early age and, realizing that their sensory world differs from others, can be reticent to accept or share their experiences (ibid.: 662). They tend to be exceptionally attuned to the senses and therefore artistic—Scriabin and Messiaen were synaesthetes (ibid.: 661)—and many become visual artists to communicate their unique vision. Several ancient

vessels, I contend, illustrate synaesthesia directly, as discussed in chapters 7 and 8.

Many other visual effects involving multiplicity and flux deserve mention as well. Unusual, multiple, or shifting scale of perceptual phenomena is typical in visions. This dysmegalopsia (seeing things in the wrong size) includes micropsia (seeing things as undersized) and macropsia (seeing things as oversized). Perception of exaggerated size characterizes various entheogens. Under ayahuasca, snakes may appear as tall as two-story houses (figs. 1.2, 1.3, 1.7; Metzner 2006: 119); there may be giants (Luna and Amaringo 1999: 64–65, Vision 9) or tiny green "ayahuasca jungle elves" or little pastel cartoonlike people (figs. 1.1, 1.7; Metzner 2006: 121, 179). Under mescaline, "'transparent

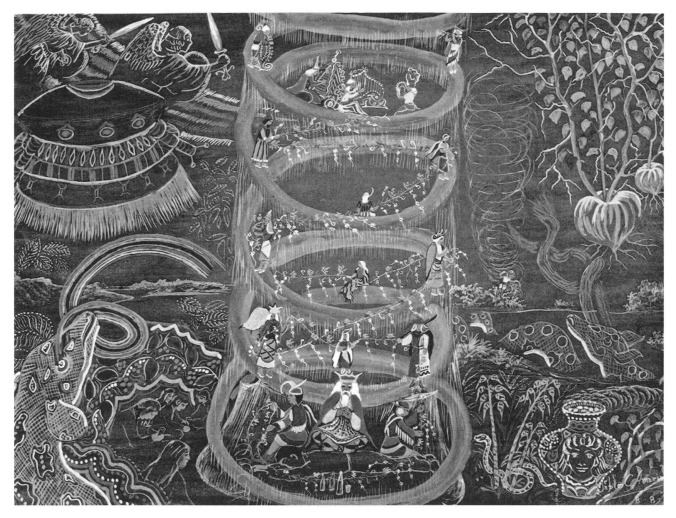

FIG. 1.7. Pablo Amaringo, Vision 27, *Spirits Descending on a Banco* (Luna and Amaringo 1999: 101). Permission of North Atlantic Books, Berkeley, California.

oriental rugs but infinitely small'" have been seen (in Klüver 1966: 21); under mushrooms, minute dancers gyrated inside a vase (Wasson 1980: 29). Scale can shift while one looks at something or takes some action; one's hand can grow huge when one waves it, or when one takes a bite of a loaf of bread the other end of the loaf can enlarge (Klüver 1966: 38–39). Much art dedicated to conveying the visionary experience features the impossible mixture of scales, such as Yando's drawing of an ayahuasca experience in which a tear falling from an eye contains faces, mushrooms, people, landscapes, and more (fig. 1.9; Schultes and Hofmann 1992: 127).[9]

Related to shifts in the apparent size of visionary entities are those in perspective, seeing things from above, below, or inside, for example. Conceptual changes in perspective, meaning how one understands an object or a situation, are also fundamental since the revelatory aspect of visions is paramount. However, on the visual level, taking an aerial viewpoint is widely described and results from the typical sensations of suspension and flying. Doña Isabel recounts, for instance, "'I sat in the clouds, not on the earth . . . If I reached out my hand, I felt nothing, I touched the emptiness [of the sky] in spite of the fact that I was really sitting on the ground'" (in Glass-Coffin 1998: 64). Doña Olinda, at the same ritual and also under the influence of San Pedro cactus, further explains that Isabel's spirit was not at the mesa but in the sky: "'It was as though from there she looked out over

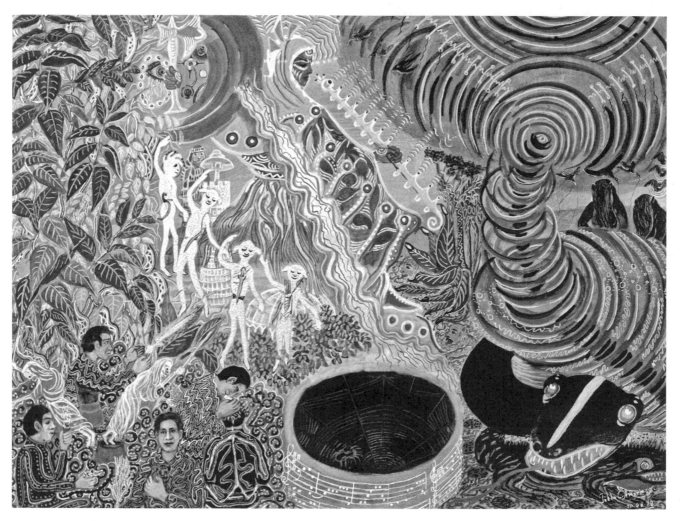

FIG. 1.8. Pablo Amaringo, Vision 47, *Electromagnetism of the Yana-Yakumama* (Luna and Amaringo 1999: 141). Permission of North Atlantic Books, Berkeley, California.

all the problems the patients would have'" (ibid.). The widespread experience of flight when taking San Pedro is credited for the idea of creating the enormous Nasca Lines to be seen from above, in the supernatural sphere (Reiche 1993: minute 21). Be that as it may, a higher visual perspective and comprehensive understanding seem to go hand in hand in shamanic thought. Under ayahuasca, one subject watched from above a colorful rotating umbrella, and another floated above the field as a butterfly and witnessed his own death (Naranjo 1973: 180–181). A scientist-visionary under *Banisteriopsis caapi* saw DNA from the point of view of a protein flying above the strand (Narby 2002: 160). Under mescaline, aerial perspective is characteristic as well (Siegel 1977: 137, lower right). Wasson avers that under the influence of mushrooms,

"many feel as though they are rushing through the air, riding a great bird with wide wings, whirling high in the sky in wide gyres, looking down on the earth far below" (1980: 47). Aerial perspective can be experienced simultaneously with the usual human corporeal sensations as another aspect of dual consciousness:

[T]here is no better way to describe the sensation than to say that it was as though my very soul had been scooped out of my body and translated to a point floating in space, leaving behind the husk of clay, my body. Our bodies lay there while our souls soared . . . we were split in the very core of our being. On one level, space was annihilated for us and we were traveling as fast as thought to our visionary worlds. On another level we were lying there on our

petates [palm sleeping mats] . . . alive to every twitch and twinge in our heavy (oh so heavy!) earth-bound bodies of clay. (Ibid.: 15–18)

These comments demonstrate the keen awareness of two ways of seeing/being at once, the soaring and the earthbound. In art, the addition of wings, inversion, and denial of a ground line are common ways to signal suspension. Artists select various ambiguous body positions to help convey shamans' paradoxical freedom from gravity as well as of being in two places at once. Amaringo's visions are full of suspended scenes, beings, trees, and so forth, as well as unusual body poses.

Other viewpoints from below and even through percepts occur as well. Siegel illustrates a mescaline vision that took an underwater perspective (1977: 137, lower left). Another man reported, "'I saw the outline of the body of a huge lizard, looking up at him from below, as if he had just landed on a skylight in the roof'"; later, as if on the ceiling, he saw a man in a cave (in Metzner 2006: 125). Moving or looking through matter also occurs. "'I realized I was falling slowly through the earth, through soil and rock, moving faster and faster, then dropping out the other side into deep space'" (ibid.: 120). One man moved through the Wailing Wall to find joyous rabbis on the other side (ibid.: 210). Luna describes looking through the closed roof at the stars (Luna and Amaringo 1999: 11), and a Shuar shaman saw a coiled snake inside a patient's abdomen (Harner 1973a: 170, fig. IV). One of Klüver's subjects saw a skeleton as in an X-ray (1966: 18). Seeing into one's own body is reported as well: "I could see the insides of my body, red" (Narby 1998: 7–8); "'I also could then look at (feel into) my visual system itself and feel that it was very clogged up'" (in Metzner 2006: 207). Percepts may be felt as passing through oneself: "'the swirling, swaying mass of kaleidoscopic, geometric shapes flowed around and through me, softly exploding and imploding'" (ibid.: 126). Brilliant light "'that seems to pass through the viewer . . . [and] touch the very essence of one's Self'" is noted (145). This penetration can manifest conceptually as well: "'I was able to see through [the human technological world] to the pulsating energies of the world of all-encompassing nature'" (119). The idea that visions access the internal essence of a situation, disease, or future is

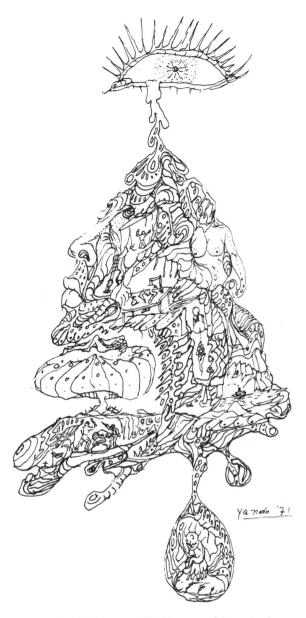

FIG. 1.9. Yando, *Lágrima*, 1971. Courtesy of the artist.

a conceptual equivalent to the perceptual effects (Stone-Miller 2002b: xxi–xxiii). Ancient American art certainly reflects a concern for the interior, often featuring "X-ray" views.[10]

Reversed or interior perspective, that is, upside down or looking from the inside out, are also described. "The earth spins and the ground rises to the head" under ayahuasca (Reichel-Dolmatoff 1969: 329). "'I felt like I was in areas of my body I had never consciously been in before, this lifetime. At one point I felt I was turned inside out—some force reached into my mouth and throat and pulled my insides out, until my inner organs

were all on the outside, hanging out, so to speak, and limbs and muscles had become packed on the inside'" (in Metzner 2006: 121). Being systematically disassembled, cleaned, and reassembled was another of this person's visionary experiences, and others report the common shamanic death by dismemberment (ibid.: 245; Halifax 1982: 76–77). In a larger sense, being "turned inside out" epitomizes the general dissolution of everyday boundaries that permeates the visionary experience and shamanism itself.

One of the most radical of all perspective changes is the perceived dissolution of the usual sense of self—the ego and its accustomed relation to a weighted human body—and concomitant access to a different, more all-encompassing Self. Ayahuasca "'brought me in touch with something very essential,'" said one person, "'something very deep within myself, allowing me access to a core identity that is normally obscured by ego and attachment . . . I have been catapulted to a domain of being other than my self, more akin to my True Self'" (in Metzner 2006: 135, 140). This has been called the "depersonalization" effect of entheogens (Schultes and Hofmann 1992: 13). Examples abound: "'I felt I was losing my identity. It was as if I was being re-formed, re-wired, re-made, and that in this process there is not content for the mind to work upon, only the experience itself'" (in Metzner 2006: 204); "'I had the sense that my ego, my familiar identity, was beginning to fragment'" (136); "'My world implodes . . . leaving only vague outlines of what had once been an identity'" (230); "'It was not that there was a "me" pretending to be "them," or a "me" plugged into the five senses of another. It was more like the "me" had become "them," therefore the "them" was now "me"'" (255). The difficulty involved in verbally conveying this ineffable experience is readily apparent.

Often the soul is experienced as separable from the corporeal and the ego; what was assumed to be a unified whole suddenly consists of distinct parts whose roles and importance are called into question. A person may equate this with death of the body and ego but not the new, overarching Self:

"I began to experience dying. I knew that it was my ego dying and that my mind was emptying out, stilling. Soon there were no thoughts left, only conscious-ness. My body was now on a barge floating down a river. It felt like the Nile, but it was known as the River of Letting Go. My body was dead, but I remained in it." (Ibid.: 149)

Obviously "I" and the body/ego were no longer synonymous, as another explains:

"I was realizing that my body and my mind were such autonomous forces that if they ever had converged in me it seemed pure chance. What during my entire lifetime I had sensed like mingled confusion now appeared to be divided into three precise domains: outside lay the world, people, buildings, and noises (for which I cared less and less); closer, as a boundary, stood my organism, with those hands, that mouth and its laugh, now commanded by itself; inside, at last, in the innermost and recondite, warmly floating in the skin that was always with me, was I. That is, my mind." (In Naranjo 1973: 179)

The switch from "my organism," already a rather objective term, to "those hands, that mouth and its laugh" exemplifies loss of bodily identification. The floating "I" conveys both the recurrent visionary experience of the lack of gravitational pull on a body and more metaphysical mental/spiritual detachment. Certainly identifying oneself as an invisible mind housed inside a skin casing profoundly redefines everyday consciousness.

Another such fundamental recasting of self was introduced in the case of the "spherical soul" individual, who further contended, "'My soul sees, hears, thinks; it perceives odors, I believe, but has no sense of touch for the simple reason that it repels matter'" (ibid.: 178–179). In such a dissolved body, the core Self is the soul, yet this bodiless entity continues to experience the senses (except touch, understandably underreported by visionaries given the loss of corporeal sensation). This sensation without anything material to house it obviously represents a significant departure from usual human experience of the body. This reduction to an abstract, moving, sensing being with little materiality at all has major implications for how seriously artists compromise and essentialize the body while simultaneously exaggerating the sense organs in a shamanic effigy.

Importantly, visionary detachment and reidentification contain deeper implications for art

objects that must somehow embody the disembodied shaman. In short, visions radically transform the normal relationship between subject and object itself. As Klüver explains, under mescaline,

> the line of demarcation drawn between "object" and "subject" in normal state seemed to be changed. The body, the ego, became "objective" in a certain way, and the objects [that are seen in visions] became "subjective." They became subjective not only in the sense that they behaved as visionary phenomena, but also in the sense that they gained certain affective qualities. (1966: 55)

In other words, the visionary becomes objective about or detached from herself (I call this the "objective subject" effect) but can identify with and find life in things normally understood as inert and external to her (the "subjective object"). What feels like "you" extends to what were previously thought to be other phenomena; you and not-you are revealed to belong to a larger gestalt. The experience of larger, fully animated unities in which the human is a relatively minor component is a common, fundamental revelation of trance consciousness.

Of immediate and central importance to the present study is how the dynamic of the objective subject/subjective object effect may have a significant impact on the function of shaman effigies in ancient American cultures. Objects in general can never be "inanimate" in a visionary worldview since the shaman may report seeing them breathing, communicating with him, being him, and so forth. This animation doubly applies to the effigy, an object directly made to encapsulate only secondarily the shaman's bodily appearance and primarily his essential nature as a locus of sensory and transformational activity during trance. I argue that ancient Central and South American artists created effigies of shamans in trance primarily to be understood as containers for the shamans' essence identities, places for their visionary selves or spirits, rather than as images or illustrations of terrestrial, corporeal beings. One can readily identify with the effigy as a subjective object, given the detachability of the shaman's body, mind, and soul. Within this dynamic, both the visceral shaman and the effigy shaman are containers that function as intermediaries. The shaman has little

reason to privilege his everyday body as the "real" one. Through repeated visionary encounters with this separable partitioning of the Self and unified view of Self and Other, shamans grasp their role as conduits rather than agents, as I will discuss in chapter 3. The construction of an "art-body" that truly conveys this nonordinary objective/subjective perspective implies creating an intermediary object to be occupied by the shaman's wandering spirit. In fact, Amaringo shows a personified vessel in the lower right of figure 1.7 that he identifies as "Fadanat, a great magician woman with a thousand faces" (Luna and Amaringo 1999: 100).

Though the physical body may be rendered as profoundly secondary in visions, there are nevertheless ways in which physical distortions experienced under altered consciousness pertain to ancient American depictions of shamans' bodies. The usual feelings of hunger, thirst, or tiredness may not be felt, and one may not be able to speak or walk normally. Conversely, one might pace restlessly, the need for freedom of movement so great that clothes feel strangulating (Klüver 1966: 47–49; Metzner 2006: 233). San Pedro numbs the body (Schultes and Hofmann 1992: 156–157), and ayahuasca often causes extreme loss of motor control (Grefa, personal communication 2005). Problems walking may stem also from variable weight sensations, from weightless limbs to ones that feel abnormally heavy (Klüver 1966: 49). It may not seem "appropriate" or "necessary" to walk because one feels suspended, even flies, and so enjoys radical freedom from usual gravitational constraint. During visions, many see others levitate, sing, and dance in the air, as shown throughout Amaringo's paintings in which the top half is as full as the lower portions that take place (sort of) on the ground (Luna and Amaringo 1999: 26, 49). It may be significant that shaman effigies rarely portray "realistic" standing or striding; feet may dangle (Stone-Miller 2004: 57–58), or toes arch off the ground. Many portray sitting, but not necessarily on the ground, or pinwheeling positions of utmost bodily freedom.

During trance the body can lose its familiar unity, as if arms or legs were detachable or muscles did not belong to the person (Klüver 1966: 49, 73). "Another subject felt that with regard to his left hand, there was no 'feeling of continuity' with the rest of the body" (ibid.: 48). Parts of the body

transform or meld into the environment; one person's throat became a garden in which his arms were the paths, and another person's right half was felt to be completely continuous with the outside surroundings (ibid.). Amaringo conveys this blending of person and externals in the plant spirits in figure 1.1 through creative use of contour rivalry. For example, the hair of the cat-eyed female spirit of the left-center tree (*puka-lupuna*, or *Cavanillesia hylogeiton*) becomes the trunk and branches of a tree and the feet the roots. A group of four shamans is shown as part of the ayahuasca vine in figure 1.3.

In terms of corporeal distortions, the head may feel it is physically expanding (Metzner 2006: 118), which is germane to the pervasive cephalo-centrism, emphasis on the head, in shaman effigies. In Amaringo renditions this appears, for instance, in figure 1.2, in which the men in the upper left corner appear as only heads. The head alone may transform into a different being; Amaringo has seen snakes with toucan heads (fig. 1.6), snakes with women's heads, and humans with crocodile heads (Luna and Amaringo 1999: 61, 65). Limbs may elongate or truncate, swell or melt away, and the whole body may shrink or enlarge dramatically. Shaman effigies from various Amerindian cultures definitely betray such idiosyncratic corporeal distortions.

A final and perhaps more systematic and predictable expression of flux regards the movement of percepts in ways strikingly divergent from everyday circumstances. Keeping the eyes open under mescaline means that "on the one hand, actually performed movements may be perceived in an abnormal way; on the other hand, stationary objects may perform apparent movements" (Klüver 1966: 39). A normally inanimate thing can hop around and its various iterations remain simultaneously in the visual field. A walking person may appear discontinuously, that is, frozen at a few different points along her path. A lighted cigarette's movement may be translated into a series of balls of light that stay suspended in the air, then all jump onto the end of the cigarette as if on a rubber band (ibid.: 39–40). These kinds of odd effects, while not necessarily illustrated literally in ancient art, nevertheless reinforce the overall animism of objects in cultures with a visionary aesthetic.

LIGHT

While specific visionary effects may be idiosyncratic, there are important general ways in which light and color are reportedly perceived in trance experience.

> "When I had the eyes closed, it became brighter and brighter around me . . . this brightness which possessed depth . . . increased more and more and was finally so impressive that, in spite of being in the dark room and knowing that my eyes were closed, my critical attitude surrendered to this sensuous vividness and I opened my eyes expecting as a matter of fact to sit in a bright room. I found that the brightness impression lasted. I turned around to find the source of the light. It seemed very strange that it was bright but that I could not see anything." (In Klüver 1966: 20–21)

Before seeing patterns or imagery, the visionary was simply bathed in intense, almost pure light. Seeing preternaturally brilliant light, despite knowing through dual consciousness that one is in fact in the dark, constitutes one of the most common initial effects of trance. In addition to the other color effects, a generally high level of illumination affects everything that is witnessed. Almost all of the visionary paintings of Amaringo show light and supercharged colors on a dark, usually black background (figs. 1.1–1.4, 1.6, 1.7). One in particular, figure 1.5, directly illustrates the people lying down during the nighttime ritual in the dark left-hand area and the visions being seen in the vibrantly colored right-hand area, which is even more striking in the color original (Luna and Amaringo 1999: 111). Seeing light in the dark, impossible in everyday life, is a way that the visionary realm takes over immediately and irrevocably, reversing expectations. Thus, like nocturnal animals and unlike the uninitiated, the shaman has access to an intensified degree of light that elevates the seer beyond even animals' naturally superior experience of light. As in other religious traditions, in shamanism one is "illuminated" by the bright light shed on all phenomena, enlightened with new understanding and clarity. Not merely akin to turning on a light in a dark room, radiance completely pervades subsequent bodily sen-

sations and revelations as well: "'I began to experience a radiance at my crown center, at the top of my forehead, and at the brow center. This light remained throughout the rest of the journey'" (in Metzner 2006: 219). More far-reaching light-related revelations are typical: "'Our true identity as beings of light, at one with the forces of nature [was] revealed to me'" (ibid.: 232).

Besides general illumination, shamanic thought attributes certain specific types of light effects to the spiritual realm. Perceptually, centrally located points of light often serve as the origin of the diagnostic tunnels, spirals, and/or radially explosive forms (Siegel 1977: 134–135). The visions captured in figures 1.1–1.3 and especially 1.8 feature such radial light elements. These points naturally can be allied with the stars, the actual light source for most outdoor rituals, although their importance extends further. Stars figure prominently in visions as material and spiritual beings. Doña Isabel recounts: "'San Pedro [the saint] appeared in the sky like a light, like an exploding star . . . and the mesa was lit up . . . everything was lit'" (in Glass-Coffin 1998: 65). By the same token, when the starlight dimmed during a ceremony "'as if a giant switch had been thrown,'" it was interpreted as a very bad sign (90–91). Glass-Coffin herself had a revelatory experience in which the stars were reflected as pinpricks of light on the mesa, and she interpreted them as spirits (135–136).

Similarly, anthropologist and initiated Maya shaman Duncan Earle's initiatory dream involved star-as-illumination imagery. In his dream, after he received wisdom from twelve skeletons, the ceiling opened up and the entire sky was revealed to be one giant, bright star (personal communication 1993). Because the dream overlapped with the ability to see "through" the ceiling to the type of star illumination characteristic of visions, the community interpreted it to mean that he was called to become a shaman. Others from a variety of contexts and cultures often report star-related visions as well (Metzner 2006: 120; Klüver 1966: 15).

Visionary light can take other idiosyncratic forms, but these remain related to spiritual enlightenment. Don Agustín sees the spirals of the carved rock he calls Rayorumi as suspended light patterns that increase his ability to communicate with other shamans across the world (Stone 2007b: 16). It is significant that two of the most pervasive experiences, the spiral form and the intense light, go hand in hand. Light can make connections manifest in other ways as well: a number of visionaries report seeing lines of light linking others and patches of luminosity remaining visible where one has touched another (Metzner 2006: 223). Amaringo illustrates a vision in which an electric chain of laser light connects a fairy with a healer (fig. 1.6). In another iteration, I experienced a northern Ecuadorian highland Quichua family, the Tamayos, diagnosing their clients through candlelight, literally, by looking at them across a lit candle on which the clients had blown, breath being considered to transfer life force and personality. Later in the ceremony they blew fireballs at their patients, so in a way light also served a curative function. The Tamayos do not ingest entheogenic substances but are in trance, so the centrality of illumination goes beyond the specific effects of plants to characterize altered consciousness in general, the heart of the shamanic enterprise.

During visions light and color effects are not only intensified but can be especially ineffable and unprecedented, such as colors appearing as "shines," mentioned earlier. A subject under ayahuasca described a different experience of light:

"I then had the absolutely incredible experience of having iridescence poured into my eyes. It was as though I was lying on my back under a great waterfall and this iridescent water was flowing into my eyes. The experience was so overwhelming that I was afraid at first that I would drown or gag, but instead it just flowed into my eyes. Later this same iridescent liquid was poured into my heart." (In Metzner 2006: 221)

Shininess and iridescence, two textural qualities of light, become perceptually separable from hue, again rendering the usual experiential categories obsolete. This light-as-water experience reiterates the deeply multisensory character of the vision as well. Finally, the light/water pervading the body and specifically the heart, the emotions, extends visionary heightened illumination from the corporeal into the spiritual realm.

COLOR

Color also appears in an extremely heightened fashion throughout the experience; its strong role highlights the remarkably aesthetic quality of visions. It is one of the more consistently anomalous aspects of trance consciousness in that wholly new colors are seen and even familiar colors become unrecognizably intense.

> "The multitude of shades, each of such wonderful individuality, make me feel that hitherto I have been totally ignorant of what the word colour means . . . Green, purple, red, and orange . . . all seemed to possess an interior light . . . all the colours I have ever beheld are dull as compared to these . . . vast pendant masses of emerald green, ruby reds, and orange began to drip a slow rain of colours." (In Klüver 1966: 15–16)

After the experience another subject reported "'such magnificent hues and such singular brilliancy that I cannot even imagine them now'" (21). Many describe saturation so intense it is blinding, even painful, especially as the colors explode. Multiple textures characterize the colors, too, such as "'fibrous, woven, polished, glowing, dull, veined, semi-transparent'" (25).

At the outset of trance, colors can appear as percepts on their own, washing the visual field and changing from one to another, in a prime example of multiplicity and flux. Under the influence of peyote, one person described

> "delicate floating films of color . . . then an abrupt rush of countless points of white light swept across the field of view . . . the wonderful loveliness of swelling clouds of more vivid colors gone before I could name them . . . Then for the first time, definite objects associated with colors appeared . . . green, purple, red, and orange. All the colors I ever beheld are dull compared to these." (In Furst 2003: 92)

Color in and of itself gives way to being assigned to other percepts in astonishing ways due to its unprecedented intensity, beauty, and lack of correlation to everyday appearances. In visionary art, attempts are made to match otherworldly color. Huichol yarn paintings capture a riotously colorful visionary world in which deer may be purple,

faces blue, and bodies green (Furst 2003). Amaringo's colors are similarly extremely saturated as well as nonmimetic. Ipseic (self-referential) coloration represents another subversion of the usual rules of perception in which the Other Side relentlessly transforms the recognizable. A particularly dramatic change in overall coloration may occur under the influence of peyote. For an unnamed Huichol shaman, the visions begin in black and white, then everything turns blue, then completely red at the peak of the trance (Siegel 1992: 27). For him, the Other Side erases all color differences between the things that exist in various colors in the terrestrial world; thus, color remains fundamentally independent of what is being seen. The separation of color from form constitutes another powerful, alternative way to perceive reality and is akin to partitioning the Self into ego, body, and soul. Categories are not only "embarrassed," they are frankly obsolete.

Furthermore, the two colors in his vision, red and blue, play significant roles in several entheogens' effects. Red is a prominent visionary color for many. Among the Barasana's many kinds of ayahuasca (yagé), one called *yagé de sangre* (blood) yields red-suffused visions (Reichel-Dolmatoff 1969: 332). A shaman commented during a vision that "red color is the Master of the Animals," which may be an idiosyncratic observation but nevertheless links red to one of the most significant spiritual forces in the greater Amazon (ibid.: 335). The Cubeo of the Colombian Amazon at the outset of visions see blurred lack of color, then white, then "the white vision turns to red. One Indian described it as a room spinning with red feathers" (Harner 1973c: 162). Narby recalls, "I closed my eyes and all I could see was red. I could see the insides of my body, red. I regurgitate not a liquid, but colors, electric red, like blood" (1998: 7–8). Another taker of ayahuasca concurred: "'Everything went blood-red'" (in Metzner 2006: 172). Under mescaline, "all colors were reported, although the incidence of reports that the color was red increased as the dosage of the drug increased" (Siegel 1977: 134). Interestingly, Amaringo highlights in red the eyes, nose, mouth, and ears, he says because those are affected by ayahuasca, which activates the nervous system (Luna and Amaringo 1999: 52). It is also key that he has singled out the sense organs and left the rest of the

shamans' bodies barely there, conveying the pattern of sensory enhancement without corporeality that visions create. This is played out in the ancient effigies, as I will demonstrate.

As for blue, Klüver reports that under mescaline, "the prevailing tint is blue . . . The color is intensely beautiful, rich, deep, deep, deep, wonderfully deep blue" (1966: 15). Siegel concurs that "the black-and-white images began to take on blue hues" (1977: 136). Schultes on ayahuasca likewise comments that he saw "a play of colors, at first mainly a hazy blue" (1960: 176). A myth holds that Kashindukua, ancestral father of the Kogi of northern Colombia, used a blue stone to turn himself into a jaguar (Legast 1998: 144). Perhaps germane is that even without entheogens a modern Peruvian woman reporting on a near-death experience said that upon leaving this world she "went to the centre [of the universe] through a bluish medium" (Zuidema and Quispe 1989: 34).

Red and blue may figure together in visions, as they did for the Huichol shaman. Another Barasana type of ayahuasca is called *yagé de los animales de la selva* (yagé of the jungle animals) and reportedly produces red and blue experiences. Further, in a Siona's vision "women of the dry season dressed in red . . . and women of the wet season dressed in dark blue clothing" (Harner 1973a: 167). *Banisteriopsis caapi* alone makes everything turn blue, purple, or gray (described as "a hazy smoky blue that later increases in intensity"), yet adding *Psychotria viridis* often makes percepts turn bright yellows and reds (Schultes and Hofmann 1992: 122–123). Thus, ayahuasca can be seen to highlight both blue and red.

Elsewhere I have considered how these two colors were prestigious and noteworthy in ancient American art, especially because they are rare and challenging to achieve. Indigo in particular goes through dramatic transformations during the dyeing process and in ancient Andean textiles often

assumes the role of design anomaly, thus gaining shamanic valence and high cultural prestige (Stone-Miller 1994: 104–106, 109–110, 115–116, 165–167, 174–175, 178–179; Stone n.d.b). Blue and green are the very words for preciousness in several Mesoamerican cultures, and rare jadeite reigns supreme as a medium through Central America as well (Miller and Taube 1993: 101–102; Stone-Miller 2002b: 26–31, 147–160). Red is a hard-won dye color most notably generated from cochineal beetles (Stone-Miller 2002b: 261) but also valued in the even more difficult-to-attain *spondylus* shell (ibid.: 40–41, 194–197). Analogous anomalousness and control over difficult situations are basic qualities of the shaman to be explored in chapter 3. That visions feature and therefore sacralize these two colors may be seminal in establishing the wider importance of red and blue in ancient American art and culture. At the very least, certainly visions reinforce preexisting societal values, if not help in creating them.

This must suffice to cover the overarching tendencies and principles of visionary states, although myriad idiosyncratic and entheogen-specific effects are reported. The relentless creativity of visions is obvious and their potential to influence art equally plausible. Inherently believable and memorable to begin with, the experience does in some sense organize the parade of flux and multiplicity. Visions are not per se chaotic; for example, the tunnel spiral is a very coherent and dominant structure into which other varying percepts fit. These general repetitive characteristics may create assumptions—everything changes, more than one of something is expected, what goes around comes around—that apply more widely in ancient American art and culture. Before we turn to artistic case studies, however, the most common stages and components of the typical visionary experience sequence will provide a more complete basis for exploring how visions and art interrelate.

THE COMMON PERCEPTUAL PHENOMENA AND STAGES OF THE VISIONARY EXPERIENCE

Most visionary experiences are generally bipartitioned in the sequence of perceptual phenomena: geometric effects precede narrative content, although the former can continue throughout the latter. The more abstract geometric effects often take precedence during visions; the effects come first and maintain a prominent role. Yet the narrative content is particularly impressive and nearly always features themes of flight, attack, transformation, spiritual communication, and cosmic revelation. In many cases the two main types of percepts are intertwined; patterns not only become images and vice versa, but they also act as frames for narrative content. Therefore, an exact differentiation and ordering of the trance experience is impossible. Our culture, based fundamentally on linear thinking, may favor orderliness in sequencing to a distorting degree (Stone 2007a: 397). Shamanic cultures, on the other hand, feature overlapping, simultaneous, and repeating ways of knowing, likely related to the value placed on the visionary realm in which these cyclical happenings hold sway. In visionary recall, too, order seems less important than content: despite vividly remembering very long and complex visions, forgetting the precise order of component parts is also common (for example, Metzner 2006: 137). Thus, the presentation here of the second-stage visionary phenomena follows how the complex narrative elements are generally described but remains basically arbitrary.

GEOMETRY

Many scholars comment on the primacy of geometric patterns in visions.

First came simple geometric forms, flashing and dancing through the air. Despite individual differ-

ences, all my subjects reported the same basic geometric structures. These simple forms were followed by complex scenes: cartoons, pictures of familiar people and places, and images so fantastic that the subjects wept in awe. (Siegel 1992: 1)

Stahl concurs: "The onset of visual hallucinatory imagery includes the appearance of symmetrical and geometrically patterned polychrome designs . . . which eventually give way to progressively more complex hallucinatory themes" (1986: 134). Harner agrees: "Other experiences which are commonly reported by the Indians [of South America] include . . . visions of geometric designs" (1973a: 173). Wasson too reports, "At first we saw geometric patterns, angular not circular, in richest colors, such as might adorn textiles or carpet. Then the patterns grew into architectural structures . . . everything was resplendently rich" (1980: 15–16).

Geometry, like everything else, is subject to flux and multiplicity; it is constantly moving, changing, repeating, and multiplying in myriad ways during trance. For example, lack of patterning may give way to patterning, as when one of Klüver's subjects saw the dome of a mosque with "'absolutely no discernible pattern. But circles are now developing upon it; the circles are becoming sharp and elongated . . . now they are rhomboids; now oblongs; and now all sorts of curious angles are forming'" (in 1966: 15). Motifs start out simpler and become more complex in many cases (20). Patterns tend to appear relatively close and large: the majority of Klüver's subjects saw abstract geometric patterns "at reading distance" or closer (17), and some circles seemed about five feet across (14). Geometric motifs most often are notable for their "symmetrical configurations" (26). Typically they seemed to continue ad infinitum in the visual field, "a never-ending uniformity," "growing into the infinite" (22, 23), and "geometric fields of writhing green grasses" (in Wiese 2010: minute 32). Being close, large, precise, and endless infuses visionary patterns with importance.

Even individuals who are blind see geometric patterns when administered the same entheogens as the sighted. In an experiment with mescaline, partially and totally blind individuals (though none congenitally blind) saw vivid geometric and color effects (ibid.: 69–70). One subject in trance saw more colors and patterns in front of the eye that he had lost than in front of his functioning eye. Such visionary seeing that completely bypasses usual seeing represents merely a more extreme example of how trance vision is enhanced in mysterious and powerful ways. We must distinguish limited physical, everyday sight from that of the visionary whose closed or "nonfunctional" eyes nevertheless see the Beyond. Images of the blind play a notable role in ancient American art, and many feature high-status shamanic accoutrements and poses, as discussed in chapter 7.

Visionary sight in general is separated from normal sight through the intermediate stage of seeing geometry: normal terrestrial sights and human bodily experience are first replaced by patterns and the loss of usual corporeality (since one can become the patterns), then eclipsed by otherworldly sights and narrative experiences. Geometry stands at the liminal center moment of change in cosmic realms, signaling the onset of Elsewhere. This has important cultural and aesthetic implications: geometry introduces the Other Side, foretelling metamorphoses and revelations to come, and thus evinces great power and prescience. Furthermore, as mentioned earlier, looking at the same patterns can reintroduce the Other Side via the well-documented effect of vision recurrence (Siegel 1992: 65–80); therefore geometry retains the power to summon the Beyond. Understandably, the following case studies feature many images of shamans with geometric patterns on their bodies, faces, and clothing. Amaringo's visionary records are likewise filled with circles, dots, swirls, lines, and geometry of all kinds (especially figs. 1.2, 1.5, 1.6). Works of art entirely devoted to geometric motifs are found in many ancient American styles and should not be dismissed as "decorative" in these cultures in which visions are acknowledged as central (Stone-Miller 2002b: xxv).

While geometry can move the shaman between worlds, realms, and states of being, pattern also defines, pervades as background, and frames subsequent otherworldly experience itself. Like the emcee, geometry not only introduces the show but also narrates as it progresses. Repeated patterns frame, contain, and connect the other perceptual occurrences. In Siegel's experiments, "a number of the subjects had difficulty in describing the imagery but they agreed that there were many geometric forms in it . . . The [complex] images

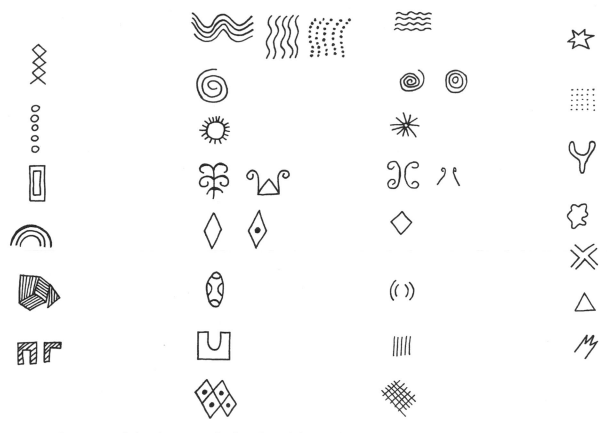

FIG. 2.1. Comparison of phosphenes seen by the Tukano (left two columns) and European scientific subjects (right two columns). Drawing by Nina West (after Reichel-Dolmatoff 1975: figs. 39, 40).

[of scenes, people, and objects] were often projected against a background of geometric forms" (1977: 134). One of his subject's illustrations of a vision shows figural scenes within each of the squares of a spiral lattice structure (ibid.: 137, top right). Klüver avers that "(a) the forms are frequently repeated, combined, or elaborated into ornamental designs and mosaics of various kinds; (b) the elements constituting these forms, such as the squares in a chessboard design, often have boundaries consisting of geometric forms" (1966: 66). Thus, geometry actively interacts with other perceptual entities during the entire visionary trance, binding them in various ways. I will highlight examples in which patterning links design elements, particularly by framing and connecting figural motifs, such as spiral bands and jaguars in chapter 6. It can be argued that the perceptual role of geometry during trance experience and its artistic role in shamanic art are therefore analogous.

More specifically, a fairly constant set of par-

ticular patterns, known as phosphenes, recurs from one vision to the next, from one visionary to another, even across wide gaps in time, space, and culture because they are features of the human brain (fig. 2.1; Cordy-Collins 1989: 35). Phosphenes are defined as "visual sensations arising from the discharge of neurons in structures of the eye . . . include spots, disks, concentric arcs or circles and checkerboard designs" (Siegel 1977: 139). For Klüver and Siegel, visionary patterns fall into four basic categories: grid-based (lattice, fretwork, filigree, honeycomb, chessboard), radial (cobweb), conical (tunnel, alley, funnel, cone, vessel), and concentric (spiral). Reichel-Dolmatoff's recorded phosphenes concur with this schema, only a few of them being relatively amorphous (fig. 2.1). One could argue, however, that radial, conical, and concentric shapes constitute variants of a larger category of forms organized from a center outward and could be subsumed loosely under the spiral. Thus, a more succinct bifurcation of phosphenes would be into grid-based and spiral-based

forms, the latter being especially key to artistic images involving trance.

Not only do visionaries see spirals, zigzags, and radiating motifs, but individual percepts and the visual field as a whole tend to move in these three characteristic motions at the outset of the visions, at any point, or throughout their duration. Known as *remolino* (Spanish for whirlwind) in much shamanic discourse (Sharon 2000: 11), the spiral seems to dominate among the visionary movement types. People often feel themselves spiraling, getting dizzy, to the point that they cannot move and feel quite nauseated, often vomiting (Harner 1973a: 155–156). Words may be seen arrayed in a spiral (anonymous, personal communication 2006). Intriguingly, mention is made of entranced shamans taking off from their bodies in a spiral (Mann 1999: minute 26). Aztec poetry noted this effect from ingesting mushrooms steeped in water more than five hundred years ago:

There are songs in flower: let it be said
I drink flowers that inebriate,
Already came *flowers causing vertigo*.
Come, and you will be in glory.
(Wasson 1980: 90–91, my italics)

Psilocybin mushrooms give rise to "fantastically colored visions in kaleidoscopic movement" (Schultes and Hofmann 1992: 148). Doña María Sabina's chant includes the line "Whirling woman of the whirlwind am I, it [the mushroom spirit] says" (ibid.: 149). After ingesting ayahuasca, Don Agustín sees the spirals from Rayorumi as patterns of light suspended before him (Stone 2007b: 16), as well as undulating lines and radiating forms that may be iridescent and pulse or throb (personal communication 2008). Other ayahuasca perceptions of spiraling forms are of dancers turning in spiral movements (Grob 2002b: 203), the aforementioned rotating soul sphere (Naranjo 1973: 178–179), "'merry-go-round-like rotation'" of an umbrella (ibid.: 181), and a single leaf that "'without evident cause, continued to gyrate, rotate, and turn continuously, long into the night'" (in Metzner 2006: 139). One subject went into detail:

"I saw tiny dots . . . that agitated and turned . . . around a cone forming a sort of funnel, like the whirlpool that is formed when one removes the stopper.

They turned, rather slowly, and this funnel opened upwards from the floor I was gazing at, and extended to the sides into my entire visual field . . . And in this swirl of particles lies all my visual experience. It all comes from it, this is the foundation of the scenes I saw, this was their spirit . . . even the meaning of this incessant turning was in everything . . . images in incessant transformation, never permanent, meaning nothing but change as such, like the whirlpool that turned and carried in it all these visions." (In Naranjo 1973: 182)

The spiral as a cosmic organizing device was described: "'I saw an image of the Great Spiral and had the physical sensation of moving within it. The images, colors, and depth intensified until I was totally within the Spiral. I felt a knowing that God was there, teaching me my place on the Spiral,'" and later from a four-dimensional diamond pattern in the spiral emerged "'the sacred serpent, a boa, who taught me about the importance of the Spiral'" (ibid.: 171–172). The swirling of colors, lights, and patterns is a constant feature (ibid.: 126, 156, 174). Amaringo's giant spirals (figs. 1.7, 1.8) and series of smaller ones (fig. 1.2) support these descriptions.

Under the influence of mescaline, Klüver's subjects (1966) saw "'colored threads running together in a revolving center'" (22), "'a vast hollow revolving vessel, a brown spiral, a wide band, revolving madly around its vertical axis'" (23), and "'a procession, coming from the lower right, [that] moved slowly in spiral turns'" (23–24). One even felt his leg become a spiral, and as previously mentioned, another saw himself from waist down as a spiral-wound green cone that sounded like an accordion (24). Klüver himself recounts seeing a wheel rotating around a picture of God, then moving wheels, and later "rotating jewels revolving around a center" (ibid.: 17–18). In experiments, subjects report the center of a series of concentric circles seeming to whirl (Oster 1966: 35; Klüver 1966: 14–15). Another reported seeing a dog "flying around like 'super dog' doing loops" (Metzner 2006: 221). There are many examples in the following case studies of how important spiral motifs and visual movement are in effigies of shamans.

Undulating movement is also characteristic of visions, including curvilinear serpentine and angular zigzag types. Those in trance frequently

feel themselves vibrating, an undulating movement (ibid.: 230, 245). Many repeatedly saw Don Eduardo's staffs vibrate on his mesa (Sharon 1972: 43), and the contours of objects seemed to wiggle. One subject who recounted watching food on his plate undulate said of his doctor and dining partner that he "'admired the certainty with which Dr. B. was convinced of the death of the fish'" (in Klüver 1966: 42). Several of the typical ayahuasca phosphenes are series of either vertically or horizontally parallel undulating or zigzag lines (fig. 2.1). Nearly every Amaringo painting features undulations in some form or another. "Zigzag lines of very bright colors" are often seen with peyote (ibid.: 15) and figure prominently in Huichol yarn paintings (Schultes and Hofmann 1992: 63; Furst 2003). Mescaline likewise induces seeing many patterns based on the zigzag (Siegel 1977: 134). Perceptually, the waving or zigzag line is consummately dynamic since the eye follows diagonals back and forth, which creates great visual tension (Arnheim 1974: 424–428). A zigzag allows the viewer to balance one oblique with the subsequent one yet always leads the eye on to the next segment that counters the last in a restless pattern of serial compensation. Because humans identify kinesthetically with what they behold, looking at a zigzag causes viewers to feel that type of movement in their bodies (and doubly so during trance). In visions a plethora of other things undulate, such as flames a person felt moving up her spine (Metzner 2006: 225).

Although narrative in content, the absolute ubiquity of seeing snakes in motion under *caapi* and to a lesser extent other entheogens must be mentioned in light of their natural coiling and undulating movements. Snakes' movements in visions serve to unite the spiral and the zigzag as they typically coil up and down as well as side to side. One person describes "'one enormous serpent mother, coiling and rippling through the entire length and breadth of the valley in which we are situated'" (Metzner 2006: 119), another "'a gigantic life-form, a purple amoeba-like organism with undulating fringes'" (ibid.: 226). Hardly a single Amaringo work lacks a writhing snake or pile of snakes. One subject under mescaline saw wire rings turn into a cone and then the rings became banded: "'these bands move rhythmically, in a wavy upward direction'" (in Klüver 1966: 14).

Siegel finds that images tend to pulsate spatially toward and away from many subjects (1977: 134), as they do for Grefa (personal communication 2005) and on the above-mentioned "kaleidoscopic roller coaster." These examples constitute movement that undulates in the third dimension. This type of visionary movement, though perhaps less central than the spiral, plays a role in the design and elaboration of shamanic effigies. Of particular interest may be a zigzag pattern added to the Vision Serpent in a Costa Rican toad effigy discussed in chapter 4.

Radiating movement is another very common experience of the visionary trance. Most of the phosphenes project out from a central point or space, whether sunburst, pinwheel, flowerlike or starlike shapes, concentric circles, or curved lines. As mentioned, all types of moving percepts may originate from a central point of light to create a funnel or tunnel coming toward or away from the viewer or sometimes moving in both directions (Siegel 1977: 134). The movement can be explosive, such as a white light projecting out in all directions, creating a bold, radiating, striped effect (ibid.: 135, top illustration). The moving tunnel, while radiating, is another spiral turning in space ever outward from a distant center point, reinforcing the ubiquity of the spiral as a visionary principle. One person "'watched the light of creation spiral round and round in the center of the circle'" (in Metzner 2006: 219). The individual motifs making up a spiral tunnel may themselves be irregular starbursts (Siegel 1977: 135, lower illustration). A tunnel of a diagonal lattice pattern is so typical that Siegel and Klüver call it a "form constant" (Siegel 1977: 136; Klüver 1966: 66), and it "occurs again and again in mescaline hallucinations; it also appears in hypnagogic hallucinations, entoptic phenomena, and in the phenomena arising when flickering fields are viewed" (Klüver 1966: 68). This organizing device is so powerful that when the more narrative imagery appears, it may first be seen superimposed on the periphery of the lattice-tunnels (Siegel 1977: 136, 137, illustration top right).

Specific patterns and movements aside, geometry clearly plays a significant and predictable role in the realm of visions and therefore has supernatural connotations that cannot be ignored in images relating to the Otherworld. If seen

through the lens of visions as seminal, geometric pattern is not symbolically neutral and therefore can rarely be interpreted as merely decorative in intent when it appears on works of art. Effigies of shamans in trance feature many examples of sacred geometry.

LATER VISIONARY STAGES

ANIMAL INTERACTIONS AND TRANSFORMATIONS

Like geometry, animals figure prominently in Amerindian and Latin American narrative visionary experiences, whether in traditional or less sacred contexts. Indigenous people, shamans, anthropologists, scientific subjects, and other trance-seekers almost invariably comment on the same types of animals appearing to them: snakes and other reptiles, birds of prey, and big cats (Harner 1973a: 160–165, 172). Naranjo comments, "Strangely enough, tigers, leopards, or jaguars were seen by seven of the subjects even though big cats are not seen in Chile" (1973: 183). These formidable animals show up in many ways to entranced persons: merely as present, attacking and even killing them, psychically connected, in a friendly guiding relationship, and/or as the animal into which they transform. In a given vision, several of these eventualities may well occur: the visionary animal may be aggressive or graceful, terrifying or cooperative and change character in an instant. Animals may be mythical (dragons), extinct (dinosaurs), or composites of several, such as "an animal with the head of a crocodile and the body of a fatter, larger animal with four feet" (Metzner 2006: 218, 221, 184, respectively). Luna describes completely alien animals he saw as "other animals which I cannot recognize in the world" (1999: 26). Animal-human combinations are common, such as bird-headed and dragon-reptile people (Narby 1998: 53). Again, the powers of description may fail at the prospect of conveying the "impossible" beings that populate trance. Certainly many of these strange beasts appear in the artistic record, as exemplified in the following chapters.

Although reptiles, cats, and birds predominate, almost any animal can play a role in visions. Amaringo was given all kinds of power animals by a master shaman during initiation, among them wolves, bears, tigers, panthers, eagles, and worms (Luna and Amaringo 1999: 26).[1] He illustrates human-wolf composite beings (fig. 1.4), a shaman who is a bat (ibid.: 133), and any number of animals that appeared in his visions. Sharanahua shamans Yopira and Ndaishiwaka envisioned a capybara (the largest rodent), a land turtle, a peccary (a piglike mammal), and several types of monkey spirits during different trances (Siskind 1973: 34–35). Narby mentions seeing an agouti, a large rodent that looks like a guinea pig (1998: 6); in Metzner a person witnessed a giant fish (2006: 243).

Regardless of the species, a strong connection and often communication with the animal is typical: "'At first many tiger faces. Panthers and all kinds of cats. Black and yellow. Then the tiger. The largest and strongest of all. I know (*for I read his thought*) that I must follow him'" (in Naranjo 1973: 184, my italics). A belief in many Amerindian cultures is that animals communicate with shamans (Halifax 1982: 13; Cameron 1985: 32). Overall communication during visions is often nonverbal, instant knowing, as exemplified by the book Doña María Sabina saw in her vision or such statements as "'What I heard, or saw, or somehow grasped on a deep intuitive level, was that the spirits of the Earth were communicating to us through these extraordinary plants'" (in Metzner 2006: 139). Narby reports,

> I suddenly found myself surrounded by two gigantic boa constrictors that seemed fifty feet long. I was terrified. These enormous snakes are there, my eyes are closed and I see a spectacular world of brilliant lights, and in the middle of these hazy thoughts, the snakes start *talking to me without words*. They explain that I am just a human being. I feel my mind crack, and in the fissures, I see the bottomless arrogance of my presuppositions. (1998: 6–7; my italics)

During and after the trance, he believed the snakes had revealed great wisdom, providing perspective about human hubris and our actual inferiority in the natural order. Renewed respect for natural predators of humans—the tropics are full of them, from thirty-foot anacondas to three-hundred-pound jaguars—is an understandable consequence of seeing them so vividly during visions. Not just

witnessing these animals, visionaries react to and interact with them as fully present in the same physical space: "I stood up feeling totally lost, stepped over the fluorescent snakes like a drunken tightrope walker, and begging their forgiveness, headed toward a tree next to the house [to vomit]" (ibid.: 7). Their veracity was so convincing that he stepped over and acknowledged them as he would a person. Indigenous people confirm the reality of the ubiquitous visionary snakes and other animals. Narby addressed Ashininca shaman Carlos Perez Shuma: "'Tío [uncle],' I asked, 'what are these enormous snakes one sees when one drinks *ayahuasca*?' 'Next time bring your camera and take their picture,' he answered. 'That way you will be able to analyze them at your leisure.' I laughed, saying I did not think the visions would appear on film. 'Yes they would,' he said, 'because their colors are so bright'" (ibid.: 19).

Snakes seem to dominate states of altered consciousness. For instance, Spanish chronicler Toribio Motolinía commented that the Aztecs and their colonial descendants "would see a thousand visions and especially serpents" under the influence of sacred mushrooms (Wasson 1980: xvii). Ayahuasca in particular creates snake visions for nearly everyone who ingests it:

> "Snakes! The small room was suddenly full of writhing serpents, crawling on the wall, ceiling, floor, over my body, into my nose and ears. Some of them morphed into other animals—spiders, wolves, fish, fabulous multicolored firebirds—then abruptly reaffirmed their true nature as snakes, hissing in my face with fangs bared and tongues flicking." (In Metzner 2006: 176)

That other animals' true nature is snake shows its priority in visions and reiterates that the perceived essence of something counters its outward appearance during altered consciousness.

Snakes have primacy, too, in that they often appear early in the trance experience as the first narrative element after the geometric patterns (ibid.: 119, 121, 143, 147, 150, 163, 172, 175, 176, 179, 183, 193, 197, 200). Geometry may give way directly to snakes: "'a large serpent head would appear out of the [geometric] patterns'" (ibid.: 207). Diamond grids, whether abstract or taking the form of snake markings, bridge the two initial stages of percepts. Thus, while geometry may

introduce nonordinary reality itself, it gives way to snakes that may herald deeper messages from the Other Side and lead to more elaborate narrative experiences. Snakes therefore play several roles: connecting to sacred geometry, imparting messages of their own, and introducing other spirit-beings as the vision progresses.

The movement of the envisioned snakes is that of the animals themselves, and significantly it establishes the key visionary spiraling and undulating motions. Reichel-Dolmatoff describes a Tukano man "overwhelmed by the nightmare of . . . the menace of snakes that approach while he, paralyzed by fear, feels how their cold bodies go coiling around his extremities" (1969: 332–335). In *caapi*-based visions, other Tukano and Desana report "snakes in the form of necklaces . . . coil[ing] around the houseposts" or "brightly colored snakes winding up and down the houseposts" (ibid.). Another saw "vipers which approach and wind down his body or are entwined like rolls of thick cable, at a few centimeters distance" (ibid.: 156–157). One type of ayahuasca, according to the Desana, makes one see "snakes that jump" (ibid.: 162).

Seeing and feeling huge, deadly, moving snakes certainly challenges the person to overcome one of the most deep-seated primate fears.[2] By facing the innate human fear of snakes, a shaman demonstrates necessary bravery. The Siona say, "He who conquers *yagé* also conquers nature and all the dangers which attack men" (Harner 1973a: 162–163). For the Iquitos of northeastern Peru, "even though one may see many animals, for example jaguars and great serpents rushing about, one is to have no feelings of fear" (ibid.: 163). Not remaining paralyzed by fear, but confronting and ideally learning from the huge serpents, represents an aspect of controlling the vision that a neophyte learns during apprenticeship. "With time I began almost to enjoy focusing on the patterns on the skin of the anacondas that moved before my closed eyes" (Luna and Amaringo 1999: 18).

In images, snakes may coil around body parts such as the waist without the figure betraying any fear whatsoever. It is almost needless to say that naturalistic to abstract snakes are prominent in all ancient American art styles.[3] Fantastical snakes known as Vision Serpents are a staple of Mesoamerican art (Tate 1992: 88–91; Miller and Taube

1993: 181–182) and occur in Costa Rican art as well (figs. 4.16, 4.17). None of these provoke fear in the humans around them, as in Lady Xoc, the Maya queen of Yaxchilan, who gazes calmly and fixedly upward at the figure emerging from the Vision Serpent's maw (Tate 1992: 44, fig. 14; 206, fig. 98). The Vision Serpent's two heads indicate its supernatural status and relate to much double-headed shamanic imagery, to be discussed in chapter 4.

I will also contend that the double-helix spiral often featured in Costa Rican art refers to the *caapi* vine/snake/spiral configuration, linking it to jaguars and shamanic transformation. Amazonian peoples recognize the visual and causal relationship between the snake and the twisting, intertwined form of the *caapi* vine. For the Siona, "these snakes represent the vines of the *yagé*; at times many snakes are seen in one bunch and one cannot escape from them" (Harner 1973a: 162–163). *Caapi* vines can grow in tangled bunches, very like a nest of snakes (Schultes and Hofmann 1992: 120, lower right), as is considered in regard to Costa Rican art in chapters 5 and 6. Amaringo "explains that because *ayahuasca* is a vine, its most appropriate symbolic representation is a snake. So the mothers of the *ayahuasca* and *chacruna* [*Psychotria viridis*] plants are snakes" (fig. 1.3; Luna and Amaringo 1999: 42). Don Carlos Shuma concurs: "'The mother of *ayahuasca* is a snake. As you can see they have the same shape'" (in Narby 1998: 34). Obviously, drinking an infusion of the snakelike vine brings on the visionary snakes; although ayahuasca would seem to "give birth to" snakes, the snake is in fact the "mother" of the vine in these statements. Not literal, throughout the traditional Amazonian world "mother" denotes the spirit of something, especially a plant spirit appearing in human or animal form. Amaringo's painting *Ayahuasca and Chacruna* (fig. 1.3) illustrates the snake spirits/mothers of the two plants that make up the brew. Luna describes the image:

> Out of the *ayahuasca* vine comes a black snake with yellow, orange, and blue spots, surrounded by a yellow aura. There is also another snake, the *chacruna* snake, of bright and luminous colors. From its mouth comes a violet radiation surrounded by blue rays. The *chacruna* snake penetrates the *ayahuasca* snake, producing the visionary effect of these two magic plants. (Luna and Amaringo 1999: 52)

Again the spiritual, not the physical or chemical, is held responsible for the visions; the snake spirits mingle to create the plants' effect. When initiates learn that the snakes are sacred spirits of the plants, then their terrifying aspects are better mitigated as well.

Besides the capacity to see the great predators, conquer fears, and learn much, visions often offer people the sensation of actually becoming the animal in a profound act of recorporealization. "Aggressive animal familiars—reptilian, feline, avian—are the agents of ecstatic trance-state transformation which enhances the shaman's communication with and mediation between the natural and supernatural worlds, as well as between normal and altered states of consciousness" (Sharon 2000: 11). Numerous visionaries describe how it felt to transform into animals and how their perspectives changed along with their bodies. Amaringo felt himself turn into a bat on one occasion; another time, he recalls, "I was becoming a snake. I had the desire to jump out into the water to find frogs and insects to eat" (Luna and Amaringo 1999: 27, 11). He refers to the widespread shamanic experience of transforming into a jaguar on tape (Wiese 2010: minutes 21, 27). Grefa said he felt himself become a jaguar early in his visionary training (personal communication 2008), as do Kogi shamans who "turn into jaguars under the influence of a substance designated as 'jaguar's sperm.' Once they have assumed this shape they can do good or evil, according to the use they make of their new supernatural faculty of perceiving things in the way jaguars do" (Reichel-Dolmatoff 1975: 59). The Tukano in transformed jaguar state run after tapirs and deer (Reichel-Dolmatoff 1969: 329). Likewise, Ashininca shamans "see, think, and act like jaguars—human beings appear as peccary, and dogs as coati," (Weiss 1975: 288–290); having become the top predator, their perception is so changed that they see humans and dogs as the usual prey of jaguars, namely peccary and coati.

Nonshamans have similar transformational experiences. Under ayahuasca one may become a snake: a man felt his "'abdomen crackle as if the skin of a snake were being shed'" (in Metzner 2006: 163), and another reported that "'spontaneous undulations began as I became the serpent and experienced serpentine movements, swaying

back and forth'" (193). One felt himself become an iguana (125); another turned into "'some sort of small, long, fine white-haired creature'" but refused to take on peacock consciousness, which he later regretted (201); and a third "'became the frog and was moving my joints the way he did . . . such wide movement in the joints . . . such agility'" (203). These perceived metamorphoses obviously entail an all-encompassing change from human corporeality and perspective to those of the animal in question.

Perhaps the quintessential transformational experience was that of a woman who watched her fingers becoming feathers and went from being a giant bird to a fish (Naranjo 1973: 180), then said,

> "I wasn't a fish anymore, but a big cat, a tiger. I walked, though, feeling the same freedom I had experienced as a bird and a fish, a freedom of movement, flexibility, grace. I moved as a tiger in the jungle, joyously, feeling the ground under my feet, feeling my power; my chest grew larger. I then approached an animal, any animal. I only saw its neck, and then experienced what a tiger feels when looking at its prey." (Ibid.: 185)

It is key that she became a tiger, not a jaguar: as a resident of Santiago she drew on a different store of predators, at least conceptually. Also intriguing is that a tiger does kill by snapping the neck vertebrae, while a jaguar crushes the prey's skull (Wolfe and Sleeper 1995: 81, 94), showing that she was identifying specifically with the tiger, not another cat or a generic one. Another said, "'My face became a tiger or a large cat'" (in Metzner 2006: 165). As a leopard, a woman "'felt the alertness, the ease, the strength, and total surrender to the power of instinct'" (ibid.: 225).

A Westerner may well become a jaguar, though, as in the case of a woman who had "'awareness of moving through the jungle. The jungle moving aside as I quickly and stealthily, with focus, passed. I was the jaguar'" (in Metzner 2006: 179). One woman welcomed the jaguar and mountain lion that taught her to breathe through her nose, mouth open, so as to smell and sense the surroundings as felines do (ibid.: 172). Yet another person describes being snake, then jaguar, then snake again:

> "My whole body became involved in a slithering movement, and I was not in control of this movement. It felt good. It felt freeing. This went on for some time before I realized I was a snake slithering across the ground . . . This time I began to move on all fours . . . As I moved, I felt power, the power of long sinews, of powerful muscles stretching and contracting, of four paws solidly connected to the earth, of blackness, of sleekness, and of shininess. I felt the power of the jaguar or black [jaguar] . . . with the ability to explode into movement, leaping, running, charging . . . [then back] as the snake I raised up and felt a hood over my head." (Ibid.: 200)

Taking animal form, the shaman is projected beyond normal human realities into realms that offer the spiritual power to cure. Since in the tropics humans are reminded daily that they are not necessarily the dominant species, it is natural that animal powers would be perceived as superior to humans', and in some ways they are; for instance, jaguars see six times better in the dark than humans (Wolfe and Sleeper 1995: 97), and a white-tailed deer can run thirty-five miles per hour (Hiller 1996: 32). One of the important attributes gained by the shaman in animal form is the aggression of that predator, useful in fighting spiritual battles on behalf of the client.[4] Many other qualities and advantages of these top predators are accessed, such as crocodilian fertility and the avian aerial perspective and keen eyesight. Powers to multiply or to see afar are not just metaphors of the shaman's responsibility for natural fecundity or ability to see the future. Through visionary identity transformation, the extraordinary animal powers are truly and deeply embodied; when the shaman shapeshifts, he or she experiences directly possessing those attributes from the inside out. The shaman has, one might say, walked a mile in a jaguar's paws. Through metamorphosis one truly inhabits not only the animal's physicality and viewpoint but ultimately its spirit. Taulipang shamans in curing rituals say, "'Call upon me for I am the black jaguar . . . I drive away the illness . . . It is me they have to invoke if they wish to frighten it [the illness] away'" (Saunders 1998a: 32). They do not say, "Act as if I were a jaguar" or "Would that I had the powers of a jaguar." For their part, the artistic images visually convey that in many Amer-

indian languages the same word signifies "jaguar" and "shaman," usually embedding the two selves in artistically complex and innovative ways. The black jaguar will figure specifically in a number of effigies discussed in chapters 6 and 7.

Not resolvable into our familiar categories of metaphor, analogy, the subjunctive, pretense, or chicanery, indigenous peoples state that the shaman *is* the jaguar, with the visionary experience as proof. We may query in what sense and how literally the shaman is a jaguar; like other Western preoccupations, this is basically the wrong question to ask. "The shaman is believed to become a jaguar. Transformation is a key element of shamanic power, where things are hardly ever fixed or permanent, but rather in constant flux, a 'state of becoming' that is structured by myth and calibrated by ritual" (Saunders 1998a: 32). Repeatedly becoming a jaguar or a bird in a dualistic human-animal unity represents a profound interchangeability foreign to our worldview but endemic to visions-conscious cultures. Souls, or more neutrally spiritual components, are experienced as separable and can be lost and reinstated; likewise one being can "house" both a jaguar and a person self. (It is as if in our culture someone could not quite comprehend that someone can be a woman, a mother, and a professor all at the same time and can change roles to fit the varying circumstances of the day.)

There is an important larger Amerindian cultural context for the human-animal self: in a general sense, humans are recognized as already being animals, and they can be grouped with other specific animals according to a given conceptual schema. Humans may be classified with all sorts of animals; for instance, the Ashininca place us in the same animal family as otters, herons, and hummingbirds (Narby 1998: 25). Native North American beliefs embrace humans and all animals together as family: the Siouan prayer *Mitacuye oyasin* claims, "We are all related" (Cameron 1985: 35). Therefore humans and animals are not inherently distinct, and as a result, shamans are capable of a wide range of animal interrelationships and interchanges; for instance, the word for shaman may mean "full of the quality of bat," as discussed in chapter 3.

However, shamanic transformation remains difficult to pin down in Western terms. For example,

where do animal selves reside, if indeed they do relate to the physical body? Luna offers a clue as to one way in which indigenous viewpoints resolve the dual or multiple animal selves: they live inside the shaman's body. Don José Coral, an Amazonian shaman of northeastern Peru, instilled his snake "defenders" into Luna and his other apprentices during training when he deemed the neophytes powerful enough to absorb them. The animal selves were presented as living inside the shaman's chest: "He said that he was going to give me defenders. He was going to put in the *ayahuasca* pot several snakes that he kept in his chest . . . he did so symbolically and accordingly I also made the noise of eating the snakes from the *ayahuasca* pot. This procedure was repeated during two subsequent ceremonies . . . this took place in the dark" (Luna and Amaringo 1999: 15–16). The ritual suggests important aspects of the human-animal spirit relationship. Although they were extracted several times from the master, he did not lose his snakes as defenders, so this was considered a spiritual power transfer rather than a literal snake removal. By being put into and taken out of the ayahuasca pot, the snake spirit power is transferred, appropriately enough, via the entheogen that reveals visionary snakes. Almost like a vaccination, having spiritual snakes inside you may protect against the terrifying prospect of them in the visions and make you one of them rather than a separate target. Don José calls them "defenders" against all harm, to keep the visionary safe from attackers encountered on the Other Side. This interior animal-self idea applies to the Warao as well: helper spirits live in the chest of the shaman, and when he sings, those spirits sing the second half of the song (Olsen 1975: 28). This containment accords with the typically shamanic importance of the interior, also reflected in art (Stone-Miller 2002b: xxi–xxiii). The many ways animal selves are embedded into shaman effigies will be explored and the chest as a prime location for wearing animal-self art suggested in chapter 6.

The idea of animal selves residing inside the body may be generated by the properties of visions: often animals enter the body during trance, whether through ingestion or simply existing there magically. For example, one person describes a human-sized snake that "'entered my body through my mouth and started to slowly

wind its way through my stomach and intestines . . . Then, as I was lying sideways on a couch, a jaguar suddenly came into me. It was an enormous black feline male, and he entered my body assuming the same semi-reclining position I was in'" (in Metzner 2006: 120). Another "'felt as if I had swallowed a live boa who was inching through the acidic labyrinth of my guts'" (ibid.: 175). Don Fidel told a man occupied by a jaguar that "'the visions come into you and heal you'" (ibid.: 120). This works both ways: one can go inside the snake, another way that the human ego is devoured by the animal consciousness, or even exist both outside and inside simultaneously, as depicted in the famous Aztec sculpture of Quetzalcoatl (Easby and Scott 1970: 302). "'Along the way there were many visions of the *ayahuasca* serpent god. An awesome, majestic being, both within me and around me. I was also inside the serpent'" (in Metzner 2006: 209). One visionary "'had the distinct impression that we were all in the body of a large serpent or lizard'" (162). Another expressed "'wishing the serpent to swallow me, and it came forward, and I felt myself tumbling down its throat'" (207); a third saw a devouring amoeba primordial mother (227), a fourth the ayahuasca spirit as a giant spider-dragon that "'began to eat me, starting with my hand. When I did not resist she devoured me completely. Once she had eaten me, instead of me disappearing she did'" (221). In one vision the ayahuasca spirits explain, "'If [you are] eaten by the serpent, [you] acquire its power and knowledge. Allow someone to eat you and you gain their power'" (121). Like the experience of Don José Campos, who had a vision in which the spirit of ayahuasca instructed him to let the *plant* drink *him* (Stone-Miller 2004: 53; discussed in chapter 3 of the present volume), visionary ingestion is particularly paradoxical but consistently favors the animal and the plant over the human in the metamorphosis equation.

Visionary expulsion, the complementary action of releasing beings from inside, is also a common experience. Certainly the powerfully emetic effects of entheogens—actual vomiting, diarrhea, and mucus and saliva excretion during trance— and the shamanic curing practice of ingesting and regurgitating the disease obviously relate here.[5] However, one subject felt he was vomiting not food but rather his attachment to ego, seeing it

as a stream of heads emerging from his mouth (Metzner 2006: 137). Amaringo portrays a shaman vomiting (fig. 1.2) and another shaman's powerfully curative phlegm as white snakes coming out of his mouth and attacking the patient's illness (Luna and Amaringo 1999: 114–115). Metzner (2006) offers other examples of visionary emiting, such as a woman who describes giving birth to herself in the form of millions of larvae (121) and another birthing the earth itself (227), while a man felt all his insides being pulled out (213). Amaringo, in turn, illustrates a woman giving birth to snakes (fig. 1.5).

Besides snakes and jaguars, an important animal self allows humans perhaps their most nonhuman, nonterrestrial experience: the bird. A Yanomami shaman wearing feathers and moving like a bird is one of many indications of this animal's significance (Mann 1999: minute 19). Space does not permit a full consideration of the avian; however, its essential visionary role is encompassed in the flying sensation that permeates most visions.

SUSPENSION AND FLYING

Many corroborate a loss of the normal sensation of gravity pulling on the body during trance (for example, in Halifax 1982: 23–24, 86–87). This may encompass floating, aerial suspension, and flying, that is, moving through the air. Ayahuasca "livens the kinesthetic sense, giving one the imagined state of being suspended in air . . . a sensation of being lifted into the air and beginning an aerial journey" (Harner 1973a: 155–156). "'I "see" R. and I slowly begin to elevate out of our chairs, rising, until we are suspended above the congregation'" (in Metzner 2006: 230). The aerial viewpoints mentioned in chapter 1 represent instances of suspension above landscapes, DNA strands, women twirling umbrellas, and so forth. Wasson describes, as a consequence of ingesting mushrooms, "the sensation that the walls of our humble house had vanished, that our untrammeled souls were floating in the empyrean [the highest heaven], stroked by divine breezes, possessed of a divine mobility that would transport us anywhere on the wings of a thought . . . Don Aurelio [Carreras, a Mazatec shaman] and others . . . had told us that the mushrooms . . . would take you there where God is" (1980: 16). Typical occurrences include thoughts

moving one through space and perceived freedom of movement entirely unlike the usual corporeal groundedness of the human condition. Of the traditional people who take *Banisteriopsis caapi* brews, the Tukano of Colombia describe it in terms of strong winds pulling them up to the Milky Way (Reichel-Dolmatoff 1975: 167, 172) and the Záparo of Ecuador as being lifted into the air (Schultes and Hofmann 1992: 122).

Flying in bird or butterfly form is a common way to embody the feeling of lightness and movement.

> The first thing I did, involuntarily, was lift my hand. It seemed to lose weight, it rose, rose . . . and then I felt that it was no longer a hand but the tip of a wing. I was turning into a winged being. I then stretched my wings and felt extreme freedom and expansion. My wings were growing and as they did my feeling of freedom increased, as if I had been imprisoned during my entire lifetime . . . I then, timidly, began to move them. I felt the movements of flying clearly: how the wing rested on the resisting air, and how a wave of motion went from the tip to the other end permitting me to lift the body. . . . I just flew and the air passing through my body gave my breathing a special rhythm of flying which expressed not only the movement but the joy. (Naranjo 1973: 180)

The very distinct and nonhuman kinesthetic experience of knowing how to fly is highly convincing, the detailed feeling of the wind's resistance and the wing's motion constituting an example of the "different veracity" of visions. Like the person who turned into the tiger and only noticed necks or the one who became a snake and craved the taste of frogs, the transformation into flying bird or insect entirely and specifically replaces the human everyday understanding of corporeality.

Flying is also the way to experience far-off places, a very common phenomenon experienced, for example, by the group that agreed, "let's see cities!" (Harner 1973a: 168–172). Omnipercipient acts such as finding lost items or spying on other people may be accomplished by flying or at least by some kind of extranormal means of travel. Don Apolinar Jacanamijoy, an Ingano shaman of northeastern Peru, instructs Luna that by taking more yagé, "you will be able to go wherever you want.

You can go to see your friends in Europe" (Luna and Amaringo 1999: 11). More contemporary ways to achieve ultimate freedom of visionary movement are found as well. Luna avers,

> Flying is one of the most common themes of shamanism anywhere. The shaman may transform himself into a bird, an insect, or a winged being, or be taken by an animal or being into other realms. Contemporary shamans sometimes use metaphors based on modern innovations to express the idea of flying. Thus it is not strange that the UFO motif which is part of modern imagery—perhaps, as proposed by Jung (1959), even an archetypal expression of our times—is used by shamans as a device for spiritual transportation into other worlds. (Luna and Amaringo 1999: 35)

Amaringo depicts UFOs in a number of his paintings (fig. 1.2 among them); indeed, in his compositions almost anything may appear suspended in the air.

Artistically, an effigy of a shaman who is to be understood as flying may incorporate wings into a human body, turn the body in space, and/or otherwise deny the ability for feet to visually support it: Paracas shaman figures evidence all three stratagems (Stone-Miller 1994: 54, 56–58; 2002a: 60–63). To convey floating in a more abstract manner, various ways are found to communicate suspension, including a general approach to the body as generic, focusing compositions ever upward to the head and beyond, creating less than solid bases, and throwing the effigy's connection to the ground into shadow, as will become evident in the case studies.

SPIRITUAL COMMUNICATION AND REVELATION

Being out of body but in touch with many cosmic levels brings up the issue of shamanic communication in general, which is—predictably—enhanced, nonverbal, magical, and wide-reaching. Don José Campos told me he could understand foreign languages while in trance (personal communication 2003), and Don Agustín averred that he talked with healers in Africa in a bodiless form via the Rayorumi spirals (Stone 2007b: 16). Dream connection, also noncorporeal, is another way to interrelate across vast gaps in space and is con-

sidered by Don Agustín as equivalent to trance communication. The wonderful inclusiveness of the contemporary shaman is demonstrated by his parting comment to me: "We can keep in touch via the rocks, in dreams, or we can use email" (personal communication 2005). As "magical" methods that have in common a lack of bodily presence, trance, dream, and cyberspace would naturally serve as equivalent systems to project oneself nonlinearly through space and time in contemporary shamanic practice.

Speaking with nonhuman beings of various kinds occurs as well. Communication with actual animals is typical; Don José and a friend both saw and heard a jaguar say, "Welcome to my kingdom" (personal communication 2003). Talking to the dead is frequent, as in Maya shaman Earle's initiatory vision/dream of skeletons and for those under the influence of ayahuasca (Metzner 2006: 207, 222). To the Ashininca, spirits in general come to the entranced shamans "in human form, festively attired" (Weiss 1973: 44). However, one of the most widely reported phenomena is seeing and talking with the spirit "mothers" of the plants, often in anthropomorphic or theriomorphic (animal) form, as mentioned above (figs. 1.1, 1.3). The spirit of *caapi* is almost always seen as female; she appeared as a beautiful bride dressed in white to Don José (personal communication 2003) and represented female fertility in Siona visions (Reichel-Dolmatoff 1969: 330). The Amahuaca call the ayahuasca spirits *yoshi* and hold long conversations with them (Carneiro 1964). Nonshamans likewise speak to the plant spirits. A Swiss scientist with no prior knowledge of the concept of plant spirit-beings, under ayahuasca spoke with the Mother of Tobacco (Narby 2002: 159, 161). Metzner met the spirit of *iboga*, an African entheogen, while under its influence; this transfer of an Amazonian idea onto an African plant by an American represents a multicultural religious experience, one Metzner avers he was not expecting (2002: 173). Many report meeting trickster figures under ayahuasca: "'Perceptions of *ayahuasca* spirit helpers circling around and around in groups of three. Each was smiling broadly and had three colorful feathers sticking out of a headband, very large eyes. They were full of humor and mirth'" (in Metzner 2006: 168). One "'became aware of the Plant Kingdom Guardians sitting along the side of the room. They were in deep meditation and I could sense they were overseeing our visions. I felt they were permeating the room with their presence, giving me a sense of respect and knowing of Plants that I had never known before'" (ibid.: 172). This is highly reminiscent of the Amazonian concept of the Master of Game Animals (*Vaí-mahsë*), a spirit seen and consulted by the Desana in trances (Harner 1973a: 166).

Many people see spirits as very tiny, presumably as part of the widespread micropsia effect (Stahl 1986: 136). In later trance stages, "amidst such associated phenomena as spatial and temporal distortion, the experience of historical and mythical events, and religious introspection, is the repeated, consistent appearance of and/or communion with small anthropomorphic figures" (ibid.: 134). Scale of percepts is so variable in visions and such unexpected things happen that for formidable spirits to be minute is unsurprising. Half of Siegel's experimental mescaline-ingesting subjects reported seeing "images of small animals and human beings . . . most of them friendly," although they made no comment on their spiritual nature; however, he admitted subjects were not pressed to describe in detail the "complex imagery" in their visions (1977: 133). According to the Bora, Muinane, and Witoto of Amazonian Colombia and Peru, *epená* (*Virola*) allows them to communicate with "the little people" (Schultes and Hofmann 1992: 167). The Otomi-speaking Matlazinca of Central Mexico call mushrooms *santitos* ("little saints") because by ingesting them they see "tiny beings the size of playing card kings," while the Mazatec of Oaxaca note recurrent visions of little trickster divinities the size of mushrooms (Wasson 1980: 38–39). Morning glory makes one see "the two little girls in white," according to the Zapotec (ibid.: 38). The diminutive nature of these spirit-beings does not diminish their revelatory powers, however.

Furthermore, Siegel found that approximately 72 percent of subjects reported spiritual communication or overtly religious percepts during visions (1977: 133). Here the visionary's cultural framework pertains perhaps more than in seeing geometry and snakes or having the feeling of flying. Traditional shamans who also identify as Catholic often describe visionary contact with Christian religious figures. Doña Vicky, a sha-

man of north coastal Peru, sees and communicates with the Virgin of Túcume (Glass-Coffin 1998: 155–156), and Doña Flor recounts that another shaman had a vision of her with stigmata (ibid.: 202). Under ayahuasca Siona men — members of a group with a long history of missionary contact — saw God, a big cross, a beautiful church (although the Eucharistic wine was an indigenous healing mixture), a ship full of devils, heaven, and hell (Harner 1973a: 167–168). Naranjo's contemporary Latin American subjects, presumably because they were Catholics or at least familiar with Christianity, encountered Jesus, angels, the Virgin Mary, the Devil, heaven and hell, priests, churches, altars, and crosses (1973: 184–188), as did one of Metzner's informants (2006: 226).

Many people see in great detail deities that belong to other cultural traditions, such as those of ancient Greece, Rome, China, and Egypt. "The spirit of this medicinal plant [ayahuasca] transcends cultural, religious, and geographic boundaries, transporting one into the collective unconscious realm of all spiritual metaphors" (Metzner 2006: 154). Amaringo's visions reveal a wealth of foreign religious figures: "One sees people of many races and nationalities, what they said and did, their customs, ritual, religion" (Luna and Amaringo 1999: 28). In his Vision 4 (fig. 1.1), one tree has a Chinese kingly spirit, another an African cat-eyed woman, a third a leprechaun-like man, and in others a Shipibo woman, a fakir (a Muslim ascetic), and the Angel of Solitude (54). Nymphs and Nereids (61, 73), mermaids and fairies (65), cherubs (69), a guru in the temples of Krishna, an African fetishist, and a lama (73), and many other spiritual beings appear throughout his oeuvre. While Amaringo is well versed in other cultures' spiritual systems, several takers of ayahuasca did not even know they were seeing Egyptian gods, though their descriptions match specific ones exactly (Metzner 2002: 173; 2006: 148, 151). Naranjo mentions subjects seeing sirens, nymphs, and Greco-Roman gods (1973: 188), while Metzner (2006) presents visions with yin-yang (163), Sehkmet (148–150), Maya gods (120), Quetzalcoatl the Plumed Serpent (194, 204), kundalini (150), Kali (148, 213), mandalas (238), Osiris (149), and Buddha (238). Traditions may meld: one of Naranjo's subjects first reported that he became an Egyptian pharaoh and later said it was as if he were the Christian God (1973: 188). From this Naranjo concludes, "I believe the mythico-religious element [in visions] is more pervasive in the experiences than what appears from their outward descriptions" (ibid.: 188).

Informants indeed often describe recognizing the sacred in otherwise mundane things; Naranjo reports "ecstatic feelings which were described in religious terms" (ibid.). One woman went in a vision to the bottom of the sea and found that the sea and all its life was her and was God; "'there was a continuity of the external with the internal'" (ibid.). In general, during visions the emotional component is heightened so that potentially any percept can be ascribed great portent, wisdom, and spiritual content. Sweeping emotions are felt, such as sadness for all humanity's suffering or the agony and ecstasy of creation, birth, and liberation (Metzner 2006: 122, 213, 230). There may be more of this numinous aspect than appears in accounts because it can defy description, as Naranjo concludes, be unstated because it is taken for granted in shamans' descriptions, and not be pursued by Western anthropologists and scientists as a line of questioning.

A final common spiritual revelation and shift in perspective entails a feeling of unity of the human with other natural life forms (in Metzner 2006): "'I felt myself ball up and become the earth'" (169). "'I felt rooted in some tangled, steamy jungle, rich with the scent of death and rebirth, slowly becoming one with the vines and the very earth itself'" (197). "'As a field of light saturates my being, I perceive the back of my skull lifting up, allowing a current of energy, the vegetable energy of the earth, to stream through me. I dissolve and merge into the harmonious, welcoming vibrations of the plant world . . . The particles of my being are one with the flowers, the trees, the elements'" (231–232). "'I am planted in the ground, taking root, becoming one with nature'" (235). The man who became a snake, then a jaguar, then a snake again recalled, "'I saw/felt him [the jaguar] not as apart from the environment, but as a part of the environment. The Earth supports the jaguar and the jaguar feels himself to be the earth — there is no separation'" (201). The general visionary themes of recorporealization as an animal and the reconfiguration of human ego identity allow this sort of unity experience, since by

definition the separate categories of everyday existence are rendered irrelevant.

Revelations of oneness and universal consciousness are often based on a further understanding that all things are alive and sacred (163–164, 173), that "'seemingly separate unrelated events appeared to be inextricably interrelated'" (182), and that not only is all of humanity interconnected (219, 238), but everything is (214, 238, 243). One visionary concludes, "All humans are divine children" (in Wiese 2010: minute 35). Paradox, too, can be resolved: "'It was as if my body accepted ideas of oneness, duality, paradox, etc., on a cellular level'" (in Metzner 2006: 197); "'I became aware of the nature of illusions . . . [and] the difficulty and impossibility of paradox'" (167–168). Understanding the sad and frightening as well as the beautiful is mentioned (197), as is human arro-gance (165): "'I became aware of the phrase "we are less than we think we are"'" (144). Acceptance of death is also achieved (120), as reiterated by many (in Wiese 2010: minute 60). In all these revelations, the sense is that humans are not the separate, superior, or central elements in the cosmos, as shamans aver.

With this phenomenological consideration in mind, we can now explore central themes in core shamanism that I argue are based on the vision experience. In other words, the shaman as an entity can only be understood in ritual and social practice based on what goes on in trance. With the human shaman's roles and approaches characterized in more anthropological detail, the ancient images of shamans can be analyzed in terms of all these factors.

VISIONS AND SHAMANIZING

THE INTERMEDIARY ROLE, ANOMALOUSNESS, CONTROL, AND BALANCE

A brief conceptual overview of certain core characteristics of the shaman's role in modern traditional Latin America is needed to set the stage for how ancient effigies may relate to the tradition as maintained over the millennia. To avoid redundancy with previous scholarship, keep the primacy of visions in mind, and provide concepts that may relate to visual art, the themes of the intermediary role, anomalousness, attainment of control, and dynamic balance will be explored. These four themes are by no means exhaustive, and many good introductions to Amerindian shamanism exist (among them Halifax 1982 and Harvey 2003). I argue that what happens in visions directly relates to how the person who shamanizes—more a set of actions than a personal ego—is understood to function both in this world and the Beyond. I will suggest some ways these basic roles can illuminate how we approach ancient objects as well.

THE INTERMEDIARY ROLE

It is easy to argue that in shamanic thought all physical manifestations are seen primarily as vehicles for spiritual power: the landscape, its animals and plants, the shaman, the means to achieve visions, and the power objects used in healing. In one sense this renders all shamanic elements liminal, less about what they are than what can pass through them on its way from the unmanifest to the manifest world. "It is this, we might say, that defines a shaman: the ability to readily slip out of the perceptual boundaries that demarcate his or her particular culture—boundaries reinforced by social customs, taboos, and most importantly, the common speech or language—in order to make contact with, and learn from, the other powers in the land" (Abram 1996: 9). Indeed, "Shamans are

liminal people, at the thresholds of form, forever betwixt and between" (Joralemon and Sharon 1993: 166).

The key role of shamans as intermediaries, a role that grants agency to forces outside their human physical form, can be traced back to the Siberian Tungus, for whom "the shaman's body is a 'placing', or receptacle, for the spirits" (Lewis 2003: 45). This type of role is restated in numerous ways by modern Amerindian healers. For instance, it may be acknowledged that the shaman's patients are helped by the curing ritual but ultimately heal themselves with the shaman acting as the catalyst (Tedlock 2005: 128; Glass-Coffin 1998: 134). On the other hand, agency may be believed to lie in the hands of the long-dead: "The power to interfere in the order of things was given to words by the Desana's ancestors. The current ritual specialists, known by the name of *kũbũ*, do nothing but reactivate this power" (Buchillet 1992: 211).

Most predominantly, however, as Dobkin describes for modern northern coastal Peruvian culture, "the power to cure is believed to reside not so much in the folk healer . . . but in the power of the substance used by the healer" (1968/1969: 25). Doña María Sabina consistently states that the sacred mushroom spirit "'has a language of its own. I report what it says'" (in Schultes and Hofmann 1992: 144). Though her recorded ritual verses contain statements about herself, such as "I am a lord eagle woman . . . Our woman who flies . . . Our woman who looks inside of things . . . whirling woman of color," each line ends with "*tso*," meaning "he says," referring to the spirit of the sacred mushroom as talking to and through her (Wasson 1980: 39; Metzner with Darling 2005: 19–20). When complimented on his depth of knowledge, Don Apolinar protested, "It is not me, it is *yagé*" (Luna and Amaringo 1999: 11). Ashininca shamans likewise credit tobacco as the source of their power to see and communicate with spirits and to diagnose sicknesses and ayahuasca as making contact with other dimensions (Weiss 1973: 43). Don José, Glass-Coffin's informant, asked the San Pedro cactus spirit to come to the patients' aid by "conversing all things clearly" (Glass-Coffin 1998: 96). Again this implies that the San Pedro is talking—with a deliberate confusion of the saint, the plant spirit, and the plant that share the same name—rather

than the shaman. Luna sums it up: "Knowledge— particularly medicinal knowledge—comes from the plants themselves, the senior shaman only mediating the transmission of information, protecting the novice from the attack of sorcerers or evil spirits, and indicating to him or her the proper conditions under which this transmission is possible" (Luna and Amaringo 1999: 12–13). Thus, the shaman does not take personal credit for the diagnosis or cure but rather receives, interprets, and passes on plant wisdom.

Lest we fall into a Western assumption that the actual physical plants are believed to cause visions, Don Agustín articulates that ayahuasca only opens him up to the other coexisting realms (personal communication 2005). Thus, plants' power is situated in the spiritual rather than the chemical realm: the shaman ingests the plant and its spirit manifests as a visible entity, positing both shaman and plant as intermediaries. It is clearly the spirits of those plants that are today considered the master teachers, the sources of knowledge and wisdom, who instruct and interact with the shamans (for instance in Wiese 2010: minute 5). While Amaringo dedicated his book to the plants, animals, and people of the Peruvian Amazon, in that order, and images of plant forms are key elements in the paintings of his many shamanic visions, he illustrates the anthropomorphic spirits of "plant-teachers" emerging out of the actual plants (fig. 1.1).[1] Don José Campos says hello to the ayahuasca plant spirit and thanks her (Wiese 2010: minutes 10, 70). The physical plants are addressed as living containers for spiritual entities, as are shamans.

Not only the entheogens but all plants related to shamanism have spirits: Don Eduardo Calderón has reported that the San Pedro cactus activated his ability to be led by the magical attending plants, in this case *seguros*, containers of sacred herbs steeped in perfume (Sharon 1978: 173), that form a crucial part of his mesa:

The herbs have their spirits, because they speak and direct the activities in the realm of *curanderismo* during the nocturnal session . . . Their spirits are susceptible to the *curandero* who manipulates them. They can advise or warn him . . . They indicate to him how the cure is to be effected . . . They enumerate the dangers to watch out for . . . They have a spirit that is matched with the power of San Pedro and the intel-

lectual power of the *curandero* [who] also influences them. He imposes his personal spiritual force over the plants . . . The plants receive this influence and return it toward man. (Ibid.: 36–37)

There is a strong reciprocal relationship between the plant spirits—whether ingested, consulted, or prescribed—and the shaman. However, the direction of imparted knowledge runs predominantly from plant to person.

The dominant teaching and curing role of plant spirits is based on their ability to remove the shaman's normal human ego attachment in ways reminiscent of Zen paradox. For instance,

a contemporary Peruvian shaman [Don José Campos] recently reported to me a relevant vision in which the *caapi* plant spirit asked him, "Do you want to learn?" and he replied, "Yes." The plant enjoined him, "Then let yourself be taught," and its spirit pulled very hard on his ear and whispered into it, "Let me drink you, you don't drink me. When you drink me, you drink with your ego. If I drink you, as a plant, a pure plant, I'll show you the wisdom of all the plants." In this worldview the plants are the "bosses," as this informant called them, so the plants can "drink us." (Stone-Miller 2004: 53)

Regardless of whether one willingly relinquishes the ego—allows the plant to drink oneself—the visionary state will tend to prevail, as discussed. Calling into question all everyday assumptions that the individual human ego is an entity in itself, much less an agent, lies at the core of how visions create the understanding that a shaman is an intermediary. The permeability of the person—who lacks even a body at times, inhabits two states of consciousness at once, and becomes a geometric pattern or a ferocious beast—programs the shaman to function as a go-between, a portal, a conduit for energy transfer (Wiese 2010: minute 6).

The ego stepping aside so that the shaman can adopt the intermediary role is not only felt by the shaman internally and communicated verbally to others during or after the trance but also potentially observable by others. Often while entranced a shaman acts differently from his usual self, which is perceived as the spirits communicating through him. In the indigenous Americas, this is very rarely spirit possession (being completely taken over by a spirit and losing all recall) but rather a shared, eminently memorable relationship to the spiritual forces. For instance, under the influence of ayahuasca, an unnamed Ashininca shaman sings with

an eerie distant quality of voice. His jaw may quiver, he may cause his clothing to vibrate. What is understood to be happening is that the good spirits have come to visit the group . . . [to] sing and dance before the assembled mortals, but only the shaman perceives them clearly. It is further understood that when the shaman sings he is only repeating what he hears the spirits sing, he is merely singing along with them. (Weiss 1973: 44)

Singing along, he posits himself as an intermediary versus being unconscious or out of control. Don José Coral had "the spirits of powerful shamans who talked through his mouth in a disturbing manner . . . Don José calmly questioned the spirits in Spanish about how to treat his patients, even about how much to charge them for his work. The spirits nervously answered in the Cocama language" (Luna and Amaringo 1999: 15). He asks questions as himself, and they answer through him and thus are not him, in a back and forth sequence involving two languages, aptly epitomizing the dual-consciousness state.

Related to languages spoken during trance, Don Pablo reported that he could sing in Quechua while under the influence of ayahuasca, although he could not speak the language otherwise (Wiese 2010: minute 20). Don Santiago Murayari of northeastern Peru reportedly would host underwater spirits that made his voice stronger and dramatically changed his personality (ibid.). Likewise, Doña Isabel "began speaking with the voice of a very old man . . . Her entire body was like that of an old man and her voice was that of an ancient one" (Glass-Coffin 1998: 64); another time her "voice commanded, but the directions seemed to come through her from another source" (82), and a third time she seemed to have God speaking through her (130). As an intermediary, she temporarily took on the aches and pains of her clients during the healing ceremony (83); the shaman typically absorbs and then sloughs off patients' symptoms (Sabina with Estrada 2003: 76; Lizot, Curling, and Jillings 1996: minutes 14, 33).

The transformation into animal selves is another major way for the shaman to exist between states of being, to channel information from the animal world. The shaman's human ego must step aside for the animal power to be expressed through him/her as an intermediary, a process that is also potentially apparent to beholders. As their animal selves, shamans eschew words and vocalize very persuasively, moving their bodies in appropriately nonhuman ways. Under *Virola* the Yanomami act like wild animals, darting, flapping, and grimacing impressively (Mann 1999: minute 18). They adopt angular squatting movements, and saliva and black mucus drip from their mouths and noses in dramatic fashion (Lizot, Curling, and Jillings 1996: minutes 10–13). Convincing jaguar growls made by an unseen Shuar shaman were understood by the indigenous peoples to mean he was truly transformed physically into a jaguar (Lucas Carpenter, personal communication 2008). It is significant that animal sounds are encoded into ancient effigies that feature in-between states of being. For example, a Marbella-style Costa Rican flute depicts a vampire bat in its humanlike walking position and when inverted produces musical tones; significantly, bats only make audible sounds when roosting upside down, which seems to have inspired the artistic design (Stone-Miller 2002b: 80–81).

Just as spirits come through human vessels, so also invisible forces and spirits manifest in and through the power objects used by contemporary shamans.[2] Doña Flor fashioned a doll that was rubbed all over the body of a sick baby to absorb his essence and thus fool the evil spirits (Glass-Coffin 1998: 113). The use of dolls in seventeenth-century Peruvian "sorcery" is very similar (ibid.: 41). More commonly, the mesa objects function to contain a spirit essence that can protect and attack and "are also used to cleanse the patient of evil and illness, absorbing the *daño* [illness, harm] from the patient's body and trapping it until it is dispatched into the air by the *curandero*" (ibid.: 20). The object has its own spirit and, as a vehicle, absorbs and transfers imperceptible forces; there are both permanent and temporary spiritual roles for physical objects in shamanic practice, as I argue for ancient effigies as well.

Among the objects in them, quite often mesas feature stones (*piedras*), Dobkin notes:

These constitute the largest category. Many are highly polished and oddly shaped. Each one has its own name and the curers believe that each of these stones adopt the form of persons and animals which then attack enemies. Each stone, moreover, can receive orders from the curer. (1968/1969: 26)

Thus, the stones are considered to have agency and transformational ability and to act as channels for the shaman. Multiple examples exist: Don Esteban Tamayo Sr. has a large stone on his mesa that he appropriated because it was causing social strife in the village and he needed to redirect its energy toward healing (Stone 2007b: 22); Don Agustín centers his healing practice around the spirits in large carved boulders, some of which were animals previously and can absorb and release actual animals from within them (personal communications 2004, 2005; Stone 2007b). Don Eduardo said stones held a specific energy for as long as a millennium. At a ruin near the ancient city of Chan Chan he found a set of stones he interpreted as a pre-Columbian "sorcerer's kit" (Sharon 1978: 7). However, when he added them to his mesa, in a vision he saw them as possessed by ancient evil spirits who caused his modern power objects to bleed and release horrifying beings that could not be converted to his benign purposes, so he destroyed the set (ibid.: 54). While we might recoil at this destructive act, it nevertheless underscores how material things are seen to bear potent, long-lasting, and perceptible spiritual charges.

Neither shaman nor power object acts as a conduit randomly or generically; both are talented in directing certain energies. For example, for many shamans the deer foot possesses the power to drive away all that is unwanted, due to the animal's fleetness (Glass-Coffin 1998: 133; Scher 2007: 39–41). Doña Isabel calls for specific combinations of her many staffs to cleanse a particular patient: a quince wood staff to pull sorcery out, one of garlic wood to prevent evil shamans from sending the smell of garlic that invalidates the effectiveness of San Pedro, scissors to cut the ties of daño that bind the patient to the illness, and the so-called Cripples' Cane to cure paralysis (Glass-Coffin 1998: 128). She has one staff on her mesa that is her alter ego and most directly moves her personal power into others and vice versa (ibid.: 128–129, 132). That shamans are deeply affected by

a particular staff was made clear to Glass-Coffin personally when she assisted at a healing and inadvertently used Doña Isabel's alter-ego cane instead of the Cripples' Cane, noticeably weakening the shaman and even making her suicidal (128–129).[3] In his curing rituals Don Eduardo had patients stand at the mesa, and one of the upright staffs at the back would visibly vibrate, indicating the type of problem involved and which spirit manifested in the staffs could allay it (Sharon 1978: 105). For example, the swordfish beak was used to find souls lost underwater (ibid.: 71). To him these were not arbitrary relationships: a bird incarnation would not work as a conduit for rescuing a soul lost at sea but only one adrift in the sky. The characteristics of the animal in nature determine what powers its spiritual equivalent can harness. Nor did Don Eduardo believe it was the staff itself that could find someone but the power of the staff channeled from the spirit of the swordfish or bird. This reminds us to avoid becoming too fixed on objects' material aspects, given Western nominalism.

As opposed to natural objects, with mesa objects that have been fashioned (in his case by Calderón himself, who was also an artist), the specific powers are related to what we call the imagery of the object. However, the active capacity for a carved owl to transfer "owl power" from all owls or owl spirits to Calderón and through him to his patients during the trance makes the idea of embodiment—giving a physical form to something intangible and invisible—more relevant than that of superficial depiction. Embodiment as a vehicle for shamanic transfer of energy will be explored for effigies in chapters 4 through 8. These are key lenses through which to look at ancient objects for which we do not have surviving informants' interpretations.

The idea of the object as vehicle helps provide alternatives to the anemic archaeological categories of "offerings" or "grave goods." Archaeologists rarely pose the fundamental question of what the material objects in a burial are doing there and whether they functioned in a material fashion. Seeing objects as transfer points for spiritual energy certainly helps explain the widespread ritual "killing" of images found so often in ancient American cultures. Of the very early Valdivia figurines (in Stone-Miller 2002b: 174, catalogue nos.

410, 411), thousands of which have been found intentionally broken in middens on the southern coast of Ecuador, Stahl maintains that they served as far more than simple fertility figurines:

> Recent examples of non-secular usage suggest that an intimate relationship is shared between figurines and otherworldly spirits. During ecstatic contact with hidden worlds, the figurine often serves as a mundane repository for otherworldly spirits. Upon completion of the ritual visit, the figurine is vacated. (1986: 136)

Stahl gives as current traditional examples the Taino *zemi* figurines whose spirits served as messengers to the supernatural, Upper Xingu–region use of dolls to hold the soul that has been recovered from the Other Side, Cuna *mimmisuara* that find lost souls in enemy spirit villages, and Chocó *jai* figures that house spirits during ceremonies (ibid.: 136–138). "As with the Chocó and Cuna examples, . . . helper spirits were ecstatically contacted and introduced into the [Valdivia] figurines. Upon conclusion of the ceremony, the imbued power of the figurine was lost and it was then discarded as a useless item" (ibid.: 144). Interestingly, the same kind of curing, breaking, and discarding pattern is found with Aztec figurines (Smith 1998: 242); it seems quite widespread in the ancient Americas. This treatment is complementary to the obvious fertility message of the Valdivia figurines with their bulging thighs: if the ceremony were intended to generate fecundity and the woman in question became pregnant—infused with life like the figurine self—then the purpose of the vessel was accomplished, so it was appropriate to "kill" it. A subsequent problem would require a new vehicle, which would account for the vast numbers of such figurines and their consistent ritualized treatment and disposal. It is important to note that some of the Valdivia figures have two heads (Chambers 1990: 24, plate 1) and other shamanic indications such as, arguably, two sets of eyes (Ontaneda Luciano 2001: 19), making them more spiritually oriented than simple records or unwanted trash.

A very late pre-Hispanic example serves to underscore how intermediary thinking continued to characterize the approach to material objects in ancient Andean cultures. Inka huacas, introduced

briefly earlier, are the most widespread evidence of the importance of intermediary points where active participation of various people and forces took place. Through huacas, which can best be likened to portals, ancestors and original ethnic groups manifested, oracular knowledge came through huaca "priests" (shamans), and food and offerings were transferred to Pachamama (the animate earth) and the spirits (Cobo 1990: 158; Stone, n.d.a; Classen 1993: 68, 70–71). Being a locus for transformation, huaca is more a verb than a noun, as is the concept of the intermediary; both have a physical component but primarily fill a spiritual energy-moving function. Huacas distinctly relate to duality, since they include double-yolked eggs, anything split (such as a cleft lip or outcropping), and twins, discussed in chapter 8. Thus, *huaca* also means something that is inherently more than one thing at once, has a "between" (the cleft, for example), and thus matches the shamanic dual stance and liminal intermediary power. They are nothing if not odd, a quality that serves as the common denominator of the many things listed in the chronicles as having (more than being) huaca, or extraordinary spiritual energy. Aside from phenonmena of dual nature, huaca can mean a person with six fingers (*huaca runa*), again considered powerful rather than unfortunate (Classen 1993: 15).

ANOMALOUSNESS

By definition, then, an intermediary entity is distinct from other phenomena in some ways, an anomaly in relation to the usual. The characteristic of anomalousness overlaps productively with liminality and multiplicity, encompassing both human and animal, Here and Not-Here. To us it may connote that which is weird and potentially unacceptable, but most ancient American civilizations, especially those of the Andes, seemed to embrace the anomaly wholeheartedly as sacred and illustrate unusual bodily conditions along with markers of the shaman's role.

Often shamans' bodies *are* distinctive, one of the many ways they are anomalous in their societies. As argued in the case studies, being born with or acquiring a physical distinction predisposes people to the curing professions via the logic of the wounded healer. Illness, which may permanently mark the body, can be seen as anomalous; the shaman-to-be and later her clients becoming sick is at odds with the healthy progression of life. More permanently altering than disease itself, however, Amerindian shamanism often encompasses individuals who are intersexed (historically known as hermaphrodites) and thus visibly bridge the usual sex/gender categories. The Siberian–Inuit–North American traditions particularly embrace the fluidity of a shaman's sex, with a "third gender" created for ritual specialists. d'Anglure finds that "ternary thinking" and androgyny characterize shamanism and the entire culture of the Inuit (2003). Balzer avers,

> Within the cultural traditions of Siberia, some of the most diverse variations on the theme of gender flexibility are reflected in beliefs about shamans (spiritual healers), animal spirits, and power through manipulation of sexual energy. Gender transformations perceived according to some European standards as deviant instead become sacred . . . The attitude . . . toward hermaphrodites is quite simple: they evidently view it merely as an anomaly and nothing to be abhorred at all. (2003: 242, 247)

It is a form of power to be outside the usual limited roles prescribed for males and females; shamans are expected to intercede in fertility issues of all kinds, so that to be both sexes grants them the special status necessary to be effective shamanic intermediaries. Intersexuality is straightforwardly depicted in ancient images from various cultures, as discussed in chapter 5, and a significant "gender-complicated" category exists among Moche ceramic human effigies (Scher 2010).

Beyond the unusual body, it has been demonstrated that the ability to have visions, although it does not manifest outwardly, also constitutes a shaman's productive sensory anomalousness. Visions allow the shaman to experience other realms and spirits by definition distinct from the terrestrial and the everyday. A shaman cannot be limited to normal consciousness or corporeality if solutions are believed to come from the nonordinary cosmic levels only perceptible in altered consciousness states. In short, sensory anomalousness is a necessary condition for the shaman. Equally, the content of visions has been shown to

be deviant in relation to everyday life: one does not walk around feeling oneself to be music, for instance. The bizarre feelings, senses, revelations, and actions a shaman undergoes during trance have been described in detail. Especially key are the flux experiences that catalyze the shaman to become part human and part Other, the combination of beings they encompass, their multiplicity, profoundly different from other people's singularity. Indeed, it is uncommon to be a shaman in the first place.[4] Shamans, living out their intentionally divergent role, tend to reside at the edges of a village or outside it (Schultes and Raffauf 1992: 84; Glass-Coffin 1998: 54, 58, 66, 73, 77). They pursue a different lifestyle, routinely avoiding prized foods such as salt and meat, and activities such as sex. They may starve themselves to achieve visions. The challenges inherent in taking on this role are detailed later, but their purpose is to detach from the quotidian and terrestrial so as to achieve the freedom to pursue nonhuman solutions to human problems.

In terms of art, the anomaly plays an interesting visual role in various ancient American styles and can be associated with shamanic subject matter in some intriguing cases. Formal anomalies—colors and shapes that intentionally break the regularity of a composition—are especially characteristic of the Andean imperialistic styles such as the Wari, Chimú, and Inka but occur in nonstate contexts as well, such as the Paracas. My doctoral research on Wari tunics unearthed that "one of the rules was to break the rules," meaning that deviations and anomalies were so prevalent within the repetitive patterning system that they constituted an official requirement of the style itself (Stone n.d.b). While I did not link the formal with iconography in previous work, it now seems obvious that the winged, animal-headed figures that dominate Wari art clearly represent transformational shamans (Stone-Miller 2002a: 134).

The issue of anomalies as shamanic in the case of Wari "staff-bearers" will be considered in chapter 7. However, in the textiles of other Andean cultures, especially the later Chimú and Inka states, color anomalies continue, and I argue that irregularity itself indicated high status, even the prerogative of royalty (Stone 2007a: 399–416). I have related the fact that most color anomalies are blue-green to the magical transformation that the dye indigo undergoes (Stone-Miller 1994: 115–116; Stone, n.d.b). With regard to the earlier Paracas aesthetic, a tunic acknowledged to represent shamans in trance contains particularly noticeable irregularity in the number of figures per row, and "it is tempting to conclude that the shaman image, representing an intermediary with the supernatural realm who breaks the rules of everyday life, was to be illustrated with an equally rule-breaking composition" (Stone-Miller 1994: 84). No attempts are made to hide or redo such anomalous elements, indicating that they are purposeful and meaningful in and of themselves, just as the shaman's unabashed anomalousness forms the source of his or her capacity to heal.

An anomaly does not in and of itself constitute power, however. The distinctiveness, like all potential, must be honed toward healing ends, trained and harnessed as it is during the process of becoming a shaman.

ACHIEVING CONTROL

Learning to channel differentness toward socially and spiritually useful ends entails being called to the profession, apprenticing, and gradually attaining expertise in the rigors of the visionary realms and the related ritual practices of the shamanic path. The route to becoming a shaman is typically an arduous one, evidences fairly predictable stages along the way, and is guided by the goal of acquiring knowledge, experience, and successful cures that indicate that the individual has attained control over the essentially uncontrollable spirits, diseases, other shamans, wild animals, forces of nature, the weather, fertility, and so forth.

CALLING

Halifax concurs that "the steps of the journey of shamanic initiation seem to have a patterned course. The call to power necessitates a separation from the mundane world: the neophyte turns away from the secular life, either voluntarily, ritually, or spontaneously through sickness, and turns inward toward the unknown, the *mysterium*" (1982: 6). Though it involves turning inward, the act of being called is figured as coming from outside; one does not elect oneself to become a sha-

man, nor does one's community do so. The spiritual realm is considered to select individuals who, as discussed, have something special about them and either calculatedly or spontaneously experience nonordinary events.

Typically, at first the visions that form the core of this process are overpowering, frightening, and confusing. According to Don Aurelio, a Mazatec shaman of Oaxaca, Mexico, an apprentice usually finds the first experiences with psilocybin mushrooms to be bewildering and out of control. Over time the initiate "comes to deal with the mushroom on equal terms," and when finally ready to become a *menjak* (a shaman, one who knows), "from that moment the mushroom teaches you all things" (Wasson 1980: 18, 46–47). This implies that it is impossible to learn from the plant masters without a certain level of control over the visions they provide. The bravery of the individual must be tested early, as the profession of shaman requires constant risking, battling, and overcoming of fear (Narby 1998: 7). Visions require courage even for trained shamans such as Grefa, who must face being constricted by enormous snakes almost to the point of death each time (personal communication 2004). Yanomami shamans comment, "The voices of the spirits are frightening" (Lizot, Curling, and Jillings 1996: minute 32).

Similarly, "Like most Sharanahua men, the shaman Ndaishiwaka had taken *ayahuasca* many times and had overcome his terror of the first frightening hallucinations of snakes before he decided to become a shaman" (Siskind 1973: 32). Munn avers, "It is not everyone who has a predilection for such extreme and arduous experiences of the creative imagination or who would want to repeat such journeys into the strange, unknown depths of the brain very frequently" (1973: 87), as others concur (Dobkin de Rios and Katz 1975: 67; Grob 2002b: 191, 201–202, 208; Klüver 1966: 53, 55). Wasson finds that "the novel effects on the initiate are overwhelming, sometimes terrifying. Nausea is the least of these distressing effects . . . [Mazatec master shaman] Aristeo [Matías] warns the beginner that he may see 'visions of hell' . . . they little suspect what they have yet to learn" (1980: 48–49). Don José Campos discusses how insane and incomprehensible his first visions were to him (Wiese 2010: minute 29). The Tukano ideal is to

achieve only agreeable visions, and initiates learn to magically influence the experience to that end (Reichel-Dolmatoff 1969: 333). It is interesting to note that the three innate fears of primates appear to be the fear of snakes, as mentioned earlier (ophidiphobia; Association for Psychological Science 2008), of the dark (nyctophobia; Boaz 2002: 6–7), and of heights (acrophobia; Jones 2002: 66).[5] A shaman must conquer all three of these deep-seated fears during nighttime rituals featuring snakes and the experience of flying and/or suspension in celestial locations.

As the process unfolds, the master shaman conditions the initiate to perceive certain phenomena and interpret them in culturally specific ways. For example, how one reacts to the giant snakes can be directed away from fear and toward communication. Reichel-Dolmatoff discusses how the Tukano during trance describe their visions to a shaman who identifies a red shape as the Master of Game Animals or swirling shapes as a dance of certain spirits: "In this manner a process of imprinting is brought into play, and any individual who is acquainted with the basic significance of color symbolism, of ritual paraphernalia, and of the corresponding music will soon be able to identify a number of images each time they appear in his visions" (1975: 180). Sheer familiarity with the challenges of the visionary realms helps mitigate them (Grefa, personal communications 2004, 2005). However, measures of power over the uncontrollable visionary realm are only gradually and partially achieved, since power does not exist in an absolute, willful, or egotistical sense but in the sense of participating in the other realms from a position of strength, aided by animal and plant spirits and objects acting as vehicles. Control by humans over all else is not sought in the inclusive, flexible shamanic worldview; as we have seen, visions will dissolve such ego attachment and provide the animal perspective that makes such an approach obsolete. Shamanic control comes in learning to be a talented intermediary. It is very relative and commonly begins with experiences of its opposite, powerlessness.

Before being called, often the already anomalous but untrained person experiences what a veteran shaman does regularly: healing of self or others, prophetic dreams and visions, journeys to or with the dead, supernatural or interspecies

communication, synaesthesia, and so on. In the cyclical Amerindian worldview in which all is precedented, a shaman-to-be is already a shaman, waiting to be revealed, honed, and proven effective. It is important to underscore that the person called may be male or female as well as intersexed or ambiguously gendered. Shamanism is inclusive as to gender because given spiritual rather than human agency, whoever is called is called, regardless of the political or social conventions that hold sway.[6] Hence, the subsequent case studies prominently feature a number of female shaman effigies.

This "equal opportunity" aspect has pertained in the Andes for a long time, given the many Moche images of female curers (Sharon 2000) and the comments of the Spanish regarding Inka shamans (Stone n.d.a). For example, Cobo makes specific mention of a highly influential woman diviner by the name of Galina "who was considered very eminent in this occupation" (1990: 160). Colonial women healers, albeit defiled as "witches," are well known in the literature (Glass-Coffin 1998: 42–46). Modern women shamans are in some cases famous, like Doña María Sabina in Mexico and others throughout Siberia, North America, and southward, as Glass-Coffin (1998) and Tedlock (2005) have shown, redressing a strong male bias in the field. A renowned and very powerful—as well as feared—Shipibo woman artist and shaman named Vasámea is mentioned by Gebhart-Sayer (1985: 150).

While not necessarily unusual, women shamans may be extraordinary in the control they evince: Don Agustín said female shamans and spirits are the most powerful of all (Stone 2007b: 19–20). Likewise among the Shuar, although "women rarely become shamans, when they do they are thought to be particularly powerful because they are believed to possess special *tsentsak*—spirit helpers" (Harner 1973d: 17). Northern Peruvian shaman Doña Clorinda contended that "the work done by a *maestra* [female shaman] can only be undone by God in his power" (Glass-Coffin 1998: 79). Amaringo illustrates female shamans throughout his paintings and mentions extremely daunting women shamans who both positively and negatively affected his development as a shaman (Luna and Amaringo 1999: 25–28).

There is another element female shamans often have in common: they may deny or resist the call because of conflicts between spiritual practice and child-rearing responsibilities. Since entheogens can cause miscarriage, taking them while fertile is usually considered dangerous (Schultes and Hofmann 1992: 62).[7] For example, future shaman Isabel "was too pregnant to drink the San Pedro" (Glass-Coffin 1998: 62), and another pregnant shaman was likewise prohibited from taking mushrooms (Wasson 1980: 34). Doña Clorinda said marriage weakened and distracted a woman, but single ones were very powerful (Glass-Coffin 1998: 79). Don Hildebrando of northeastern Peru allowed only postmenopausal women to conduct ayahuasca healing (Dobkin de Rios 1992: 137). To avoid the problem of family versus work, women may take up the calling later in life, refusing to acknowledge their powers until it is more socially acceptable and convenient (St. Pierre and Long Soldier 1995: 25–26; Langdon 1992a: 53). Men, too, like Amaringo, often refuse to heed the call until repeated experiences force them to accept the difficult path of the healer (Luna and Amaringo 1999: 21–30).

Whether or not they immediately accept their role, a common pattern is for shamans to be revealed as somehow extraordinary as children. Grefa's childhood featured an amazing long-distance solo journey at the age of nine, guided in dreams by the spirit of his deceased shaman-grandmother (Stone 2007b: 7–8). This feat singled him out as favored by the spirit realm. In a way it was a death-defying achievement, since he was a small boy escaping slavery without money, food, or transportation. Dreams of communication with the dead likewise are interpreted as calls among the Maya (Duncan Earle, personal communication 1993). Many scholars note the recurrence of skeletal imagery in shamanic costume and visionary art from Siberia and across the Americas (Halifax 1982: 76–77; Paul and Turpin 1986).

At whatever age, to almost die or to die and be revived after suffering a disease or an attack is by far the most common sign of special spiritual calling. To die while young and be brought back to life by an experienced shaman, often a family member, commonly signals one's future spiritual vocation. Esteban Tamayo Sr. reports dying at age seven and being miraculously revived by his grandfather (personal communication 2004). In shamanic terms, such a person has visited the land of the dead and returned, exactly what a trained shaman routinely does. Eliade called this miracu-

lous survival "sickness vocation" (1964: 33), others "the wounded healer" (after T. S. Eliot's "wounded surgeon"): [8]

> The shaman's mastery of chaos can take the form of a battle with disease spirits that overwhelm the neophyte to the point of near-death. These horrific adversaries become tutors as the shaman learns the ways of the spirits that ravage and cause sickness. The neophyte Underworld-voyager learns the battlefield that he or she will enter on behalf of others in the future. Here, the shaman acquires direct knowledge from direct experience. (Halifax 1982: 10)

The Akawaio of Guyana declare that "a man must die before he becomes a shaman" (Lewis 2003: 63). Wright explains the logic succinctly: "When a person heals himself without any external help, it is considered to be evidence that he has some kind of power. From this point, the disease from which he suffered will be part of his personal power and he will subsequently be able to cure others suffering from the same disease" (1992: 162–163). Thus, from the beginning some individuals evidence inherent power over death; some possess abilities to control life-and-death issues, while others lack them.

Examples of the wounded healer abound. After medical experts were baffled by his illness, Don Eduardo was miraculously cured by a shaman (Sharon 1972: 12). Northern Peruvian shaman Doña Yolanda almost died and then was taken to a folk healer; "but, instead of turning her cure over to José, allowing him to intervene with the spirit world, on her behalf . . . she felt obliged to take an active role in her cure. As she put it, 'I decided it wasn't right to continue with [José performing] the cure, in other words I began to defend myself alone'" (Glass-Coffin 1998: 56–57). Amaringo was cured numerous times. First, on his own he pulled himself back from death from a heart ailment; years later he took ayahuasca and had a vision in which a medical doctor performed successful arterial surgery, and after the vision he did not suffer the problem again. Finally, after Amaringo's second paralyzing illness was cured by Don Pascual, he "realized that the world is full of things that human beings do not understand," and he began to learn the songs and diagnoses to become a curer himself (Luna and Amaringo 1999: 23–25).

Thus, various scenarios of being cured and taking up the mantle of curing play out in different individuals' lives, but the theme remains strong. One way that a shaman-to-be is singled out is by falling ill and recovering naturally; another is for an established shaman to heal the person's unknown, often bizarre, and previously intractable condition, which convinces both healer and patient that the latter too should take up the profession. The shaman, being a conduit of power from Beyond, cannot be completely credited with a miraculous cure; it involves the spirits on behalf of the patient and thus shows spiritual potential or blessing. In this logic, to be cured—even "by" another—means that the spirits have "spoken."

Surviving other kinds of attacks predisposes one to this path as well, since that too demonstrates pre-existing power in relation to nature spirits. Among the Mojo of Bolivia, a man who survived a jaguar attack was singled out to apprentice as a shaman (Furst 1968: 147–148). As a boy, Huichol shaman José Benítez Sánchez of western Mexico was attracted to a baby rattlesnake and so was given its heart to eat and was drawn on with its blood to begin his shamanic training (Furst 2003: 13). The perhaps best-known Huichol shaman, Don Ramón Medina, survived a coral snake's bite that paralyzed him from the waist down and nearly killed him; he was cured by his shaman grandfather in exchange for promising to complete his own training (ibid.: 14–15). An unnamed Sharanahua man survived a venomous snakebite, was cured by two shamans, and then became one himself (Siskind 1973: 32).

Another recurrent way to be called is to have visions, especially prescient ones, under "normal" conditions. Like curing oneself or being cured, spontaneous visionary experience suggests a capacity to have more controlled visions on behalf of others. Although we may think such experiences would be vanishingly rare, in fact "visions," defined broadly, are accessible to all, even when produced unintentionally. They occur in various ways without the introduction of substances, such as during fevers, while at high altitude, in a hypnagogic (preceding sleep) or hypnopompic (preceding awakening) state (Siegel 1992: 6–7). Our culture may discount these as meaningless, yet a shamanic culture places value on such experiences as analogous to the ones that shamans intentionally utilize for the good of others. If what is seen

in such "natural" visions comes true, it represents a powerful spiritual sign. To see the future or distant reality without entheogens, even if they are seen as catalysts more than agents of visions, indicates a particularly talented visionary. In fact, in many systems the most experienced shamans no longer need any external catalyst for their trances; therefore, the person who is untrained and yet does not need a catalyst is all the more extraordinary. Luna provides a good example of such unaided visions leading Don Manuel Shuña of the northern Peruvian Amazon to become a shaman:

> One evening he heard the whistle of a strange bird several times. He thought it was a spirit and said aloud: "Come here, I invite you to smoke tobacco." Soon two people came, smoked with him, and told him to take the bark of a certain tree. They then said, "We will always be with you, and you with us." And then they left, and in this way Don Manuel became a *palero* [a type of plant shaman who uses tree bark as an entheogen]. (Luna and Amaringo 1999: 21)

In this example an animal spirit, two human-looking spirits, and two types of entheogens (one taken, one prescribed), along with the visionary experience that brought them all together, succinctly encapsulate how nature in its transformative spiritual guises conspires to convince a prospective shaman of his vocation (given his predisposition to interpret his experience in this way, of course). There is no conceptual disconnect in one bird becoming two shape-shifters, as part of shamanism's inherent emphasis on nonlinear multiplicity and flux.

Like visions, dreams are a way in which calling takes place. Tedlock considers how shamanic peoples, from the Mapuche of Chile to the Zapotec and Maya of Mexico, embrace dreams as real, prescient, active communication with supernatural realms on a par with visions and equally necessary to share publicly (2003; 2005: 103–128). During fieldwork, the Tedlocks themselves experienced prescient dreams and recovered from illnesses before apprenticing with two K'iche' Maya shamans, Don Andrés and Doña Talín, who required them to share their dreams as an indication of their spiritual progress (Tedlock 2003: 113–115). Among the Maya, a dream of flying "signifies that one's soul (the part of the self that flies)

is knowledgeable, a prerequisite for shamanic training" (Tedlock 2005: 111). The Maya interpreted Earle's aforementioned dream of consulting with skeletons to mean he was to train as a shaman.[9] He had recovered from a major illness, showing that multiple signs may converge to pinpoint a future shaman. Ten-year-old Doña Clorinda's dream with explicit instructions on where to find tarot cards to use in divination comes to mind again (Glass-Coffin 1998: 70–71). After calling, dreaming is inextricably linked with the ongoing practice of the initiate, who learns to remember, interpret, and control dreams, as well as that of the fully trained shaman, who relies on them in curing (Kracke 1992; Wright 1992; Tedlock 2003: 103–128). Modern Maya apprentices learn to revisit their dreams and "complete" them, showing impressive control over that which most people have none (Tedlock 2005: 104–105). The Makiritáre believe the shaman can reenter a client's dream and change it (Kracke 1992: 145–146). For the Kagwahiv,

> dreaming . . . was the vehicle through which the shaman exercised his power to change or influence conditions or events in the world: through his dreams a shaman could make a particular kind of game available for a hunter; he could assure vengeance against an enemy in warfare; he could send illness; or he could cause a woman to conceive a child who would later become another shaman, his successor. (ibid.: 129)

I have already hypothesized that other spontaneously occurring, distinctive sensory experiences, especially synaesthesia, might similarly predispose certain individuals to the shamanic path. A small but significant proportion of the population, estimated at around one in two thousand (Duffy 2001: 2), is naturally synaesthetic during daily life; many more likely have isolated or limited such perceptual overlaps, when falling asleep, during sexual excitation, and so on.[10] Because sensory cross-over is a fantastical visual/sensory effect so often experienced in visions, it follows that naturally synaesthetic neophytes would be elevated in relation to accomplished shamans who must rely on catalysts. The predisposition for synaesthetes to become shamans remains hypothetical; however, the parallels are striking. Synaesthetes report their

condition beginning in childhood, they experience dual consciousness (their extraordinary perceptions coexist with normal sensory input), and they are often inspired to render their multiply sensory world artistically (Duffy 2001, Smilack 2005, Steen 2005). Shamans not only experience synaesthesia when they travel to the Beyond but in general exist in two worlds at once, make unusual connections others do not perceive, and have more ability to cross from one modality (the dead, the past) to another (the living, the future). Two ancient Andean compositions that suggest the connection between synaesthetes, shamans, and the land of the dead will be considered in chapters 7 and 8.

Synaesthetes as shamans may sound less farfetched considering other extremely idiosyncratic perceptual phenomena involved with shamans being called to the profession. For example, Amaringo as a youth had a bizarre condition in which he saw only half of a person or thing in front of him (Luna and Amaringo 1999: 22). His father gave him ayahuasca as a medicine to "strengthen" him, presumably under the logic that it enhances sight and so could cure a partial-sight problem. In any case, the condition was ameliorated and later he did become a shaman, thus exemplifying not only that unprompted unusual visual phenomena indicate potential to have such experiences intentionally but also that taking entheogens helps determine if someone might be capable of pursuing the profession. In fact, as mentioned earlier, many modern shamanic cultures administer entheogenic substances to children, youths, and others. Patients typically take San Pedro or mushrooms or ayahuasca as part of a healing; both shaman and patient are understood to be on the Other Side, where spirits affect the cure (Grefa, personal communications 2004, 2005).

Yet some people, even given extremely potent doses, nevertheless do not experience visions from entheogenic substances. Thus, taking substances and having visions serves as a test of shamanic potential and figures prominently in the initial process. There are numerous examples of people not having visions. Peyote's only effect on Klüver was to make him physically sick (1966: 17); Reinburg and others were equally unaffected by ayahuasca (Harner 1973a: 157–158; anonymous, personal communication 2008); and two of

Naranjo's thirty-five subjects likewise saw nothing (1973: 177–178). In traditional terms, the plant spirits either pick or reject individuals, controlling access to other realms, as discussed earlier. The Tukano aver that "the snuff takes its choice" and "takes hold of them of its own accord" (Reichel-Dolmatoff 1975: 117). Ndaishiwaka only gradually was able to see elaborate visions, and finally when he saw the anthropomorphic spirit of ayahuasca he became a very powerful Sharanahua shaman (Siskind 1973: 32).

APPRENTICESHIP

Calling, however it may occur, remains simply the first step and does not automatically make one a shaman. Apprenticeship of several years' duration to a master shaman or various teachers, including the spirits themselves, is deemed necessary to train the neophyte in complex, esoteric spiritual matters and ascertain aptitude, capability, specialization, and other characteristics. Once more, the spirits are considered those who decide whether this will happen; the master shaman often consults the spirits to determine whether to train a potential initiate. For instance, after the appropriate dreams were reported to them, Don Andrés and Doña Talín

> had gone together to their family shrine on a local hilltop. There they had laid out pine boughs and dozens of multicolored flowers. They burned yellow tallow and white wax candles, followed by a large pile of dark copal incense. With these offerings and their prayers, they asked permission of their ancestors to train and initiate us as shamans. (Tedlock 2005: 123)

Don Agustín offered to the Emory University students the opportunity to apprentice but indicated that the boulder spirits would ultimately make the decision (personal communication 2004).[11]

Several years, from two or three and up to twelve, in the case of Brant Secunda under Huichol master shaman Don José Matsuwa (Brant Secunda, personal communication 2003), are required for a traditional apprenticeship. Don Eduardo worked with various masters over a period of four years to become ready "because *curanderismo* requires a long and difficult apprenticeship" (Sharon 1972: 41). Don Guillermo

complains that instead of completing proper apprenticeships, false shamans use shortcuts and substitute occult book reading to gain knowledge (Arrévalo 2005: 206). An apprenticeship is an oral transmission of voluminous information, hence its lengthy nature. One can apprentice directly with the spirits, as Don Agustín did (Stone 2007b: 11), or via dreams, as among the Tobá (Wright 1992: 162). One's childhood may constitute a long apprenticeship if at least one parent is a practicing shaman, as happened with Doña Vicky. She learned herbal medicine from her *curandero* parents, although there was still a component of being chosen from Beyond: "'Spiritism chooses you. Strange things have to happen to you, mysterious things if you are to become a spiritist . . . One goes deeply into communication with them [the spirits], but one must have a very strong character'" (in Glass-Coffin 1998: 76).

There are various challenging aspects to apprenticeships that presuppose this "very strong character." Among the Shuar, for instance, sexual abstinence for up to a year is a requirement (Harner 1973d: 20). However, the main task is repeatedly ingesting entheogenic substances in order to master their initially overwhelming and chaotic effects. Again, this ability to control visions, like the capacity to have them in the first place, varies from individual to individual; Klüver observed that a few subjects during trance could think about something and immediately see it, although most could not (1966: 29–30). This suggests that some people, and therefore some apprentices, would be more likely to succeed in learning to use the visions rather than be victims of them; the process takes time in either case. Shamanic trance visioning does not entail casually taking a substance and "seeing what happens" as in nonsacred uses (Luna and Amaringo 1999: 22; Arrévalo 2005: 204). Rather, masters' guidance during training visions keeps the apprentice safe: we might say psychologically safe, yet in the shamanic worldview this includes protection from the very real powers of the spirits to steal one's soul and kill one's body.[12] From either point of view, visions are inherently dangerous, so the master must actively direct the apprentice's progress.

The role of training and guidance to determine the apprentice's mindset, expectation, and intention to see certain things and not others is key,

although visions have universal commonalities that the neophyte must be able to handle regardless of conditioning. An early study showed that cultural expectations and experience with peyote influenced its effects; when given to Indians and to whites, the former, who were positive about previous trances, reported calm, healing experiences, while the unprepared and more doubtful whites demonstrated wide emotional extremes and greater agitation (Dobkin 1968/1969: 23). On the other hand, cases already discussed, such as the scientist who spoke to the Mother of Tobacco, show that even the culturally unpredisposed and inexperienced can have positive and strikingly "traditional" visionary encounters.

In actual traditional settings the vision is overtly being used with clear goals in mind—to diagnose an illness, see a given person far away, find a lost article—so "planted" ideas are taken for granted. Indeed, the perceptual content of visions will often reflect what is being sung about and follow the rhythms of music and drumming as part of the dual consciousness state. However, the fact that visions are susceptible to suggestion does not negate the previously discussed inherent changeability and variation in percepts, their symbolic nature, or the odd and startling effects of visions but shows that the universal types of experiences (snakes, geometric patterns, spiritual communication, flying, and more) can be accommodated within a particular cultural or individual template. In any case, a teacher does aid in the student's attainment of visionary control, if gradual and not guaranteed.

A vital part of the ascension to full spiritual power is acquiring helping spirits, usually in animal form. This can take place during trance, as a transfer from the master shaman or other authority figure, or in a dramatic supernatural intervention. Luna, as we saw, received snake powers from Don José Coral from inside the shaman's chest (Luna and Amaringo 1999: 15–16). For the Desana, the natural force of thunder appears as a roaring jaguar,[13] gives apprentices their power objects, and puts the white belly hair of the jaguar into the apprentice's ear to enable him to hear spirit voices (Reichel-Dolmatoff 1975: 78). Shuar shamans ingest and regurgitate various spirits for initiating apprentices as well as for curing and harming others (Harner 1973d: 17–26). An experi-

enced shaman simply calls his helping spirits during trance and they obey, as Grefa confirms (personal communication 2008). This key concept of helping animal spirits must inform how we approach all animal imagery in ancient American art, giving us insight into such artistic choices as snakes for tongues, among many others.

In any case, the overarching goal of the apprenticeship is gradually to gain knowledge and spiritual control not only during trances but also regarding the rest of the elaborate business of being a shaman. This includes learning to prepare entheogenic substances, use healing herbs, and make mesa objects; to recite the names of multiple spirits—Amaringo lists 230 spirits in his visionary experience—and power songs that call spirits; to practice spiritual defense techniques, some quite dramatic, such as Eduardo's seven somersaults brandishing sharp swords (Sharon 1978: 47); to interpret signs in the body (Luna and Amaringo 1999: 25) and omens in the natural world (Glass-Coffin 1998: 88–91); and in some cultures to memorize complex calendrics (Tedlock 2003: 115–117; Duncan Earle, personal communication 1993). Naturally the specifics vary from culture to culture, some very musical and others more physical or intellectual, and from master to master, some lighthearted and others draconian. Apprentices may switch masters as Calderón did, absorbing different lessons along the way. Yet, it would be an overstatement to say that the apprentice learns exclusively from the master, one human to another. Agency is granted to the spirit realm as the ultimate teacher, such as the spirits of rocks, bodies of water, and the deceased (Stone 2007b: 7–11) or sprites (Wasson 1980: 48). During visions, learning entire songs and absorbing detailed information about plants as curative agents is typical (Luna and Amaringo 1999: 15).

PRACTICING

At some point, apprentices "graduate" to independent practice. The new shaman usually acquires a title that signifies his or her empowered status variously as an accomplished visionary, holder of animal forces, and someone with knowledge rather than in the process of learning. "What is central to shamanism is not the shaman as a specific role, but the quality of power that the shaman has" (Lang-

don 1992b: 14). Among the Kagwahiv there is no noun to refer to curers, but the verb *ipají* means possessed of power, so "shaman" is best translated as "empowered" (Kracke 1992: 129). Likewise, as mentioned, for the Wayapí payé signals a quality of power manifest in trees, people, situations, and all that therefore cannot serve, as we want it to, as the name for "shaman" (Campbell 2003).

The quality of this power is often couched in terms of light and the ability to see via visions; for example, for the Siona "seer" is synonymous with "master shaman" (Langdon 1992a: 53). Interestingly, Don Andrés and Doña Talín equate knowing and light: "These customs, these traditions, give a strong light, strong knowledge. It could put out your eyes. So you must be careful, very careful" (Tedlock 2005: 127). Not only does this statement represent the almost universal metaphor of knowledge as illumination, it signals that in shamanic thought the brilliant light perceived during *visions* is linked to the transfer of knowledge. The need for care in gaining knowledge correlates to the real power of the vision experience to overwhelm. Don Agustín similarly warns that knowledge without power and experience dealing in the spirit realms can be deadly (Stone 2007b: 16). Furthermore, several Amazonian indigenous groups see shamans who have developed sufficient power to mediate with the supernatural as exuding light in a visible aura (Luna and Amaringo 1999: 132–133). The Shuar call this *tsentsak*, "a brilliant substance in which the spirit helpers are contained," and the Shipibo-Conibo *quenyon* (Luna 1992: 251n2.). Likely also the luminosity of visions, which the completed shaman has experienced many times in training, ultimately defines or is incorporated into her being. The shaman shines within and without from all those light-bathed encounters with the Beyond. I will argue in chapter 6 that the ancient embodiments of shamans may characterize such power-as-light by adding serrated edges to their bodies and features.

The shaman as a manifester of power also may be referred to by the type of animal spirits gained during apprenticeship and practice, as in the Muisca word for shaman *subquayguyn*, meaning "full of the quality of bat" (Legast 1998: 148). The visionary perception of a shaman by another may be synonymous with that animal self: Amaringo paints his vision in which the enemy shaman

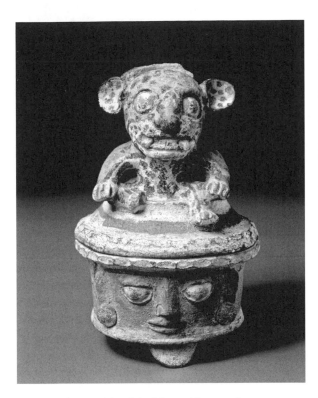

FIG. 3.1. Jaguar side of dual-figured incense burner. Mesoamerica, Highland Guatemala, Maya, 250–500 CE. Michael C. Carlos Museum accession number 1992.15.176. Gift of Cora and Laurence C. Witten II. Photo by Michael McKelvey.

There is also often a clear ranking of the various types of empowered shamans based on degree of talent and particular abilities. For the Tobá, the top shamans are "those that show their power," meaning they speak with the dead during dialogues that onlookers can only hear (Wright 1992: 163). Those with more helping spirits and those whose power is linked to the sky rank higher than others. The Siona distinguish "only a man" for the least powerful and "one who has left" for the accomplished shaman, both of which are lesser shamans than the master "seer" (Langdon 1992a: 53). The title "one who has left" signals the expertise to leave the body behind during trance journeying. This ability is a fragile sensitivity; hence the Siona "often employ the term 'delicate' to indicate that a man has reached the level of 'one who leaves'" (ibid.: 48). The extension of this ethereality, the ability to completely disappear and lose the perceptible body altogether, is similarly valued. Luna gives an example of Don Ambrosio Amaringo Vazquez, who "was able to take up to six gourds of

was a bat (Luna and Amaringo 1999: 133). Therefore in visions and in art the human shaman can be shown directly as the animal self, which is the true essence of their powers. Though bats and birds are key, more often in the American tropics the word for shaman is the same as the word for jaguar: *balam* in Maya, *ye* in Tukano (Buchillet 1992: 212), *yavi* for the Cubeo (Saunders 1998b: 31), and in Guaraní *yagua-ava* ("men in their jaguar selves," the phrase that inspired the title for this book, in fact), from whence the term "jaguar" came originally (ibid.: 32). The achievement of an interchangeable nature with the top animal spirit is crystallized into one name for the two aspects of this higher entity, the transforming shaman. It is the linguistic equivalent of the many ancient images in which human and jaguar are inextricably a dual being (for example, figs. 3.1–3.3). In fact, the Maya word *way*, meaning animal self, was written in hieroglyphs and expressed sculpturally as half jaguar and half anthropomorphic (fig. 3.4; Houston and Stuart 1989).

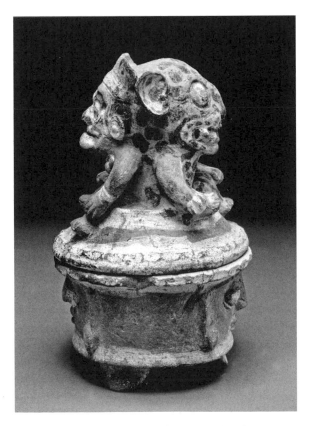

FIG. 3.2. Side view of vessel in figure 3.1. Photo by Michael McKelvey.

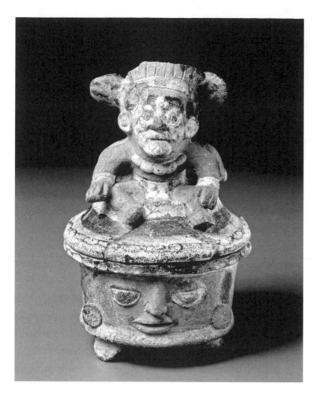

FIG. 3.3. Anthropomorphic side of vessel in figure 3.1. Photo by Michael McKelvey.

a shaman; *chotaxiventa*, "one-who-builds," for a *curandero/a*, or healer; and *tjie* for an evil sorceror (Wasson 1980: 36). Specialties are differentiated even within a general category of curandero/a: on the north coast of Peru they may perform guinea pig cleansing, turn fetuses in the womb, treat soul loss in children, or diagnose sorcery, among other specializations (Glass-Coffin 1998: 51). Yanomami shamans have particular specialties as well that they publicly perform on each other (Lizot, Curling, and Jillings 1996: minute 33:40). Among the Inka was the full range of these different roles, from diviners to bone setters to midwives to huaca attendants, with their concomitant titles (Cobo 1990: chapters 34–36; Stone n.d.a).

If there is one commonality in the ways Amerindians characterize shamans, it perhaps lies in an ineffable quality of knowing. Almost every culture has a term for "shaman" that means "one who knows": *yachac* or *yachaj* in Quechua/Quichua (Luna and Amaringo 1999: 28n31); *payé* or *pajé* in Tukano (Schultes and Hofmann 1992: 123); *tlamatini* in Nahuatl (Wasson 1980: 36); and *menjak* or *sanjak* in Zapotec (ibid.). "Knowing" is a very general word encompassing the spirit world, the cor-

ayahuasca, and thus became a spirit, invisible to others," so powerful he could talk with animals and kill game simply by blowing (Luna and Amaringo 1999: 21). In ancient times artists grappled with the incorporeality of the shaman in trance and came up with myriad creative solutions, as we shall see.

Some names for initiated shamans denote the specific spiritual tasks over which given individuals claim some control. For many groups, the herbalist curer is distinguished from the visionary diviner and the benevolent from the malevolent practitioner. Shipibo-Conibo *muraillas* ("real shamans") "have a profound knowledge regarding the administration of medicinal plants, as well as the magical aspects of nature" (Arrévalo 2005: 206). Even more skilled are *bomanuna* or "magical management," who are able to pass on knowledge and attain special states of consciousness in which to "make things happen [with a] developed sixth sense" (ibid.). The Warao of Venezuela name three types of shamans: at the top are *wisiratu* or priests/shamans, *bahanarotu* are white (good) shamans, and *hoarotu* are black (malevolent) shamans (Wilbert 1987: 160–182). There are also three types among the Mazatec: *chotachine*, "one-who-knows," for

FIG. 3.4. Drawing of Maya *way*, or "animal self," glyph (after Houston and Stuart 1989: fig. 1c). Drawing by Nina West.

rect ritual procedures, diagnosis, the future, herbal cures, and so on. In K'iche' Maya the verb *no'jonik*, "to know," is also "to meditate," linking the acquisition of knowledge to nonordinary types of consciousness in which one is seeking connection with spiritual beings (Tedlock 2005: 127).

Yet after years of apprenticeship acquiring knowledge, the learning continues during each meditative event, with each vision, ritual, diagnosis, and cure having an unpredictable fluidity characteristic of experientially based spirituality. Unlike a liturgical or exegetical religious approach, the spirits during trance are credited with conveying new information each time in response to the different problems of the shaman's clients and community. Thus, knowing is not a static but an ever-expanding base of experience, power, and control. Most ancient effigies engage this issue of control in significant ways: some are extremely self-contained, others are purposefully incoherent and visually out of control, and many signal the expansion of power and insight in creative ways involving the head or its crown.

DYNAMIC BALANCE

Due to this unscripted approach to the supernatural and the inherent lack of control over spiritual forces, the concept of dynamic balance characterizes the ritual application of the shaman's acquired knowledge and powers. The various actions and meaning layers of shamanic ritual are dedicated to the controlled change from imbalance to balance, whether from illness to health, danger to safety, or loss to acceptance. The shaman balances many elements: trance dual consciousness of This Side and the Other Side, often more than one patient, the memorized songs and serendipitous events both within and outside the ritual space, and the various mesa objects and procedures, among others. To handle the sensory onslaught of trance and simultaneously conduct a ceremony represents a remarkable feat and one that is repeated often; Don Agustín, for example, heals every few days (personal communication 2005). It is easy to see why many years of practice and instruction go into orchestrating such events.

With the goal of restoring balance to a situation out of skew, actions of various sorts are necessary: withdrawing from the quotidian; calling in the spirits; achieving trance, figured as "waiting for the spirit of San Pedro to arrive" (Glass-Coffin 1998: 104); manipulating mesa objects as vehicles for spiritual intervention; cleansing, uplifting, and defending the patient; removing the pathology by touching, sucking out pathogens, and/or blowing air, smoke (in figure 1.8, lower left), liquids, or even fire at the client; and finally prescribing herbal remedies and types of behaviors aimed at ameliorating the physical condition. The actions often occur in roughly this order, yet how each stage is accomplished—for instance, how diagnosis is accomplished—varies widely (and for lack of space cannot be covered here).[14]

Suffice it to point out that the previous core shamanic concepts—the intermediary role, anomalousness, and control over knowledge—are reflected in the ceremonial sphere: the shaman performs the "magic" by setting up a liminal intermediate space for change and taking on the intermediary role, removing the anomaly causing the problem, then applying the knowledge of herbs and other cures gained during trance. Finally, the ritual and by extension the practitioner must prove effective; the patient's catharsis and subsequent cure must have positive aftereffects for the shaman to be deemed a powerful conduit of divine forces. His control over the uncontrollable must be evident. For while the shaman as a human ego is not considered the source of transformative power, the transfer of it from other realms depends on a knowledgeable, active, strong, and dedicated practitioner here on the terrestrial plane.

The dynamism of ritual echoes that of the visionary experience that lies at its core; both constitute arrays of changing, moving perceptual phenomena, senses, and realizations. The ability to maintain balance during the flux and transformation so central to the visionary experience itself is required to provoke the needed change in the client. Thus, again, it can be argued that what happens during the vision deeply conditions the rest of what constitutes shamanic practice. How ancient effigies visually convey this active yet balanced approach will be considered, along with the rest of the established themes, in the next chapter and subsequent case studies.

EMBODYING THE SHAMAN IN TRANCE
EMBRACING CREATIVE AMBIGUITY

Thus far this study has presented a number of characteristics of visions and how they relate to broad themes of shamanism. Each theme or perceptual experience applies to various modern indigenous/traditional Latin American shamanic cultures and/or is pertinent to the effects of many different entheogens, supporting its potential relevance to other expressions, namely art. Yet a great deal remains to be discussed as to how visionary experience may have been expressed artistically. Indeed, thousands of ancient Central and South American works of art could be analyzed in light of these concepts, though space allows consideration of only relatively few.

More ancient American images reference shamans' bodies than might be readily apparent because the images occupy multiple points along a continuum of transformation, marking stages in a process of flux. From the predominantly human to creative mixtures embedding animal selves to images almost wholly given over to the ineffable, shamans' embodiments take an array of forms. At one extreme, they depict humans simply sitting quietly with the eyes closed or staring. Some are what historically have been called "disabled," people whose bodies are not normal in the statistical sense and so epitomize shamanic anomalousness, as discussed previously. Other images initially appear human but with more scrutiny betray subtle hints of the animal, and vice versa. Legast notes, "When the human and animal worlds are joined, the human being adopts characteristics of animals, possibly of several species, but the animal in turn acquires human properties, and both of them are transformed into an anthropozoomorphic, mythical being" (1998: 152–153). Although the word "mythical" is vague and unfortunately connotes the imaginary or legendary, a

truly novel being does result when the human and the animal meld.

Still other objects are almost unrecognizably fantastical, indescribable like so many visions, transcending our distinctions of animal, human, and supernatural. The artistic solutions to the problems posed by shamanic experience are many, creative, and not easily resolved into Western categories. I argue that a deliberate engagement with ambiguity, perhaps the essential feature of shamanism, productively fires the artistic imagination, catalyzing inventive ways to express the ineffable cosmic flux. There is inherent ambiguity in representing a liminal being who is both Here and Not-Here. Yet these new entities born of visionary multiplicity can be lent physical form through a variety of artistic strategies, usually more than one in a given image. Such strategies include juxtaposition, conflation, substitution of parts, *pars pro toto* (the part stands for the whole), inversion, double reading (through contour rivalry, figure-ground reversal, and three-dimensional versus two-dimensional aspects), mirror-imaging, abstraction, and interiority.

Certain general traits inform the overall artistic enterprise of depicting the shamanic body in physical form: creative ambiguity, authority, cephalocentrism, and the trance gaze. The first two apply to shamanic corporealization as a whole, while the second are more specific to the body parts highlighted in trance. In this way it is possible to plumb some of the myriad possible artistic approaches to the paradoxes intrinsic to embodying the shamanic Self.

CREATIVE AMBIGUITY

On at least three levels, ambiguity characterizes the enterprise of physically rendering a shaman in trance: the choice to embody the disembodied at all, the function of an object in relation to the incorporeal shaman (the spirit realm), and the formal properties that converge to convey the out-of-body state in such a vessel created for spiritual transfer. Given the visionary assumption of incorporeality—including flying, souls leaving the body, and ego dissolution—and the basic ineffability and flux of visionary perceptions, it is

inherently paradoxical to make an image of the entranced shaman's body. Simply put, if the shaman is not really considered by others or himself to inhabit his body during the most important moments of trance revelation, it calls into question how showing the shaman in, or as, his body can be relevant, much less attainable. If the shaman cannot precisely convey where or in what state she was—the indescribability factor—how could the artist hope to convey such impossibility? If the image functions as a vessel for the shaman's spirit, then how does an artist describe the shaman's spirit-body in such a way that she can recognize it during trance? How can colors, shapes, lines in a static image capture the flux of liminality, of existing somewhere suspended between states of being, of true multiplicity in the Self?

The evidence that just such a balancing act is possible lies in the plethora of such images in the ancient American corpus. Artists do have at their disposal an array of technical, formal, and iconographic means to embrace fully the dichotomies of the shamanic experience, especially if they eschew naturalistic rendering as a basic approach. I contend that without the constraints of an artistic mandate to reproduce terrestrial appearances, the artistic goal is a recorporealization of the shaman. This reconfiguration entails a decorporealization, just as does the visionary experience, and then a rebuilding of a different idea of a spirit-body as a holder for the being in trance. The artist embraces the natural paradoxes of shamanic embodiment—ego detachment, orientation toward Elsewhere, animal transformation, and necessary lack of clarity—rather than accept the seeming impossibility of embodying a shaman who is out of the body. Dual consciousness makes such a process appropriate; as they journey shamans are simultaneously physical and metaphysical beings.

It becomes immediately apparent that the terms we enlist, such as "paradox," "ambiguity," and "liminality," must be understood in the positive, creative, transcendent sense. "Ambiguous" is not to be taken as meaning uncertainty or confusion but rather something having more than one possible meaning or interpretation. "Paradox" can be used not in the sense of absurd, contradictory, or unresolvable but to denote qualities that only *seem* to contradict each other and may be contrary

to conventional opinion or common experience. "Liminal" refers to a transitional stage in a process, straddling a border or threshold between two places, occupying a boundary. All these terms presume the suspension of everyday, static, polarized phenomena and the engagement of the productive middle ground, the place where change takes place, not the before or the after, but the during. In short, and in their positive valences, they are well suited to capture the experiential aspect of visions and the artistic engagement with the challenges that communicating visionary reality entails.

Furthermore, the profound difference between visionary perceptions and the quotidian means that we must qualify what point of view creates paradox itself: it only appears from outside the trance experience that any two things are in irreconcilable opposition. This is because the trance experience itself typically contains a higher resolution of apparent duality, such as the revelation of unity and shared life force among all phenomena. The visionary participation in a convincingly nonhuman-centered gestalt of all nature infused with life obviates the need to make hard-edged visual distinctions between a person and a bat or a peanut and a divine being (Stone-Miller 2002b: 80, catalogue no. 146; 229, catalogue no. 520). While in a state of dual consciousness, one feels both human and animal, ego and soul, Here and Not-Here, precisely without the sense that these different phenomena are wholly distinct. Other selves can be present, many at once, some implied, still others possibly more conceptual than necessarily expressed.

This transcendence of human ego-based singularity and the dialogues it necessarily sets up between various forms and formats makes the shamanic visionary experience such a hugely creative challenge. Great artistic freedom abounds in throwing aside discrete categories and mimetic attachment to this world and its static constituents, in exploring possibilities beyond how things look under normal conditions, and in creating combinations that defy description. Some frankly enigmatic and bizarre solutions were found by the creative artists in the cultures represented here, such as what I interpret as triangular rents or tears symbolizing the shaman's outer self being torn

open during visionary transformation (figs. 7.14, 8.2, 8.15, 8.16).

The Western worldview limits our understanding of such art objects as well in that seemingly neutral terms such as "image," "depiction," and "representation" inevitably communicate the opposite of the shamanic approach to the object. These terms connote inert, disconnected, and static pictures or likenesses, not to be confused with living beings or the subject's physical reality. If visionary experience were as influential as I contend, the process of creating an "image" of a shaman was really to embody, that is, to make her a subjective body that by definition is not inert or superficial in any way. I am proposing that the object we call an effigy of a shaman served as both a visual rendition of the shaman's many selves and as one of the shaman's subjective selves.

To reiterate what was introduced in chapter 1, the shamanic relationship to objects is as subjective entities (the visionary identifies with the objects she sees in trance), yet the relationship to herself as a subject is objective (she is detached from herself as an ego). This suggests that the effigy can be or hold the shaman's subjective self, alive and active, outside the shaman's actual body. The effigy does not reify the shaman's ego, which is disengaged, nor his outward daily appearance but performs an ambitiously ambiguous task by embodying his various selves, the multi-selfhood of the shaman, in an essentialized form that is fundamentally not physical but spiritual. The shamanic Self is not the human body at all, as visions teach; thus the task of the "image" was not to render particular, static, human features, as our tradition of heavy representationalism and portraiture might predispose us to think. It was to bring into being a new synthesis of many selves in a visual, material rendition that the shaman's spirit self could actually enter at will.

In trying to understand the role an effigy played in ancient times, it is important to note that the vast majority of shaman effigies come from grave contexts. I would hypothesize that an effigy's inclusion in a grave does not usually or necessarily mean the deceased was a shaman accompanied by a self-portrait; arguably, the great numbers of effigies outstrip the probable numbers of shamans. I think we might reconceive these

many images as loci into which the shaman could manifest on the Other Side in order to spiritually assist the deceased. In many modern instances, shamans require "visuals" of people or places in order to find them during their visions. For instance, among the Shuar,

> non-shamans frequently employ a shaman to "look" and tell them what is the current situation of distant relatives or sweethearts. These distant persons apparently have to be individuals with whom the shaman is already acquainted, so that he can "know whom to look for." In addition, it is normally necessary for the shaman to be already acquainted with the distant locale and the route to get there and preferably he should know the appearance and location of the house of the person being sought. (Harner 1973a: 168)

Although this example concerns locating living beings and earthly places, one might argue that it would be even more of a challenge to fix specific places on the Other Side to "meet" or "go to," and thus a physical object as a landmark becomes all the more necessary. If the shaman, as the spiritual officiant, made the image itself and/or saw, touched, or infused it during interment, she would have a fix on where to "visit" later. The shaman regularly trance-travels to the land of the dead and back, but death represents the deceased's first (or most significant) time there; the planned inclusion of the shaman's spirit container, then, would allow him to continue to fulfill the role of intermediary for the deceased. Considering that Andean tradition from earliest times eschews death as an ending, there would be no reason for the shaman to stop interacting with the dead, and a vessel would allow for an ongoing means to do so.

As mentioned in the introduction, Inka culture may provide some concrete clues about the possible relationships between living people and images thereof in pre-Hispanic times. The Inka certainly emphasized the creation of doubles in numerous ways, making images active participants in daily life, especially through the sculpted versions of nobles that functioned as satellite representatives of the person. The wawki, or "brother," was one or several sculpted versions of an impor-

tant person coexisting with the "real" body, living and dead. Cobo describes royals and nobles commissioning life-size and perhaps larger precious-metal sculptures of themselves, while lesser folk had smaller doubles in wood, stone, or other materials (1990: 37–38). Wawkis could travel separately, conduct business, and wage war; in short, they acted and were treated just like the person himself. Through mediums, wawkis communicated the person's desires (Gose 1996), just as shamans of a certain specialty spoke for all oracles, often if not always from a trance state.[1] The practice of creating "brothers" may have predated the Inka; Cobo avers, "The custom in question was so ancient that . . . it dated back to their earliest historical memory" (1990: 37).[2] If so, there seems to have been an ancient Andean predisposition toward multiple material versions of the self, such as the Chancay fiber figures, for example (Stone-Miller 2002a: 176, illustration 141), and certainly shamanic visionary values long predated the Inka. With the wawki in mind, I will therefore appropriate the word "double" as a synonym for "effigy" and "embodiment."

Other well-documented Inka approaches to the body support the idea of the material embodying the life force in a participatory, equal way with living humans. First, the Inka are well known for keeping the ruler's dead body, the *mallqui* or royal mummy, above ground and acting as if he were, for all intents and purposes, still alive and functioning (D'Altroy 2002: 141). The deceased's corpse constituted an ongoing housing for his spirit and his earthly power base. As with wawkis, others spoke for the dead ruler, which did not diminish his continued authority. Second, related to maintaining the ruler's bodily health and marking his death, the graves of the *capac hucha* child sacrifices include elaborately outfitted tiny metal figurines that directly reiterate the deceased, such as the famous Mount Copiapó girl in the feather headdress and her figurine double (McEwan and van de Guchte 1992: 364–365). Since the accompanying figurines match the sex of the child, they seemingly restate the child himself or herself.[3] Considering that the intention of the sacrifice was to transfer healthy life force to the ruler, one might postulate that the figurine embodied the child's life energy as an intermediary entity, especially

since they were made of precious metals reserved for the highest classes. Third, the royal golden gardens were fashioned to infuse actual maize plants throughout the kingdom with life energy. Fourth, an Inka watering device was used to share corn beer with the earth during planting rituals (Stone-Miller 2006). These examples, among many, show how Inka art at base functioned in a participatory, energy-transferring mode.

By extension, modern shamans' mesas that hold objects they experience as their alter egos indicate that this attitude toward the subjective object has remained strong in shamanism over the centuries. The alter-ego object as a living embodiment of a shaman is by no means a simple concept. Modern staffs and ancient effigies are doubly intermediary in that they communicate a conduit being (the shaman) via an intermediate entity (the effigy object). Likewise, the object considered alive in its own right (since it is capable of being dressed, "killed," and so forth) was then perhaps doubly vivified when occupied by the shaman's spirit. How did ancient American artists grapple with this twice-removed role and still produce a body of some sort? To create an infusable spiritual container, the artist may first eschew rendering the specific features of a shaman's human body. In other words, pursuing what we call a portrait, a physiognomically accurate description of the outward appearance of a human being, becomes simply not germane, with the exception of depicting defining attributes of the anomalous body.

Thus to some degree, an ego-dissolved body making way for forces well beyond the physical may be most effectively portrayed by promoting the generic. The objective subject, the person who is not identified with or by the ego, can be appropriately embodied through creative ambiguity in facial or bodily features, avoiding telltale large noses or dimples that would pin down who exactly it is representing in everyday life. Effigy doubles may purposefully prevaricate as to whether the shaman is absolutely male or female and certainly do not limit such a paradoxical figure to being wholly human, since the power resides in harnessing both genders and multiple types of animals. Depicting a shaman as a particular deer—for example, a specific doe identifiable by her crooked tail or a certain recognizable individual jaguar—would distract from a message

of shamanic access to the power of all deer or all jaguars. In some cases the animal referent may be as generalized as a round eye or exaggerated teeth, purposefully communicating not even a species but rather "animalness."

"Generic," a term that often means undistinguished in our culture of supposed individuality, has a relevant secondary definition: usable or suitable in a variety of contexts. It is in this sense, once more downplaying the static, that the generic becomes an appropriate choice, allowing the irrelevant particularities of the untransformed shaman as an identifiable human being to give way to the conduit role. A generic image has the capacity to inhabit more quotidian and otherworldly contexts, just as a shaman does, precisely by not declaring an allegiance to too specific a form. Similarly, the visual ambiguity of a generic body part, such as a simple cylinder for a leg, more easily stands for or visibly transforms into the leg of an animal than a very detailed rendition of human kneecaps, ankle bones, or musculature. It can be both if it is not very convincingly either. Thus, it may be argued that the generic naturally allows for greater flux in form, one of the foremost visionary experiences and most fundamental artistic goals in creating doubles. For instance, Moche ceramic figures often display particularly generic bodies and limbs (as in figs. 7.3–7.9, 7.19, 7.22, 7.23).

The generic may be seen as a powerful mode. In a consideration of how Inka power was communicated by the paradoxically disorderly dress of the ruler (Stone 2007a) I have argued that the visually generic was consciously employed as a more persuasive way to reach diverse subjects than a complex, referential iconography. Being indefinite can be powerful precisely because it deals in the potential and unknown; the Inka ruler's generic geometric patterns could stand for the future conquests of yet unknown peoples, for instance. The unscripted quality of shamanism means that a shaman must hone an unspecified capacity for action in the unknown, much like the conquering Inka ruler who, appropriately enough, relied on his shamanic advisors at every turn.[4] Engaging the power of the potential by sidestepping specificity represents a creatively ambiguous stance.

A related but slightly different way to frame the artistically advantageous choice of the generic

is as an abstract essential form. Abstraction allows for essence to be expressed, and visions promote internal, more elemental essences (the spinning spherical soul returns to mind). An effigy may therefore approximate the universal, true, and timeless more readily with simple, generic shapes that visually communicate the essence of Self over the appearances of the shaman's or animal spirit's actual body (for instance, the hoof-hands in fig. 5.1, discussed in chapter 5). Thus, creating an abstracted, generic body thereby mitigates the inherent irrelevance of depicting the shaman as a terrestrial, corporeal being.

Dynamic balance is surely and comfortably ambiguous and easily applies to the double. Just as a shaman, considered to be in two places at once, inhabits multiple selves but equilibrates it all, her artistic embodiment may contain formal elements like lines, shapes, and colors that conspire to communicate opposites: movement yet stability, suspension yet substantiality, simultaneously centrifugal and centripetal radiating energy, and so on. Each tendency is visually countered by its "equal and opposite reaction" to create wonderfully contradictory, lively arrangements whose lack of easy resolution helps ensure them continued appreciation, as in the great art of other cultural traditions. Here it is not the half-smile of the Mona Lisa or the recently turned head of a Girl with the Pearl Earring that fascinate, but rather an eye that might be a human's, a whale shark's, or both but might not (figs. 7.10, 7.13), a bipedal person rendered four-legged (fig. 7.24), or an animal that almost exists, but does not really, in nature (fig. 4.1).

Artists rely on the perceptual tendencies in the human brain to create multiple readings in various ways, as we shall explore. One of the most interesting may be the artistic choice to move freely in and out of the third dimension, with a two-dimensional reading contrasting with the volumetric one (figs. 5.1, 7.7, 7.15, 8.2). Another way to create many in one image is contour rivalry, in which the same lines create two different gestalts (figs. 1.1, 8.5–8.7; Stone 1983: 68–70; Stone-Miller 2002a: 36–46). Many different optical illusions promote the lack of visual resolution in shamanic art, because by definition a shaman simply cannot be resolved as one thing and so cannot be depicted appropriately without ambiguity. However, rather

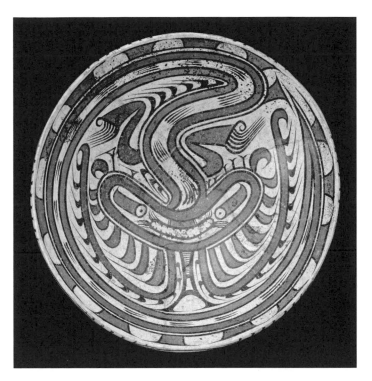

FIG. 4.1. Pedestal plate with composite lizard, boa, stingray, and hammerhead shark attributes. Panama, Conte, 600–800 CE. Michael C. Carlos Museum accession number 1990.11.296. Gift of William C. and Carol W. Thibadeau. Photo by Michael McKelvey.

than blurred, chaotic contradictions, the result is choate ambiguity figured as the dynamic counterpoint of different forces. The effigy must ultimately unify the apparent oppositions, just as the shaman transcends the dichotomies of her existence in order to effect change. Dynamic visual balance creates an equally challenging image; the viewer actively engages and participates in the dialogue of contradictory parts as they crescendo into a transcendent whole. The artist thereby gives viewers a taste of the visionary experience itself. The split face(s) of a Cupisnique composition are a case in point, among others (fig. 7.14).

Art is almost uniquely equipped to give physical materiality to the ineffable quality of the shamanic Self and the visionary experience. Art concretizes that which cannot be described in words (Prown 1980, 1982), and visions routinely defy word descriptions ("I tried to name what I was seeing, but mostly the words would not stick to the images"). Artists are not tied to the linearity and specificity of words in order to reify the indescribable through sculpted form or painted sur-

face effects. The aforementioned visionary "animal with the head of a crocodile and the body of a fatter, larger animal with four feet" could certainly be rendered from the shaman's verbal description. The artist would add parts together until the bizarre conglomeration the shaman saw emerged. What may make little sense verbally acquires a presence when formed from clay, fiber, wood, or metal; one can imagine an artist, shaman peering over her shoulder, modifying the fatness of the torso to correspond to what the shaman witnessed. Such an image as that in figure 4.1 could be constructed from another such description: "a body like a snake, but two legs like lizards, and a head like a cross between a hammerhead shark and a stingray."

These wonderfully nonexistent animals populate the shelves of museums the world over; they represent the stuff of visions and so often are the bane of registrars and curators in search of familiar identifications. What makes ancient American art so successfully ambiguous is perhaps that the inspiration of visions was visual in the first place; art exists in the same mode as visions. One could argue that even something as odd as the visionary experience of "colors [that] lack 'color'; they are nothing but . . . 'shines'" has an equivalent in a clay piece so highly burnished that the "shine" almost becomes an independent feature.

The ineffable extreme of ambiguity means that there are bound to be some aspects of visionary perception that will defy translation when made into a physical form. Costa Rican Altiplano-style compositions are barely decodable, if at all (fig. 6.25), like some body-art seals (fig. 5.32g). Certainly Moche visionary scenes celebrate the incoherent (figs. 8.10–8.17). This assessment may seem like an easy out: anything we cannot interpret can be chalked up to the strangeness of visions. Instead, a better way to approach extreme shamanic imagery may be by perusing the other visionary experience commonalities, such as illumination, flux, and spiral movement, in search of what may inspire certain recurrent but iconographically resistant visual forms. Since the choices made by artists follow an internal logic — for instance, a visually dynamic form stands for something active — we are not at a complete loss as to interpreting "unidentified" forms. Many images have some similar elements that might be

categorized as "emanations" or something that projects out from the head and/or body, tendril-like, swirling, often with jagged edges (figs. 4.2, 6.15, 6.17). Labbé avers, "Such emanations are associated with empowered shamans and are called *tingunas* by certain groups in the Peruvian Amazon" (1998: 27). When they end in animals' bodies or heads they can be seen as a way to convey the animal helpers that reside inside and manifest spiritually. Purposefully ambiguous as to how they "connect" to the body or what they "come out of" (only overtly the mouth), these selves are appropriately shown as both of and not of the shaman's body. They almost always bend to create spiral eddies throughout the composition. Paracas and Nasca shaman imagery epitomizes this, but curving emanations appear in nearly all Andean styles (as in Stone-Miller 2002a: 88–89, illustrations 67, 68). Many Central American works feature extravagant emanations as well. Panamanian ceramics are replete with them (fig. 4.1), and a Potosí-style Costa Rican incense burner lid with a two-headed crocodilian (fig. 4.2) is already in the visionary mode, its visually active, looping, serrated projections possibly further representing the sound/light/movement/life-force message. This example, among many, shows that if we accept ambiguity as purposeful and the visionary experience as central, many aspects of intentionally liminal, paradoxical imagery begin to yield layers of previously inaccessible meaning.

AUTHORITY

The multifaceted ambiguity of the shaman and therefore of the shaman's effigy double constitutes a state and a statement of authority. Shamanic power, we have seen, is based on flexibility, transcendence, and the ability to do/be/display many seemingly contradictory things simultaneously. Authority follows from such dualistically balanced power manifested outwardly in acts of healing, divining the future, and integrating natural forces, all considered crucial acts for group survival. So too the shaman's physically rendered double would seek to communicate the strength that reflects the fullness of esoteric knowledge, the power that manifests from within, the capability of the mediator, the one in dynamic balance who

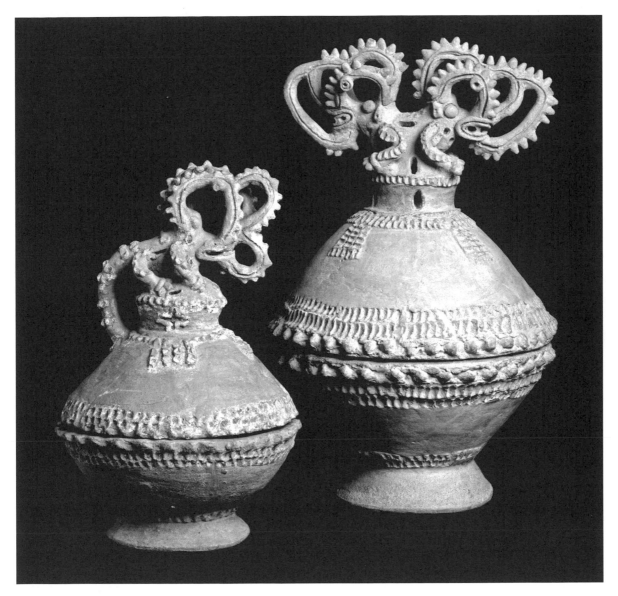

FIG. 4.2. Incense burners with single- and double-headed caimans. Costa Rica, Guanacaste-Nicoya, Potosí Appliqué, Potosí Variety, 500–1350 CE. Michael C. Carlos Museum accession number 1991.4.381 (left), 1991.4.382 (right). Ex coll. William C. and Carol W. Thibadeau. Photo by Michael McKelvey.

goes Beyond and lives to tell the tale. In another apparent paradox, a strong physical presence serves to denote the one who can lose physicality the most completely, as in the Siona shaman category of the "one who has left" (Langdon 1992a: 48). This follows from my proposal that one whose spirit can most easily abandon the human body would need more access to a container, the effigy double. For the effigy to serve as a worthy vehicle for the powerful spirit, it must communicate and embody power effectively.

The term "authority" can be nuanced to apply to the shamanic worldview; I use it in two senses that de-emphasize its ego-driven and absolutist connotations. Rather than the primary meanings of official governmental control, the secondary ones are once more relevant: truthful and reliable knowledge, skill, and experience that garner the respect of others and hence give the person influence over others. It is productive to return to the root sense of the word, "author," taken generally as someone who causes or creates something. Both shaman and artist engage with creative, causal power, and so this sense of authorship fits present

purposes well. Beyond these, the high status that comes from being an authority is important; however, that status is not inherited, elected, or incontrovertible but rather must be maintained and proven by palpable success in curing, divining, bringing game, and so on. The authority that stems from powerful ambiguity may elevate one within the community yet is not as extreme as superiority, since the shaman's authority only extends as far as his or her clients are motivated to grant it. Another dialectic becomes, therefore, wielding power within the context of a community, not in and of itself. The right amount of power and authority forms another delicate dance of liminality. Thus, shamanic effigies are meant to be convincing but not overbearing, arresting not terrifying, persuasive yet not autocratic or dictatorial. Authority of this sort can be expressed in effigies through iconographic or formal means or both. Of the various examples in the next few chapters, perhaps the Rosales female shaman with deer attributes, broad shoulders, and staring eyes best epitomizes this artistic "dance of liminality" (figs. 5.1–5.5).

The iconographic elements that detail authority and status in Amerindian terms include copious body art, ornate and plentiful jewelry, elaborate hair and/or headdress, and patterned or layered dress. Role is communicated by including shamanic accoutrements, such as snuff tubes and benches as tools of the trade. Subject matter that bespeaks authority would encompass the animal attributes of spirit selves, such as round eyes, horns, hooves, tails, spots, ears, and horizontal posture. We can never relegate these animal parts to secondary status in a shaman embodiment, as the mighty jaguar or anaconda or even the small bat comprises the multiplied power of the shaman. Being "full of the quality of bat" provides the special sight that establishes authority itself. A final iconographic method to convey these qualities would be to include the diagnostic details of the anomalous body, in many cases to connect visually to the power of animals.

Formally, the shaman's double can convey power by perceptually encouraging monumentality, that is, making even diminutive objects seem larger than they are, slightly larger than life, like the shaman is in the community. Most Costa Rican gold work measures only a few inches (figs. 6.15, 6.16), and the Rosales female shaman effigy in figure 5.1 stands only slightly over twelve inches in height but seems bigger. It remains difficult to pinpoint what exact visual factors convey monumentality; the interplay of many choices can be as individual as particular works of art. Remoteness (which is keyed to the trance gaze) and stillness (albeit achieved via dynamic balance) may play parts in establishing a sense of monumentality. An image must achieve timelessness, perhaps through emphatic forms that nonetheless cycle within a self-contained whole, creating a complete microcosmic unity, always bringing the eye back to the body, not out into the surroundings. In this cyclicality, shamanic art may contrast to other images of authoritative power, such as the heroically gesticulating Roman male, gazing outward, outstretched arm indicating dominion over all. Viewers may wonder, "When will he drop that arm?" while in shaman images few such momentary, terrestrial concerns apply. By contrast, the shaman's usual meditation pose, with hands attached to knees or chin, creates a centripetal, bounded image of connected body parts (figs. 4.3, 4.4, 5.1, 5.18–5.21, 7.5, 7.8, 7.19, 7.23). With this formal choice and others, the viewers also are controlled in a sense, their vision focused inwardly rather than dispersed. It is the inward journey of the shaman that gives him authority, after all.

In further support of inwardness, the strong formal message of containment often coincides with the reality that effigies are containers, that is, actual vessels and symbolic holders of spiritual essence. The double is thus capable of conveying the idea of being a vessel or vehicle for the shaman's spirit by actually being one in physical terms. Furthermore, by focusing on the inward-directed image of a concentrating person, the viewer is united with the shaman; through identification with the image the viewer absorbs what important people do and is encouraged to detach from the terrestrial, go within, and transform, like a shaman does. Finally, ambiguity again works in favor of this focused, internalized presence, as the viewer is encouraged to prolong looking by the lack of resolution possible between the contradictory forces of movement and stasis, different readings of human and animal, and the piece's small

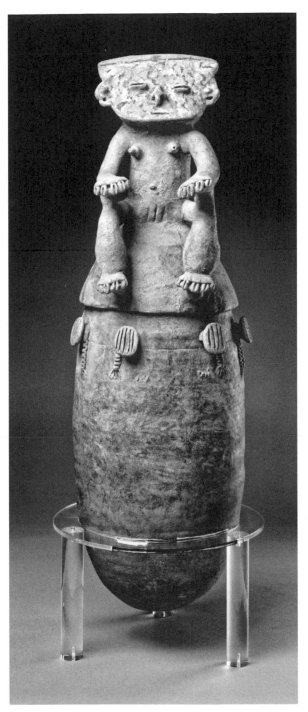

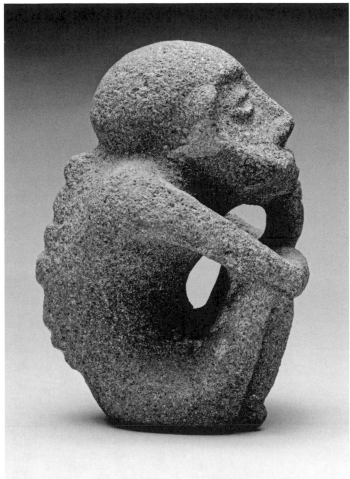

FIG. 4.4. Side view of meditating male shaman. Costa Rica, Atlantic Watershed, 1000–1500 CE. Michael C. Carlos Museum accession number 1991.4.215. Ex coll. William C. and Carol W. Thibadeau. Photo by Michael McKelvey.

FIG. 4.3. Secondary burial urn with female shaman in meditation. Northern Andes, Colombia, Lower Magdalena River, Moskito, 1000–1500 CE. Michael C. Carlos Museum accession number 1990.11.1a,b. Gift of William C. and Carol W. Thibadeau. Photo by Michael McKelvey.

size yet sense of monumentality. Like the shaman it represents, the object achieves a measure of authority by focusing attention on the mysteriously unresolvable.

CEPHALOCENTRISM

There is, however, a particular direction of focus that applies to almost every shaman double: toward the head of the figure. This emphasis, which can be termed "cephalocentrism," dovetails with the generic body proposed above; a generalized body contrasts with and therefore helps draw attention to the large, complex, and more detailed head area. A natural way of perusing such an asymmetrical top-oriented figure, moving upward from a quick intake of the body to a slower study of the head, may in fact help establish authority in the effigy. By leading the eye up, skimming over the body to rest on a dominant head, the perceptual experience is one of looking up. When one looks up at someone's face, one also may naturally "look up to" that person. Even if viewers are actu-

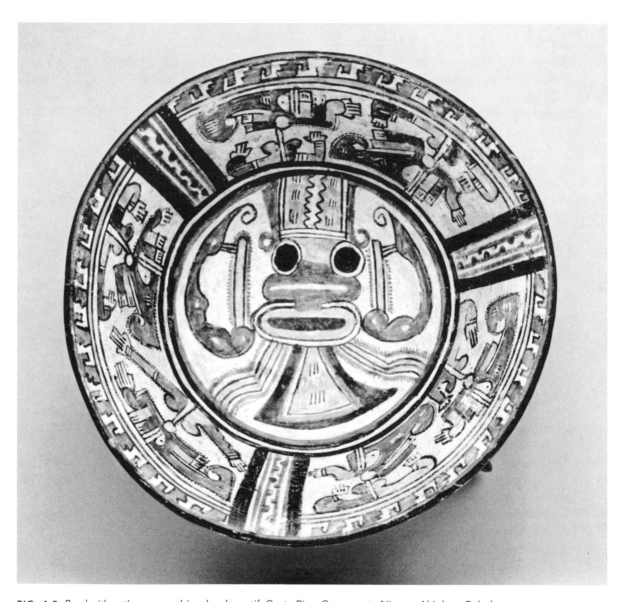

FIG. 4.5. Bowl with anthropomorphized crab motif. Costa Rica, Guanacaste-Nicoya, Altiplano Polychrome, 800–1350 CE. Michael C. Carlos Museum accession number 1991.4.304. Ex coll. William C. and Carol W. Thibadeau. Photo by Michael McKelvey.

ally looking down on a small work of art, they are encouraged to look at it as if they were subservient to it. Although not objectively true, it is as if one is looking up at something bigger than oneself, up into a large, strong, often fierce, and impressive face.

Looking up as a cultural value correlates with the visionary experience of suspension, of rising up and beyond the body. If decorporealization feelings (numbness, loss of feeling, lack of gravitational pull, flying) encourage the downplay of lower bodies in effigies, the intensified experiences of seeing, hearing, tasting, smelling, and synaesthetic combinations of the senses find appropriate artistic expression in a relatively emphasized head.[5] Few ancient American effigies delineate the details of genitalia, navels, elbows, necks, or buttocks, much less all of these. Yet, by contrast, faces are complete in all but the most extreme cases of abstraction.[6]

In several of the case studies, body parts (as well as spirit selves or shamanic paraphernalia associated with each) are rendered two-dimensionally more than facial features, another way the body is less "fleshed out" than the head (figs. 6.3, 6.5–6.7, 7.7, 7.10–7.12, 8.4–8.7). Facial three-dimensionality may be exaggerated to communicate the dramatic, contorted expressions some entheogens cause (figs. 8.10–8.13; Schultes and Hofmann 1992: 119). These contortions may be suggested two-dimensionally in order to create the sense of the third dimension, as well (figs. 7.1, 7.2). Furthermore, the face often combines the three- and two-dimensional messages, being typically decorated with the body's most elaborate painting, stamping, and/or tattooing, which gives the head more visual saliency. Not merely decorative, facial art refers directly to visions in a number of ways, from spirals projecting from the eyes (fig. 7.10) to bands of illumination through them (fig. 5.5) and undulating lines across the face (figs. 4.3, 7.4, 7.5, 7.8). The eyes are obviously a central focus of this attention, as will be discussed.

Noticeable artistic emphasis on the head is in some senses measurable and literal. In general, a high ratio of head-to-body size characterizes almost all styles of ancient American art. While this reflects in some sense the corporeal reality of Native Americans in the tropics and mountains, the artistic effect is exaggerated well

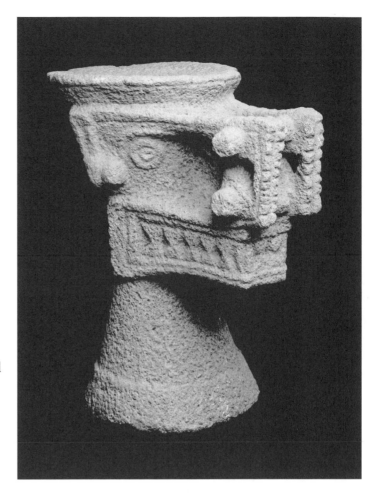

FIG. 4.6. Crocodile-human head seat. Costa Rica, Guanacaste-Nicoya, 1000–1520 CE. Michael C. Carlos Museum accession number 1988.12.11. Gift of William C. and Carol W. Thibadeau. Photo by Michael McKelvey.

beyond mimesis. Figures considered here as shamanic embodiments range from 50 percent head (fig. 4.5), to 35 percent (fig. 5.1), to a low of 30 percent (fig. 7.10). While it is beyond the scope of this study to compare head-to-body ratios in shamanic effigies to those in other human-based imagery, it seems safe to say that shaman doubles have heads at least as large as or larger than other types. It is a widely accepted generalization that varying the relative size of figures and other elements in ancient American art as a whole is used to distinguish between lesser and greater levels of power, importance, and authority (a choice known as hieratic scale). Here it is displayed not only between figures but within them.

Featuring the head as the seat of authority makes particular sense in the shamanic context, as power comes from having experienced visions in

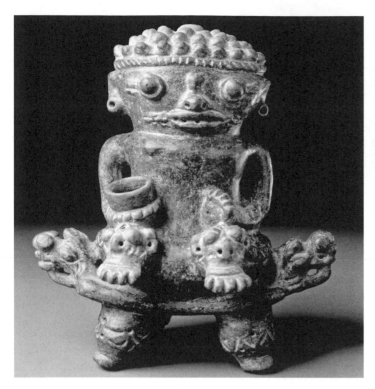

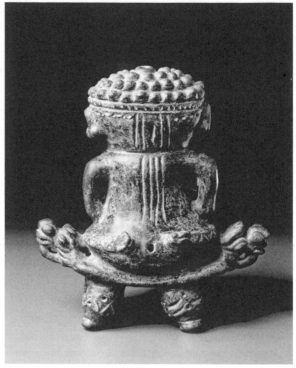

FIG. 4.7. Front view of crocodile-transforming female shaman. Costa Rica, Atlantic Watershed, El Río Appliqué, 500–800 CE. Michael C. Carlos Museum accession number 1991.4.319. Ex coll. William C. and Carol W. Thibadeau. Photo by Michael McKelvey.

FIG. 4.8. Back view of effigy in figure 4.7. Photo by Michael McKelvey.

trance. There is a natural asymmetry in the human body: most of the sensing apparatus is located in the head, only the tactile being distributed throughout the body. Since visions activate all the senses (and then some) but remain predominantly visual, the head—and by extension the eyes— best serve as the "locus" of visions in the body. It is important to qualify this immediately: while in Western culture the idea may prevail that visions are "all in the head," meaning they are percep- tual illusions and visual tricks of the imagination, brain chemistry, or psyche without reality value, a shamanic culture does not define or limit them as such. Yet, because everyday sight and visionary sight overlap, the eyes and the other sensory appa- rati in the head are inevitably going to be where visions are associated, and so artists will gravitate there to communicate the visionary state. Even if the shaman is believed to be Elsewhere, it remains true that her senses are engaged even more fully than they are Here, and they are not experienced as contained within a body, as we saw in the case of the spinning spherical soul that retained senses

of smell, taste, and more. The enhanced senses not only converge in the head but with each other, and so depictions of synaesthesia will natu- rally occur in the head (figs. 8.8, 8.9); even when they do appear in the body, the artist may make the body into another head by adding eyes (figs. 7.1, 7.2).

To embody the various disembodied but heightened senses, special artistic treatment of the facial features contributes to encoding complexity and visual interest in the head. Eyes are of the utmost significance; however, the mouth, nose, and ears may be singled out as well. Later I will discuss various types of "trance eyes," denoting a person in trance and/or transforming as taking on otherworldly and animal-self vision.

The mouth may be emphasized to reference the sense of taste that can be activated in visions. Its prominence may reflect the importance of shamanic physical and ritual actions that involve expulsion from the mouth and ingestion into it: vomiting, vocalization (singing, chanting, and speaking), blowing, spitting, oral spraying, ingest-

ing entheogens, and sucking out disease and other attacking objects, which are ingested, then spit out again, completing the cycle. There is no doubt that the mouth serves as an obvious place to signal animal selves, especially by multiplying, enlarging, crossing, and baring the teeth. One prime, dramatic example is the snake tongue in the more human side of the Cupisnique split-face representation (fig. 7.14).[7] Perhaps the most characteristic choice is to substitute long, pointed fangs for small, square, human teeth, encapsulating "predatory animal" as a general category. If the artist specifically chooses crossed pairs of canines among smaller square teeth, then the referent is jaguar or puma (figs. 3.1–3.3, 7.14, 7.15, 7.27a). If denoting crocodilian or shark, the choice is wide jaws of minute, pointed teeth of equal height (figs. 4.6, 7.10). Because humans share teeth with most other animals but not certain other body parts such as tails or hooves, the mouth may be a feature well suited to ambiguous representation, as in the Chancay female shaman whose small, modeled, human mouth is literally overlaid with a wide, painted (I will argue whale shark), open maw (fig. 7.10). The human mouth may be expanded horizontally in other ways, as with enigmatic raised elements that "crocodilize" some doubles (fig. 4.7). Further infusions of ambiguity draw attention to the mouth, as in a split lip to refer to that of an alter-ego deer and/or to congenital anomalousness (fig. 5.1). Thus, the mouth can encapsulate many roles, aspects, and actions of shamanism and so communicate the important concepts of paradox and transformation in shorthand form. Its location as the viewer begins to look at the face helps the mouth focus the viewer on the conceptually significant upward sweep out of the body and into other states of being.

The specific depictions of ears offer opportunities to draw attention to heightened hearing as a visionary perception. Ears arguably reference the diagnostic and curative information the entranced shaman receives aurally from supernatural sources and the magical chants, rhythms, and songs passed down verbally from master to apprentice. An artistic choice may be to give them deep indentions (fig. 4.2, 6.11, 7.10; Stone-Miller 2002b: 128, catalogue no. 268) to convey sounds entering the head, enlarge them beyond the normative (fig. 7.15), or outline them (fig. 5.2). Ears easily func-

tion as a status-indicating location in the ancient Americas because of the symbolic value of large and elaborate earrings. Often, earrings appear as part of the piece (figs. 4.6–4.10, 4.13, 7.19, 7.21), or separate real ones were inserted into pierced holes (ibid.: 103, catalogue no. 208; 186, catalogue no. 432), or both (fig. 4.3). While these types of ear decoration choices are not limited to shaman effigies, they do establish any figure's relative social status.

Animal and human selves combine through ear substitution, such as vertical, human-shaped ears with cylindrical earspools on an otherwise crocodilian head seat (fig. 4.6) or bat ears on an upside-down human figure (Calvo Mora, Bonilla Vargas, and Sánchez Pérez 1995: 57, fig. 26). In the split Cupisnique transformational head, the ear of the more human side has been replaced with an animal head (fig. 7.14), which strongly suggests hearing with animal acuity during trance. It is not clearly the head of a particular species; again, ambiguity in ear form plays into the same issues of transformative flux as in other bodily parts. The exaggeratedly large, fanned ears on many Moche shaman effigies (figs. 7.3, 7.15, 8.14) cross over into the rounded, alert, feline ears of the animal self, especially those of the ocelot, which are quite large and white inside (7.17). Markedly round ears are found in Costa Rican examples as well (fig. 4.9), and some even specify the markings of deer ears (figs. 5.2, 5.8). Spirals are common in artistic versions of jaguar ears (fig. 5.18), perhaps denoting odd sound effects or information coming into the ear or making an interesting synaesthetic parallel with visionary perception of spirals. Double spirals are found in the ears of a Moche head with fangs, open trance eyes, and individual-hair eyebrows (Berrin 1997: 150), characteristic features of transformational shamans and animalistic visionary heads.

The nose, though perhaps less so than other organs, may nevertheless be activated in visions and therefore is ripe for human-animal artistic substitution and ambiguity. A flatter nose belongs to an animal, especially with nostrils that are more evident than usual (figs. 4.12, 6.10, 6.11; Stone-Miller 2002b: 143, catalogue no. 311). The nose of the Pataky-style jaguar is midway between human and animal, projecting like a human nose but arguably snoutlike and accented with whis-

kers (fig. 5.18). The Moche ocelot shaman effigy has a narrower, humanoid nose as well (fig. 8.1). An enigmatic double nose constitutes one of many facial and head protrusions underscoring a transformative state (fig. 4.7, 7.14, the more human side). As regards figure 4.7, her alter ego being the crocodile is not surprising, since by far the most salient and fantastical nose throughout Costa Rican art is the flamboyantly spiral nose/snout seen on nearly every image of a crocodilian (figs. 4.2, 4.6, 4.9). The spectacled and brown caiman species inhabiting Costa Rica do have snouts with prominent ball-like ends (Ross 1989: 62–63) that are likely the concrete inspiration for this element, but it becomes truly visionary emanation in its spiral elaboration (fig. 4.2). I speculate that the exaggerated nose may also represent the bellowing sounds that crocodilians make when their mouths are open and noses therefore elevated (Ross 1989: 104–108). A spiral nose appears on the more transformed half of a Cupisnique face (fig. 7.14), and a spiral nose connected to the spiral eye is a particularly rich case of unified but multiple sensory experiences referenced in a Costa Rican stone effigy (fig. 4.9). A Wari jaguar-shaman figure has a spiral nose (fig. 7.27a), as does a sea lion in a Moche visionary scene (fig. 8.17). The key role of the spiral in trance perception seems to mean that it can be substituted or added to various sensory organs to denote their enhancement.

The importance of the crown of the head or fontanel as a spiritual entry point is reflected in effigies that may be open at the top or that wear fancy headgear. Effigy doubles can have a primary, large, semifunctional opening on the top of the head. In one case (fig. 5.1), the large opening allowed the artist to support the leather-hard clay with his or her hand and thus better achieve the highly burnished surface. It also makes it possible for something to be placed inside her body, although there is no evidence that there was, and literal inclusion of substances is not necessary if container-effigies are understood as spirit vehicles. In the case of the Moche goblet (fig. 7.15), the opening means that one would drink from the top of the head, the practical and symbolic functions obviously conflated. Other figures of shamans often combine marking the fontanel (fig. 4.8) and/or back of the head (fig. 4.11) with the technically

necessary firing hole. Yet the crocodile shaman (fig. 4.8) features an outlined, raised fontanel hole differentiated from the other holes in the back of the head and between the buttocks that actually released the air pressure during the firing. Thus, the fontanel hole was not necessarily practical but seemingly carried symbolic weight.

Another artistic choice actively implicates the fontanel area in a different way, by placing a real or depicted alter ego in that location. A full figure of a feline may be placed on the fontanel, as in figure 4.13. In the crocodile-human head seat (fig. 4.6) a person would sit on the crown of the head, and the archaeological evidence supports such seats as being used as benches for special group meetings of important people, perhaps shamans (Stone-Miller 2002b: 136). In a telling arrangement, during meetings or rituals such seated shamans would become the living alter egos of their seats' dual beings. Birds are often placed in this position as well, particularly in greenstone carvings (ibid.: 155–156). Clearly placing the animal self directly on the fontanel seems to cement the visionary content of this location. It visually and conceptually doubles the head, dramatically juxtaposing the human and animal selves, the before and after of transformation.

Placing animals atop the head shades into a wide variety of headwear that occupies the same position and connotes status and/or the shamanic role. Sometimes two-dimensionally indicated, such as a painted headband (fig. 7.10), more often headwear is three-dimensionally part of the effigy. A crownlike hat found on a ceramic female figurine with jaguar features (fig. 4.12) is seen on many high-status female figurines (Wingfield 2009: 16). A stacked or tiered headdress type is characteristic of Costa Rican stone figures with transformational masks/faces (fig. 4.9). Headwear may be both painted and projecting, as in the Moche goblet's strongly modeled headband elaborated with the diagnostic ocelot spots and stripes (figs. 7.15, 7.16). In a more extreme case, the Chancay figurine's painted headband was obviously augmented with now-lost materials attached by holes to the head itself (fig. 7.10). Such actual dressing of doubles certainly made them all the more equivalent to their subjects; real head cloths are included in Chancay fiber effigies (Stone-Miller 2002b:

268). Depicted headgear not only can accompany real feathers, textiles, or hair but can cross the line back from hat to alter ego draped over the head: in the Moche goblet nearly the whole animal is present, with the frontal ocelot head in the center, two outstretched cat paws to either side, and tail falling down the back of the head (fig. 7.16). Similar circlets or ringlike headdresses made from real birds do survive for the Moche (Donnan 2004: 62; Bourget 2006: 25, fig. 1.18). Such wearing of symbolic alter egos again underscores how costumes and transformational imagery are not really separate categories in shamanic practice (Stone-Miller 2004: 54–58).

As shamanic cephalocentrism might suggest, there are many other forms of the clearly doubled head, making it one of the most diagnostic components of shamanic art in these regions. Double-headed felines (figs. 4.14, 8.4–8.7), crocodiles (figs. 4.2, right, and 4.15; Stone-Miller 2002b: 127, catalogue nos. 264, 266), sometimes as shamans' benches (figs. 4.7, 4.8), Vision Serpents (figs. 4.16, 4.17), and people (figs. 8.2, 8.3) are represented. At a basic level, showing a being with two heads is an immediate way to signal the out of the ordinary. If depictive of reality, then one is certainly anomalous with two heads, perhaps the most dramatic human congenital condition. More symbolically, with a two-headed animal self one may be considered "extra animal." With the sense of one's head and consciousness expanding and "double" the intensity of normal sensations during the visionary experience, a second head as an artistic device certainly makes sense. The dual role and consciousness state of the shaman is aptly communicated by a being with heads looking in two directions, whether pinwheeling (fig. 4.14) or back to back (fig. 3.2). Ambiguously single/dual heads that encode two readings, more and less human (as in fig. 7.14), epitomize this concept that more heads equals more sensing in both terrestrial and otherworldly realms, as well as more flux between the two.

An entire monograph could be devoted to the subject of two-headed-snake imagery, particularly the Vision Serpent, as it is called in Maya art, which appears in a related form in Costa Rican art (figs. 4.16, 4.17; Stone-Miller 2002b: 124–125). I have argued that the two-headed snake does have

direct equivalents in nature, both in the unusually common duplication mutations of snakes and the repeated process of snake molting, which does create a two-headed snake, first with two heads at the head end, then a snake with a head at each end (Stone-Miller 2004: 59; Cunningham 1937; Corn Snakes Site 2010, picture 105; Mattison 1999: 13). However, it is important to add what real two-headed snakes may mean in relation to visions. First, visions do contain imagery from everyday life, and with the vast numbers of snakes in the tropical and subtropical Americas plus the relatively high incidence of naturally occurring snake mutations, it is likely that in ancient times more people than we might imagine saw or heard about sightings of real aberrant two-headed snakes, which then infiltrated their visions. Second, and more likely, are the symbolic associations with molting, or ecdysis, a process every snake goes through numerous times a year and so would be eminently familiar to Amerindians. Before molting, a snake's eyes become cloudy and white or bluish as the normally transparent eye scale and head skin release (Mattison 1986: 73). This could be interpreted as going into a trance, seeing in a different way, or sight changing before the corporeal transformation takes place, a cogent encapsulation of the essence of shamanic visions. The old translucent head retains a three-dimensional popping eye throughout ecdysis, like a "trance eye" that sees in a shadowy, spiritual, otherworldly way. The premolting snake eyes are temporarily sightless, which may symbolically relate to blind shaman effigies (figs. 7.3–7.9). The old skin—including the head—is turned inside out, a good image of the intense transformative and inverting aspects of visions and reminiscent of reports like "some force reached into my mouth and pulled my insides out." The new snake is more iridescent, and its colors, texture, and shine increase, which might be seen as indicating that it partook in the brilliant light effects of the Other Side. The process creates a double of the original snake, one that is readily apparent as it lies on the ground even if one did not witness the actual molting itself. The sloughed skin is both a version of the snake and yet no longer the snake itself, along the lines of the multiple shamanic selves commemorated in sculpted doubles. Obviously there are provocative ways in

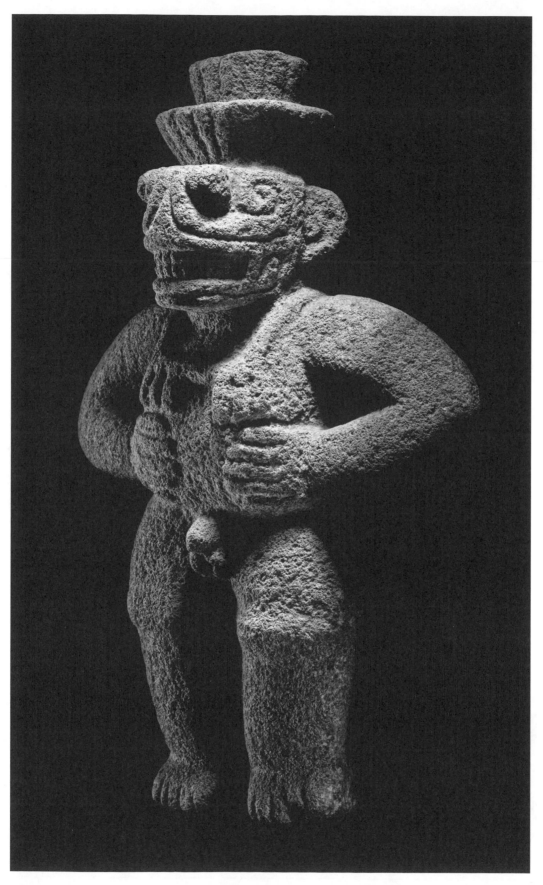

FIG. 4.9. Crocodile-masked standing male shaman. Costa Rica, Atlantic Watershed, 700–1100 CE. Michael C. Carlos Museum accession number 1991.4.35. Ex coll. William C. and Carol W. Thibadeau. Photo by Bruce M. White, 2009.

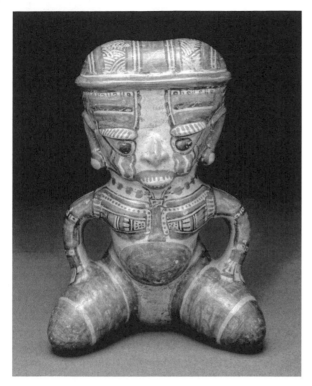

FIG. 4.10. Front view of seated female shaman in meditation pose. Costa Rica, Guanacaste-Nicoya, Papagayo Polychrome, 1000–1300 CE. Michael C. Carlos Museum L2006.21.1. Collection of Teresa Westwood-Smith. Photo by Michael McKelvey.

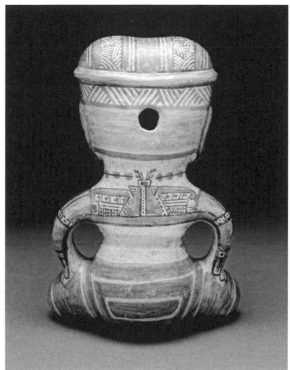

FIG. 4.11. Back view of effigy in figure 4.10. Photo by Michael McKelvey.

which the two-headed snake, both in nature and in symbolism, relates to the visionary experience.

A final aspect of cephalocentrism that molting also raises is that any head may be shown as detachable from the body in shamanic imagery. First, the human head may be gone and the head of an animal, such as a bird or a puma, placed on an otherwise predominantly human body (figs. 7.26, 7.28); this conveys that the animal self has displaced the human ego during visions. The recombination of body parts communicates "one who has left," or that the human body is visibly left behind Here, while the sensory-laden head area functions as a being in other cosmic contexts. The opposite situation, an animal body with a human head, exists, although it appears less often (Conklin 1986: 41, fig. 27). The latter possibly represent animal-shamans—meaning animals that are the shamans for other animals (Buchillet 1992: 216)—that carry references to their human selves in the head to show that they turn into *people* dur-

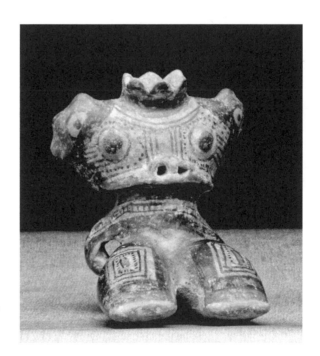

FIG. 4.12. Female jaguar-shaman effigy. Costa Rica, Guanacaste-Nicoya, Birmania Polychrome, 1000–1350 CE. Michael C. Carlos Museum accession number 1991.4.24. Ex coll. William C. and Carol W. Thibadeau. Photo by Michael McKelvey.

FIG. 4.13. Standing male shaman with jaguar alter ego on head. Costa Rica, Guanacaste-Nicoya, Marbella Incised, 300 BCE–500 CE. Michael C. Carlos Museum accession number 1991.4.309. Ex coll. William C. and Carol W. Thibadeau. Photo by Michael McKelvey.

general. In the literature, however, the detached head is virtually synonymous with the trophy head, a human head that has been violently removed from its owner (Benson and Cook 2001; Proulx 2001, 2006; Silverman and Proulx 2002; Townsend 1985). To be sure, actual human trophy heads and dismembered skeletons are found throughout various ancient American cultures, and head-taking itself is clearly illustrated (fig. 4.18), all of which seems to anchor detached head imagery in actual ancient war and sacrificial practice (Verano 2001). However, as the dominant, sometimes only interpretive paradigm in the literature, the category "trophy head" begs the question, leaving no room for other proposed interpretations such as "vision head" (Tierney n.d.). Even if they are trophies of aggression, to keep one's enemy's head or a sculpted version of it may have been understood to preempt and appropriate their potential to have visions as well as their ability to continue living or to return to their bodies after death (Bracewell 2001: 8). There is a very suggestive Nasca figurine with an emaciated body and a "trophy" head, holding a tube to his mouth (Sawyer 1962: 155, fig. 3).

Purposefully depicted as separate, "vision heads" could reflect shamanic experience; again, the person in trance associates little or not at all with the body, having become "only" a head, specifically the sensory experiences that are centered in the head. Questions arise as to how artists might differentiate a dead person's head from that of a shaman in trance (figs. 8.2, 8.3). Only a few detached-head images have eyes and/or lips shown sewn shut, a definitive sign of death and ritual treatment that mirrors the real detached heads of the deceased (Donnan and Mackey 1978: 52–53; Joyce 1998: 154). Yet these artistic examples show that sculpted heads can fully stand in for "real" heads, adding support to the art-as-double and spirit-vehicle concepts. A few Mesoamerican heads with closed eyes have slack musculature and look naturalistically dead (Pasztory 1983: 231, plate 208).

However, I would argue that most sculptures of detached heads display wide-open eyes or slit eyes—the latter shown the same in the head-taker as well as the detached head—and therefore qualify in my scheme as trance eyes. Even if other

ing their visions (the Pataky-style jaguar will be discussed in relation to this idea in chapter 5).

Indeed, one of the most "detachable" aspects of the head is that a being may be reduced to simply that, a head (figs. 4.6, 6.10–6.13, 6.19–6.22, 7.14–7.16, 7.20, 7.21, 8.8–8.13; Stone-Miller 2002b: 100, catalogue nos. 197, 198). It may be a single head or, predictably, two heads interconnected by emanations that emerge from the fontanel of one and become the tongue or mouth of the other (figs. 8.4–8.7), exploiting the artistic strategy of contour rivalry. The high level of abstraction in these renditions shows that reducing beings to heads participates in a reductive, essentializing mode in

heads may be shown with closed eyes, the widespread report that closed eyes enhance the power of visions may be invoked. In a larger sense, as an Eskimo shaman put it, the shaman "has to feel an illumination in his body, in the inside of his head or in his brain, something that gleams like fire, that gives him the power *to see with closed eyes* into the darkness, into the hidden things or into the future, or into the secrets of another man" (Halifax 1982: 26, my italics). Darkness, the future, the hidden, the dead all overlap with the entranced experience that reveals itself more forcefully with paradoxically closed eyes.

This idiosyncratic and magical way of seeing brings us to a crucial subset of cephalocentrism:

the focus on the eyes, specifically trance eyes. The artistic emphasis on an upward focus from the body toward the head means that the higher parts of the head, the eyes in particular, naturally receive extra attention.

THE TRANCE GAZE

Visions are inevitably going to be associated with eyes, the visual organ. Thus, one of the most cogent ways for artists to signal trance state and visions is to alter the eyes from the everyday. In Amaringo's visionary records, eyes are targeted as key and involved in odd effects: snakes' eyes that

FIG. 4.14. Double-headed ocelot effigy. Costa Rica, Diquís, Buenos Aires style. 1000–1550 CE. Lowe Museum of Art accession number 94.14.9. Gift of Candace Barrs. Photograph by Tim McAfee, copyright 2007 Lowe Art Museum, University of Miami.

FIG. 4.15. Double-headed caiman bowl. Costa Rica, Guanacaste-Nicoya, Luna Polychrome, El Menco Variety, 1350–1520 CE. Michael C. Carlos Museum accession number 1991.4.265. Ex coll. William C. and Carol W. Thibadeau. Photo by Michael McKelvey.

may emit a rainbow spiral (fig. 1.7) or white light (Luna and Amaringo 1999: 75); one-eyed people (fig. 1.2) and part of an eye in the sky (fig. 1.8); creatures such as the *aya-largarto*, "a spiritual being with several eyes and spines on its head" (fig. 1.2); and a monster with two heads and two sets of eyes (ibid.: 121).

Since human viewers identify with humanoid images, we will inevitably be drawn to look at and into the eyes of an effigy, just as we are accustomed to doing with one another in regular life. Therefore, an artist can convey a great deal through the treatment of the eyes to engage or, more specifically, disengage the viewer by manipulating the eyes of the shaman double. Recently "the gaze" was a popular subject in art history;[8] however, such discourse was couched in Western ego-oriented and entirely terrestrial terms (humans looking at or avoiding looking at each other and the politico-social implications, particularly regarding gender relations, of those dynamics). Robert Ryan contrasts the two cultural stances:

> [W]hile the modern Western human being looks obsessively outward, the shaman cultivates what the Australian Aborigines call the "strong" or "inward" eye . . . The shaman's world unfolds from within, and consequently his journey is inward, toward what he

experiences as the inner source of form, a necessary and universal world of essential and paradigmatic reality. (Ryan 1999: 9)

Yet, the inwardness of the shaman's looking/journeying must be understood as leading to an outward-oriented endeavor, out into other cosmic realms. This represents the shamanic dialectic, disengagement from the quotidian in order to engage the extraordinary, which naturally focuses on the eyes as the locus for this reorientation toward universal reality.

The trance gaze involves eyes that look through, beyond, in, out, but not *at* something or someone else and so might appear to us as flat or blank. We tend to value how ego-expressive eyes purposefully let one in to glimpse the personality, the presence, and the thoughts of the subject, while trance eyes purposely deny entrance, withholding it due to the premium placed on the ineffable and the Not-Here. They positively look Elsewhere. Thus, the trance eye is once again ambiguous, an eye but not a normal one, intentionally mysterious. By being refused the usual type of interactive visual contact between sighted beings, the viewer of an ego-dissolved embodiment is encouraged to adapt to the otherworldly sight the double demonstrates; viewing a disengaged eye teaches the observer a softened or inward gaze. Without engaged, interactive gazing to fall back on, the viewer is forced to peruse the rest of the image, thereby discovering animal referents, levitation, spirals, and all the elements that reinforce the message of the Beyond.

Originally, however, the ancient American audience's visual interaction with the object may have been limited or even nonexistent (the object placed in the dark and/or in a tomb) or at best secondary (the ritual object not clearly displayed except to the initiated). Hence looking at the image and the image looking back at a viewer may not even have been assumed to be an option in ancient times. Furthermore, if primarily it is the shaman's spirit that inhabits the vehicle of the effigy, that spirit is inherently not a visual or visible phenomenon, at least for nonshamans. Therefore, the effigy's adopting the trance gaze creates necessary congruence between the spiritual state and the vessel forms, both expressly taking place outside the ordinary parameters of seeing.

There are different types of trance eyes, all of which avoid the choice of a typically human open and level almond shape with a pupil and an iris. At least four main types and three less common versions can be proposed: wide open, slit, round, and pendant pupil; reflective, spiral, and projecting. Each eye choice arguably captures an important element of the visionary experience, whether from the shaman's internal point of view, that of a viewer, or both. Human eyes may be inserted into a largely animal image as well, implying that the transformation from human to animal may be understood in the other direction, from animal to human.

First, the most common type of trance eye in the artistic record is the wide-open, bulging, enlarged eye, with white or space left around the pupil if it is included (figs. 3.1, 5.1, 5.17, 5.23–5.27, 5.36, 5.37, 6.9–6.12, 6.19, 7.1, 7.2, 7.7 [proper right eye], 7.10, 7.15, 8.2, 8.8, 8.10, 8.14, 8.16, 8.17). It may be almond-shaped or oval in overall form and include several concentric elements, which relate to feline eyes. Like the oversized head, the enlarged eye immediately draws viewer attention, and artists may darken or outline it for further visual aggrandizement. This exaggerated eye successfully expresses the wonder and intensity of all the fluctuating, moving, changing, colorful percepts being experienced. In many cases, the entranced message seems incontrovertible because images, lines, and patterns surround the open eyes to overtly represent seeing phosphenes. The most direct of these remains the Chavín stone tenon head with the images of San Pedro cactus diago-

FIG. 4.16. Side view of *Bufo alvarius* toad effigy bowl. Costa Rica, Atlantic Watershed, El Río Appliqué, 500–800 CE. Michael C. Carlos Museum accession number 1991.4.332. Ex coll. William C. and Carol W. Thibadeau. Photo by Bruce M. White, 2008.

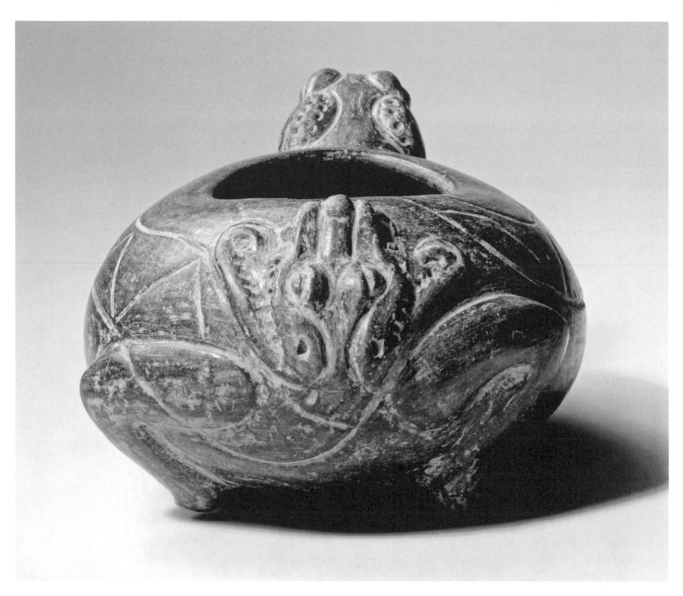

FIG. 4.17. Back view of effigy in figure 4.16. Photo by Bruce M. White, 2008.

nally projecting from the eyes (Burger 1995: 176, fig. 181). Yet, many effigies achieve the same message without illustrating the means to, but rather the effects of, visions in the realms of light and geometry (figs. 4.7, 5.1, 6.10, 7.10).

In terms of the possible mimetic basis of the exaggerated eye, all entheogenic substances cause marked mydriasis, or dilation of the pupils. Furthermore, *Trichocereus pachanoi*, or San Pedro cactus, creates the kinesthetic feeling of one's eyes bulging out of the head (exophthalmosis or proptosis).[9] As another physical manifestation I will argue in chapter 7 that the disease leishmaniasis' facial ravaging resulting in exaggeratedly open

eyes (figs. 7.19–7.24) overlaps with the trance state via a resemblance to feline animal selves.

Second, in contrast, the trance eye may be purposefully closed, slit in order to fully shut out this world (figs. 4.3, 4.18, 5.12, 6.13). Unfortunately and unproductively, this was referred to as the "coffee bean" eye in the past, an especially misleading "neutral" descriptor (for example, Kubler 1975: 117). The slit eye appears to be squinting, according to the line down the middle of a raised oval eyeball rather than at the bottom of a semicircular upper lid. This slit or half-closed format conveys the action of intentionally squeezing the eyes together, signaling that there is a conscious-

ness inside rather than the lack of consciousness characteristic of sleep or coma. It very succinctly encapsulates the shamanic dual consciousness in general and the action of closing the eyes to heighten the visionary effects in particular. A bisected oval is an appropriately liminal form, providing the overall shape and the tripartite arrangement of an eye but simultaneously withholding it because it cannot be perused. Half-mast eyes may be actually mimetic of the effects of certain entheogens; for instance users of *Virola* have "faraway dream-like expressions . . . which the natives believe are associated with the temporary absence of the shamans' souls as they travel to distant places" (Schultes and Hofmann 1992: 170, photos top, center). Those under the influence of ayahuasca tend to close their eyes to reduce dizziness and nausea, and those under datura come closest to unconsciousness. Images of slit-eyed people often adopt the meditation pose and do not loll their heads as in sleep (fig. 4.3). The blind may have naturally slit eyes due to their condition or to closing a nonfunctioning (in the everyday sense) organ (figs. 7.3–7.9); however, this does not preclude reference to seeing visions, as I will argue in chapter 7.

The third main type of trance eye, another recurrent artistic choice, eschews the mimetic human oval or almond altogether in favor of the circular (figs. 4.6, 4.7, 4.12, 4.13, 5.14–5.16, 6.1, 6.7, 7.25–7.28). At one level, the round eye isolates the essential physical characteristic of trance state, the dilated pupil, and allows it to stand for the eye as a whole. In that sense the opened pupil has substituted and essentialized the exaggerated open eye; the round eye is a shorthand of the bulging one. The round eye can thus still stand for a human eye, but only one in trance state. However, it is perhaps as or more significant that most nonhuman animals do have round eyes, from owls to crocodilians to snakes to bats. Since so many animals have round eyes, in an image that combines various animal characteristics the artistic choice of a circular eye efficiently encompasses them all. Being intentionally ambiguous, it can show the shaman as becoming one animal or several; again the generic is used to visual and conceptual advantage.

The overlap of animal and human physiognomy—the human eye's iris and pupil are circular, and the most typical animal eye is circular—

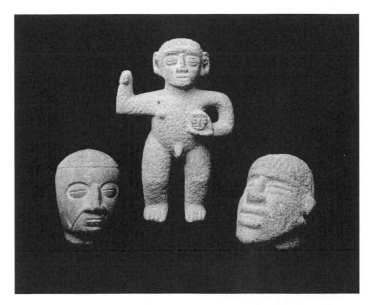

FIG. 4.18. "Trophy"- or "vision"-head bearer and heads. Costa Rica, Atlantic Watershed, 800–1520 CE. Michael C. Carlos Museum accession numbers 1991.4.34 (left), 1991.4.42 (center), Ex coll. William C. and Carol W. Thibadeau. 1992.15.99 (right). Gift of Cora W. and Lawrence C. Witten II. Photo by Michael McKelvey.

highlights the basic dynamic in which humans are animals. Yet the shaman is more liminal than others, being more capable of transforming into his animal self, and so his effigy would preferentially be given a round eye to stand for both states of being. The round eye therefore can do double duty visually, conveying the mydriatic trance state as well as the transformation into the animal self (or selves). Indeed, dilated eyes access the superior sight of actual animals that take in more light, particularly at night. Animals' eyes form particularly salient, colorful circles when they eerily reflect light at night (Wolfe and Sleeper 1995: 26; Luberth). The two are fundamentally interconnected conceptually as well: it is the animal self that transfers its special visual powers to the shaman during nocturnal rituals. In contemporary practices this interest in animal eyes sometimes takes a dramatic form, as it did with Don Eduardo, who had actual feline eyeballs as part of his mesa.[10]

Even without a specific animal referent, perceptually and conceptually speaking a shaman remains well represented by a circular eye since circles as shapes are anomalous; they are rare in nature and do not relate visually to other surrounding shapes. As such, they are the most salient among all the shapes. Arnheim notes

FIG. 4.19. Close-up of a jaguar's eye. Courtesy http://www.cocori.com. Photograph by Michael L. Smith, copyright 1998.

> the visual priority of the circular shape. The circle, which with its centric symmetry does not single out any one direction, is the simplest visual pattern . . . The perfection of the circular shape attracts attention . . . The roundness of the pupil makes the animal's eye one of the most striking visual phenomena in nature. (1974: 175)

Artists may therefore choose round eyes to draw the viewer in and hold interest, as the simpler perceptual phenomena have visual priority (ibid.: 55–63), but they may also do so in the service of propelling the double out of the human world of less regular forms. In all cultural and spiritual traditions artists use circles to communicate grand, otherworldly messages (from rose windows in medieval cathedrals to Tibetan sand mandalas) because the circle naturally expresses the ideal, the all-encompassing. When the eyes give a message distinct from the rest of the face or body, by being the only circles, they communicate an ideal, powerful sight that differs from the bounded, corporeal human type. The body is thus shown as limited by gravity and irregularity, while the eyes and sight are not. By using round eyes the artist can convey in a very simple but persuasive way the dual consciousness of the visionary shaman whose body is left in the material plane yet whose special sight soars in the Beyond.

A fourth type of trance eye, the pendant pupil, may be considered an important subtype of the animal eye. This configuration, in which the pupil hangs from the top of a round or squared eye (figs. 7.14, 8.4–8.7), most closely mimics the eyes of felines, including jaguars, ocelots, and pumas (figs. 4.19, 7.17, 7.18). It may encompass certain birds, too, since owls have pendant pupils (König, Weick, and Wink 2008: 179). The feline or owl pupil, even when not dilated, is high in the iris. Especially when cats stalk, their heads hung characteristically low, this placement of the pupil is quite noticeable.[11] Cat eye color also figures in the equation. At night when the pupil reflects yellow, green, or orange, it is all the more arresting—as well as terrifying. Around the pupil the iris has darker, semicircular, yellow to green areas, lighter toward the edges of the eye. Occasionally an anomalous and striking blue-eyed jaguar occurs.[12] Since human Amerindian eyes were brown, such an animal would have been even more stunning in ancient times.

Besides the pupil placement, feline eyes are visually complicated and suggest a number of artistic strategies. An artist could reduce them to the clearly round pupil or use concentric circles to denote jaguar eyes in simplified form. Yet it is easy to blur the distinction between jaguar and human eyes. Toward the outer corners of a jaguar's eye the white is slightly visible, somewhat like a human eye, because the opening extends out into a point. A key feature that distinguishes the feline from the human almond eye, however, is that this outer point is higher than the inner corner of the eye, where the tear ducts are black. Thus, a feline eye is shaped most like a teardrop on the diagonal. Certain styles, especially the Papagayo in Costa Rica (fig. 4.10) and the Lambayeque or Sicán in the Andes, feature just such a "comma" eye, another misnomer (for example in Stone-Miller 2002a: 156–160, illustrations 123–127). In the cat, the teardrop shape is outlined in black skin so that this shape has strong visual saliency. Dark hairs extend the shape out from the outer corner and down from the inner corner toward the nose, exaggerating it further. Then a white, unspotted area sets off the eye and its markings, reinforcing the concentricity of the whole eye area, as may be indicated by the treatment of the eye area in the Pataky jaguar (fig. 5.19).

Thus, a horizontal or slightly tilted almond shape suffices for either jaguar or human, or

both (figs. 5.36, 6.3–6.6, 6.10–6.12, 8.1). Like the generic body concept presented above, the almond eye is almost a generic eye, at least if the subject involves humans and felines. The jaguar-like almond with higher outer point actually approached more closely the human-shaped eye in the past when Native Americans' genetic ties to Asia were stronger. However, the specific features of the feline eye, the pendant pupil and the teardrop shape, are found in certain art styles and must be accorded proper attention, particularly in a predominantly human image, as to their animal referent. Conversely, the level, almond, human eye in an otherwise animal image (such as fig. 8.1) seems to communicate the idea that the human shaman has gone almost entirely into his animal self, but not quite. Though the human-shaped eye is not rendered abnormal in any way, it is not normally placed in an animal, which gives it a trance valence as well. Again, it warrants our noticing exactly what kind of eye has been created in what gestalt.

A few less common but nonetheless relevant types of trance eyes deserve mention. The more fantastical ones capture visionary experiences in a rather direct manner. The "reflective eye" often may be ignored as it appears in modern times only as an empty socket where originally was embedded a piece of shiny and/or colorful material such as *spondylus* or mother of pearl shell, pyrite, jade, turquoise, obsidian, or bone. Examples vary from Olmec figurines of transforming shamans, Sicán *tumi* knives, Tiwanaku wooden snuff tablets, and many Moche effigies in different media, among others.[13] The reflective eye certainly expresses the brilliant color and light effects of visions as well as the eerie nocturnal shining of a number of key shamanic animals' eyes, not only the cats but owls, crocodilians, and deer, due to the *tapetum lucidum* membrane (Wolfe and Sleeper 1995: 27–28). Most of the empty sockets in effigies are, in fact, round, like those animals' eyes. Saunders has discussed persuasively and in depth this idea of shiny reflection as a shamanic value (2003).

The spiral eye is primarily but not exclusively found in Mesoamerican art; in Maya art the eyes of divine beings are distinguished from those of humans by the inclusion of a spiral in a pronounced, large, sometimes circular or squared eye

(fig. 3.3; Stone-Miller 2002b: 8, catalogue no. 4). However, as mentioned earlier, a Costa Rican example incorporates the eyes into a double spiral with the curled snout of the caiman (fig. 4.9). In these cases the artist directly places in the eye the pervasive visionary spirals, making them unequivocal trance eyes. Spirals can be attached around the eyes, emanating outward from them, as in the Chancay female (fig. 7.10).

A final piece with a projecting trance eye must be noted, though the art of the northern Andes is not featured here simply for lack of space and expertise. There is a deservedly famous ceramic sculpture in the Ecuadorian La Tolita style (Ontaneda Luciano 2001: cover) that shows a snake coming out of one of the figure's eyes and being grasped in the hand. The overwhelming tendency for ayahuasca to induce visions of snakes cannot help but come to mind. The disturbing quality conveyed by the snake emerging from the eye mirrors the feelings that most experience during these visionary snake encounters. Yet this effigy announces that such fears were definitely conquered by this high-level shaman, his advanced status indicated by the crossed-fang mouth and very odd planar body without legs and missing one arm. Dual consciousness is further encapsulated by the great contrast between the human almond eye (with a cut-out pupil, to show deep seeing in the dark) and the emanating one.

To conclude this consideration of eyes in relation to the shamanic and visionary themes, it is not surprising that eyes are often multiplied in some way in shamanic embodiments. Like the doubled heads, and sometimes in concert with them, more eyes can be added to a range of images. For example, the double-headed crocodilians have one set of eyes on their heads and another on the fantastical serrated projections that sprout from them (fig. 4.2). A spectacular Moche visionary head pot adds huge eyes to the forehead, nose, mouth, and back of the head (figs. 8.8, 8.9), while Nasca ecstatic shamans may have eyes for navels (figs. 7.1, 7.2). On the parading jaguar alter egos in the Sunken Courtyard at Chavín de Huantar, spots are shown as eyes (Stone-Miller 2002a: 32, illustration 21). Seeing eyes as motifs during visions is fairly common; many report witnessing a curtain of eyeballs in trance states (Siegel 1992: 17). It is easy to conclude that supernumerary eyes,

particularly when placed on emanations, represent the superior sight in visions, transformation, and the extraordinary multiplicity of the shaman. The prevalence of fantastical effects involving eyes in cultures that are shamanic, and therefore oriented toward the wisdom gained from special sight, is unsurprising.

We now turn to the specific analyses of effigies in Costa Rica and the Central Andes to explore how creative ambiguity, authority, cephalo-centrism, and the trance eye manifest in an array of shamanic embodiments, along with the themes developed earlier from the abstract and narrative visionary experiences and from core shamanism.

SHAMANIC EMBODIMENT IN ANCIENT COSTA RICAN ART I

AT THE HUMAN END AND THE BALANCE POINT OF THE FLUX CONTINUUM

The art of ancient Costa Rica has received scant attention in art historical circles yet well deserves consideration, especially in relation to the shamanic subject matter so prevalent in the corpus. Effigies run the gamut from seemingly very human to almost entirely illegible, with many degrees of animal-human transformational beings in between. The prodigious creativity of this area is evidenced by the many art styles that engage the visionary experience to embody the shaman in trance. In this chapter I will analyze a few pieces at the human end of the flux continuum and at its center, where human and animal selves stand in dynamic balance.

The collection of Emory University's Michael C. Carlos Museum will provide most of the pieces in question here and in the next chapter. The quality of the holdings, my familiarity with them as the curator, and the fact that they have been reviewed and tested carefully over the years for authenticity make this a practical choice. Works I was able to study personally from the Denver Art Museum, the Hearst Museum of Anthropology, the National Museum of the American Indian, Museo Arqueológico Rafael Larco Herrera, the Staatliches Museum fuer Voelkerkunde Muenchen and the Lowe Art Gallery are included as well. Any number of other examples would also illustrate my points, and ideally, archaeologically excavated objects would be featured; however, this cannot be a comprehensive study of either Costa Rican or Andean art, and well-provenanced objects are sadly rare in the corpus.

TOWARD THE HUMAN END OF THE FLUX CONTINUUM

ROSALES DOE SHAMAN

The human presence is very obvious in this Rosales Zoned Engraved (c. 500 BCE–300 CE) ceramic sculpture of a female shaman from northwestern Costa Rica/southwestern Nicaragua ("Greater Nicoya"; figs. 5.1–5.5; Carlos Museum accession no. 1991.4.344). However, she represents the subtlety with which the animal-self subtext may be encoded, in this case a deer. My previous consideration (Stone-Miller 2002b: 70–74, catalogue no. 131) emphasizes her outstanding aesthetic quality, the formal dynamism that underlies her message of fertility, and, in contrast to much of the world's preoccupation with female nudes, her role as a powerful shaman. Considering her self-containment, balance, and orderliness as universal civilized ideals, nevertheless,

> her timeless generativity embodying a sacred power . . . is projected into the afterlife by her shamanic vision and her place in the tomb. In Costa Rican terms, it was on the Other Side that her female strength was to be realized forever. She represents rebirth, at once the most stable and the most dynamic principle of the cycle of life and death. (Ibid.: 74)

Here, the shamanic visionary component and the deer spirit referents require greater elucidation.

A large number of elements support the reading of her spirit self as a deer, most probably the white-tailed deer (*Odocoileus virginianus*; figs. 5.6–5.11), whose wide American range includes Costa Rica (Hiller 1996: 5). These identifying features include overall coloration; head protrusions; split lip; solid hoof-hands; narrow, tapering lower limbs; specific eye, nose, ear, and hair treatments; and dark knee circles, among other fertility referents.

As to coloration, the white-tailed deer's coat in this region is orange-red year round (ibid.: 29–31), very close to this shade of slip paint, minus the discolorations from manganese deposited in the grave (fig. 5.4; color photograph in Stone-Miller 2002b: 70, cover). The animal becomes progressively darker the more southerly its location in the Americas, so the fairly intense color here echoes that of the Central American animal.

Regarding the head protrusions, the two round bumps in the black hair area, set slightly back and over the ears, could be identified as buns. However, elaborate coiffures are rare in Costa Rican art (Wingfield 2009: 188), the black area on the head is not differentiated by incised lines for strands, and the crown of the head continues in red above it. In any case, small, round buns could reference the permanent stumps of deer antlers, or pedicels (Hiller 1996: 43), found on the animal's forehead near the ears (figs. 5.7, 5.8). Pedicels are covered with "velvet," or soft, hairy skin (ibid.: 48); they are darker than the rest of the head (fig. 5.8, lower black dots in front of the ears), and thus easily ally with human hair. Even bucks have pedicels after their antlers fall off and until the new ones regrow, as they do each year (ibid.: 43–46). Therefore, although the visual shorthand for deer would seem to be a full rack of antlers, at any given time most actual deer have only pedicels. Both sexes lacking antlers for part of the year makes male and female deer look more androgynous; we have seen that transcending sexual dichotomy is characteristic of Amerindian shamanism, and this effigy certainly displays both masculine and feminine features. Indeed, on rare occasions does do grow antlers (ibid.: 50–51), so even though this deer spirit effigy is predominantly female, the pedicels/buns add a latent message of aggression that suits a shamanic image well. Deer may be prey animals known primarily for their flight, but bucks fight dramatically by locking antlers, making them apt alter egos for shamans who can choose to either avoid or engage in spiritual warfare. The antlers highlight magical death, healing, and rebirth; there is a "touch of mystery to the annual miracle of antlers" (ibid.: 52). Deer that continuously regenerate impressive emanations from their heads provide clear parallels with shamans, like snakes that molt, lizards that regrow tails, and crocodilians that reproduce teeth. Such miraculous regenerative powers can be ascribed to shamans who heal that which is lost and repeatedly return from the dead to restore life. Originating in the head, again engaging shamanic cephalocentrism, dynamically growing antlers easily denote visionary prowess as well.

The figure's enigmatic split lower lip, plus her strongly protruding mouth and chin, are similar to a deer's muzzle (fig. 5.9). The upper lip of a deer is notched, and the surface is pitted and divided

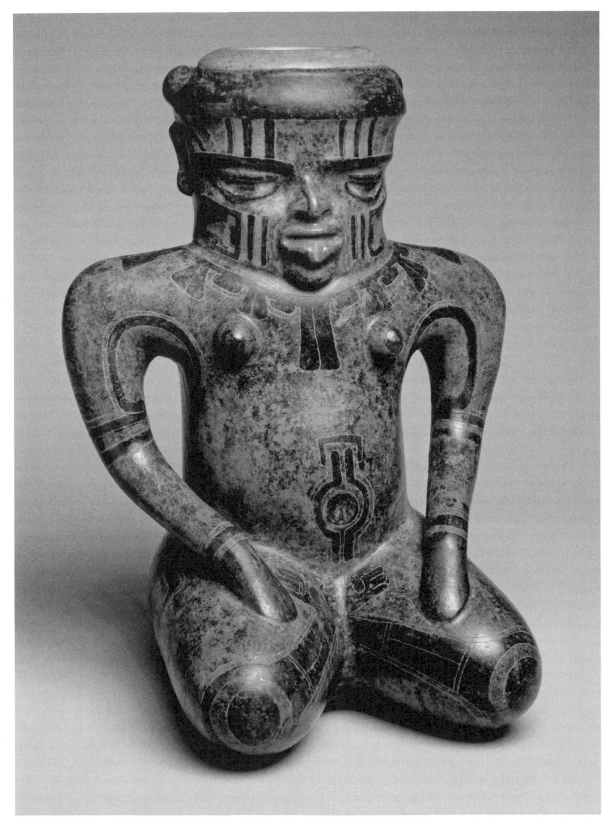

FIG. 5.1. Front view of Rosales female deer shaman. Costa Rica, Guanacaste-Nicoya, Rosales Zoned Engraved, Rosales Variety, 500 BCE–300 CE. Michael C. Carlos Museum accession number 1991.4.344. Ex coll. William C. and Carol W. Thibadeau. Photo by Bruce M. White, 2008.

FIG. 5.1A–D. Drawings of body art on effigy in figure 5.1: (a) hip, (b) arm, (c) navel, (d) cheek. Drawing by Nina West.

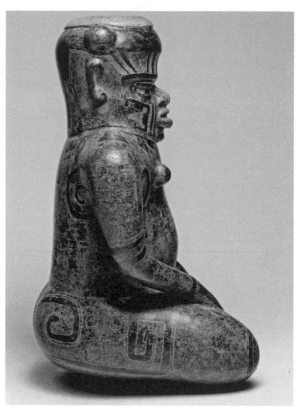

FIG. 5.2. Side view of effigy in figure 5.1. Photo by Bruce M. White, 2008.

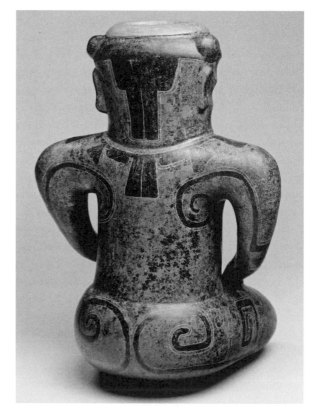

FIG. 5.3. Back view of effigy in figure 5.1. Photo by Bruce M. White, 2008.

superficially down the center. While in the effigy admittedly her lower lip is centrally cleft or pitted, a second reading in which the chin forms the lower lip of another mouth allows a more analogous interpretation.[1] On the other hand, Van der Woude Syndrome in humans, a congenital pitting of the lower lip that can create two mounds on either side of a central dip (Dronamraju 1986: 115, fig. 24; Simone Topal, personal communication 2006), looks strikingly similar to this effigy's lip. The two possibilities may be interrelated: a physical condition that splits the lip could suggest deer morphology, and such an individual therefore might be ascribed a deer spirit self. If the splitting instead represents an intentional act of body sculpting, it still may imitate a deer or a condition that is deerlike. It is quite obvious and must be accounted for in some way. The pronounced, rounded chin is like that of a deer, and together the jutting mouth and chin create a protruding muzzlelike effect, particularly when seen from the side (figs. 5.2, 5.7).

The most overt features of a deer are the figure's solid, black, hoof-shaped hands. No ungu-

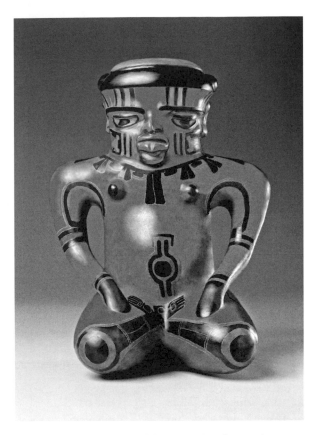

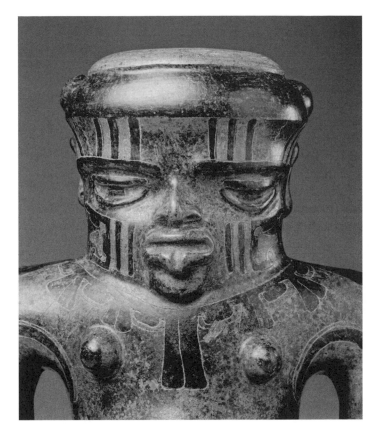

FIG. 5.4. Reconstruction of the original surface (without manganese deposits) of effigy in figure 5.1. Rendering by Sarahh E. M. Scher, 2008.

FIG. 5.5. Detail of the face of effigy in figure 5.1. Photo by Michael McKelvey.

lates other than deer were indigenous to the area in ancient times to constitute viable alternative candidates for identification. The hoof-hands are certainly dark, smooth, shiny, trapezoidal, long, and set at an angle, so they convincingly evoke hooves (fig. 5.6). There are no fingers, nor is this a usual type of hand in this or any Costa Rican style (Wingfield 2009). However, while the artist placed a split in the lip where there usually is none, the hoof-hands show no central split where deer have them (fig. 5.10). The two parts of a deer's hooves do converge at the tip rather than flare out, and shadow naturally fills the narrow gap, so the split is not as obvious as it might be. The proposed efficacy of generic body parts to bridge human and animal selves may also be at play in the undifferentiated treatment of the hooves. Overall, in this piece the artist keeps the human aspects dominant and the animal elements understated and not altogether literal. Since only the hands have been portrayed as hooves and not the feet, the key shamanic idea of her *changing* into a deer may

be conveyed. With the hands and the feet closely juxtaposed, the contrasting treatment cannot be missed.

The shape and interpretation of the limbs also make strong reference to deer morphology. While the upper arms and thighs are thick and triangular, the lower arms and especially the two-dimensional lower legs are markedly tapering, thin, and straight-edged like deer legs (figs. 5.6, 5.10, 5.11). Deer's lower legs are often darker, and the figure's calves are indeed black. The two-dimensional lower legs read as flat and light and aptly evoke the animal's delicate, bony, narrow lower legs. They are subdivided with incised lines (cut through to the orange slip) that further perceptually lighten them and closely mimic the two parallel bones highly noticeable in deer limbs. Light but tough legs allow the animal's notorious fleetness—white-tailed deer are the fastest of the species, hitting thirty-five miles per hour and bounding fifteen to twenty feet per leap (Hiller 1996: 32)—and so help communicate an impres-

FIG. 5.6. White-tailed deer, doe with leg scent glands (dark dots on back legs). Permission of Yellow River Game Ranch, Lillburn, Georgia. Photo by Meghan Tierney, 2009.

FIG. 5.7. White-tailed deer, doe's head with pedicel. Permission of Yellow River Game Ranch, Lillburn, Georgia. Photo by Meghan Tierney, 2009.

sive shamanic animal self. The characteristically fast movement of things in the Other World, as experienced during visions, would likely raise the spiritual stock of deer. Shamanic spiritual battles in animal forms necessitate both attack and defense, and since deer can jump in one leap almost exactly as far as a jaguar can pounce (Benson 1997: 56), the deer is a worthy animal self or adversary for even the most powerful shaman. The high esteem of deer in contemporary traditional cultures of western Mexico suggests that such thinking may have prevailed in other Amerindian cultures. The Huichol believe that deer carry the shaman swiftly to the Other Side during visions and that the Sacred Deer Káuyumari resides in the land of the dead (Furst 2003: 21, 25–26).

The Rosales figure has several other deer-like features. Its darkly outlined, wide-set, over-sized eyes evoke the dark-eyed deer, presumably at night with the naturally dilated black pupil (figs. 5.7, 5.9). The pupil in deer does not touch the lower eyelid, and here the artist has carefully left that same gap. White-tailed deer have large, prominent eyes that appear even bigger because they are surrounded by large outer white rings that get even more pronounced in the winter. Like those of other prey animals, the eyes are set wide to enhance peripheral and distance vision, of great survival value. Deer see well in both daylight and twilight, and their visual apparatus is especially attuned to picking up movement (Hiller 1996: 33–34). These characteristics of deer vision make a natural analogy with that of the shaman, who must see far and wide and whose visions empha-size movement. The intense gaze in the wide-open and widely spaced eyes of this figure echo the deer's alert stare and the shaman's nocturnal trance state.

Her ears may be seen as rather proportion-ately large, long, and narrow like deer ears (ibid.: 35). Furthermore, they are outlined in black just as deer ears are marked, the line often undulat-ing or likewise spiraling in at the lower edge (figs. 5.7, 5.8). Certainly her elaborated ears empha-size superior hearing, which the large ears of deer ensure. Prey animals' heightened senses naturally correlate with those of the entranced shaman. Her flared and open nostrils suggest the engage-ment of her sense of smell, another of the deer's keen natural abilities. Her parted lips could con-

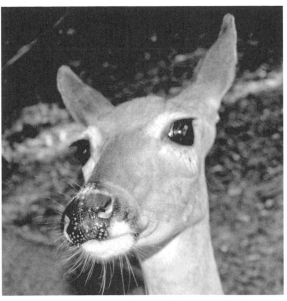

FIG. 5.8. White-tailed deer, detail of doe's outlined ears. Permission of Yellow River Game Ranch, Lillburn, Georgia. Photo by Meghan Tierney, 2009.

FIG. 5.9. White-tailed deer, doe's head (showing muzzle). Permission of Yellow River Game Ranch, Lillburn, Georgia. Photo by Meghan Tierney, 2009.

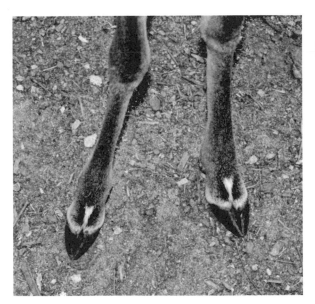

FIG. 5.10. White-tailed deer, detail of hooves. Permission of Yellow River Game Ranch, Lillburn, Georgia. Photo by Meghan Tierney, 2009.

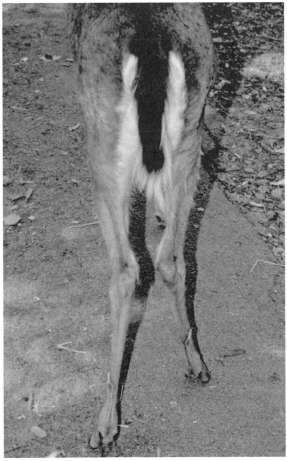

FIG. 5.11. White-tailed deer, detail of tail. Permission of Yellow River Game Ranch, Lillburn, Georgia. Photo by Rhiannon Stone-Miller, 2009.

vey the deer's shrill whistling sound used to startle predators as well as denote shamanic chanting or singing.

It may pertain that white-tailed deer have markedly large tails, ten inches long, wide, squarish, and outlined in white (fig. 5.11). When startled they hoist the tail, which is white underneath and thus very salient. The hair or headdress pendant down the back of the effigy's head is quite tail-like, in fact (fig. 5.3), and even the incised outline may echo the white outlining. Having a tail on her head is congruent with the predominance of animal alter egos in that position in shaman doubles. Like her hoof-hands, this reference remains not absolutely mimetic. However, the value placed on ambiguity in shamanic imagery works against literalness in any given reference.

The pronounced black dots on her knees are found on deer hocks in a similar position (fig. 5.6). These are female scent glands that serve to attract mates, getting darker and more fragrant during rutting season (Art Rilling, personal communication 2009). Thus, the knee dots subtly reinforce the message of fecundity in the effigy. Does in general are fertile animals: they usually produce twins and can give birth to up to four fawns at a time. They make devoted mothers, willing to sacrifice themselves when facing predators that threaten their young (Hiller 1996: 59–61). Thus, the fertile body and maternal behavior of female deer and women shamans may relate on several levels. It is important that this figure, particularly when seen from the side (fig. 5.2), is obviously pregnant, unlike most female figurines from Costa Rica.

To move beyond the deer iconography, the visionary theme of cephalocentrism definitely applies: about 35 percent of the effigy is head. Its sheer size and other design factors draw the viewer's attention upward to it. The head is centered over the enormous plane of the shoulders, a strong horizontal that, together with the black hair area, sets off the head as a liminal zone. Though much detail is found elsewhere, most is concentrated on the face. The series of vertical lines through the eyes provide the main vertical focus in the composition and as such stand out, performing the usual perceptual functions of establishing stability and encouraging down-up perusal. Above these bars are the solid black

horizontals of the heavy brows and then the even more emphatic hair or headband that caps the upward movement at the crown of the head. This is significant since the crown plays the role of the entry/exit point of consciousness in shamanism and is associated with revelation. The viewer's eye is also thereby drawn outward to the pedicels, garnering the deer alter ego message.

Her head literally expands toward the top; the visionary sense of opening up and losing bodily connection is thus engaged. The smaller brows in the same basic shape as the hair reiterate this upward expansion. The head is markedly open at the fontanel, which has practical features—as a firing hole and to allow a small hand to support most areas of the leather-hard clay while being burnished—and carries the symbolism of the consciousness expanding. It is appropriate to emphasize the container aspect of the piece, both for the fertile-female and rebirth connotations and for the double to perform as a holder for the shaman's spirit.

When a viewer is encouraged to look at the head opening, an important piece of information is conveyed: just how thin the walls of the effigy are, about an eighth of an inch thick. While this might seem a minor detail, it would have carried more significance in an ancient "ceramic-literate" culture, one in which most people understood, if not directly experienced, the basic processes and challenges of hand-building with clay. Because thin walls are notoriously prone to collapse, others would recognize how adept the artist was to successfully balance the outward thrust of the head and shoulders with the inward-curving crown of the head and the massive head itself. Furthermore, in shamanic terms, there might have been a magical connotation to this achievement: suspending clay in the air could have been interpreted as the result of spiritual aid. As we have seen, suspension in general and especially that of the body is a recurrent trance experience and as such carries supernatural connotations.

The color of the effigy, as in visions, is maximized within the parameters of ceramic technology and execution. Her overall color is about as brilliant a red-orange as possible with slip paint. Visions often emphasize the color red, although most ancient American ceramics employ the natural color of the earth, so this is not conclusively

reflective of visions. The highly burnished treat- · ment of the slip adds the element of light, which reflects off the surface like many media favored in shamanic cultures (Saunders 2003).[2] These hue and texture effects lend her inner light, a brilliance that mirrors that of the Other Side. Allusion is made to her illumination and revelation by the noticeably lighter orange slip chosen for the areas between the vertical lines framing her eyes (more apparent in the piece than in the photographs). This shade further accentuates the eyes—locus of visions—and subtly symbolizes her ability to see in an illumined way. The crown of her head is like-wise painted lighter orange, perhaps to convey the inspiration point opening to the Celestial. Indeed, the light-filled part of the head lies above and beyond the hair, so that in a subtle but effective manner using color and light, the artist encourages the viewer to look beyond the figure's physical extent in the terrestrial world and recall a shaman "who has left."

Not only through color or the deer subtext, the spiritual force of the shaman is encapsulated in the oversized, widely spaced, and dark-outlined eyes. The aforementioned vertical lines appear to simultaneously come from the eyes and continue underneath them. Patterns representing geomet-ric visionary percepts emanating from the eyes are a common indication of a trancing shaman (for example, in fig. 7.10). The wide-eyed trance gaze is characteristically intense, mydriatic, and not completely focused. It may be relevant that, without propping up, this figure naturally leans back, though this could be mitigated if placed in a depression in the earth or on a ring. In such a posi-tion the eyes would turn markedly upward, fur-ther precluding direct eye contact with a viewer. Even with the figure sitting straight, the pupils not meeting the lower lid angle them slightly up, a universal gesture of the religious visionary. In any position, however, the figure evinces an authori-tative, unwavering stare of great intensity that underscores her strong visual experience and lends power, commanding respect.

The same message is reinforced by her extremely authoritative shoulders, which are unavoidably masculine and create an ambigu-ous gender reading appropriate for shamans. The very feminine breasts, belly, and thighs counter the shoulders, but nothing projects outward as

far as they do. Equalizing the gender message, the viewer alternates between looking at the similarly projecting triangles of the shoulders and the legs. The shoulder exaggeration also can be interpreted as referring to many pervasive kinesthetic bodily distortion and scale shifts experienced under trance.

Calm, power, status, and authority are strongly communicated by the simplicity of the pose, with its nearly perfect bilateral symmetry. Only using two colors plus a secondary linear subtext of incised patterns helps streamline and monumen-talize the composition. A visual counterpoint, but still conveying status and authority, is the elabo-rate body decoration: hairdo/headpiece, face paint and perhaps facial sculpting (of the lower lip), necklace, and body paint. These features, not only the lines through the eyes but the extensive body art, certainly reflect the preeminence of geometric percepts during visions, her experience of which gives her authority. Furthermore, the strong body decoration celebrates the types of movement most prevalent in the visionary experience. Radiating, spiraling, and undulating are all well represented in the composition and body ornamentation. Interestingly, spirals are the most overt pattern, as is true for visions in general. However, there is a potent subtext of undulation in addition to some strong radiating aspects to the design.

Four double spirals are prominently featured as body painting on hips/buttocks and arms/upper back, while eight others are more subtly included. The most obvious double spirals are drawn in black on her flanks, connecting the thigh and the buttocks (figs. 5.1a, 5.2). They form a bilaterally symmetrical U shape with the top ends curled in toward each other. (Here I will call an "S" double spiral "recurved" and the two types of U either "inward" or "outward" for the direction of the top ends.) Both edges of the black inward double spi-ral are incised, and a free-floating incised line lies above the top edge in the red ground. Being only on the upper edge, this outer outlining represents another upward-directed and dynamic, if very subtle, design element. As a whole, this hip double spiral moves the viewer around the body and accentuates the plump thighs and backside, her fertile areas. From the rear view, the two buttock double spirals almost meet and suggest an outward double spiral (fig. 5.3). They thereby trace the

contours of full buttocks and generate a different visual take on the same lines as the viewer circumambulates. This constitutes a perfect example of encoding flux into design, the incurving side view becoming the outcurving back view. This deceptively simple but effective device underscores the importance of seeing all sides in order to grasp the full fertility message, as the viewer discovers her pregnant belly along the way.

The second major pair of double spirals connects the armpit and upper arm to the shoulderblade area (fig. 5.1b). These have the same outlining as the thigh-buttock spirals. When followed around the arm, these form an upside-down outward U, but the bottom of the U doubles back to extend partially around the arm. A separate black edge-outlined band encircles the arm below. From the front, the curving portions accentuate the large shoulders and wide upper arm. From the rear, the upper set of curls creates a sense of shoulder blades and interacts with the buttock spirals in a lively way; since the shoulder and buttock spirals are rotated counterclockwise from one another, the interaction of the two creates a further spiraling motion in the composition. The arm-shoulder spirals help bring the viewer's eye toward the head, since they turn inward and are smaller and more tightly curled than the lower spirals. There is a dynamic interplay of circling and centripetal visual movement. Although the three-dimensional forms of the body may convey quiet meditation, the two-dimensional message is one of action, movement, and especially spinning that aptly evoke what is "really" happening in the visionary realm. The artist juxtaposing two different messages, calm and frenetic, creatively conveys dual consciousness.

On subtler levels, smaller and less salient drawn and incised spirals are included. The ears' edge has been accentuated with a thick, dark outline that makes an inward U double spiral. Not only relating to actual deer ear patterning, spirals may denote enhanced visionary hearing; this embracing contour line naturally conveys sound being captured. The black cheek pattern forms an asymmetrical, sideways, inward U with a stepped and notched inner outline (fig. 5.1d). Finally, the painted feet originally contained two incised and therefore lighter orange spirals; the proper right foot reflects the original ancient pattern, most

visible in figure 5.4.[3] Under the toes is a slightly curled, oval-shaped, incised line. The heel is indicated by a more tightly wound spiral moving in the opposite direction, so the two together make an asymmetrical double spiral like the arm-shoulder one. If the proper left foot were not retouched, the two feet would visually interact via a more complex array of four spirals. This swirl of visual activity highlights the female center of her body hidden beneath the feet, partaking in the overall shamanic emphasis on the unseen, the mysterious and withheld being all the more powerful, like visions.

Finally, the middle of the thigh-buttock double spirals is further elaborated with red-on-red incised spiral and descending undulating line patterns (figs. 5.1a, 5.3). Although subtle, these lines do pick up light in her overall shiny surface, and the viewer has been "trained" to notice incising by the linear patterning elsewhere. They connect the two incurling parts of the large black spiral and link them to the flat base line. The two tiny curls spring from the black spiral's outer floating incision line and are bridged by an arc. Down from the arc runs a zigzag line flanked by two straight lines that join the base line below. This incised motif not only adds more spiraling elements but may refer to the female organs and thus to fertility; similar curling fallopian tubes and birth canal depictions occur in Costa Rican "womb" pots (Brannen 2006).

Simultaneous with all this spiral motion, undulating movement pertains. An overtly undulating element, the painted navel design (fig. 5.1c), is certainly prominent as the viewer's eye traverses the protruding belly. There are four other instances of undulating lines: the zigzag vertical lines in the two incised hip spiral elements and the diagonal incised zigzag lines on either side of the forehead, above the eyes between the three vertical lines and the two diagonal lines on the temples (fig. 5.5). Although they are small and match the forehead color, these latter zigzags are set on the diagonal and so become doubly dynamic visually. Interestingly, a contemporary Maya shaman observing this sculpture identified them as "body lightning" or involuntarily twitching nerves or muscles that carry specific divinatory information.[4] The choice of inscribing the lines in the body color itself would convey appropriately a kinesthetic effect

felt under the surface of the body. If so, then the ones on the hips might be interpreted likewise.

Undulation is more crucial yet in the figure's three-dimensional design: the silhouette from both frontal and side views moves in and out in a complex, sinuous way (figs. 5.1, 5.2). The contours move out from the crown of the head, in and out numerous times, all the way down to the final bulbous outward thrust of the leg and its inward swoop to the crotch area. A viewer is encouraged to use more short, quick eye movements to take in the head region, reinforcing cephalocentrism and even mirroring the quick motions visionarily taking place in her head/senses. The larger, slower curves below help skim the eye over the body so that, while her body is far too elaborated to call generic, this relative simplification of it generally supports the proposed shamanic embodiment concepts. From the side view (fig. 5.2) more undulations accrue to create "a waterfall of curves" (Stone-Miller 2002b: 72). Thus, all views of this effigy feature the undulating silhouette.

Another source of serpentine movement in the effigy occurs in the placement of features slightly off center and offset from one another: her nose/mouth sits slightly to the viewer's left, the larger shoulder right, breasts left, navel right, feet crossing left, and left knee further right. This is again a subtle, subtextual aspect of the design, but these diversions from absolute bilateral symmetry enliven the composition with a swinging motion. In complex hand-built ceramic sculptures absolute symmetry is rare; however, the artist here was so talented that we must ascribe these to choice. The fact that they set up an undulation, a valued type of visionary motion found throughout the composition, makes these complementary placements all the more integral.

Finally, the design conveys some radiating movement as well. The navel lines around the dark central circle and the less obvious red-on-red incisions outside them, both on the most forwardly projecting part of the torso, visually expand outward (fig. 5.1d). The knee circles are concentric and have a similar effect, as do the breasts accentuated with black nipples. The thighs push out from the torso emphatically, as do the shoulders. The necklace flares out around the neck, and within it the individual pendants flare. Radiating motion is certainly lower in saliency among the vari-

ous types but lends an undercurrent of outward projection that dynamically counters the inward motion encouraged by other artistic choices. She cannot be perceived as static, not with so many spiral, back-and-forth, and outward motions encoded in her flat and volumetric elements. The figure vibrates with energy, intensely engaging the viewer to resolve the interrelated patterns skillfully counterbalanced to create visual ambiguity. The viewer's restless eye gains the understanding that she exists in swirling visionary space, her calm belied by the implied activity taking place on the Other Side.

The emphatic visual movement of the bodily forms and decoration simultaneously helps break up the body, promoting the decorporealization that is key to the visionary experience. None of the black accents outlines the edges of the body to anchor it in space or provide large areas of filled solidity; they primarily float as complex lines on a red ground. This atomizes and thus lightens the entire composition. However, the black is primarily used to subvert a static, bounded reading by drawing attention away from the volumetric and toward the two-dimensional. The quality of flatness that solid black areas inevitably possess may be periodically interrupted by fine incised subdivisions and outlining, but those merely increase the sense of their shallowness. The terrestrially present body is called into question everywhere, the subdivided, two-dimensional lower legs being the most obvious instance. Her human body is shown as completely ungrounded by depriving the lower legs—on which she would stand under normal conditions—of all volume, reducing them to thin, tapering lines like the body painting elsewhere. In addition, the feet are tiny, noticeably smaller than the hand-hooves beside them. Showing their undersides presents standing as impossible, and adding incised spirals further compromises their solidity. The viewer's eye rises up from where feet are supposed to be, in our kinesthetic understanding of our bodies, toward the crossed ankles suspended somewhere in limbo on the ground of red thighs and finds only flat, tiny, inverted, cutinto feet. The viewer inevitably concludes that the figure has been released from the hold of gravity, levitating just as shamans experience in visions.

The base of the effigy is rounded, physically refusing to hold it up. Furthermore, where a

viewer might seek a visually solid, unified base, it is split, creating mostly shadow below the painted legs, which prevents the body from sitting heavily in this space. Not only the two-dimensional but also the three-dimensional make her levitate slightly, lifted on curves and shadows. With the eye drawn ever upward by the aforementioned effects, any focus on how she sits is repeatedly subverted. This artistically restates the basic dialectic that one appears to be Here but feels Not-Here during trances ("I sat in the clouds, not on the earth . . . If I reached out my hand, I felt nothing, I touched the emptiness [of the sky] in spite of the fact that I was really sitting on the ground"). The open space between the arms and torso visually lifts the piece and makes it penetrable, and the extremely shiny surface and visibly thin vessel walls lighten the overall effect as well. Thus, many creative choices allowed the artist to embody the dynamic balancing of paradoxical realities of the shaman who is in dual consciousness, bodily sensing without a body fully present at all. She flickers in and out from three- to two-dimensionality, from solid calm to energetic movement and flux in state of being, defying strict characterization, embarrassing the categories.

This ineffable quality of how she is supported and "where" she is exactly extends to her body in other ways, as part of an emphasis on that which is not shown, withheld, mysterious. The shamanic value placed on the hidden as the most important becomes apparent, especially in a pregnant woman, with the implied transformative birth. Principally, the crossed feet that obscure the seat of her femininity and fertility between her legs create the most potent mystery. The viewer's eye, denied entrance where the feet cross, is encouraged upward to where the baby within makes itself felt, if not yet seen, in the taut, rounded belly. The black painting around the navel area adds focus and further expansiveness, setting up a series of concentric circles: the black navel, the lines that diverge around it, then the plain incised reiteration further out, framed by the three-dimensional sphere of the belly itself. Throughout the composition the inside seems to push the body out, emphasizing her life force and power; she also swells with breath with flared nostrils and parted lips. The place where she was attached to

her mother, over where the baby inside is attached to her, certainly vies for one of the essential messages of the piece as a whole, referencing "the chain of mothers from time immemorial" (Stone-Miller 2002b: 72). It is even possible that the navel pattern (fig. 5.1c) itself restates in a highly abstract fashion a pregnant woman, with the horizontal element as the headdress or hair, the two lines coming down as head/neck, the swollen belly, and the two lines below as legs. This type of nesting of images, a pregnant woman with a pregnant woman for a navel, is found in other shamanic art, such as the Pataky jaguar-shaman with jaguars as spots, as will be discussed. The abstraction of this figured navel, however, represents creative ambiguity.

There is no question that most of the themes generated by the visionary experience are expressed in this elaborate, paradoxical, and intriguing shamanic double. Another important theme, the different body as predisposing one toward becoming a shaman, relates the Rosales figure with her split lower lip to other effigies with unusual conditions.

COSTA RICAN EFFIGIES WITH ANOMALOUS CONDITIONS

Individuals who are atypical physically are represented in Costa Rican art, including those born with both male and female genitalia (figs. 5.12–5.15) and those with rickets (figs. 5.16, 5.17) and scoliosis (Stone-Miller 2002a: 86, catalogue no. 159), among various conditions. While there may not be large number of such images, at least ten have come to my attention.[5] I would place these effigies at the human end of the continuum, though various elements bring in the animal subtext.

An elaborate Carrillo-style image of an intersexed individual (figs. 5.12, 5.13; Denver Art Museum accession number 62.1992) clearly displays female elements: protruding breasts with red nipples and an everted navel, plus the hands-on-the-belly pose taken by many female, often pregnant figures. The figure has male features as well: a detailed, partially erect penis and testicles. The body position with legs wide apart ambiguously communicates both the squat of parturi-

kyphotic individual, since the front of the torso is flat; multiple physical anomalies increase the power of the wounded healer (figs. 7.9, 7.24). Several aspects of the complex body art lend themselves to the shamanic reading: the spiral lines that curl around the shoulders and under the arms; the criss-crossing verticals on the legs, center chest, and back of the head that might essentialize the *caapi* twisting vine (as will be described in chapter 6); and the zigzag "power edge" (also in chapter 6) on most of the black patterns. In sum, there is much support for reading this individual as the physical embodiment of shamanic androgyny in its most obvious corporeal expression.

A matched pair of vessels in El Bosque style (figs. 5.14, 5.15; Carlos Museum accession nos. 1991.4.52, .53) features types of alternating horizontally positioned figures (Stone-Miller 2002b: 118–120). One figure has a head at each end and so is frankly fantastical and visionary, and the other appears to have both sets of genitalia, an

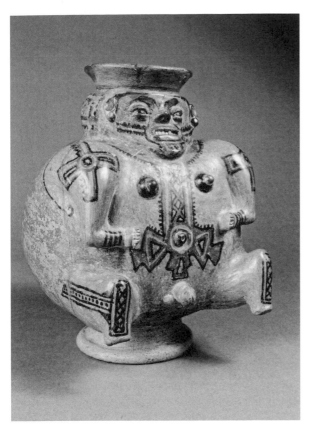

FIG. 5.12. Front view of intersexed shaman effigy vessel. Costa Rica, Greater Nicoya, Carrillo Polychrome, 500–800 CE. Denver Art Museum accession number 62.1992. Denver Art Museum: Collection of Frederick and Jan Mayer. Photograph © Denver Art Museum 2008. All Rights Reserved.

tion and the arrangement of an animal's four legs at the edge of the body (the feet are broken off). The figure's facial features are human except that the teeth are bared and each tooth appliquéd carefully, an unusual elaboration that calls attention to them. The end of the nose is painted black, a probable jaguar reference. Unusual, bulging yet half-closed eyes split the difference between the open and the slit trance eye types, communicating both, and look characteristically upward. Other shamanic indications include the suspension of the figure above the vessel base, the expanding crown of the head/rim, and high-status earspools. Vertebrae projecting from the back (fig. 5.13), similar to those on the stone meditating shamans (fig. 4.4), arguably represent the fasting that brings on visions. The very rounded back could suggest a

FIG. 5.13. Back view of effigy in figure 5.12. Photograph © Denver Art Museum 2008. All Rights Reserved.

SHAMANIC EMBODIMENT IN ANCIENT COSTA RICAN ART I

FIG. 5.14. Bowl with appliqué intersexed and two-headed figures, one of a matched pair (with fig. 5.15). Costa Rica, Atlantic Watershed, El Bosque, 100 BCE–500 CE. Michael C. Carlos Museum accession number 1991.4.52. Photo by Michael McKelvey.

FIG. 5.15. Bowl with appliqué intersexed and two-headed figures, one of a matched pair (with fig. 5.14). Costa Rica, Atlantic Watershed, El Bosque, 100 BCE–500 CE. Michael C. Carlos Museum accession number 1991.4.53. Photo by Michael McKelvey.

erect penis and round circles for breasts,[6] as well as quintessentially round animal trance eyes. The two-headed being is standing on four legs, and the intersexed one is similarly splayed out, lying on its back; both figures assume more animal than human positions. The striped bodies and stamped round eyes link directly to toad imagery in many other pieces (ibid.). Whether the juxtaposition of the figures is that of a visionary animal and one on the way There, the before and after of transformation, or simply an equivalence set up between the two states, all these messages strongly support a shamanic reading. Being intersexed may have related an abundance of fertile human body parts to the notorious fecundity of the toad or frog. Toads with entheogens in their glands make a strong shamanic connection to this iconographic configuration as well (figs. 4.16, 4.17).

Survivors of the disease rickets form another intriguingly enigmatic group of images (figs. 5.16, 5.17; Denver Art Museum accession numbers 1993.536 and 1993.811). Their protruding chests and backs represent the skeletal distortions created by rickets, known as osteomalacia in children, a deficiency in vitamin D, calcium, and/or phosphate that results in softened bones (David 1991). Among its various symptoms, rickets produces unusually short stature, bowed legs, kyphosis, a protruding breastbone, and/or a circular pattern of knobs on the ribs known as rachitic rosary, or "bony necklace" (ibid.: 109). The short, bowed legs and large head of figure 5.16 and certainly the torso exaggeratedly arching out both front and back clearly represent this condition. Though more integrated with the vessel form and abstracted, the kyphosis and bulging chest of figure 5.17 also convey diagnostic skeletal distortions. The curved outlining of the protruding ribs created by rachitic rosary appears to have been artistically rendered by a raised line or plane that curls at both ends to make an inward double spiral. The curling end as an artistic flourish draws attention to the unusual body form and, probably not coincidentally, adds spirals into the mix.

The animal aspects of this condition are subtle; most effigies have a flat nose with nostrils punched into them rather than a protruding human nose, while figure 5.17 specifically has the black nose of a jaguar, and all the rickets survivors have bulging and/or round eyes. One might argue that the front

and back protrusions give the bodies a horizontality that in relative terms belongs more in the animal kingdom. In figure 5.17, spots have been added to these humped areas, not a symptom of the condition itself but suggesting a spotted animal self such as a feline. Rickets survivors may be shown wearing a spotted hat (fig. 5.16) that features a single twist of over-and-under lines forming an X, possibly to represent the most extreme essence of the *caapi* vine.[7] An X is often paired with jaguar spots in other styles, as will be discussed below, supporting the idea of an individual with rickets having a jaguar self. The effigy in figure 5.16 is carrying a vessel, perhaps containing an entheogenic brew, as suggested with the crocodile-transforming female shaman (fig. 4.7; Stone-Miller 2002b: 127). High-status earspools on both rickets survivors and the negative or resist-painted technique of figure 5.17 help reinforce a shamanic reading as well. Thus, there are a number of indications that these individuals were not only survivors of a disease but elevated to the role of healers as a result.

TOWARD THE CENTER OF THE FLUX CONTINUUM: PATAKY JAGUAR-SHAMAN

The Pataky-style jaguar-human effigy from northern Greater Nicoya, circa AD 1000–1400 (figs. 5.18–5.21; Carlos Museum accession no. 1991.4.337), may seem to strongly favor the animal reading. Nevertheless, it contains key human features that place it at a central position in the transformational continuum. Previously I emphasized the jaguar characteristics but concluded, "this piece achieves a masterful artistic balance of naturalism and internal presence, the implied shaman within" (Stone-Miller 2002b: 110). The bared, blood-red canines of the growling cat, the rattle ball that recreates the jaguar's grumbling voice (especially when the piece is lunged forward like the aggressive predator itself), the low-placed head in the stalking pose, and the jagged claws evoke the impressively dangerous qualities of the top shamanic alter ego (ibid.: 108–109). However, striking a vertical human pose, specifically that of the meditating shaman with hands on knees, encodes

FIG. 5.16. Survivor of rickets carrying a bowl. Costa Rica, Guanacaste-Nicoya, Marbella Incised, 300 BCE–500 CE. Denver Art Museum accession number 1993.536. Denver Art Museum: Collection of Frederick and Jan Mayer. Photograph © Denver Art Museum 2008. All Rights Reserved.

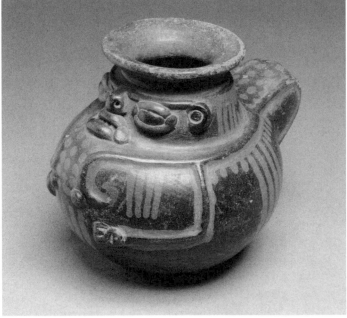

FIG. 5.17. Survivor of rickets with resist spots. Costa Rica, Guanacaste-Nicoya, Guinea Incised, Resist Variety, 300 BCE–500 CE. Denver Art Museum accession number 1993.811. Denver Art Museum: Collection of Frederick and Jan Mayer. Photograph © Denver Art Museum 2008. All Rights Reserved.

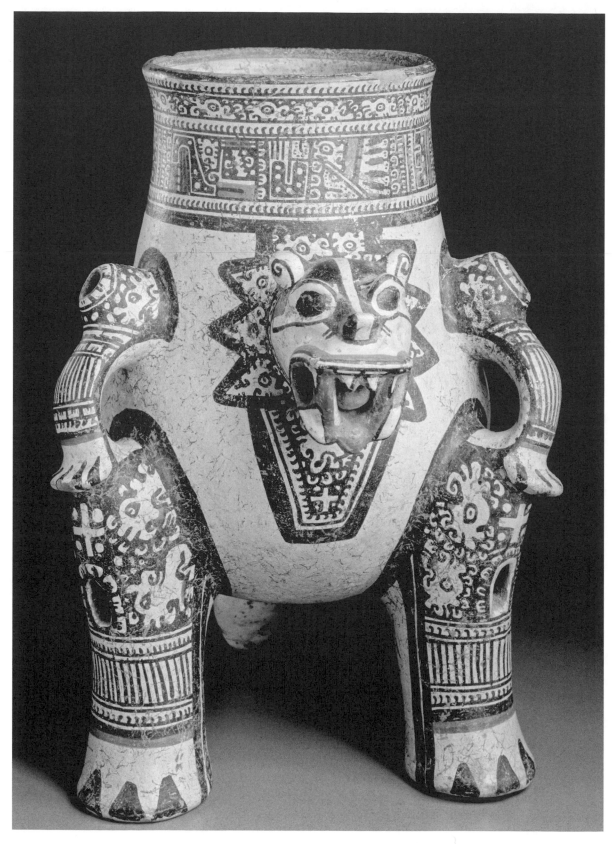

FIG. 5.18. Front view of jaguar shaman vessel. Costa Rica, Guanacaste-Nicoya, Pataky Polychrome, Pataky Variety, 1000–1350 CE. Michael C. Carlos Museum accession number 1991.4.337. Photo by Michael McKelvey.

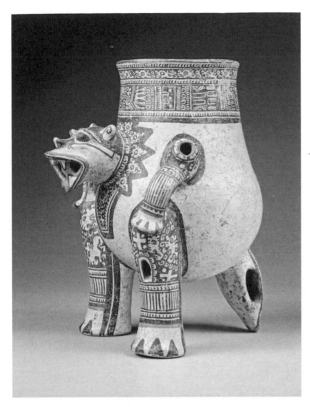

FIG. 5.19. Side view of vessel in figure 5.18. Photo by Bruce M. White, 2008.

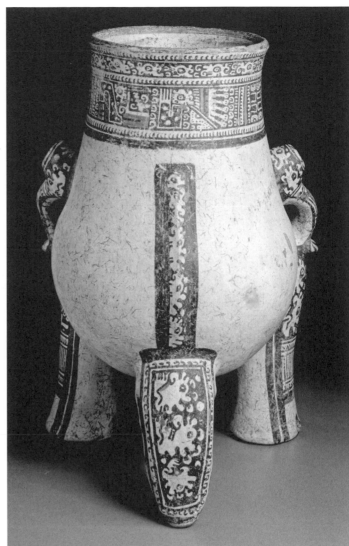

FIG. 5.20. Back view of vessel in figure 5.18. Photo by Michael McKelvey.

FIG. 5.21. Detail of vessel in figure 5.18: two miniature jaguars as spots at the top of the proper right leg, beneath the front paw/handle (oriented sideways relative to the piece standing on its feet). Photo by Bruce M. White, 2008.

FIG. 5.22. Black and tawny jaguars. Permission of Leroy McCarty, http://www.exzooberance.com.

the human essence within the jaguar appearance (ibid.: 109; Stone-Miller 2004: 60, 62). Jaguars rear up on their hind legs before they pounce (Perry 1970: 28), so they take on a human verticality momentarily but do not rest the front paws in this way. More remains to be elucidated on the relationship between human and jaguar alter egos, particularly the spotting as body art and the artistic encoding of the visionary themes.

A key mediation of the jaguar and human selves lies in the treatment of the spotting. Certainly jaguars are exuberantly spotted (fig. 5.22, right), as is this piece, although it does not depict the terrestrial appearance of all-over rosettes in an overtly mimetic fashion (unlike the depiction in fig. 3.1). Most of the body is left white, and only separate outlined areas are spotted; on closer examination the individual spots turn out to be miniature jaguars (fig. 5.21). This miniaturization might invoke well the micropsia effect of visions and the tiny beings seen under the influence of most entheogenic substances. However, looking at other, more human shaman effigies suggests

why the spotting is segregated here, while looking at real jaguar markings (figs. 5.22, 5.23) reveals a visual logic to the innovative artistic choice to make the jaguar spots into diminutive jaguars.

I argue that outlining areas of spotted decoration stands for the human component of the dual being for two reasons. First, the actual animal has no spot-free areas except the nose. Second, various Costa Rican human effigies allude to ancient people's use of roller stamps and seals to spot their bodies precisely to reveal their visionary transformation into felines. In other words, the Pataky effigy spotting is mimetic of a person whose body art represents his/her jaguar self rather than being mimetic of the spotted jaguar as an animal. Since actual human bodies do not survive from ancient Costa Rican graves, we must rely on evidence from other ceramic effigies as to how bodies were decorated in ancient times (figs. 5.24–5.28). The many remaining roller stamps and seals help reconstruct body art quite specifically (figs. 5.29 through 5.33a–e).

Effigies that are almost entirely human except

for their wide-open trance eyes are elaborately painted, tattooed, and/or stamped, mostly in black patterns that may be organized in outlined areas. Like the Pataky piece, other styles' images of roller-stamped people may leave large areas of the body undecorated (figs. 5.24–5.28; manganese deposits from burial obscure this effect slightly in figs. 5.26 and 5.27). It is significant that on an unusually densely decorated effigy (figs. 5.24, 5.25; Denver Art Museum accession no. 6.2000), thick double lines outline the areas patterned with dots and diamonds, just as double lines outline the patterned parts of the Pataky jaguar's legs (fig. 5.19). On the latter, similar thick, single, black lines segregate the other spotted areas: the zigzag-edged area framing the head; the outer sides of the limbs, down the back, and around the tail; and the uppermost rim band, which contains tiny jaguar heads. Thus, the thickest black lines, whether

single or double, serve to separate out the spotted zones. Being intermittent, segregated, and finished in a similar way thus reinforces the reading of the Pataky spots as representing body art rather than as naturalistic feline markings.

Body art was achieved in large part by the use of roller stamps and seals, of which a large variety survive (figs. 5.29–5.33a–e). Roller stamps were pigmented and used like rolling pins to transfer long geometric swaths of zigzag and fret patterns; seals were pressed into the skin. While not all effigies' body patterning and actual stamps can be matched up, there are instances in which they correlate, such as the pattern above the eyes in figure 5.29 top row, right center, and the diamonds on figure 5.24 compared to figure 5.30, lower row, center. The line of spots down the back of the Pataky piece (fig. 5.20) is particularly evocative of a roller-stamp aesthetic: it deliberately and abruptly ends before joining the upper rim bands; when a roller stamp is lifted up, it creates such a horizontal edge. The human effigy's back (fig. 5.25) displays a strikingly similar set of two dark lines that also ends bluntly and avoids connection to other pattern areas; even if these represent hand-painted lines, the general idea of banded, abruptly ending patterning as diagnostic of body art still holds. Despite their geometric precision, these lines down the back can refer to the dorsal stripe of melded spots visible in many jaguars, underscoring that the intent of body painting was to evoke the animal self in its essential features.

Seals with handles (figs. 5.30, lower row, and 5.31 through 5.33a–e) could be used to transfer discrete motifs, whether once or multiple times to fill larger surface areas (figs. 5.24–5.27). The butt ends of a roller stamp could be utilized to stamp, making solid circles with dynamic edges or internal cross patterns, among others (fig. 5.30, top left, top right). The seals, whether circular or diamond-shaped, often feature concentric patterns and wavy edges, and some have inner circles made up of open circles (figs. 5.30–5.32a–g). Though abstracted, all these stamp patterns communicate the essential features of actual jaguar markings (figs. 5.22, 5.23), which include random solid dots, sometimes melded into short stripes, and open circles, interspersed among rosettes that may have one or more smaller dots inside an irregularly circular outline. The outer circles of rosettes

FIG. 5.23. Drawing of various representative jaguar spots. Drawing by Nina West.

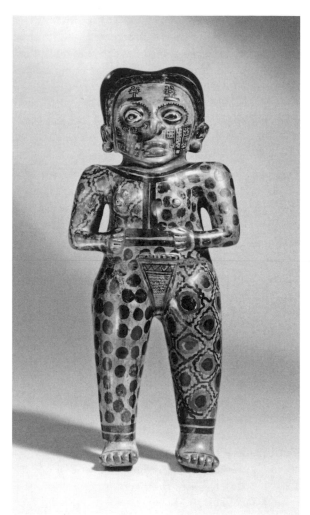

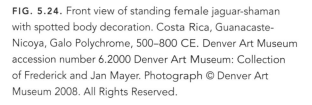

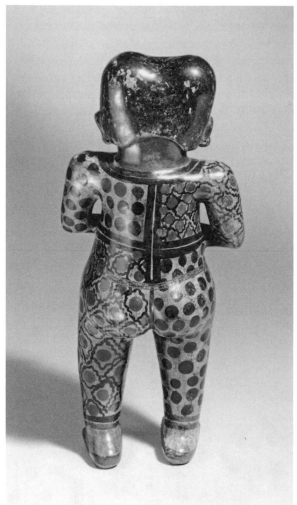

FIG. 5.24. Front view of standing female jaguar-shaman with spotted body decoration. Costa Rica, Guanacaste-Nicoya, Galo Polychrome, 500–800 CE. Denver Art Museum accession number 6.2000 Denver Art Museum: Collection of Frederick and Jan Mayer. Photograph © Denver Art Museum 2008. All Rights Reserved.

FIG. 5.25. Back view of effigy in figure 5.24. Photograph © Denver Art Museum 2008. All Rights Reserved.

often have broken edges and scalloped contours. Thus, the seals with their zigzag outer edges and inner circles, as well as the roller stamp butts with the solid circles and small lines, could create feline markings on a human body, albeit essentialized, geometricized, and regularized ones. It is worth noting that Galo-style bowls have highly abstracted jaguar spots that resemble the seals' patterns very closely (figs. 5.31 and 5.34, for instance). In these bowls the spotted areas are set off with lines, just as around the areas of spots on the Pataky effigy. In terms of "geometric" elements as

spots, the occasional introduction of an X or cross shape in the stamps and seals (figs. 5.30, butt end of top right stamp and stamp in lower row center; 5.32d,e) is interesting since among the spots below the "hands" and the mouth in the Pataky piece are interspersed crosses. A related Galo bowl combines a cross and extremely shorthand jaguar spots (fig. 5.35). If one looks at a cross as separating four diamonds, reversing the usual figure and ground reading, perhaps it relates to jaguar markings in a semimimetic fashion, because on some individual animals the rosettes are noticeably arrayed like a grid of diamonds (fig. 5.22, right). The diamond-grid spotting variant appears in the all-over spotted effigy (fig. 5.24, viewer's top left

and bottom right quadrants; fig. 5.25, viewer's top right and bottom left quadrants) and numerous stone jaguar effigy metates (fig. 5.36). The all-over spotted effigy's diamond grid is made up of stepped edges, and a great many stamps are in the shape of a stepped-edge diamond or feature them as internal motifs (figs. 5.30, lower row, center; 5.32f). Stepped diamonds are found within the spirals of roller stamps as well (visible in the rolled out impression of the stamp in fig. 5.29, bottom right; Stone-Miller 2002b: 113, catalogue no. 239). Certainly the geometric patterns of stamps and

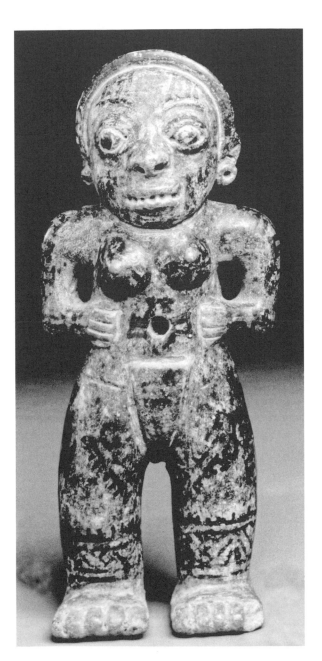

FIG. 5.26. Front view of standing female shaman with stamped body decoration. Costa Rica, Guanacaste-Nicoya, Galo Polychrome, 500–800 CE. Michael C. Carlos Museum accession number 1991.4.338. Ex coll. William C. and Carol W. Thibadeau. Photo by Michael McKelvey.

FIG. 5.26A–D. Drawing of body art on effigy in figure 5.26: (a) above eye, (b) navel, (c) thigh, (d) ankle. Drawing by Nina West.

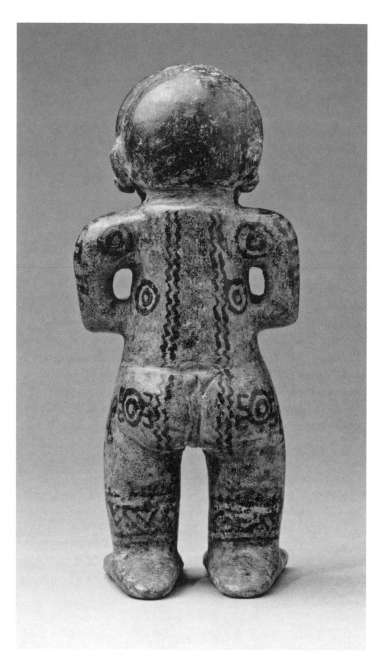

FIG. 5.27. Back view of effigy in figure 5.26.
Photo by Bruce M. White, 2008.

FIG. 5.27A–C. Drawing of body art on effigy in figure 5.27:
(a) back, (b) arm, (c) buttock. Drawing by Nina West.

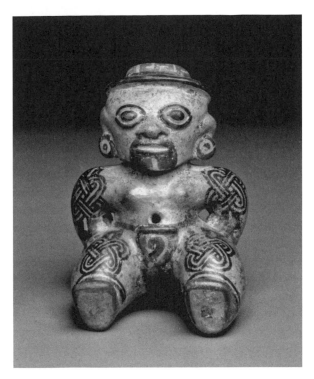

FIG. 5.28. Seated female with interlaced body decoration. Costa Rica, Guanacaste-Nicoya, Galo Polychrome, 500–800 CE. Michael C. Carlos Museum accession number 1991.4.292. Ex coll. William C. and Carol W. Thibadeau. Photo by Michael McKelvey.

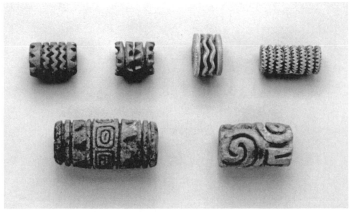

FIG. 5.29. Roller stamps with geometric patterns. Costa Rica, Guanacaste-Nicoya, 1–700 CE. Michael C. Carlos Museum accession numbers 1991.4.182 (top left), 1991.4.178 (top left center), 1991.4.180 (top right center), 1991.4.177 (top right), 1991.4.183 (lower left), 1991.4.179 (lower right). Ex coll. William C. and Carol W. Thibadeau. Photo by Michael McKelvey.

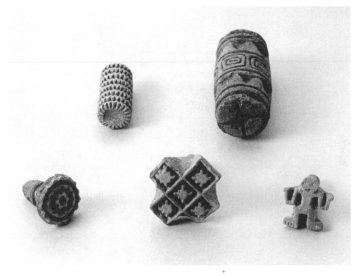

FIG. 5.30. End view of roller stamps with geometric patterns and seals with jaguar-spot-related abstract patterns and a human figure. Costa Rica, Guanacaste-Nicoya, 1–700 CE. Michael C. Carlos Museum accession numbers 1991.4.177 (top left), 1991.4.183 (top right), 1991.4.186 (lower left), 1991.4.181 (lower center), 1991.4.185 (lower right). Ex coll. William C. and Carol W. Thibadeau. Photo by Michael McKelvey.

seals owe their variety to the important visionary role of geometry in general, yet the visual ties among roller stamps and seals, actual jaguar spots, and spotted effigies remain hard to discount. The desire for shamans to decorate themselves as their jaguar spirit-selves can be seen as an inspiration for this configuration.

An intriguing and unusual stamp (fig. 5.32g) would create a pelt-related diamond grid if stamped repeatedly, but its internal patterning is asymmetrical, in contrast to nearly every other Costa Rican stamp or seal. If its internal wandering line does not represent anything in the terrestrial world, it at least captures the inherent irregularity of a jaguar's spotting (as can be compared in different markings on figures 5.22 and 5.23). However, it may be read as an ecstatic human figure: legs bent and pinwheeling, arms up, a vestigial triangular protrusion for the head. Indeed, a jaguar's irregularly filled-in diamond-grid pelt made up of dancing shamans would be a perfect encapsulation of the animal spirit transformational experi-

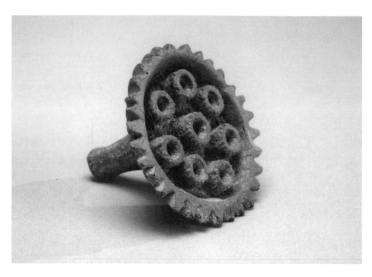

FIG. 5.31. Stamp with jaguar-spot-related abstract pattern. Costa Rica, Guanacaste-Nicoya. 1000–1550 CE. Lowe Art Museum accession number 94.14.25. Gift of Candace Barrs. Photograph by Tim McAfee, copyright 2007 Lowe Art Museum, University of Miami.

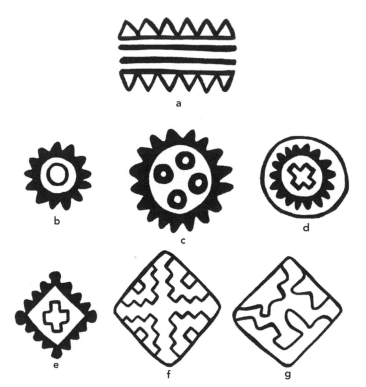

FIG. 5.32A–G. Drawing of designs on seals with jaguar-spot-related abstract patterns. Costa Rica, Cartago, site of Las Mercedes. National Museum of the American Indian (a) 240837, (b) 240846, (c) 240845, (d) 240842, (e) 240833, (f) 240812, (g) 240825. Courtesy National Museum of the American Indian, Smithsonian Institution (240837, 240846, 240845, 240842, 240833, 240812, 240825). Drawing by Nina West.

ence. In a larger sense, the inherent anomalousness and ambiguity of such a design follows the shamanic mandate to explore all that is different and unclear. Most of the Pataky effigy's jaguars-as-spots are similarly inchoate and therefore perfectly "visionary."

Other seals that are definitely figural support this argument that the Pataky figure represents a person decorated like a jaguar. Figural seals represent animals such as monkeys, frogs, and crustaceans (fig. 5.33a–c) and, importantly, vision heads that mix human and animal characteristics (fig. 5.33d,e). Ones with round animal eyes or mydriatic human ones, wide noses with visible nostrils, mouths with jagged teeth, and rounded ears place feline features in an ambiguously human arrangement. The frog's head shades toward the human since it has a narrow mouth, while frogs have wide mouths, so it is also overtly transformational.

These different stamps and seals suggest that actual people could be spotted with versions of jaguar spots to show their jaguar selves directly, with complete miniature animals to show their other or various animal selves, or with vision heads or composite animals to show their transformation into jaguars or frogs. The Pataky effigy, in fact, has all of these for spots: dots and crosses, miniature jaguars, and jaguar heads. When seen from a distance, spotting the effigy or the human body with those of other animals would announce that the shaman was a jaguar or at least a Spotted Predator. Close up, specific animal selves would become apparent. This provides a wonderfully nuanced way to embed the shaman's multiple selves and delineate the depths of spiritual power. Significantly, the fact that body art is two-dimensional and the body three-dimensional reiterates the way flat patterns on effigies are more referential of the ethereal realms and the volumetric of the terrestrial.

Yet, in the Pataky piece a jaguar shaman spotting his body with miniature jaguars references the actual animal's pelt in another important way. Almost every rosette on a real cat is made up of spots (fig. 5.23); thus an individual rosette restates the overall cat's markings in miniature. It is but one step further to make a spot into a miniature cat. This Pataky image takes those two facts, the human marking itself with animals and the feline markings as spots within spots, and com-

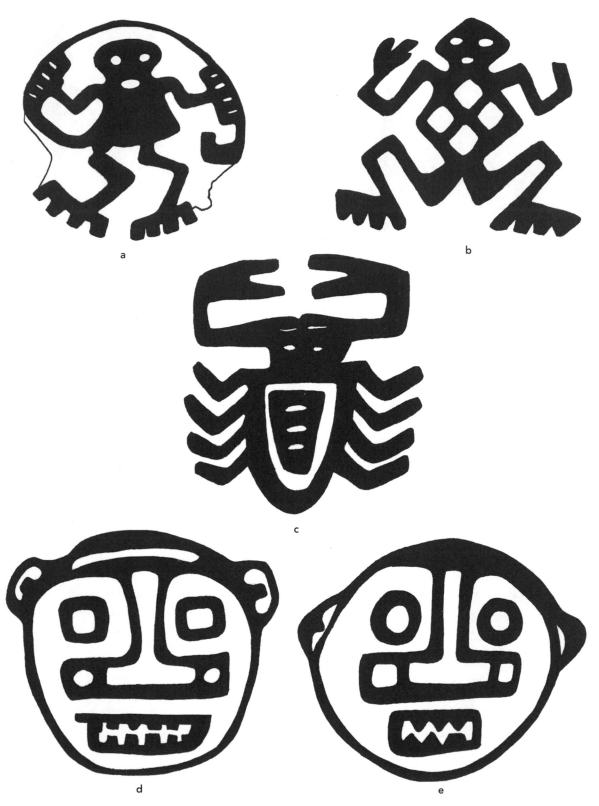

FIG. 5.33A–E. Drawings of designs on seals with animal transformational figures and faces. Costa Rica, Cartago, site of Las Mercedes. National Museum of the American Indian (a) 240861, (b) 240858, (c) 240862, (d) 240850, (e) 240840. Courtesy National Museum of the American Indian, Smithsonian Institution (240861, 240858, 240862, 240850, 240840). Drawing by Nina West.

FIG. 5.34. Jaguar-spotted bowl. Costa Rica, Guanacaste-Nicoya, Galo Polychrome, 500–800 CE. Lowe Art Museum accession number 72.16.6. Gift of Seymour Rosenberg. Photograph by Tim McAfee, copyright 2007 Lowe Art Museum, University of Miami.

FIG. 5.35. Abstract jaguar-spotted bowl. Costa Rica, Guanacaste-Nicoya, Galo Polychrome style, 500–800 CE. Michael C. Carlos Museum accession number 1991.4.255. Ex coll. William C. and Carol W. Thibadeau. Photo by Bruce M. White, 2009.

bines them in a particularly creative solution. The little jaguars as spots run the gamut from readable to quite free-form and can be reduced to the head only or made to fit the points around the neck. All variants can be decoded as jaguars on the basis of the readable ones, such as the one on the left in figure 5.21, with its round or concentric eye, snout, curled ear, front leg, and tucked-under back leg. The "extra" curls and protrusions may represent fur, two ears instead of one, and vestigial legs or simply shade into the fantastical. I would argue it is not coincidental that all the versions of jaguars in the figure's spots include spirals, the dominant visionary movement, or that there is a great deal of purposeful ambiguity in their variations.

At the same time, it becomes relevant that a few seals depict humans (such as fig. 5.30, lower right): if a human could wear little humans as spots, then a jaguar could wear little jaguars as spots. I previously described this: "Cats as the spots on a cat convey that the animal/shaman is 'concentrated jaguar.' Visually doubling 'jaguarness' exemplifies the typical ancient American intensification of essence" (Stone-Miller 2002b: 110). The Pataky piece can thus convey simultaneously a jaguar made up of jaguars and a human spotted with little alter-ego jaguars. Indeed, this embeds and interchanges the jaguar and human aspects of

the shamanic Self in a perfectly ambiguous conflation, forming an aptly multiple being. The choice of jaguars for body-paint spots impressively communicates the interpenetrated dual being that is the shaman, making a single reading impossible. This series of artistic choices epitomizes the creativity inherent in engaging with the paradoxes of a transformative self.

Finally, to complicate matters further, some modern tropical Amerindian cultures, such as the Desana, believe that animals have their own shamans; that is, the animals' spiritual leaders are also animals. For them, one of the main animal-shamans is the jaguar, called the *basa yeri* or *yuki basa yeri* (Buchillet 1992: 216, 229nn7,8). While this category is not well interrogated by anthropologists, within the overall logic of transformation such animal-shamans might turn into humans as their other selves. In other words, images may not always be of humans turning into animals but rather of animals turning into humans. Privileging the animal over the human is such a strong force in shamanic thought that it makes this an appealing possibility, especially for those effigies in which only a vestige of the human can be extracted (figs. 6.1–6.5, 8.1). It may be again our Western anthropocentrism that prevents us from allowing the animal to be the starting point of transformation rather than the end goal. Yet the

whole idea of the human-to-animal continuum rests on the assumption that such extremes exist and that each type of animal has its counterpart. The Pataky piece can be interpreted as embodying just such a figure so far into its animal self that it has to "backtrack" to suggest the human by showing body-art spots.

Alternatively, if this effigy is meant to represent an animal that is beginning to access the human, we might see the overall spotting of the jaguar animal-shaman as giving way to the segregated spot patterning of the human shaman. Even further, one could re-conceptualize the segregated spot areas as plain human skin pushing the spots aside as the animal-shaman's inner human alter ego emerges. Alternative selves often may be conceived of as inhabiting the inside of the body, as previously discussed, and some ancient American transformational figures seem to have tears in the skin to reveal the emerging inner self (figs. 7.14, 8.2, 8.3, 8.15, 8.16). There may be no way to tease apart the human-turning-animal from the animal-turning-human, nor perhaps should those discrete categories remain sacrosanct; yet it nonetheless remains important to challenge our limited conceptual frameworks to better reconstruct shamanic ways of thought. Privileging of the ani-

mal self represents an abiding value in shamanic art and belief; for instance, the ears of the jaguar remain visible from the human side of figures 3.1 through 3.3, but not vice versa.

Another key artistic choice regarding the Pataky effigy's spots compromises the perceived corporeal solidity, as is typical of shamanic embodiments. The fact that the mini-jaguar spots are the same color as the vessel's white background makes the dark areas seem transparent, reading as two-dimensional planes that have been cut out to reveal the light ground below.[8] The dark areas lie on the surface—not coincidentally like body paint on skin—and therefore much of what defines the body is flat and two-dimensional, since the rest is white and almost disappears. Yet the figure-ground relationships are not that simple: the spotted areas have incorporated the vessel's white ground, setting up a strong visual ambiguity in which the little white jaguar spots read simultaneously as figure (white on top of the black areas) and as ground (white underneath the black, as a continuation of the vessel's overall ground). The principle of simplicity means that the viewer wants to resolve the white as ground continuing under the cut-out black areas, but when the focus shifts to the black parts, that ground changes into

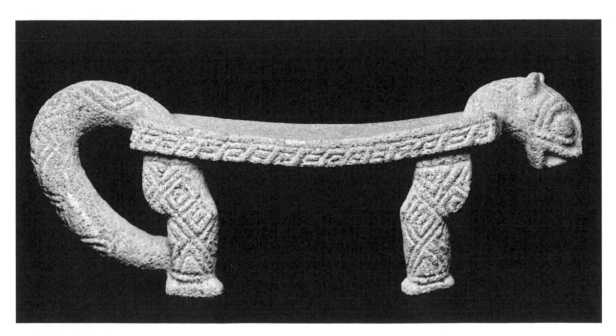

FIG. 5.36. Jaguar metate with diamond and heliacal vine markings. Costa Rica, Atlantic Watershed, 300–700 CE. Michael C. Carlos Museum accession number 1991.4.49. Ex coll. William C. and Carol W. Thibadeau. Photo by Michael McKelvey.

figure. Such a perceptual shift echoes those often found in the visionary experience, modeling flux for the viewer. This apparently simple choice thus strongly conveys a transforming being through shifting surfaces that call into question the body as a solid presence.

The spotted areas—limbs, face, tail, and the abstract rim area—break up the body into disparate, separate parts all floating on white. Perceptually white is almost a lack of color and ethereal by nature, which explains why in many cultures it is the color chosen for spirits. It also evokes the brilliant illumination that is so universal in visions, and the piece itself reflects brightly to "blind" the viewer with light. In this sense, choosing unmitigated white areas instead of all-over spotting increases the visionary component further. Therefore, the choice of white for the main, supposedly three-dimensional body does not create a solid presence to begin with, nor does it bind the dark parts together in any authoritative way. The only point of cohesion and near-solidity is where the front paws/hands meet the back legs/thighs, drawing attention to the shaman's meditation pose. This physical nexus point represents the trance, in which bodily ambiguity is created but also resolved; in visions the paradoxes of having a body and not having one are both highlighted and transcended.

The arrangement of white and black seems to intentionally subvert clarity concerning corporeal boundaries. The edge of the figure/pot is hard to grasp visually, being neither predictably and consistently white in silhouette nor outlined in black, aside from a thin line at the rim. Rather, short sections of the edge are white and the rest heavily patterned, breaking up potential edge continuity into sections of vertical and horizontal lines, parts of the complicated spots, the zigzag claws, and so forth. The most definite edges in the composition are not those of the body delineated from the space around it but rather those internal subdividing lines drawn and sometimes doubly drawn around the spot areas. These body-art lines do not overlap with the vessel edges; they wrap around the legs and arms, creating parts without contributing to a coherent three-dimensional body form.

Visually avoiding anchoring the effigy in the third dimension, this color scheme and other factors lead to the familiar sense of suspension as well. Clearly the whiteness of the body is perceptually lightweight, and the lacy, cut-out, flat patterned areas cannot anchor it persuasively. Quite a bit of actual negative space is incorporated as well: small half-circles between the arms and body, a large amount under the body and between the two legs and tail, and even more inside the vessel, which is visibly accessible from the very large opening at the top. Perusing it from bottom to top, the long legs markedly lift the rounded bottom of the vessel off the ground. Exaggerating how jaguars walk on their toes (Legast 1998: 141), the painted black triangles balance the whole bulbous being on the pointed tips of the abstract claws. It does not reassuringly settle on its feet, similar to the Rosales figure who refuses to sit securely; again, the basic human response to gravity is not a given in shamanic art. The elaborately patterned, connected limbs send the eye up the sides and frame the strongly salient jagged-edged head area. Its two- and three-dimensional dominance typifies visionary cephalocentrism. However, the sides of the Pataky vessel/body stretch up to near parallel and continue on beyond the head for about a third of the overall height, so one is not just focusing on the modeled jaguar head but on the whole vessel top as an extension of it. The elaborate rim designs also bring the eye up, and the open, slightly outwardly flaring, decorated crown of the head once again conveys expanded visionary consciousness. Yet the horizontal rim-band patterns do cap the composition, which brings the rim itself into focus, and there the body is revealed to be hollow, a skin thinly stretched over empty space, a perfect invitation for spiritual occupation.

Thus, the vessel as container competes with, and in some ways may win against, the effigy aspect; the solid reality of the jaguar-human is again called into question. Its bulging animal-human parts are shown to be subsets of a holder for spirit, just as they are in actuality appliquéd onto the pear-shaped vessel. The arms, legs, and head do not interpenetrate the interior of the container, which is why each of them has to have a firing hole. The artist made no attempt to hide the firing holes and in fact did quite the opposite, drawing attention to them by making the upper-arm ones project and by creating large, oval, black-outlined leg holes with edges further

accentuated by painted radiating crescent motifs. Likewise, the mouth openings around the teeth not only are large, centrally located, and visually complex but serve as the head's firing holes. These prominent penetrations force the viewer to acknowledge that each part is hollow, lightening the body once more. To construct such a composition, the container had to be made first, then had separately constructed body parts attached to it, a more complicated and difficult procedure than at first glance. Thus the atomized body design was technically additive as well, a congruence of all levels of the artistic enterprise often found in ancient American art.

The lively and complex composition conveys decorporealization and suspension as well as the expected three types of visionary movement. Though the upper rim's floating heads are consistently oriented, most of the piece's miniature jaguar spots create a spinning motion by taking various upended and sideways positions. The two shown horizontally in figure 5.21 face downward on the proper right leg of the standing vessel (fig. 5.18), while the top two on its tail face upward (fig. 5.20); a viewer looking for consistency will not find it. The one on the proper left shoulder is oriented up, but the corresponding one on the other shoulder has its head down, creating a circular movement across the piece (fig. 5.18). Some individual jaguar spots pinwheel, their heads facing one way and their back haunches another; an example is the one at the base of the tail shown in figure 5.20. The more abstracted and fantastical versions are ambiguous as to which way they face since they do not show the full complement of body parts to clarify the situation. All the versions, but especially the less readable ones, are made up of a mass of curls and projections, encoding yet another level of spiral motion in many directions. The little white crescent filler motifs add further spinning dynamism at a subliminal level. When crescents follow a jaguar's outline, as in the one on the right in figure 5.21, it appears perceptually as if one crescent is turning in space. Further spiral subtexts occur in the rows of slightly hooked lines flanking the bands of vertical lines on the lower arms and legs, in the lower neck outline, and above and below the two rim bands. Certainly the two bold, outward-curling spiral lines in the ears restate this primary visionary motion. The Rosales

figure had spirals outlining her ears as well, perhaps both cases referencing otherworldly sounds.

Undulating movement definitely characterizes the overall silhouette of the work, especially its profile (fig. 5.19). The bulk of the wavy outline occurs where the feline is most dominant, from the projecting shoulders down. It is tempting to conclude that this reflects that the visionary undulations occur when the typical attacking and transformational content is strong. The jutting cat's mouth with its canines and intervening teeth appropriately sends the message of ferocious lunging motion in the form of deeply serrated shapes. Jaguars are indeed known to gnash and crack their teeth (Perry 1970: 25). Undulation is likewise featured in the clear, abstracted zigzag of the talons.

Both undulating and radiating motion characterize the head area, as the modeled head thrusts out of the vessel in a very aggressive outward movement that the open mouth reinforces. The three-dimensional statement is restated two-dimensionally with an explosive, expansive, radiating, undulating design painted around the neck. Its largest emanation projects downward, which serves to exaggerate the open mouth's radiating motion. The upper points are lost, perceptually speaking, under the rim bands above. Again the rim bands' horizontality plays the role of containing the more violent movement of the animal self, and so once more the vessel and the effigy aspects are placed in some ambiguous competition. I suggest that the issue of the shamanic control over visions is raised, that the knowledge and power to contain the wild animal self may be a subtext of this artistic choice to blunt the jaguar head points. The rim bands are more repetitively orderly than the rest, more cerebral one might argue, and positioned uppermost; being toward the crown of the head, they participate in that visionary area of the body where the shaman mediates supernatural messages. What they show is still the jaguar self, reduced to heads alone in a cephalocentric gesture, and other patterns that evoke visions, full of wings and dots but not adding up to a recognizable image. The rim bands are the place in the composition where the parts cohere, visually linking jaguar self, visions, and spiritual container. It is no accident that this takes place at the top, given the emphasis on the Celestial and the expansion of consciousness in shamanic trance states.

Another connective device with visionary reverberations is the use of geometric shapes to frame narrative elements. Like the patterns that precede the other types of trance imagery, in the Pataky piece more abstract and linear patterns outline the more representational content. For example, the solid lines and repeated small hooks bound the rim patterns above and below, the long point below the chin, the bottoms of the legs and arms, and around the tail. The dark areas containing geometric elements likewise surround the jaguar-human's head. Framing of jaguar elements in an otherworldly context is thus communicated at various levels. It is important to remember that geometric patterning coexists with narrative unfolding in many visions and can be seen as a frame through which the rest occurs. In any case, it is unwise to discount the geometric component of any shamanic composition, given the priority abstract patterning enjoys in altered consciousness.

Maximized color, and the hue of red in particular, have been presented as key in the visionary aesthetic as well. Here the highest possible contrast of white and black was achieved. While this may not strike us as colorful in the same sense that a polychrome palette does, presenting the extremes makes the composition about color at its essence. The darker gray in the photographs represents red in the original that accentuates the bloody gums but also frames the jaguar once more above (in parts of the lower rim band) and below (in the lines just above the talons).

Another significant multisensory aspect of this piece is its sound capacity: it contains three rattle balls that make an emphatic noise when the object is moved. The rattle balls produce "a low, grumbling rattle very evocative of the jaguar's low grunt, precisely when the vessel itself lunges forward" (Stone-Miller 2002b: 109). In fact, jaguars growl when they are hunting and near their prey, presumably in anticipation of their meal (Perry 1970: 17–18), so the noise becoming apparent when the piece is moved in an attacking motion is highly appropriate. Importantly, the sound may also relate specifically to what occurs soon after ingesting ayahuasca: the loud, driving, low-pitched sound that Grefa likens to bees buzzing or the sound of a train approaching (personal communication 2005). The sound may be frightening to a neophyte, and the louder it is, the stronger the

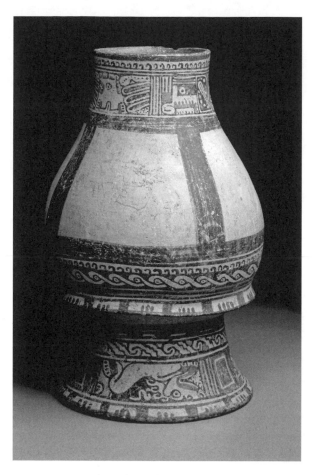

FIG. 5.37. Pear-shaped vessel with inverted jaguar on base. Costa Rica, Guanacaste-Nicoya, Pataky Polychrome, Pataky Variety, 1000–1350 CE. Michael C. Carlos Museum accession number 991.4.366. Ex coll. William C. and Carol W. Thibadeau. Photo by Michael McKelvey.

brew and the more intense the subsequent visionary revelations, as experienced shamans know. The similarity between the introductory sound of the supernatural realm and the vocalization of a jaguar specifically as it is coming toward prey makes sense analogically, since the visions bring the jaguar spirit in shamanic thought and experience. As will be elaborated in chapter 6, the physical presence in Costa Rica of *Banisteriopsis inebrians*, a close relative to *caapi*, the basic ingredient of ayahuasca, makes it possible to link this sound to this effigy. It also allows the identification of many representations of a twisted pattern as the entheogenic vine in other Pataky pieces (figs. 5.37, 5.38). These related pots include jaguar figures (inverted in 5.37 and upright in 5.38, right), and their rim-band patterns correspond to those of the

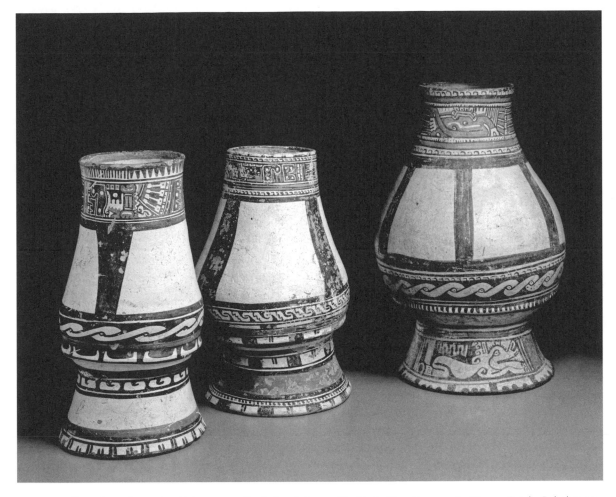

FIG. 5.38. Pear-shaped vessels with jaguar and/or heliacal vine motifs. Costa Rica, Guanacaste-Nicoya, Pataky Polychrome, Pataky Variety, 1000–1350 CE. Michael C. Carlos Museum accession numbers 1991.4.279 (left), 1991.4.557 (center), 1991.4.305 (right). Ex coll. William C. and Carol W. Thibadeau. Photo by Michael McKelvey.

jaguar-human effigy. Thus, as a group the overall set of iconographic elements includes vine referents, although they are not directly depicted in the effigy. One might reiterate that the rattling noise references the vine directly, though not by depicting it. The jaguar and the twisting vine pattern are ubiquitous and occur in concert with each other in various ancient Costa Rican styles, such as Belen and Birmania (figs. 6.1–6.7a, 6.9–6.13), as will be discussed in depth in the next chapter.

The rattle ball also reflects the visionary theme of ingestion and expulsion. The mouth ball quite literally is being consumed by the being and draws attention to this by being visible inside the mouth (fig. 5.18). It can be seen not only from the front, looking between the open canines, but from below when it rests in the hole provided for it.

The ball travels from rear to front and back again when making noise, achieving the most sound possible and iterating both ingestion and expulsion. However, since the ball cannot escape, it brings the viewer's attention to the inside, privileging what is being taken in and potentially referencing both the ability of a predator to eat prey as well as the swallowing of the entheogen that catalyzes the jaguar transformation. The inclusion of the rattle ball linking the sound the jaguar makes before pouncing and devouring prey to the sound of the entheogen before it "pounces" relates to ingestion in that then the ayahuasca begins to consume the shaman's ego. The trance situation in which the shaman feels her body also being killed and/or eaten by ferocious animals is well documented. The vision comes to mind as well

in which the visionary transformed into a feline hunter; this predatory effigy likewise stalks, ready to crush the viewer's skull (circular, like the ball itself) and insert it into its mouth. Along the same lines, the piece as vessel seeks to ingest the shaman's spirit in its inescapably wide mouth and capacious belly. Finally, the shaman might potentially drink from this vessel. Thus, on various levels the composition stresses terrestrial and spiritual ingestion. Yet the centrifugal and centripetal motions, the pouncing and the eating, are well balanced.

The general shamanic cultural interest in the internal, on that which can be only glimpsed, also comes to the fore in relation to the rattle ball. The artist had to go to significant lengths to contain the moving ball inside the head: forming the ball first, letting it dry or firing it so it would not stick to the head, building the armature of the head around it, and successfully firing this configuration that was even heavier and so even more prone to detach from the vessel. The interiority principle applies in that the head was envisioned and executed from the inside out during the creative process. In this sense the jaguar's perspective, from its body outward to that of the shaman, takes precedence, as it does throughout the composition.

There is certainly a great deal of unquestionable authority in such a capacity to annihilate both real prey and the human ego, and this remains a very threatening work. Its eyes, the only ovals and some of the only solid black areas in the composition, are suitably riveting. They are ambiguous, splitting the difference between human and jaguar eyes, playing on the visual overlap discussed earlier. The nose is somewhat ambiguous as well, though it tends toward the human. The main authority may be that of the king of the jungle, but the human shaman within claims a subtle presence throughout the dual being and thus partakes of that animal power.

In sum, these works of art from ancient Costa Rica embody the shaman in trance in different ways as the human shades into the animal self. Further along the continuum, those that follow take steps into the Beyond.

SHAMANIC EMBODIMENT IN ANCIENT COSTA RICAN ART II

TOWARD THE ANIMAL END AND BEYOND THE FLUX CONTINUUM

While by definition a continuum has no exact or separate categories, nor does shamanic expression, the animal self becomes dominant in many works of art from ancient Costa Rica. Yet it is important to observe closely the subtle signs of the human shamanic presence that remain in seemingly straightforward natural subject matter. Certain styles and objects seem to have been created to encapsulate the wild, illegible, abstract images seen in visions, thus moving beyond the continuum of human-to-animal transformation altogether.

TOWARD THE ANIMAL END OF THE FLUX CONTINUUM

BELEN DARK JAGUAR SHAMANS

Of the many unique expressions in Greater Nicoyan art, Belen Incised blackwares and related brownwares dating to 800–1350 CE stand out (Stone-Miller 2002b: 92–95). Certainly dark wares (figs. 6.1–6.7a, 6.10–6.14) were the natural choice, in terms of technique, color, and conception, to characterize what I argue was the most prestigious shamanic alter ego of all, the melanistic or "black" jaguar (fig. 5.22, left).[1] In nature, dark jaguars can appear completely black, with their texturally different spots only intermittently visible under certain light situations, or their coats may assume a shade of brown with differentiated black spots (Perry 1970: 26).[2] I argue that the Belen ceramic artists depicted the full color range of melanistic jaguars, choosing either true blackware (figs. 6.1–6.4, 6.6, 6.7, 6.10–6.14) or a close relative, brownware (fig. 6.5). Clearly "dark" jaguars, a term I am proposing to include both black and brown types, are distinguished from tawny or "light" ones in artistic representations such as the

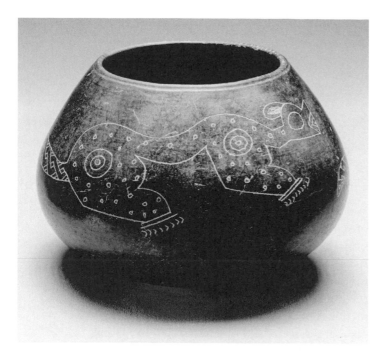

FIG. 6.1. Side of vessel featuring the body of one of two jaguars. Costa Rica, Greater Nicoya, Belen Incised, Belen Variety, 700–1350 CE. Michael C. Carlos Museum accession number 1991.4.313. Ex coll. William C. and Carol W. Thibadeau. Photo by Bruce M. White, 2008.

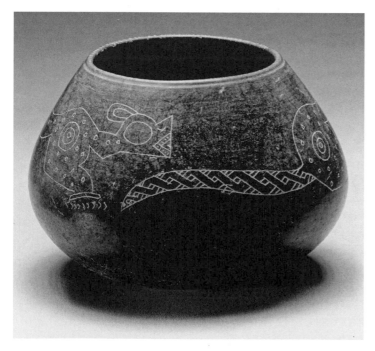

FIG. 6.2. Side of vessel in figure 6.1 featuring one jaguar's heliacal vine tail and head of other jaguar. Photo by Bruce M. White, 2008.

Pataky effigy. Significantly, in nature both black and brown animals can produce the light variety of cubs but not vice versa, so the dark jaguar could be ascribed extra transformative powers. Specifically, I think the all-black variety topped the shamanic alter ego hierarchy, being the most mysterious in nature and its characterization in blackware technique the most challenging.

Blackware is a difficult surface-decoration ceramic technique created by snuffing out the flames during firing, thus removing the oxygen and permanently depositing smoke if the pit temperature remains high enough. The darker and shinier the surface, the more successful this "reducing" fire; any lighter areas indicate oxygen contamination. It can be seen as a "negative" technique in the larger sense, that is, the opposite of all other firing techniques in which free-flowing air preserves the polychromy of slip paints. Blackware's ability to manifest ultimate darkness, the airlessness necessary to reach it, and above all the transformational, magical aspect of putting into the fire pit a white or orange pot and coming out with a black one make it ideal for encapsulating the Other Side. It is achieved "blind" in that one cannot enter the fire pit to monitor the process but only sees the successful—or more often, less than successful—result of one's external actions. Thus, the color transformation happens in the realm of the unseen; it partakes of the essential hidden quality of the Other Side. To the ceramic-literate, achieving inky blackness not only represents an admirable technical feat, but within a shamanic culture its creation also is suitably withheld and esoteric to carry visionary content. The anomalousness of negative techniques, the difficulty of producing them, and the artistic control they require reinforce their association with the shamanic enterprise.

Brownware may be produced similarly by consistently limiting, though not eliminating, the amount of oxygen circulating during the process of firing, or it can be slip-painted.[3] Controlling the oxygen to this degree and for the correct length of time represents an analogous, perhaps even more esoteric, ceramic technique requiring the same prodigious skill and goal orientation as blackware. If slip-painted, it may be seen as an imitation of such methods, getting as visually close as possible to surfaces made by negative processes.

No matter how it is created, a pot that is intentionally brown, as in other Costa Rican styles, can naturally depict an animal that is likewise brown.[4]

In the terrestrial realm the ancient peoples, like modern ones, would have experienced dark jaguars, as they are not overly rare.[5] Melanistic jaguars are found wherever jaguars roam, though more are reported today farther south in the Americas.[6] Significantly, their deep coloring does *not* result from a recessive trait, as it does in other species (Meyer 1994; Eduardo Eizirik, personal communication 2009). The scientific data do not yet exist to determine exactly how the continuum from black to brown to tan background coat comes about genetically; however, dark is either fully or partially dominant.[7] Two light parents can only produce light offspring, but dark parents may yield light or dark cubs. A light and dark parent can also create various colors of cubs. However, several factors work against seeing a light mother as often as a dark mother with multicolor litters. Since dark is dominant, there would be more dark mothers overall, especially in the past.[8] Since males and females separate after mating, ancient people would only witness the mother's color in relation to her offspring, and fewer overall genetic combinations result specifically in a light mother and multicolor cubs.

This genetic situation has several interesting ramifications: not only would ancient Costa Rican artists have seen dark ones and illustrated them, but also melanistic jaguars would seem particularly special and worthy of accurate commemoration. I suggest that while ancient peoples certainly did not share our genetic explanations, the end results visibly advantage dark jaguars: routinely seeing a black or brown jaguar mother with any color of cub would convey the impressive versatility and dominance of being melanistic. Indeed, since one to four cubs may be born at a time (Wolfe and Sleeper 1995: 97), a brown mother could be seen with both tawny and dark cubs, or even one of each of the three possibilities. In a shamanic society in which multiplicity was an important value, the dark jaguar therefore could have been seen as the more multivalent. An almost magical ability to produce something so visually different from oneself partakes in the transformational capacity honored in the shamanic way of thought. It may relate to the situation in which a

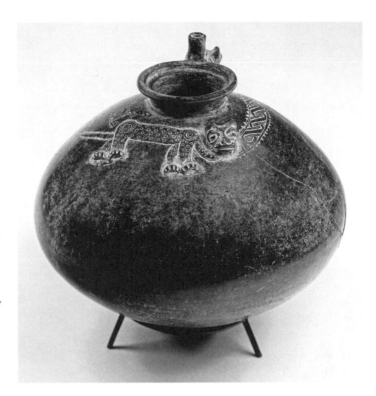

FIG. 6.3. Vessel with two jaguars, featuring the side with the incised jaguar with modeled head and paws. Costa Rica, Greater Nicoya, Belen Incised, Belen Variety, 700–1350 CE. Michael C. Carlos Museum accession number 1991.4.311. Ex coll. William C. and Carol W. Thibadeau. Photo by Bruce M. White, 2008.

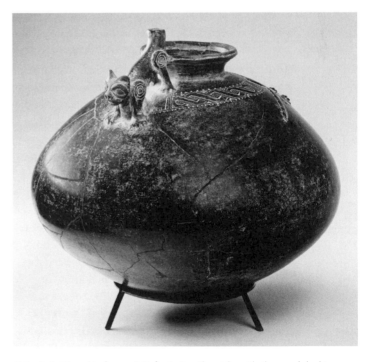

FIG. 6.4. Vessel in figure 6.3, featuring the side with the modeled jaguar. Photo by Bruce M. White, 2008.

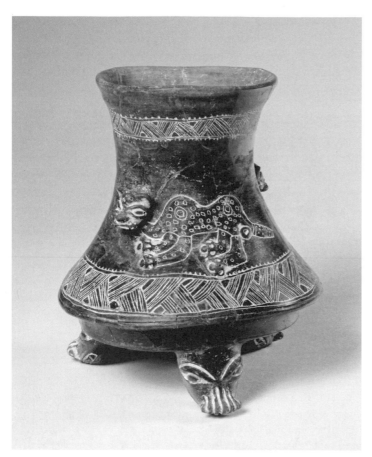

FIG. 6.5. Hourglass-shaped vessel with two jaguars. Costa Rica, Greater Nicoya, Belen Incised, Belen Variety, 700–1350 CE. Michael C. Carlos Museum accession number 1991.4.312. Ex coll. William C. and Carol W. Thibadeau. Photo by Bruce M. White, 2009.

jaguar and half with a human face and a spotted red-brown body (Wiese 2010: minute 27, cover of DVD). Native Amerindians' skin tones in ancient times would not have mimicked the tawny jaguar's light coloration but would darken with exposure to sunlight as well, approaching the black jaguar tonality.

The dark jaguar, the most shadowy of alter egos, inspires equally chimerical design choices. Another key technical aspect of black and brown Belen ceramics is the postfired-incised decoration that creates two-dimensional patterns used exclusively (figs. 6.1, 6.2, 6.14) or to complement three-dimensional modeling and appliqué (figs. 6.3–6.7, 6.10–6.13). The lines were scratched into the surface after the pot was fired, hence their lighter look; otherwise the lines would also have turned

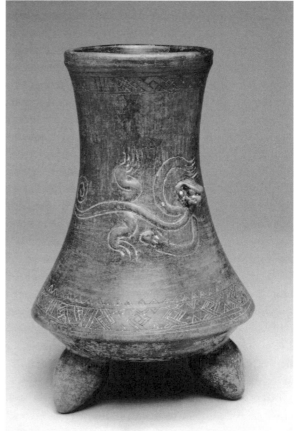

FIG. 6.6. Hourglass-shaped vessel with pinwheeling jaguar. Costa Rica, Greater Nicoya, Belen Incised, Belen Variety, 700–1350 CE. Denver Art Museum accession number 1993.548. Denver Art Museum: Collection of Frederick and Jan Mayer. Photograph © Denver Art Museum 2008. All Rights Reserved.

human parent gives birth to an anomalous baby, who then is potentially destined for the shamanic role.[9] Applying this to the realm of art, since in ceramics black and brown can be the result of a reducing fire, the idea of birthing a different-looking baby might even be seen as analogous to this "reversed" firing in which dramatic color transformations take place. The equivalence of firing ceramics and giving birth is not such a stretch: the soft and unfinished vessels go into the womblike pit and come out into the world functional and new. Childbirth and artistic creativity are and always have been natural analogies for each other.[10]

A painting by Amaringo suggested to me another way the darker jaguars naturally relate to shamans: the reddish-brown undercoat matches the skin tone of Amerindians. Amaringo shows a cross-legged shaman with half his body a tawny

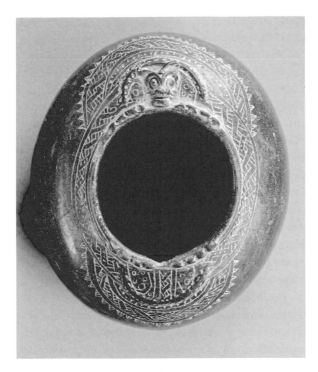

FIG. 6.7. Oval vessel with incised jaguar made of heliacal vines. Costa Rica, Greater Nicoya, Belen Incised, Belen Variety, 700–1350 CE. Michael C. Carlos Museum accession number 1991.4.315. Ex coll. William C. and Carol W. Thibadeau. Photo by Bruce M. White, 2008.

burnished is almost glassy (fig. 5.1). Burnishing consistently leaves slight marks in the surface tracing where the instrument was impressed. Postfired incisions, "since they are scratched into the hard surface of a fired pot . . . tend to be rough, with broken edges, and often made up of short scratchy strokes that do not line up smoothly. It is harder to control the line, which can veer off when a stroke achieves too much momentum" (Stone-Miller 2002b: 93). The Belen lines are not rough, indicating the artists' skill (despite rudimentary tools) as well as the achievement of a suitably fine paste to form the pot itself. Therefore, high-quality post-

dark. This linear technique is again an unusual, challenging, and "opposite" one because the vast majority of incising takes place when the clay is still moist so that the best possible line can be impressed. Moist clay moves away from the incising instrument, either compacting in the grooves or easily wiped off as it collects at the edges of marks. In polychromes, prefired lines can also appear lighter, since the artist can cut through slip paint to the different-colored paste below (figs. 5.1–5.5, 8.5–8.7). Thus, one could achieve something like the same effect as in the Belen pieces by painting a light-paste pot with black or brown slip, incising it, and firing it normally. However, the ceramic-literate can tell the difference and recognize that reduced firing and postfired incision is by far the road less traveled. Telltale features of reduced wares include the inevitable "contamination" of some oxygen that makes vaguely lighter areas and a softer, almost silky quality to the surface shine compared with burnishing. By contrast, slip covers the pot surface evenly, if high-quality and well painted, and when

FIG. 6.7A. Drawing of incised jaguar made of heliacal vines on the vessel in figure 6.7. Drawing by Nina West.

fired incision represents a premeditated choice and communicates the presence of talented artists. These technical achievements further redound to the prestige of the animal-self subject as well.

While not every design choice is a fully "reversed" one, the visual result tends to be, if not negative, then at least ambiguous. The major lines of the jaguar images may be set down in a positive way: in figures 6.1 and 6.2 the lines delineate the two cats rather than lighten the background around them. Yet the cat figures remain shadowy, since the black background of the pot outside the lines is also the black background of the cats within the lines, a "transparency" effect I will discuss later in more detail. However, other lines do reverse the figure-ground relationship: the twisted patterns that fill the tails in one piece (fig. 6.2) and connect the two felines in another (figs. 6.3, 6.4) amass parallel lines to create "grounds" that make the black twist read as "figure." Making the same light lines play different perceptual roles within the same motif (the cats' bodies versus their tails in figure 6.2) or in connected motifs (the cats versus the connecting vines in figures 6.3, 6.4) creates the back-and-forth optical flipping effect that epitomizes the shamanic visionary values of flux, dualism, inversion, and paradox. The incised circular spots in the cats almost fill in the cat's body enough to read as "figure" but still capture much of the pot's background black and so waver, appearing not quite solid, not quite perceptually separable from their surroundings.

Indeed, these creative choices express the essence of the black jaguar as an animal: it does not separate itself visually from the environment, especially at night but also in deep shadows during the day. Of all predators it is the most hidden, the most difficult to see at night when it is hunting, the time that humans see the least well and cats the best. "The color of night and daytime shadows, these nocturnal black cats are nearly invisible" (Wolfe and Sleeper 1995: 95). The black jaguar owns the night, one with the darkness. The artist, by making the cat transparent using thin, gray lines that barely demarcate it, allows it to melt into the black background and thus encapsulates how effectively the black jaguar is camouflaged. In the ceramic compositions, the transparency of the outlined body certainly decorporealizes the animal.

In fact, when prowling the night, the dark jaguar would be reduced to a growl and a disembodied set of reflecting eyes, often a stunning green. They have definitely been reported in Costa Rica and allegedly inspire great fear (Perry 1970: 20). The terror felt by humans and other prey animals would be magnified by hearing only a growl and by knowing that its capacity to move undetected between noises gives the black jaguar a crucial advantage. Although the black jaguar thus exemplifies a spiritual being of the night, during a sudden attack the ghostly presence shapeshifts into something all too real. This actual terrestrial experience may well be reflected in the many Belen examples that feature the head and claws in relief (figs. 6.3–6.5, 6.7); the aggressive parts emerge from dark potential into three-dimensional threat. Simultaneously being flat (mostly composed of lines) and rounded (with certain body parts modeled) has strong ambiguity value and communicates elegantly a being that is both spiritual/ethereal/Not Here and palpable/solid/Here, as visionary animals are to visionaries and black jaguars are in everyday reality.

In terms of color, there are further subtle meanings and potential artistic sources of inspiration regarding the animal in nature. The black jaguar's spots, barely discernible black on black, are a visual paradox since they are both there and not there, like the shaman herself. They disappear in certain lights, then reappear, and never stand out very clearly. At night the spots would not read at all, since their visibility depends on light. Perhaps reflecting this quality, one vessel (fig. 6.5) eschews spots altogether,[11] suggesting that the dark jaguar can be shown spotless, to represent the times when the spots disappear, individual animals who are especially dark, or the overall idea that they are not obviously spotted. Yet most renditions (figs. 6.1–6.4) include a shadowy, liminal type of marking, presumably since Spottedness is so central in shamanic imagery and is essentially true of the animal even when the spots are not easily perceptible. The Belen ceramic artists chose the subtlest of lighter circles on black to convey both visible and elusive spots on this cat. All the spots (except a few on figure 6.7 just outside the raised semicircles above the head and below the haunches) are open circles, like doughnuts. This choice hypothetically suggests, in retro-

spect, that the body-art seals with open circles (figs. 5.31, 5.32c) might mark one as having a black jaguar alter ego. Most spots are small, but larger concentric ones often accentuate the shoulders and hips (figs. 6.1–6.5). While actual cats do not display any larger markings there, their shoulders hunch up noticeably, especially when stalking prey, and their haunches naturally stand higher than the rest of their body, making these two joints highly prominent (Wolfe and Sleeper 1995: 94).

The most recurrent choice, an open-circle spot, claims the least possible visual presence as "figure," just as the darkness of the spot and the coat are very nearly indistinguishable in natural reality. Since the open-circle spot captures inside it the body color of the cat, just as the body of the cat captures the color of the pot, clear figure-ground relations are compromised at all levels. Furthermore, no expressive distinction is made among all these different blacks: the night, the coat, and the spot are all one black. This lack of difference, while impossible in everyday terms, shamanism embraces fully, especially when visions may convey a situation in which one's body cannot be distinguished visually from what is supposedly outside itself ("the right half of [his] body was felt to be completely continuous with the outside surroundings"). The shaman becoming one with the black jaguar alter ego, who in turn is one with the night, powerfully expresses the loss of the human self, the visible self, a process that allows the full accessing of the power of the night and the feline by that transformed being. All that is hidden and yet all that is real in that equation can be simultaneously communicated by the ambiguous artistic device of barely figuring lines within lines on a field of black.

Like the intentional indefiniteness of the all-black format, there are few ways in which these jaguars are anchored in space. The most concretely standing one is the modeled jaguar in figure 6.4, although its relation to the pot surface is not strictly naturalistic, as its feet physically melt into the pot; the holes between the toes are punched into the pot's surface. Even though the figure's three-dimensionality would seem to differentiate it from the background, this subtle detail still merges the two, as with the incised jaguars. The other black jaguars are presented at the oppo-

site extreme of being unrelated to the earth. One features incised paws with many extra toes (figs. 6.1, 6.2) that are angled forward and so refuse to engage the flat plane of the earth, which is not delineated in any case. If the cats are shown running (Stone-Miller 2002b: 94), they are in mid-stride, and thus the artist has chosen the moment with the least possible gravitational pull. Suspended, they communicate flying or running in space more than on the nonexistent ground, easily referencing the persistent reports of floating and flying during visions. In two other pieces in which the feline bodies are flat while their heads and paws are modeled (figs. 6.3 and 6.5), the projecting toes definitely flare up and out, revealing a portion of the sole. This impossible position contradicts how the actual cats walk on their toes to emphatically convey floating. Thus, accentuating the feet by modeling the toes not only highlights aggression but also profound disengagement from the regular space of this world.

On one of the hourglass vessels (fig. 6.5) below the cats is arguably a potential ground line in the form of the incised band of interlace patterns. However, the paws do not touch or overlap this band at all; at best they skim it. This veering-off from an obvious opportunity to visually anchor the jaguars is all the more telling; the choice becomes doubly apparent when narrowly avoided. The cats are shown hovering between the two bands, caught in liminality itself. The second hourglass piece (fig. 6.6) features the head projecting but the modeled limbs trailing off to incised paws; some parts are Here, others not. The body position leaves no doubt that the black jaguar is spinning, twirling, pinwheeling in an empty black space. The same kind of lower band as in figure 6.5 here remains completely distinct from the cat, placed in the land of Between.

Finally, raised bumps on the rim of the enigmatic oval vessel (fig. 6.7) represent the cat's everted toes, but the perceptual challenges of finding the other body parts and resolving them to see a cat standing on the rim in any rational way defeat whatever possible grounding the rim might have provided. The cat appears to be on its back, split into two frontal views—the foreleg and head to the top and the back legs and "tail" below (fig. 6.7a)—with its body as the vessel itself and/or the various twisted bands of patterning around the

vessel opening. However one identifies the parts, they defy the notion of a ground line in a particularly creative and complex way. Being organized around the dark and apparently empty opening, the vessel/shaman's body is ingeniously both Here and Not-Here, aptly decorporealized.

To convey even greater ineffability, the majority of these vessels' surfaces are left plain, which draws attention to the reflectivity of the blackware technique. Good blackware is not only dark but also shiny and so carries an unavoidable message of light in the darkness, another transcended paradox that virtually defines visions. Light inevitably reflects off the surfaces of these vessels, suggesting illumination in the larger sense. Reflection picks out the incisions to add a measure of definition and readability to the imagery. Again, black on black should not be confused with vague, blurry, or ill-conceived artistry but with subtleties of all sorts. Here a subtext is that with darkness and the transformative actions that take place there comes illumination.

Visionary revelations usually include seeing the essences of all things, and the overall vessel shapes chosen by the Belen artists are likewise clean, simple, and elemental. This achievement is as impressive as the skillful firing, given the difficulty of hand-coiling simple, symmetrical, thin-walled containers. There is a positive generic aspect to these shapes, as discussed in relation to the shaman's body. The essentialized shapes contrast with and set off the black jaguar selves without specifying their whereabouts; the vessel forms are cooperatively abstract and creatively ambiguous. Yet their curving outlines make a strong statement and define a black shape that would inevitably stand out in the everyday world. Thus, such compositions are dualistic juxtapositions of figures and emptiness, low-contrast color and high-contrast shape, thereby creating a strong yet minimalist message. They describe beings in a place where change occurs, a productive limbo on the Other Side, rather than a void or nothingness. The plain black expanses, mostly below the jaguars and so lifting them up in the firmament, hold space for that which is unknown, potential, and transitional. Thus, the simultaneously undefined and defined nature of these compositions underscores the shamanic dual consciousness, specifically inhabiting both night in this world where black jaguars

prowl and darkness in the other realms where shamans become their jaguar selves floating in the ether.

Other important features of the Belen pieces suggest that these jaguars are shamanic alter egos rather than simply animals, as considered previously (Stone-Miller 2002a: 94–95). The shaman as black jaguar is specifically mentioned in ethnography and related visionaries' accounts. As described earlier, Taulipang shamans in curing rituals ask for patients to "'call upon me for I am the black jaguar . . . I drive away the illness . . . It is me they have to invoke if they wish to frighten it [the illness] away'" (Saunders 1998a: 32). A very powerful *bancopuma*, or black jaguar "sorceror," tried to asphyxiate and blind the good shamans in one of Pablo Amaringo's visions (fig. 1.6). There also was the visionary who felt himself become the black jaguar "with the ability to explode into movement, leaping, running, charging." Thus, the specifically black jaguar is known as a particularly powerful shamanic alter ego in several cases.

The treatment of the eyes in Belen works once more focuses attention on the visionary truth of beings as animals, humans, or in between during trance. The eyes actually range from distinctly round, or fully animal (figs. 6.1, 6.7), to quite almond-shaped and therefore I argue human (figs. 6.3, 6.4, 6.10; in 6.5 both the cats and the ambiguous heads that serve as the tripod feet have these human eyes), to partway between animal and human (fig. 6.6). The round eyes characterize the figures that are the least visually clear, the most perceptually shadowy (figs. 6.1, 6.2) and the most ambiguously split apart (fig. 6.7). The human-eyed jaguars are those that occupy a middle ground artistically, moving back and forth between two- and three-dimensionality. The most dramatic version, the spiral-tailed jaguar (fig. 6.6), has the least defined eyes, in keeping with its wild, transitional nature in the midst of visionary freefall; yet small details like the holes for earspools and an enigmatic circular object held in the figure's "hand" clearly add the human element.

A key iconographic choice betrays the human within the apparent animal imagery: the twisted pattern found in all examples. In my previous discussion I read this as the familiar textile-based status symbols known variously as the "mat pattern" and the "twisted strand" (Stone-Miller

2002b: 94–95). The Mesoamerican intertwined motif stood for the privilege of elders and leaders to sit on mats rather than on the earth (Fash 2001: 131). In the Andes, the twisted strand encapsulated all that spinning thread, weaving, social cooperation, and joining disparate phenomena in dynamic balance imply (Frame 1986). In general such messages of high social status are undeniably central to jaguar imagery, especially given the dark jaguar as the proposed "top of the top." However, I want to add a new reading of this spiral motif as the heliacal vine or *Banisteriopsis* pattern, the all-important catalyst for the transmutation from human shaman to animal counterpart. The vine motif automatically provides another human reference since it is inevitably the shaman in human form who drinks the concoction made with it and other plant additives. When the vine and the jaguar are joined or juxtaposed, as they repeatedly are in Costa Rican art (figs. 5.35–5.38), then the sequence of transformation from human drinker to animal spirit is explicitly communicated. Many elements merge to make the vine the center of a much more complex iconographic gestalt.

It is important to reiterate that there is good physical evidence, both local and regional, for identifying the vine that serves as ayahuasca's main ingredient. *Banisteriopsis inebrians*, a botanically close relative of *B. caapi*, is definitely found in Costa Rica today, looks similar to *caapi* in its twisting and weaving appearance, and is equally potent for causing visions (Schultes and Hofmann 1992: 35, 6, 121 photo lower right, 122). The larger *caapi* twisted vine found for millennia in northern South America might well have grown in Costa Rica in ancient times and/or been traded north from those areas. Extensive interchange took place throughout the Chibchan world, connecting southern Central America, most of Colombia, and portions of Ecuador (Hoopes and Fonseca 2003). However, for present purposes it does not really matter whether the twisted pattern associated with jaguars in Costa Rican art particularly refers to the local vine or the imported one. A fairly simple double-spiral pattern, with variations but a standard visual aspect, can be seen to reference not only the vine and textiles but visionary snakes, jaguars, the two plants that make up ayahuasca, the spirals seen in trance, and even dualistic consciousness itself.

I propose that this "visionary vine complex" occurs in the Belen and other Costa Rican styles and can productively be explored as a cluster of visually and visionarily related phenomena. Many interconnections center on the plant: it looks like a heliacal spiral, a textile, a snake or snakes, and even, I will argue, like a jaguar. It causes spiraling and undulating as well as transformational visual effects in humans, including dizziness, seeing spirals and zigzags, and becoming animal selves, especially snakes and jaguars. We have noted how Amaringo depicts the two plants, *caapi* and *chacruna*, that make up ayahuasca as intertwining snake spirits (fig. 1.3). Hanging from the trees in the rainforest, the *caapi/inebrians* lianas definitely twist in various ways that relate to textiles and to arboreal snakes. In nature, thin, comparatively young vines usually undulate back and forth (Schultes and Hofmann 1992: 120 lower right). Single vines may spiral around themselves (Schultes and Raffauf 1992: 26, the thick vine behind the double one). Most often, two twist together (ibid., left), and the more mature and therefore larger and more potent the vines, the more they twist, making spiral motion and visionary power again mutually reinforcing phenomena.

Many of Amaringo's paintings, such as figure 1.3, immortalize the typical double-twisting *caapi* plant. Importantly, in nature the vine is found in large clumps whose different strands engage one another in complex, over-and-under, woven-looking compositions (Schultes and Hofmann 1992: 120 lower right). I have personally observed a particularly textile-like clump of *caapi* vines in southeastern Ecuador,[12] and similar, strikingly interwoven versions are included in Amaringo's work (Luna and Amaringo 1999: 87, lower edge, especially the lower left corner; 89, far right). Woven textiles created from multiple threads interweave, just as the groups of individual vines do. Individual threads can be single-ply (one twisted piece), like the *caapi* that twists around itself, or double-ply (two single ply threads twisted together), like the heliacal lianas.

Even more significantly for present purposes, the *interior* appearance of the vine directly relates it to textiles and, specifically, to the jaguar. The vine is composed of five or more parallel filaments inside a casing, like a telephone wire. This again makes it like spun threads, which are always

FIG. 6.8. *Banisteriopsis caapi* vine sections. Photo by Michael McQuaide, 2008.

composed of internal fibers. Yet, more unavoidably, the cross-section of the *caapi* vine looks extremely similar to a typical jaguar spot (figs. 5.23 and 6.8). When a length of vine is cut in preparation for being boiled, it becomes evident that the ends of the filaments appear as circles inside the larger circle.[13] There is a central filament-spot within a ring of spots, precisely echoing a typical jaguar's rosette. Each filament's outline is slightly irregular; it may be smaller or larger, echoing the variability within cat markings. This isomorphism would not have been missed in ancient times, especially by those who handled and processed the vine. Interestingly, the circles that look like parts of a rosette form the lighter parts of the vine's cross-section, making the plant's internal coloration reversed in relation to the actual jaguar's dark spotting. Some shamanic effigies do feature feline spots that reverse normal coloration (figs. 5.21, 8.1). Both the light-painted spots and the plant's coloration certainly express the general

inversion of the Other Side, the inside, and the shamanic enterprise as a whole.

The fact that the vine's rosette hides on the inside allies with the strong internal emphasis in shamanic art, its revelatory aspect, and the focus on essence over appearance (Stone-Miller 2002b: xxi). This internal patterning would support the Amerindian belief that everything is related and precedented; the catalytic plant manifests the shaman's feline self because it already *is* spotted. Both the plant's and the shaman's latent markings manifest from within. The vine's dots suggest an even larger conceptual category: not only Spotted Predator" but Spottedness can be seen as a fundamental quality of the Other Side, the inside, the powerfully transformative. The vine is spotted and can be shown that way artistically.

The configuration in which a spotted vine interweaves in space like a textile, transforming one into a jaguar, also encompasses the analogy between the spotted pelt of the jaguar and a tex-

tile. Examples of this connection appear in both ancient art and modern culture. Some versions of the vine patterns in Belen compositions, such as those that frame the jaguar figures in figure 6.5, seem to purposefully engage this woven look. In the same position as the more literal twisting vines and preserving their over-and-under structure, this interpretation fills the two twisting elements with multiple parallel lines and cuts off the edges so that the vine pattern resembles a close-up of a woven cloth or a basket. This is not a unique example. A Birmania-style jaguar effigy (fig. 6.9), closely related to the Pataky format, chooses an over-under woven pattern for the limbs. Discussed earlier, many carved stone jaguar effigy metates feature various twisted and interwoven diamond patterns to stand for the coat markings as well (fig. 5.36). The Galo bowl combines jaguar spots with what can be seen as a single twist, an X in which one arm is shown crossing in front of the other (fig. 5.35). This X is capable of communicating the twist of thread and that of the *caapi* vine in their most elemental and analogous form.

In looking at the animal's coat in a very essential way as well, it is fiber, hair, a material category from which textiles in general can be made. It is a colorful covering for the body (after all, we call it the animal's coat), so it serves as the cat's "clothing." Visually in jaguars' markings there are open areas of "ground" and darker ones of "figures," which could be likened to plain cloth dotted with painted or embroidered patterns. Alternatively, the dark rosettes—especially when packed densely enough—can reverse and read as ground, resembling the shadowy spaces that occur between the threads themselves in openwork techniques. In the individual felines with the strongly diamond-shaped grid of markings (fig. 5.22, right), the light background appears as linear openings on a black background and thus could read as light-colored threads on the diagonal. This perceptual inversion perhaps also helps account for the reversed color spots in the effigies mentioned earlier.

In general, the coat evokes a play of light and shadow, constituting its camouflaging effect in the jungle, which can be seen as echoing the way a loosely made basket appears, and vice versa. The crossing of fibers in such a basket makes an all-over pattern of hexagons, not unlike the array of generally circular spots. Interestingly, the modern

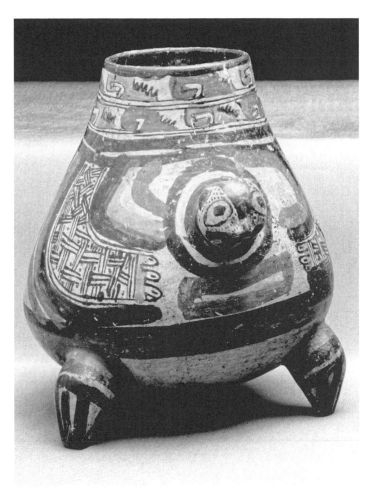

FIG. 6.9. Jaguar effigy vessel with woven pattern as spots. Costa Rica, Greater Nicoya, Birmania Polychrome, 1000–1350 CE. Michael C. Carlos Museum accession number 1991.4.552. Ex coll. William C. and Carol W. Thibadeau. Photo by Michael McKelvey.

Yaminahua, an Amazonian traditional people, call the jaguar and a certain type of openwork plant-fiber basket by the same metaphorical name. In shamanic songs, "jaguars become 'baskets' because the fibers of this particular type of loose-woven basket (*wonati*) form a pattern precisely similar to a jaguar's markings" (Townsley 2001: 270). He notes that the song-word and the referent are linked by "finely observed perceptual resemblances" (ibid.), as I am arguing for the whole iconographic gestalt of the vine complex in which spiraling forms the core characteristic.

Further relevant to the whole twisting configuration, the Yaminahua employ an intriguing term for metaphors themselves: *tsai yoshtoyoshto* or "language twisting-twisting." Townsley reports the

twisting words are associated with their ayahuasca visions and the songs that accompany them, under the logic that "'with normal words I [the shaman] would crash into things—normal words are no good—with *tsai yoshtoyoshto* I circle around things—I can see them clearly'" (1993: 460). Metaphoric circumlocutions are another way that spiral relationships are integrated into and stand for the trance experience at every possible level. This statement, that one sees things more clearly by circling around them, expresses the way visions work: out of the spinning, the multiple viewpoints, and the essentializing come revelation. That the truths revealed during visions do not appear the same as terrestrial appearances is gracefully invoked by this metaphor of circling. That the words cannot be "normal" expresses the familiar ineffability and anomalousness of trance consciousness. But their delicacy, their subtle insight, is also referenced by how regular words/percepts would "crash" into those of visionary reality.

Returning to the art in question, each Belen vessel is unique in how it visually communicates the elaborate vine configuration. Yet all the pieces relate or conflate the heliacal vine and the black jaguar in some way, several of them incorporating textile references too. The vine may be inside or outside the jaguar body or both, as well as connect, frame, or ambiguously surround one or more animals.

In the incised bowl in figures 6.1 and 6.2, the twisted vine is directly incorporated into the feline body, filling the tail completely. The over-and-under, round-and-round character of two elements in space is explicitly and carefully rendered by alternately interrupting the diagonal line segments. (Artistically, it is difficult to keep the over- and under-lapping lines even and undistorted as well as to avoid inadvertently switching their direction. In a postfired incising technique mistakes cannot be erased, either.) It is significant that the part of the design that reads as the two twisting elements is left in black. This use of negative design, proposed as a basic shamanic predilection, symbolically likens the vine to the black jaguar as well as to the whole cluster of the unknown, night, otherworldliness, ineffability, metamorphosis, and danger of predation to which the entheogenic properties of the *caapi/inebrians* open up the visionary. Furthermore, the color of the vine not only relates it to the black-on-black cats themselves (as simile), but also in this piece the black of the body is continuous with the beginning of one of the spiral tail elements, so the message of cat and vine being *one and the same* is unmistakable (as metaphor). The tail-vine flows into and out of the feline body; no distinction is made between cat formed of vine and vine that creates cat. It is tempting to call such an artistic choice "jaguar twisting-twisting."

A second way to ally the spiral vine pattern and the black jaguar is by physically connecting them. In the vessel shown in figures 6.3 and 6.4, two almost identical bands filled with the twisting vine pattern link the two jaguars. One band begins under the head of the mostly two-dimensional animal, the vine being shown as either an emanation from the animal, into it, or both. In keeping with cephalocentrism, the jaguar's head generates the vines, that is, the visions. This band ends beside the standing jaguar, its motion capped with two cross-section spirals at each corner, like the phosphene spirals but squared off. A second band begins in a bilaterally symmetrical fashion on the other side of the standing jaguar and ends by the haunches of the flat one, without touching either but linking them nonetheless. Both ends of the second band end with the squared spirals as well. The six capping spirals are shown from above, while the connecting vines are seen from the side, reminiscent of the different visual perspectives possible in trances. However, the two types are directly juxtaposed, again stating that ingesting the heliacal vine leads to seeing twisting forms.

Another important aspect of how the Belen artists present these vine patterns concerns their edges. Solidly scratched white triangles are added to create serrated outer edges on nearly every example of the visionary vine motif. Since geometric patterns in general are not neutral or decorative due to their primacy in visionary experience, I venture that artists gave the vine motif an undulating edge not only to encapsulate the undulating *caapi/inebrians* lianas in the physical world but also to refer to the perception of undulations on the Other Side caused by ingesting the plant. The zigzag is perceptually suitable since its constituent alternating diagonals create an exciting, tense, energy-filled design, easily conveying messages of life force, spiritual power, inner illumi-

nation, and any sort of dynamic energy (Arnheim 1974: 187–188). Various kinds of dynamic edges often characterize images of shamans in art from nearby Panama and Colombia (Helms 1995, Labbé 1998). I see the zigzag edge of the Pataky neck area (fig. 5.18), Potosí crocodile emanations (fig. 4.2), and elements in many other Costa Rican pieces as related.[14] In fact, the whole so-called Intermediate Area participates in this artistic choice of the dynamic, emanating edge for shamanic subjects, especially Panamanian transforming figures (Helms 1995).

It may be worth recalling the zigzag edge on many Costa Rican roller stamps and seals (figs. 5.30–5.33), suggesting that the power edge was transferred to the bodies of shamans in various ways and that the heliacal vine subtext was extremely pervasive. In some Belen pieces, likewise, the power edge may be assigned to certain body parts, such as the whiskers and eye stripes on the vessel in figure 6.10. All these Costa Rican pieces link the power edge either to the vine, to fur or whiskers (which do project out from the body and reference the shaman's animal self), or to abstract emanations from the head that embody the more fantastical visionary forms engendered by ingesting the vine. This serrated edge can help identify an element that might seem unrelated—such as the series of sideways angular S shapes along the top of the Belen head vessels (figs. 6.10–6.13)—as another abstraction of the twisted vine; indeed, Frame has called this exact pattern an essentialized "twisted strand" (1986: 69, fig. 12b).

In the hourglass Belen vessels in figures 6.5 and 6.6, the heliacal vines have power edges but appear outside the jaguars and play the role of framing devices. The vine-motif bands encircle the pieces and the jaguars, creating visual continuity and establishing the familiar type of circling visionary movement within the composition as a whole. Between the two bands, the felines are presented as in the land of the vine, the amorphous black space created by and experienced within *caapi*'s purview. Dualistic messages are elaborately nested, since vines frame the animal selves just as geometry frames narrative visions.

The geometricized vines in both pieces represent extremes of abstraction. In figure 6.5 both bands feature the close-up textile-like version tightly focused on the place where the two vines

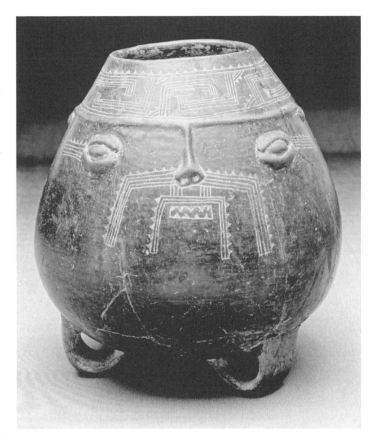

FIG. 6.10. Head vessel with feline features. Costa Rica, Greater Nicoya, Belen Incised, Belen Variety, 700–1350 CE. Michael C. Carlos Museum accession number 1991.4.562. Ex coll. William C. and Carol W. Thibadeau. Photo by Michael McKelvey.

cross. In figure 6.6 the lower framing band represents the most abstracted type of vine yet: the strand is cut into single-twist sections oriented vertically. Between the separate over-under segments small triangles are added on the inner band edge, which creates a figure-ground reversal. When the viewer shifts focus, the linear spiral elements reading as figure, in relation to the plain X areas around them as ground, give over to the plain X's reading as figure with the linear patterns reverting to ground. This active visual flux complements and restates the very energetic pose of the twisting jaguar above the band. The figure's forelegs curve one way, back legs another, and tail a third, so the body writhes as the viewer peruses it. The verticality in the vine pattern pushes the eye up toward the jaguar, while the static horizontal vine of the upper band bounces the eye back down, another zigzag visual motion. The serrated vine edge points upward, too, because it

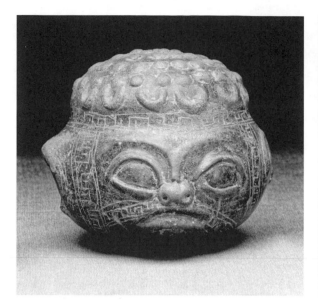

FIG. 6.11. Small head vessel with incised heliacal vine motifs (firing hole in proper right ear). Costa Rica, Greater Nicoya, Belen Incised, Belen Variety, 700–1350 CE. Michael C. Carlos Museum accession number 1991.4.328. Ex coll. William C. and Carol W. Thibadeau. Photo by Michael McKelvey.

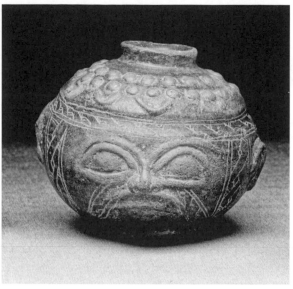

FIG. 6.12. Small head vessel with incised heliacal vine motifs (firing hole in top). Costa Rica, Greater Nicoya, Belen Incised, Belen Variety, 700–1350 CE. Michael C. Carlos Museum accession number 1991.4.369. Ex coll. William C. and Carol W. Thibadeau. Photo by Michael McKelvey.

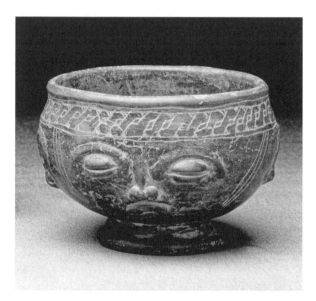

FIG. 6.13. Small head bowl with incised heliacal vine motifs. Costa Rica, Greater Nicoya, Belen Incised, Belen Variety, 700–1350 CE. Michael C. Carlos Museum accession number 1991.4.327. Ex coll. William C. and Carol W. Thibadeau. Photo by Michael McKelvey.

only appears on the upper edge of the lower band. Thus, the vine leading to the jaguar in visions applies in a novel but still direct visual sense here. A pattern found in the lower vine band, not surprisingly a spiral, is squared off and close-up, as if in cross-section (found to the viewer's left in figure 6.6, slightly to the outside of the pot from the top of the left-hand tripod leg). This is a more elaborate version of the small squared spirals that project off the ends of the vine bands in figures 6.3 and 6.4. There is a crenelated meander section in the lower band on the back of the vessel, a zigzag with squared-off points. As before, the over-under spiral, the cross-section, the serrated edge, and the zigzag constitute parts of the larger iconographic configuration and can be seen to represent different takes on the same twisting form. Just as in visions, multiple artistic iterations express the basic unity of all phenomena.

The oval vessel constitutes the most enigmatic and ambiguous yet perhaps the most integrated vine–black jaguar intersection (figs. 6.7, 6.7a). The readable heliacal vine is found throughout, with the serrated power edge included on the upper

and lower arches. The vine pattern around the vessel opening and on the arches is intermittently spotted, which clearly communicates that the spotted animal and the vine are one. Importantly, it also externalizes the interior look of the *caapi* vine: this particularly innovative artist chose an inside-out view to express the interior truth of the plant. Furthermore, the spots are rather randomly arrayed; they come and go inconsistently in the composition. This helps visually reflect the way the vine and the jaguar spirit both are fundamentally in flux; intermittent spots mimic the paradox of the shaman in jaguar self being simultaneously Here and Not-Here, as well as the unusual popping in and out of percepts in visions. It may well be relevant, too, that one does not consistently see the spots of the black jaguar; they disappear and reappear according to light conditions, just as they do on this spiral vine pattern.

Aspects of nearly all the previous strategies for incorporating the vine are included in this bowl. The visionary vine is included inside the tail, as in figure 6.2, whether one reads as tail the short, straight section between the back legs or the lower arching element. Like the connecting vine in figures 6.3 and 6.4, the *caapi/inebrians* band that circumnavigates the vessel rim in figures 6.7 and 6.7a links the other parts of the body and the composition. The nonserrated edges, like those of the straight tail section, suggest that the body is made of vine. The spots on the band further solidify the interpretation of it as jaguar body. Yet what really constitutes the jaguar's body is highly contested, since the whole vessel may be seen as such, not just the lines and appliqués around the opening. Furthermore, it is not clarified how that dual body is oriented in space. In one sense the jaguar is looked at upside down, on its back, inverted as so often is true of the shaman in transformation (fig. 5.37; Stone-Miller 2002b: 166–168, catalogue no. 393). Put another way that does not privilege the human viewer, the transformed shaman looks at the human world from below, from Elsewhere, with a different perspective as a jaguar. With parts of its body split up and arrayed around a three-dimensional open ellipse, there is no precise position in space for the transformational vine-jaguar, in keeping with the paradoxical, free-flowing spatial, corporeal, and perceptual visionary parameters. As discussed earlier, visionaries cannot exactly place percepts, often best described as "rather near but floating indefinitely in the air."

If the entheogenic liquid were put inside the container, a theory that has yet to be scientifically tested but certainly is plausible,[15] the nests of bodies proliferate: the brew would be placed first inside the inverted cat-self image/container, then inside the shaman to turn him or her "upside down" into the animal self. The nonlinearity of these various interconnections among plant, human, and animal elements is well captured in the novel conflated arrangement of the paws and belly seen from below, together with the head-on views of the front and back. Framing this complicated vine-bodied jaguar are the two serrated outer arches, like the framing in the hourglass pieces in figures 6.5 and 6.6. These vines with the power edges contain the body and enlarge it, like an energy field radiating out, like the emanations so often seen bursting from shamanic transformational imagery. This encircling vine is punctuated with spots, so it may well represent the jaguar body beyond its real one, its spiritual self, or simply spottedness as simultaneously otherworldly and worldly.

The vine complicates the design on a larger level as well. The various vines wind over and under each other in different ways. First, the uncapped straight tail seems to go on under the rim and the lower arch. Second, the circum-rim band goes under the front legs and head half and the back legs and tail half of the cat and over the beginnings and endings of the upper and lower arches, so that the arches come out from under the rim band and, in the lower part, over the tail. All this is very visually complex and spatially quite three-dimensional; the tail goes over the rim band and under the arch but elsewhere the arch goes under the rim band. However, lack of simple, terrestrial spatial relations promotes the necessary and congruent ambiguity of trance experience. It is not germane where the jaguar's body really *is* located in space; decorporealization and recorporealization mitigate against this, and the artist has obviously gone to great lengths to obfuscate spatial clarity. Yet the interactions of the different types of vines in the composition as a whole do reiterate the basic over-and-under movement

mandated by the vine's morphology. The tail can be over and under at different points if it is woven in space, undulating from closer to farther away as opposed to side to side, thus reifying in yet another creative way this important visionary type of movement.

Beyond the vine, a few additional comments on visionary aspects of these five pieces are in order. The aggressiveness of the jaguar comes out most in the incised examples in figures 6.1 and 6.2 and the related figure 6.10, which emphasize the animal's jagged teeth. Other body parts that have an aggressive cast here are the ears, which jaguars lay back when angry or on the attack, in the manner of those in figures 6.1 and 6.2; these two animals are indeed shown bounding, as jaguars do when they are on the offensive. Here the inner area has been incised to appear light; in fact, black jaguars' inner ears do look lighter due to sparser hair. The extra claws likewise add aggression to the depiction while also heightening the sense of movement and suspension, especially without any kind of ground line. They certainly recall the visionary digit-multiplying effect Klüver calls polymelia.

Movement of the predator chasing its unfortunate prey but also the speed of visions and their spinning motion are all conveyed by the way the artist has placed the running cats so that the tail of one overlaps the chin of the other, endlessly connecting the two and keeping the circle going. One is forced to turn the pot or walk around it, an action that adds actual kinesthetic spinning movement to the experience, in order to see a complete feline. In a slight variation on the shamanic location paradox, here the cat is there but not all there; it is always partly there, yet out of reach, out of sight, elusive as they are in reality and as spiritual beings. This reconfirms that normal human perception, even seeing black jaguars in a blackware rendition, is not transcendent. On a more practical note, it also communicates the very real fact that jaguars are long cats, some males as much as seven feet from nose to tail (Wolfe and Sleeper 1995: 95). The artist chose to make their images too large to fit on the side of a pot, reinforcing the animals' prodigious size. Yet one specific element implies that these giant, ferocious, bounding beasts are transformed humans: the horizontal bands above the feet. The striping of the lower legs, seen in a number of actual

jaguars, is typical in Costa Rican renditions (fig. 5.18). However, unlike any other part of the animal, these bands stretch beyond the contours of the cat's legs, becoming a subtle reference to bracelets or anklets. Such details underscore that even the most seemingly animal image maintains hints of the transformational process tying it to human shamans.

Another emphasis in shamanism is on the female presence as equal to the male. Female jaguars are delineated in the brownware piece in figure 6.5, as indicated by the oval appliquéd shapes containing an incised central line explicitly placed under the tails.[16] Exaggerated vulvae may connote that the cats are in estrus, again highlighting shamans' interrelation to fertility. In any case, with the human-shaped eyes, the brown jaguars on this piece may specifically refer to female shamans in transformation. Actual dark jaguars' ability to give birth to other colors of cubs might be another reason to single out these brown cats as particularly fertile. It is interesting that the tendency to show women as spiritual leaders extends well beyond the Rosales style in ancient Costa Rican art, as Wingfield also elucidates (2009).

In terms of closely related pieces, the Belen style features a number of the head vessel formats, also in blackware (figs. 6.10–6.13). The jaguar pieces can be seen to inform the more humanoid ones in ways not acknowledged previously (Stone-Miller 2002b: 92–93). The large almond eyes either slant up at the outer edges (fig. 6.11), slipping in the jaguar referent, or assume the wide-open (figs. 6.10, 6.12) or slit trance eye (fig. 6.13). Thus, they are all in a trance state and accessing their black jaguar animal selves. Flat noses with punched nostrils are more feline than strictly human as well.

The heliacal vine pattern in its various guises appears prominently on their foreheads as a series of slanted curvilinear or rectilinear S's. One example includes the familiar serrations or "power edge" toward the top (fig. 6.10). This head has power-edged lines throughout, its serrated whiskers framing the mouth baring zigzag cat teeth. Whiskers emanate from actual jaguars' heads, and here the analogy has been made with the life force, brilliance, and power of the shaman that pours out from the body via the visionary vine. Power bands come out from the eyes as well,

seemingly linking the cat's eye whiskers and the visions as interchangeable emanations.[17] On two of the head vessels (figs. 6.11, 6.12) the abstracted heliacal vine forms the whiskers and runs down the cheeks, aptly forming a vine frame for the liminal human-animal face. Even more succinctly, a double-chambered Belen vessel (fig. 6.14) has an incised zigzag on the strap handle, perhaps extreme shorthand for the vine brew. Double vessels are not very common in Costa Rican art, though they are in the Colombian Tairona tradition to the south, which influenced a number of isthmian styles (Labbé 1986: 187–189; Stone-Miller 2002b: 110–112, 126–127). The creator of this understated Belen piece may have chosen to feature an exotic type of doubling but one that generally relates to the repetition of two jaguars in other compositions, the two vines twisting together, and perhaps dual consciousness itself.

In sum, these pots can extend the transformational, full-body, black jaguar imagery into the purely cephalocentric, reducing the shamanic figure to a human/cat head with vine patterns or even to just a *caapi*-zigzag on a dual container. Understanding the entire iconographic configuration elucidates how seemingly disparate compositions interrelate and convey the visionary aesthetic even as abstraction becomes extreme.

CHIRIQUIAN GOLD MULTI-ANIMAL PENDANT

On the animal end of the continuum a final work of art, this time in gold, conflates jaguar, crocodile, bird, snake, and a hint of human in a single but tellingly multiple being (figs. 6.15, 6.16). It is important to include nonceramic objects in this discussion, since the Costa Rican corpus includes many media. Metalworking was highly developed here in ancient times, hence the name "Rich Coast" given by the invading Spanish. This remarkable pendant is now held at the Phoebe Hearst Museum of Anthropology at the University of California at Berkeley (accession number 3–27771) and represents the southern area known as Greater Chiriquí, which spans southern Costa Rica and western Panama. While dating gold is problematic, it likely was made between 700 and 1500 CE.

Goldwork functioned most often as "personal

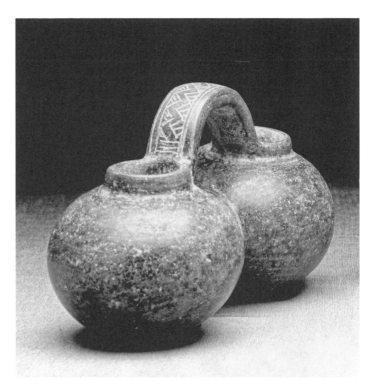

FIG. 6.14. Double vessel with zigzag pattern. Costa Rica, Greater Nicoya, Belen Incised, Belen Variety, 700–1350 CE. Michael C. Carlos Museum accession number 1991.4.314. Ex coll. William C. and Carol W. Thibadeau. Photo by Michael McKelvey.

adornment" in the ancient Americas and especially Central America (Helms 1981, Lechtman 1984). The full implications of this have not really been plumbed; it is taken usually as a simple statement of the functionality, small scale, and wearability of most high-status objects. The terms "adornment" and especially "jewelry" place pendants such as this one in a decorative, usually female, wealth-oriented Western cultural category and thereby distort the original spiritual role, the male pattern of wear, and the high status but not monetary value aspects. I argue that this pendant embodies a shamanic alter ego, manifesting the animal spirits that assist with healing, and its "personal" aspects go deep into the heart of the boundaryless shamanic multiple Self.

A material-culture approach, in which analysis of the actual sensory interaction with the work of art, reveals more information about its deeper symbolic functioning and reminds us that pendants directly touch the body, becoming a part of it in a way that containers may only secondarily when picked up and held. Being in direct relationship

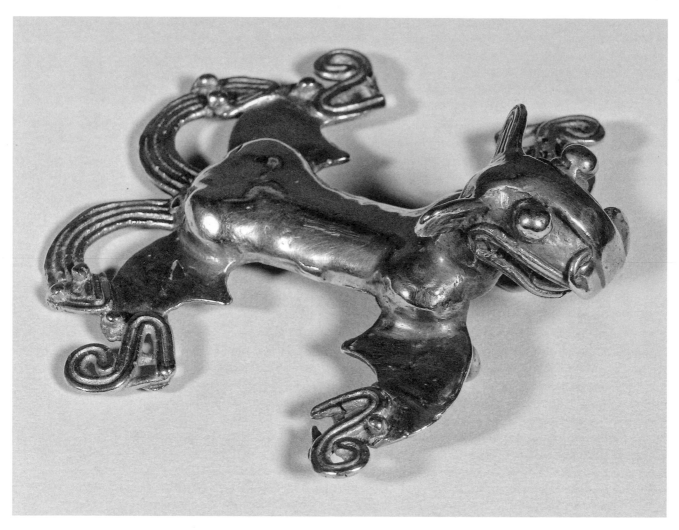

FIG. 6.15. Side view of gold pendant with jaguar, bird, and crocodile elements. Costa Rica/Panama, Veraguas-Gran Chiriquí, 700–1520 CE. Courtesy of Phoebe A. Hearst Museum of Anthropology and the Regents of the University of California, Photography by Alicja Egbert (Catalogue No. 3–27771).

with the human body, a gold necklace ornament "inhabits" the shaman more than do the ceramic effigies as external spiritual container doubles into which a shaman projects himself. A pendant such as this one was situated over the center chest; it is tempting to relate this positioning to the modern Amazonian conviction that animal selves reside in just this part of the body. Such a gold image of animal selves could be seen as manifesting from inside the shaman's chest as much as being placed externally upon it. The internalism of shamanic art and belief acts in favor of such an interpretation, as does Lechtman's concept of the technology of essence based on depletion gilding in ancient American metalwork (1984). Her research stressed that depletion-gilded metal, containing a

hidden core of alloys but only gold on the surface, expressed a deeper cultural value placed on the internal manifesting outwardly. Saunders added the important point that shamanic cultures favor the reflective materials because "these objects held an inner sacredness displayed as shiny surfaces" (2003: 16). In any case, the image and the wearer are united in a fundamental physical relationship.

The visual relationship between pendant and wearer is also an intimate one because of how the artist chose to position and hang the animal's body. According to the loop on the back, the animal was oriented with its head up and its back out, which situates it chest to chest with the wearer and in a vertical human pose like him, another human subtext in a predominantly ani-

mal conglomeration. This position has several symbolic ramifications. First, cephalocentrism is again important in that the gold and the human heads take similar positions and there are two of them, creating the familiar double-headed visionary staple. The lower one draws attention to the upper one by looking at it. Second, the animal gazing up at the human face (as recreated in figure 5.16) establishes it as a helper, aptly expressing the animal spirit role. Furthermore, when the wearer looks down at the piece they become mirror images of each other. Not surprisingly, the eyes are the link, and it is the eyes that bear the most sensory load in visions and the heaviest symbolic role in shamanic effigies. Third, in this position the audience becomes less important than the wearer interacting with the piece. The animal turns its back on other people to some degree, just as the audience may be excluded in quite a lot of shamanic art as well as during modern healing rituals. Seeing the work of art or ceremony under normal conditions is precluded because visionary seeing is elevated and happens to the shaman, as in general esoteric knowledge limits access to the initiated. It is not being outwardly seen that allows

the shaman to access healing powers but activating the essential relationship to internalized animal powers manifested externally. The artistic choices support a viewer's understanding that the pendant mirrors the person but also becomes another form the human shape-shifter can assume.

Yet, finally, the animal self stands on the person's chest as if the human body were its territory, its natural context, which one could argue privileges the golden animal self over the wearer. Shamans take on animal powers because those are considered superior to normal human ones, so it makes sense to posit an alter ego colonizing its wearer. This mutual gaze, helpfulness, and possessive stance are therefore not those of a lesser being but represent the benevolence of a more powerful one, exactly how animal spirits give shamans greater abilities from the animal and supernatural realms.

How the four animals and the human element are integrated into a gestalt demonstrates the unrelenting creativity of the artist representing shamanic recorporealization as being in flux. Despite being worn with the head up, the overall format is four legs splayed outward, that of an

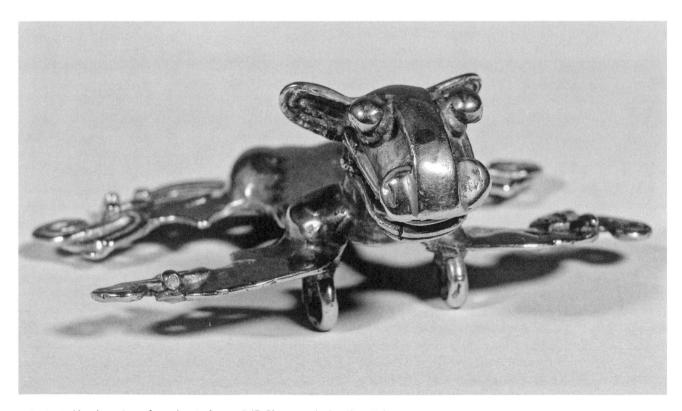

FIG. 6.16. Head-on view of pendant in figure 6.15. Photography by Alicja Egbert.

animal. The figure is thus horizontal and vertical simultaneously, a fittingly paradoxical position for an alter ego. Yet in this vertical position one notices a rather humanlike torso with rounded elements that read as either shoulders or breasts, a tapered "waist," and swelling hips and buttocks. Most other Costa Rican styles showing three-dimensional felines choose a cylindrical shape for the body. Knowing it was almost certainly worn by a man (Hoopes and Fonseca 2003: 49; frontispiece) does not negate the possibly feminine look of this interpretation. The male shaman who has female spirit teachers and wives is well documented in current times (among others, Stone 2007b: 8, 11); the overall balance of the masculine and feminine in shamanism as a whole allows this gendered reading. The two snakes issuing from the end, while their dominant interpretation would be of the jaguar tail(s), could represent menstrual blood, amniotic fluid, and/or afterbirth issuing from the birth canal. Needless to say, an actual jaguar's tail is single, while streams of liquids are almost always shown flaring outward and often are given snakes' heads in other gold animal images from Costa Rica (fig. 6.17). Fertility as a major shamanic preoccupation and duty allows both the feminine torso shape and the emanations to participate in the human aspect of the image.

Be that as it may, the overall position with four legs splayed out to the sides is likely to reference a reptile, such as a crocodilian, which in Costa Rica would be a caiman. Jaguars, of course, have four legs, but the more mimetic versions have them standing with the legs correctly attached under the torso, not out to the sides of it. Caiman walk and swim in this exact position, and the fact that each of the legs ends in an abstracted crocodile head with the diagnostic snout curl increases the association. Certainly the splayed legs make them flatter and thus wearing the pendant on the chest more comfortable; however, four-legged animal beads in the standing position are also well known, making splayed legs less of a practical and more of a symbolic choice (Bray 1981: plates 87, 88).

Other animals are integrated into the overall caiman format. The avian is subtly factored into the equation, according to the definite wing shape of the legs, flat and curving with a scallop on the inner edge, as seen in the ubiquitous vulture pendants (fig. 6.18). With four wings, the being not

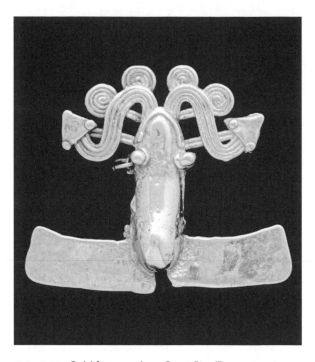

FIG. 6.17. Gold frog pendant. Costa Rica/Panama, Veraguas-Gran Chiriquí, 700–1520 CE. Michael C. Carlos Museum accession number 1991.4.244. Ex coll. William C. and Carol W. Thibadeau. Photo by Michael McKelvey.

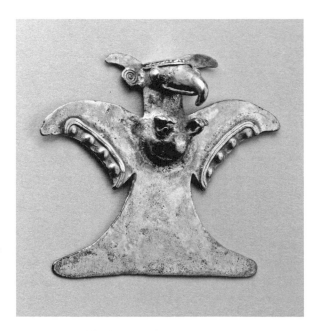

FIG. 6.18. Gold vulture pendant. Costa Rica/Panama, Veraguas-Gran Chiriquí, 700–1520 CE. Michael C. Carlos Museum accession number 1991.4.240. Ex coll. William C. and Carol W. Thibadeau. Photo by Bruce M. White, 2006.

so much stands on the wearer's chest as flies or hovers over it, as well as paddles like a crocodilian. The head is that of a cat, and despite the lack of any indications of spotting, there is no reason to assume it is not the jaguar, the top, often golden-coated feline. The ears are rounded and the canines crossed, and the eyes take the proper round shape, all of which points to the jaguar identification as generally sound. The two snakes erupting from the end of the torso, besides potentially representing female blood and birth and essentializing the cat's tail, form a double-headed snake, the Vision Serpent, with delineated triangular heads and eyes on each. They bite the two back legs near the caiman heads, circling the visual energy back to the rest of the composition and the jaguar head and indirectly up to the wearer's head.

With seven heads altogether in this composition there is quite a cephalocentric emphasis from the outset. The caiman heads at the ends of the leg-wings stand for four whole animals whose bodies are not really present except in the overall figure's pose. They are oriented in four directions, while the snake heads face two diagonals, and the cat head is on the vertical, so that the spinning, flipping, changing directionality of trance animals is captured. In a seamless and dynamic manner, this inventive and elaborate artistic statement incorporates a great deal of concentrated visionary animal-self power.

BEYOND THE CONTINUUM: CARRILLO AND ALTIPLANO ABSTRACTIONS

Since art in this area has never been strictly tied to a mimetic mode and shamanic aesthetics avoids limiting itself to depicting the terrestrial in any case, images are free to move away from appearances and surfaces toward essences and parts. They may even approach encapsulating "pure" visual movement itself. Trance reality highlights geometry and color as well as inexplicable percepts arrayed in a fast-paced, dynamically moving fashion, leaving much room for deep levels of abstraction and the celebration of illegibly fantastical shamanic embodiment. The animal self may be markedly more abstract than the human side of a shaman figure, as in a Carrillo-style head vessel (figs. 6.19–6.22; Carlos Museum accession

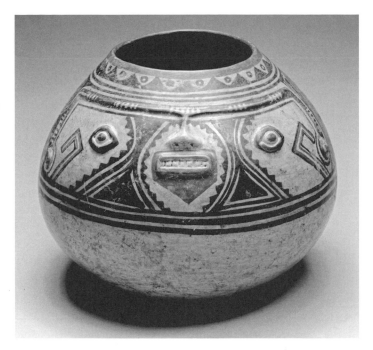

FIG. 6.19. Front view of head and abstract jaguar animal-self vessel featuring the human face. Costa Rica, Greater Nicoya, Carrillo Polychrome, 500–800 CE. Michael C. Carlos Museum accession number 1991.4.32. Ex coll. William C. and Carol W. Thibadeau. Photo by Bruce M. White, 2008.

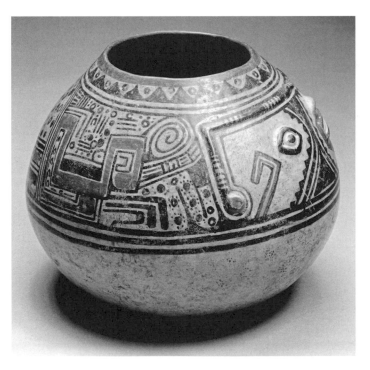

FIG. 6.20. Side of vessel in figure 6.19 featuring jaguar head portion. Photo by Bruce M. White, 2008.

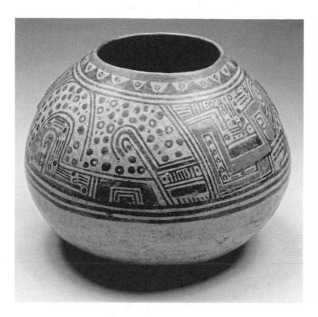

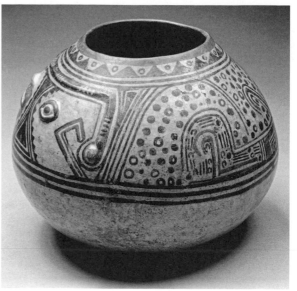

FIG. 6.21. Back of vessel in figure 6.19 featuring jaguar body portion. Photo by Bruce M. White, 2008.

FIG. 6.22. Back of vessel in figure 6.19 featuring jaguar haunches portion. Photo by Bruce M. White, 2008.

no. 1991.4.32; Stone-Miller 2002b: 84–85). The face side depicts predominantly human features arranged in a normal fashion. By contrast, the alter-ego jaguar side is a mass of spots, some red forms, and a recognizable curved haunch but has no discernible tail or eye. Yet, even without the full complement of parts and normal bodily interrelations, it nonetheless remains obviously a jaguar or at least a spotted feline. This piece communicates that the Other Side (of the pot, the being, and the cosmos) is beyond coherence; it does not have to "make sense" to encompass animal-self power. As we saw, the Pataky effigy's mini-jaguar spots likewise veer into a series of curly shapes but still convey the essence of their subject. The Belen radically simplified heliacal vine motifs encompass the essence in a less florid way. Thus, there can be both proliferation and reduction and combinations of the two tendencies in this abstract fantastical mode.

Having been steeped in the many versions of the jaguar self, another Carrillo bowl (fig. 6.23; Lowe Art Museum accession number 72.16.24) makes the cat if not apparent, then at least identifiable. Being spotted helps, and the diagnostic curve of the haunch, here with a spiral end, provides the most essential bodily shape. Whether the large arc is the back, the tail, or both is not necessary to have clarified. The squared-off shape

to the viewer's right stands for the mouth, like that of the Carrillo-head jaguar self; in the original it is red, as jaguar mouth depictions tend to be. In other pieces, such as a diminutive Galo cup (fig. 6.24), there remain only a few spots, arching curves, and spirals, yet the bits and pieces of the jaguar can be gleaned from the apparent visual wreckage. Thus, the jaguar lurks, appropriately enough, in many compositions, camouflaged by extreme abstraction and thus achieving the properly paradoxical Here and Not-Here simultaneity often desired in shamanic imagery.

One final style includes an animal self very different from the ubiquitous jaguar and ultimately explores almost total lack of an identifiable referent in characterizations of trance experience. In the colorful and intriguing Altiplano style of the far northern reaches of Costa Rica, compositions include a crab-person and strange torsos of unidentifiable beings (fig. 4.5) as well as forms that shade into the truly ineffable (fig. 6.25). Previously calling the bizarre , two-headed torsos "shamanic beings" and noting the crab's huge head and staring eyes (Stone-Miller 2002b: 98–99), now I would extend interpretation to include the themes of cephalocentrism and the trance gaze. The rare frontal, foreshortened perspective chosen for the crab is clearly a human pose, suggesting that the figure is in fact a crab-transformed shamanic self.

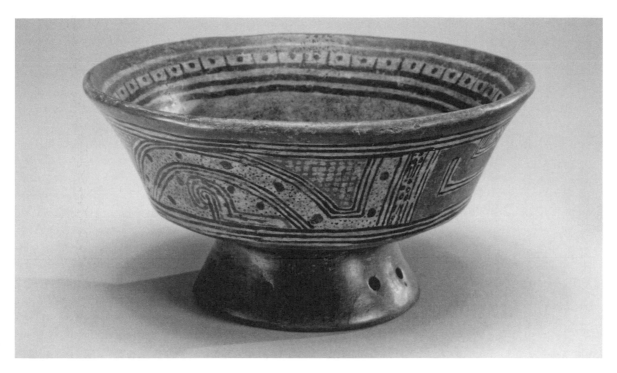

FIG. 6.23. Abstract jaguar-motif bowl. Costa Rica, Guanacaste-Nicoya, Carrillo Polychrome. 500–800 CE. Lowe Art Museum accession number 72.16.24. Gift of Seymour Rosenberg. Photograph by Tim McAfee, copyright 2007 Lowe Art Museum, University of Miami.

FIG. 6.24. Small beaker with abstract jaguar motif. Costa Rica, Greater Nicoya, Galo Polychrome, Jaguar Variety, 500–800 CE. Michael C. Carlos Museum accession number 1991.4.256. Ex coll. William C. and Carol W. Thibadeau. Photo by Michael McKelvey.

The undulating line coming up from the crown of its head and radiating out in the outer bands forcefully and directly encodes visionary movement, while the stepped frets around the edge can be seen as yet another way to show the spiraling vine. Thus, here geometrical pattern frames the transformative figures, as it does in visionary experiences. The whole composition is that of a spinning, changing, and highly distinctive crab-shaman in trance.

Other Altiplano works of art, such as the lower-left one in figure 6.25, push the two-headed shaman torsos several steps further toward atomized explosions of forms. There is a serrated power-band rim, spiral vine inner band, and head with serrated emanations, large central eyes, and spiraling elements. The familiar rotational movement, the familiar pinwheel effect, is epitomized in the circles, lines, and dashes of the lower right piece in figure 6.25: "an almost disorienting array of forms, a nearly hallucinatory visual experience. This may not be too far off the mark . . . many designs become waving arms, eyes, and swirls that no longer add up to a figure at all" (Stone-Miller 2002b: 99). The dots can be eyes and/or jaguar

FIG. 6.25. Vessels with ineffable visionary motifs. Costa Rica, Greater Nicoya, Altiplano Polychrome, 800–1350 CE. Michael C. Carlos Museum accession numbers 1991.4.275 (top), 1965.66.1 (lower left), 1991.4.547 (lower right). Ex coll. William C. and Carol W. Thibadeau. Photo by Michael McKelvey.

spots, the hook shapes snakes, arms, and/or wings; at this level of abstraction there is no real concern with identifiability, in keeping with the basic character of the visionary state. Here the viewer is drawn into the maelstrom, dizzied on purpose, and so the work of art induces the state that inspired its creation in the first place. The shamanic artist has taken us along for the ride off the end of the aesthetic continuum into almost purely creative ambiguity, just as the vision takes its par-

ticipants well beyond terrestrial limitations to the freefalling Other Side.

We now turn to the Central Andean case studies, which share with the Costa Rican many important elements of the visionary themes yet focus on anomalous bodies and betray an abiding interest in the extremes of the human-animal transformative continuum. Naturally, the styles and interpretations differ in key ways as well, as will be discussed in the conclusion.

SHAMANIC EMBODIMENT IN ANCIENT CENTRAL ANDEAN ART I

TOWARD THE HUMAN END AND THE BALANCE POINT OF THE FLUX CONTINUUM

In the case of the Central Andes, works of art again will represent first the more human end of the spectrum and then points of balance between human and animal. In the next chapter I will explore the more animal end and beyond the continuum into abstraction, as well as the overtly visionary.

TOWARD THE HUMAN END OF THE FLUX CONTINUUM

NASCA ECSTATIC SHAMAN

In a few cases, classes of figures have been identified as shamans in trance; for instance, Paul and Turpin introduced the "ecstatic shaman" theme in Paracas textiles (1986). Unfortunately, little productive generalizing from these insights has since occurred, the idea being rarely applied outside the fiber medium. However, this early Nasca vessel (figs. 7.1, 7.2) in the Phoebe Hearst Museum of Anthropology at the University of California at Berkeley (accession number 4–8705) represents the ecstatic shaman in a clear and human-centered mode of depiction.[1] This vessel was obviously a prestigious image and object, having been repaired in ancient times by drilling holes to lace it back together (fig. 7.1). Its unusual, enigmatic, black and white linear background in particular merits decoding in relation to the trance experience. Other artistic choices relating to the shamanic body are also significant, especially the navel-eye.

The correspondence between the figures on this container and the many Paracas embroidered ecstatic shamans is overt (Stone-Miller 2002a: 62, illustrations 46, 47).[2] In both Nasca and Paracas examples, as Paul and Turpin describe,

FIG. 7.1. Side of ecstatic shaman vessel featuring break and ancient holes for repair. Central Andes, Nasca, 1–500 CE. Courtesy of Phoebe A. Hearst Museum of Anthropology and the Regents of the University of California, Photography by Alicja Egbert (Catalogue No. 4-8705).

FIG. 7.2. Side of vessel in figure 7.1 without break. Photography by Alicja Egbert.

the human body is arched sharply backward as though doing a back bend. The head is thrown back, and the arms stretch out to the sides or up into the air. Long strands of unbound hair flow like streamers from the inverted or tilted head . . . All of the figures wear a skirt and most have a nude torso . . . [Many] images clearly show the torso with skeletonized ribs; others have unusual geometric markings or protuberances from the chest, analogous to the skeletonized ribs. (1986: 21–22)

The figures may be oriented in any direction in the textile versions, and Paul and Turpin interpret this bent-back pose as indicative of magical flight, achieved by dancing, flying, and then falling back to earth (ibid.: 24). They consider that the figures' unbound hair further conveys flying and note that the Spanish reported it as characteristic of Inka shamans. The visible ribs Paul and Turpin relate to the shamanic death and rebirth initiation. Sawyer, also noting the skeletal quality, had identified similar images as corpses in water (1962: 155). However, to me the wide-open trance eye and other shamanic indicators suggest otherwise. The black and white linear background seems purposely less specific than water, and elsewhere the Nasca artists used a bluish-gray slip-paint color and curving, wavy lines and shapes that could have clarified watery iconography.

The bent-back pose central to Paul and Turpin's identification can be further explored. Because it contrasts with the other Paracas figures whose "posture is more static and sedate" (1986: 22), this pose encodes anomalousness. Besides conveying how shamans' physical bodies dance, fly, and return to earth, the bent-back pose's multiple orientations make the figure appear to turn in space. The feet avoid encountering a solid ground line or assuming a standing position, aptly defying gravity but specifically creating a sense of the shaman revolving, as experienced in visions. As opposed to a textile, a flexible object that can be turned to view figures in various ways, a ceramic vessel is a more unidirectional composition. This one clearly demonstrates that the shaman is not fettered by "normal" physical constraints: the feet are definitely "up" here in relation to the pot's unequivocal base. Outlined toes and white toenails ensure that viewers notice the inverted feet, showing that the figure cannot stand.

Because there are two figures on the pot, they spin around the vessel as a whole. In symmetry terminology they are rotated in relation to each other, the rotation point being the vessel opening. If they represent the same figure seen twice, and they are nearly identical, the composition even more emphatically communicates the shaman turning in multiple directions, that is, each around its own axis and both around the pot. Doubling is typical in shamanic art as a whole, stressing duality and celebrating the apparent paradox of the same being located in two places at once. Even if meant to be two shamans, their similarity downplays each figure as a singular individual, in keeping with the ego-dissolved state of a shamanic trance experience. It may well encapsulate all these at once, given the "embarrassed categories" that shamanic expressions embrace.

Such egoless bodies are shown as extremely flexible, corporeally different from the typical human vertical alignment, loosely bridging realities, and ready for anything the spirit world produces. This supple, multidirectional body also more closely resembles how animals curl, flex, and bend. Snakes are particularly flexible, and cats' skeletons are more elastic than those of humans. In fact, "an extremely flexible spine enables a cat to turn and twist in pursuit of prey, arch its back in a half circle, move its legs laterally in sideswipes, and change direction in midair through hip rotation" (Wolfe and Sleeper 1995: 9). Thus, it may be more productive to refer to the shaman's back bend as embodying, among other things, the half-circle arch of a feline. The figure's entire body undulates, one of the main visionary motions, from the ends of the hair to the toes in one direction and across the bent arms in the other, reminiscent of the pinwheeling jaguar in figure 6.6. Furthermore, being nearly nude, the shaman here is shown as less fully participating in human society, given the Paracas-Nasca cultures' notoriously extravagant layered dress, both in life and in death (Paul 1990). The shaman's animal self may be implied as well, since animals obviously are not dressed. The turned-out feet and arms help move the human toward a more four-legged, reptilian being. There may even be a hidden reading of the torso as a fish or shark, given the sideways eye for the navel and the gill-like ribs.

The body is not only stripped and animal-

ized but also dematerialized and rematerialized in several ways relatable to the visionary experience. The prominently drawn ribs pare the shamanic body down to "bare bones." While Paul and Turpin concentrate on the death symbolism, visible ribs can denote emaciation and fasting, a potential reference to this common method of achieving visions (Eliade 1964: 84, 129). In this vessel's figures, the three rib chevrons direct viewers' attention toward the head, reflecting cephalocentrism and concomitantly deemphasizing the body. Connected to the rib line, the wide-open navel-eye is shaped exactly like the face's bulging trance eyes, which makes the torso into another, albeit minimalist, head. Thus, familiar shamanic two-headedness and decorporealization appear in a novel fashion. A stomach that can see could symbolize, like the ribs, that fasting can lead to visions.[3] Furthermore, viewers seeking to identify with the figures' normally positioned eyes must rotate their heads between the navel eye and the main eyes, and so experience yet another spinning motion encoded in their own and the shamans' bodies. Certainly the three eyes oriented in different ways on the same body bring to mind the many perspectives taken on perceptual phenomena in visions. In the way the artist has positioned the various eyes, for the viewer the navel-eye appears upright and the main eyes sideways, another disorienting choice giving precedence to the extraordinary "body vision." Moreover, this body-eye could signal visionary synaesthesia, the visual and tactile modes overlapping, for the only usual sensory function in the torso is touch. In the realm of synaesthesia, visual-as-tactile is an unusual type, the visual-as-aural interchange being more typical (Paulesu et al. 1995: 661), but it does exist.

Yet for the shaman to "see with the navel" has further possible ramifications. Since the umbilical cord connects the generations, a navel-eye could connote prescience and divinatory power, the ability to see future and past. Shamanic ability to predict births and to facilitate and disrupt fertility could be a subtext. Usually the navel is accentuated on a female figure, since it functions to unite mothers with fetuses and visibly everts during advanced pregnancy, but here the loincloth and lack of delineated nipples signal maleness. Thus, the elaborated navel may be a gender-crossing

element, in keeping with shamanic emphasis on androgyny. For a man to see with his navel could signal a feminine type of vision, even seeing with the eyes, or help, of female spirits during visions. It may be relevant that at least one modern shamanic culture, the Guajiro, associate sight, the abdomen, and the feminine:

> Sometimes the role assigned to tobacco [an entheogen] the first time it is taken is one that facilitates a dilation comparable to the experience of the body of a woman in childbirth. It is the "bringing into sight" of something that, until then, was hidden in the abdomen of the new shaman, but that originally comes from somewhere else, from the other world. (Perrin 1992: 112)[4]

The artist has connected the navel-eye to other body parts through the line running down the torso. In an already emaciated body, this line further subdivides it to lessen its visual bulk, similar to the Rosales figure's lower legs (fig. 5.1). This subdivision represents another dematerialization of the body, here directly associated with a visionary eye. The line guides the viewer to notice both the figure's upended feet and turned head, accentuating once more the overall undulating rotation of the body in space. This yet again underscores that visions, represented by the body-eye, make the spinning occur.

Other body parts are likewise presented in an unusual manner. The lack of any fingers on the hands is out of the ordinary in this style and contrasts with the three prominent toes (although in both instances it is typical of ancient American art not to include all five digits). The hooked hands may be abstracted to curve toward the head, focusing attention on and framing it. The heads themselves are markedly oversized, per the familiar cephalocentrism. The artist's placement of a huge head in the center of each vessel side crowds the rest of the body into a small space, making the body again less important. The obvious cleft in the fontanel, found in many ancient American styles with shamanic overtones, may relate to the fontanel as the spirit entrance/exit point and to the creased forehead of the aggressive jaguar spirit-self.

Long, black, flaring hair streams out of the top of the head, forming one of the most visually

salient elements in the composition. The head and hair together make up two-thirds of each vessel side, strengthening their message. The hair emanates out, projecting in a radial arrangement, and each strand is likewise an expanding trapezoid, hence well representing the free-flying, knowledgeable, and boundaryless shaman in a trance state. Since the bars of hair take precedence over the background lines, which do not continue behind them, viewers follow their stream, unimpeded beyond the shaman's head, out into the Beyond. However, they replace and resemble an enlarged group of background lines, and so suggest the ego-dissolving shaman becoming one with the universe. Being placed on the diagonal, their visual role is suitably dynamic and oriented upward. Looking at the vessel from above, the hair follows the curve of the pot itself and reinforces the two figures' pinwheel motion. Almost like the lines that cartoonists use to symbolize rapid movement, the hairs flare out as if the shaman were indeed zooming past.

The wide-open facial features, located dead center of each side, are made doubly important. The addition of eyebrows further accentuates the huge trance eyes. Not a "smile" (Paul and Turpin 1986: 23), the mouth opens to bare teeth and imitates the facial contortions engendered by some entheogens, indicating the presence of a ferocious spirit animal. Dots on the cheeks reinforce the facial features being drawn in a grimace. Visible teeth and cheek indentions are unusual in the Nasca corpus, and their innovative inclusion here reinforces the special status and underlying animal state of the shaman.

However, the vessel's background perhaps ranks as its most significant and novel feature, an irregular linear mass unlike the more naturalistic, regularly patterned, or plain backgrounds found elsewhere in Nasca art. It comes across as nearly chaotic groups of lines running over and under each other in different angled segments. Moche art also features purposefully chaotic arrangements to denote visionary experience (figs. 8.10–8.17). This nonrational space includes not only the sudden, unexplained absence of lines behind the hair strands, between the legs, and outside the lower arm, but also groups of lines that disappear behind the body and fail to reemerge along the expected trajectories on the other side. Thus, the artist suc-

cessfully foils the human perceptual desire for simplicity and continuity, effectively subverting any clear figure and ground relationship. Although the figure seems definite, its solidly colored areas securely outlined in black, the ground is only loosely delineated by groups of lines not close enough together to maintain visual unity. Therefore, the ground continually switches direction and falls away into nothingness. Yet the viewer's desire remains strong for the lines to continue underneath, so one perceptual resolution is to infer that they change direction where they cannot be seen behind the body. This raises the hidden element in shamanism, a recurrent theme that important things happen outside the bounds of usual sight. However, the simpler perceptual solution is that the lines of the background sprout off the edges of the body, a definitely nonterrestrial situation.

The two competing resolutions of the background in relation to the body create a dynamic but perceptually frustrating situation. Clarification is denied, whether the viewer concludes that the body obscures what is really happening behind it or that the shaman's body *determines* his surroundings by generating lines that begin and end with his body contours. The viewer, finding it impossible to make sense of the spatial organization, is effectively removed from normal expectations of a coherent setting and becomes propelled into placelessness, a different place, the Other Side. In that spatial "no man's land," the shaman's visions truly do generate the experience of not being Here, as opposed to an audience's accessing his location completely or rationally. The shaman spins in a nonordinary, experientially created space that is broken into bits, full of visual movement and flux, reduced to its essence as a series of fairly unrelated trajectories. Being colorless, or at least bichrome in relation to the polychromy of the rest, reduces reference to any actual place, making where he is intentionally vague, in another creative use of the generic to promote ambiguity. The shadowy, ineffable Otherworld has become defined only by its dynamic motion. Interestingly, however, the sets of crisscrossing parallel lines do capture the geometry witnessed during visions by echoing a commonly reported phosphene (fig. 2.1, left column, second from bottom).

The unusual subject matter and great aesthetic creativity of this painting and the other closely

related pieces must be acknowledged. The choice to depict a shaman in trance seems to encourage, if not mandate, innovative artistic engagement with the problems of depicting freefall, other cosmic realms, and novel sensory modes. One can imagine, having heard so many accounts of odd visionary experiences, the Nasca artist coming up with this extraordinary solution to embody a shaman who disclosed that he was seeing with his navel in a black-and-white linear nether realm. Or perhaps the artist and the shaman were one and the same, as were Don Pablo Amaringo, Don Eduardo Calderón, and others.

MOCHE BLIND FIGURES

It is worth noting that compared to the Costa Rican case studies, more images of people with unusual bodies are represented in Andean art, particularly in the Moche style.[5] The Inka, according to Spanish chroniclers, affirmed that the wounded-healer dynamic was operant in late pre-Hispanic times. For instance, Cobo reported that "the way in which many of them took up this occupation [of bonesetter] is as follows. Whoever had broken an arm or leg or any other bone in their body and got well in less than the normal time was taken among them to be an expert in curing such maladies" (1990: 164). Although a full-scale investigation has not been possible, I have surveyed more than a hundred published images of physically anomalous individuals and studied thirty-five Moche pieces.[6] Here I can only focus on a few of the many conditions represented artistically, the popularity of such imagery demonstrating its importance in ancient times.

The centrality of seeing in unusual ways in shamanism may help explain the ubiquity of Moche effigies of the blind and why many of them share characteristics with other shaman doubles (figs. 7.3–7.9; Scher 2010: figs. 5.149–5.152, 6.31–6.37). The congenitally blind and those missing an eye occupy the human end of the continuum; their appearance does not evoke animal characteristics to any degree. However, their condition relates directly to the "eyes-closed seeing" that enhances visionary experience and finds artistic expression in the slit trance eye, which arguably renders the sighted sightless in everyday terms. Under the influence of the entheogens the blind share the

same kind of visions as the sighted since visions are internal experiences unrelated to perceiving the outside world. Importantly, blind individuals experience synaesthesia, supporting this idea that someone who cannot see in normal life could easily be ascribed the power of visionary sight. There are contemporary vision-impaired shamans in the Americas, such as a one-eyed Mazatec shaman Don Aurelio (Wasson 1980: 40, fig. 2), demonstrating the strength of this tradition.

A standing figure of a blind individual at the Museo Larco Herrera in Lima (figs. 7.3, 7.4; accession number 2846, from Chiquito Playa in the Chicama Valley) betrays some features relevant to the present theme. Both of his eyes are shown as sunken slits, as is characteristic of blindness from birth. His turned head illustrates a typical strategy to localize sound more effectively in the absence of visual input. His ears are indeed exaggeratedly large, and the idea of hearing being enhanced or of relying more heavily on hearing when sight is withheld dovetails with the visionary intensification of all the senses, including hearing. Other Andean objects include enlarged ears to signal the animal self and supernormal hearing (figs. 7.15, 7.16). The tied mantle over his tunic is found in many Moche figures with the accoutrements and gender complication characteristic of shamans (Scher 2010: 251). The artist has drawn particular attention to the mantle by the innovative choice to make its hem support the figure along with the feet, but since one foot has been broken off and the piece still stands, the mantle is betrayed as the primary base. This is an extremely unusual feature of the effigy. Once more, the anomalousness of the subject is underscored by concomitant artistic creativity.

However, more direct references to this blind man indeed being a shaman are present. Certainly the flaring head emanation, potentially symbolizing a mushroom, is the most obvious. It retains remnants of red radial painted trapezoids, which could possibly signify the gills under the cap of entheogenic mushrooms (Schultes and Hofmann 1992: 144–153), or the radiating geometric patterns induced by their ingestion. Even if seen as a more generic head protrusion, it signals expansive crown-of-the-head consciousness, representative of trance state. Another iconographic clue is the three-part rattle in his proper right hand. Rattles induce trance and are a well-known, con-

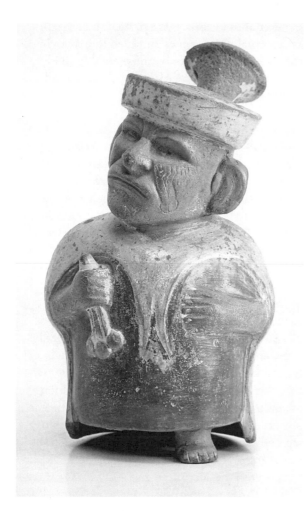

FIG. 7.3. Front view of blind individual with mushroom head emanation. Central Andes, Moche, site of Chiquito Playa, Chicama Valley. 200–600 CE. Museo Arqueológico Larco Herrera ML002846. Museo Larco–Lima, Peru.

FIG. 7.3A–C. Drawing of facial patterns on effigy in figure 7.3: (a) proper right cheek, (b) proper left cheek, (c) chin. Drawing by Nina West.

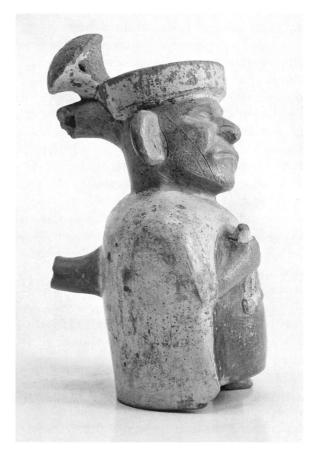

FIG. 7.4. Side view of effigy in figure 7.3. Museo Larco–Lima, Peru.

stant feature of shamanic ceremonies. Other blind individuals carry sets of rattles (fig. 7.6; Scher 2010: figs. 5.32, 6.4–6.7). Ancient rattling instruments abound throughout the Americas and are consistently used in shamanic ritual for curing and trance induction (for example, Stone-Miller 2002b: 53, 130, 201–202; Wiese 2010: minute 47).

The figure's prefired-incised facial patterns help subtly convey the shamanic message in various ways (fig. 7.3a). On his proper right cheek are a series of diagonal lines with zigzags, perhaps referencing the undulating percepts characteristic of visions. On his proper left cheek has been inscribed an erect penis and scrotum seemingly penetrating a triangle of pubic hair (fig. 7.3b). This same motif is found on a very similar Moche

effigy of a blind man (Scher 2010: figs. 5.149, 6.31). The fertility responsibilities of shamans are well documented;[7] possibly this sexual body art could denote that certain blind shamans cured impotence. On his chin is drawn a toad seen from above: toads carry entheogens and healing substances (Stone-Miller 2002b: 124–125; Stone-Miller 2004: 59; Stone 2007b: 12) and, like all animals, may represent a shaman's animal self (figs. 4.16, 4.17, 5.33b). Toads and frogs are apt alter egos given their dramatic transformational bodies and their association with rain and fertility, and here it may be germane that they are extremely vocal animals, sound being more important to the visually impaired. Taken in total, the head emanation, rattles, body decoration, his blindness, and his moderately high status strongly suggest important spiritual responsibilities. While it may initially seem paradoxical that those who cannot see can See, such an apparent impossibility constitutes a shamanic capability, and all that is opposite of the everyday defines this role.

Many images of individuals who are blind and one-eyed likewise feature familiar shamanic content and share one or more features with this piece, forming an iconographic configuration. For example, the individual in figure 7.5 may not indeed be blind but is shown as if he were, with slit eyes outlined in black for emphasis and, paradoxically, to make them more concentric, as in wide-open trance eyes. This man's eyebrows are composed of individual hairs, a feature that does partake in the animal by reference to whiskers and fur in general. These eyebrows are found in other anomalous individuals and the overtly visionary head vessels, making them a potential marker for shamanic trance status (figs. 7.9, 7.19, 8.8, 8.10, 8.14). His hands rest on his knees in the meditation pose, and he wears diagonal zigzag face paint. Other clearly blind or vision-impaired people play the rattles (fig. 7.6), wear fancy earrings and clothing (figs. 7.6–7.9), hold entheogenic paraphernalia (fig. 7.7), and have undulating face designs and big ears (fig. 7.8). The animal headbands worn by the blind depict staple animal selves such as felines (Scher 2010: figs. 6.35, 6.36).[8] Several figures combine blindness with the loss or congenital truncation of limbs (fig. 7.9). Multiple anomalies seem to have been considered auspicious for this role in the same way that other multiplicities character-

ize shamanism and visions in general—the more different, the more in touch with death, the more having healed oneself already, the better. In sum, images of the blind overlap in intriguing ways with those of shamans.

CHANCAY FEMALE WHALE SHARK SHAMAN

Introducing an animal-self element, an arresting Chancay female figure at the Carlos Museum (accession no. 1988.12.12; figs. 7.10–7.12) was previously published in regard to issues of quality, selective naturalism, layering, tattoos, and a jaguar animal self, the latter as the only reference to shamanic visions (Stone-Miller 2002b: 246–247). I have since reconsidered the jaguar attribution in light of the general overattribution of this animal, the lack of jaguar imagery in Chancay art generally, and this figure's second mouth, painted beneath the three-dimensional human lips and containing only tiny jagged teeth. Jaguars are shown almost universally with large, crossed canines among smaller, square teeth. At first the two-dimensional mouth pattern may seem more crocodilian, and the large torso spots could represent raised scutes. Yet, the Chancay Valley, a coastal desert, has no crocodilians, although it is certainly true that tropical imagery can travel far from the rainforest in Andean shamanic art. Thus, it seems more productive to look to the sea to account more convincingly for an animal spirit-self with this combination of teeth and body spots, as well as other unusual features like the square head.

I suggest a rather novel identification of the animal spirit-self subtext in this figure: the whale shark (fig. 7.13). Whale sharks (*Rhincodon typus*) are by far the world's biggest fish, the largest recorded one measuring forty feet and seven inches long (Taylor 1994: 28, 32); they swim the waters of the Pacific along the western coast of South America.[9] They inhabit the open ocean but have been found close to shore and even can enter estuaries and the mouths of rivers as far as the water remains salty; thus the Chancay people almost certainly would have seen them, especially from boats. One would not forget the sight of such a giant spotted shark with a mouth nearly five feet wide. Inside that human-length mouth lie several thousand tiny,

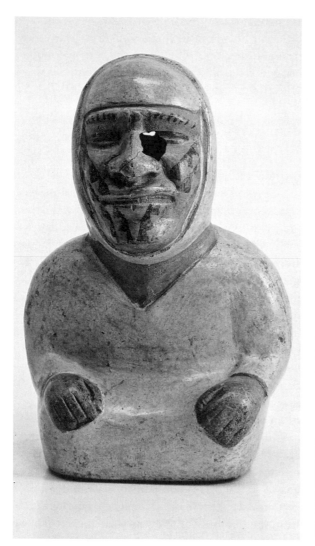

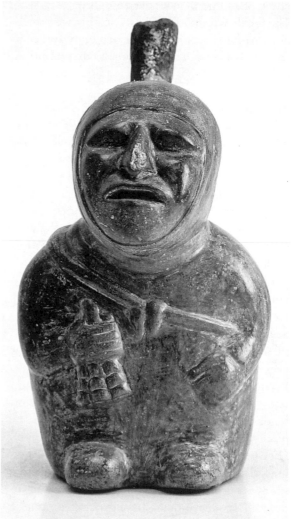

FIG. 7.5. Blind individual in meditation pose. Central
Andes, Moche, site of Huancaco, Virú Valley. 200–600 CE.
Museo Arqueológico Larco Herrera ML002815. Museo
Larco–Lima, Peru.

FIG. 7.6. Blind individual holding rattle. Central Andes,
Moche, site of Tomabal, Virú Valley. 200–600 CE.
Museo Arqueológico Larco Herrera ML002844.
Museo Larco–Lima, Peru.

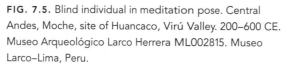

pointed teeth arrayed in eleven to twelve rows;
however, they do not use the teeth to chew but
rather filter zooplankton through gill slits (ibid.:
33). Often fish are swimming in front of and just
inside the mouth (ibid.: 101, 146–147, 169), which
could have suggested to the ancients that the
whale sharks ate the fish, that is, used their teeth.
Though the teeth are not necessarily easy to see,
as the whale shark swims it often drags its enor-
mous open maw half out of the water (ibid.: 103,
116, 122, 127; Bruce Carlson personal communi-
cation 2008), presenting further opportunities to
glimpse the teeth. While under water, the animal
often positions itself vertically, mouth up to the

water surface. This position also allows access to
the mouth, and it can make the whale shark seem
like a fish that "stands" like a person.[10] From above,
the pectoral fins and the split tail are positioned
much like the arms and legs of a person (Tay-
lor 1994: 125). In spite of their potentially fear-
inspiring attributes, whale sharks are harmless to
humans; in fact, they are notoriously gentle and
even playful with divers, another "human" charac-
teristic (ibid.: 107). The female gives birth to about
three hundred pups at a time and hence definitely
epitomizes fertility despite a ferocious exterior.
The cloaca (female genitalia) is quite noticeable as
well (ibid.: 139).

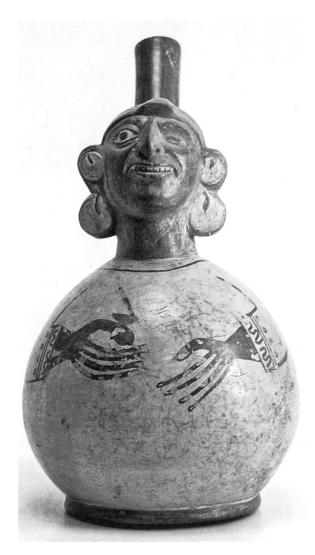

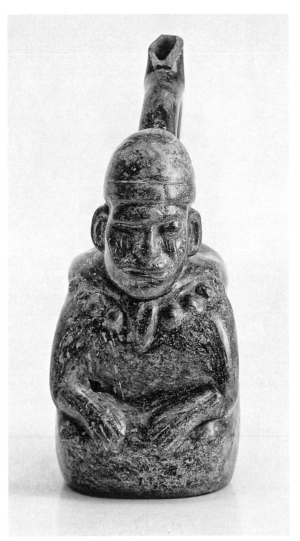

FIG. 7.7. Partially blind individual holding lime dipper for coca. Central Andes, Moche, site of Huancaco, Virú Valley. 200–600 CE. Museo Arqueológico Larco Herrera ML002805. Museo Larco–Lima, Peru.

FIG. 7.8. Partially blind individual in meditation pose. Central Andes, Moche, Chicama Valley. 200–600 CE. Museo Arqueológico Larco Herrera ML002803. Museo Larco–Lima, Peru.

Whale sharks' bodies have a number of salient characteristics that could inspire artists in creating an effigy with this animal spirit. The most obvious is the blanket of irregularly arrayed white spots on a chocolate-brown background that covers the dorsal surface of the body, leaving the shark all white underneath. Significantly, the top edge of the dorsal fin is lined in white also. The overall shape of the body features a squared snout, a very flat, wide torso, a rounded tail section, and prominent fins. A whale shark's bulging eyes are round with a dark, centrally placed circular pupil (although foreshortening can make them appear oval as they do in figure 7.13). Signifi-

cantly for shamanic art is the fact that the animal "does not have any eyelids, but is able to 'close' its eyes by rotating them and sucking them back into its head" (Taylor 1994: 30). A deep, circular hole about a foot behind each eye would easily suggest the opening of an ear; called a spiracle, it is actually a vestigial gill slit (ibid.).

Almost all of these features translate quite directly into those of this ceramic effigy. Certainly the body coloration echoes that of the whale shark, white with areas of dark brown covered with white spots in irregular pattern. This style is always white with brown, but other examples do not have these spotted areas. Importantly, the

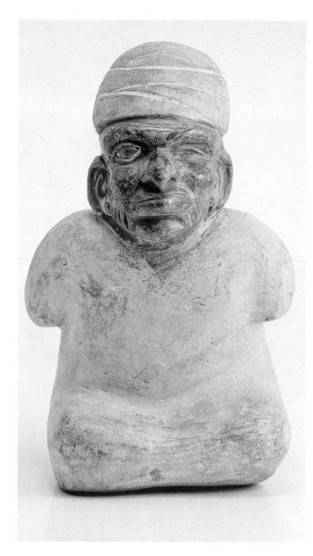

FIG. 7.9. Partially blind and armless individual. Central Andes, Moche, site of Pur Pur, Virú Valley. 200–600 CE. Museo Arqueológico Larco Herrera ML002806. Museo Larco–Lima, Peru.

oval, as it appears in figure 7.13, for what that is worth) are notably similar features, too. The short arms are typical of this type of effigy, granted, but here dovetail conveniently with the animal spirit's diagnostic pectoral fins. I would even suggest that the unusual selective naturalism of the figure's protruding kneecaps and anklebones might refer to the small set of fins above the tail. The standing pose and the fish as it stands in the water align. The painted, open mouth that runs the entire width of the head and the multitude of pointed teeth resemble the way a whale shark's huge mouth would be experienced by viewers. The sculptor has taken pains to model the figure's genitalia, which could be considered unusual attention paid to overt fertility; most Chancay figures are less anatomically correct. The female whale shark's large, obvious vulva would seem to be referenced as well.

Certainly she is not the only Chancay figure with some of these characteristics, but the gestalt adds up to this animal-spirit reading, as in the case of the deer for the Rosales figure discussed earlier. In terms of relating to a human shaman, it is fascinating to note that the whale shark has extraordinary powers of healing:

> [A] whale shark filmed in 1986 had two deep gashes down one side of its body. It was easily identifiable because of an old shark "bite" in its left pectoral fin, scars on its flank, and its lateral markings. When sighted again in 1993, the two gashes had completely healed, without any scarring whatsoever. (Taylor 1994: 34)

Whether ancient peoples might have experienced this miraculous ability to self-heal cannot be proven, but it nonetheless fits with the wounded-healer phenomenon in an intriguing way.

The elaboration of the patterns coming up and out of her eyes sets her apart from other Chancay female figures as well. Comparative pieces from the Hearst Museum of Anthropology display dark, solid, diagonal lines in this position,[12] but her double lines, circles, and outer spirals above and below are more elaborated. One suggestion is that the shark as it swims at the water surface creates lines of bubbles from just this eye area (Bruce Carlson personal communication 2009). Be that as it may, the eye decoration lines easily stand for the

white line down the effigy's back (fig. 7.12) visually corresponds to the white outlining of the dorsal fin edge: if seen from above, there appears to be such a white line down the animal's back.[11] All whale sharks have some white lines among the spots, as well, and certain individuals' spots form a line down the center of the back (ibid.: 110, 137, 143). The effigy's overall body shape, including its streamlined side view (fig. 7.11; Bruce Carlson, personal communication 2009) and markedly square head continuous with a wide, flat torso, aligns with the whale shark's bodily contours. The short arms jutting out like fins and the distinctly dark concentric eye (in the effigy it is

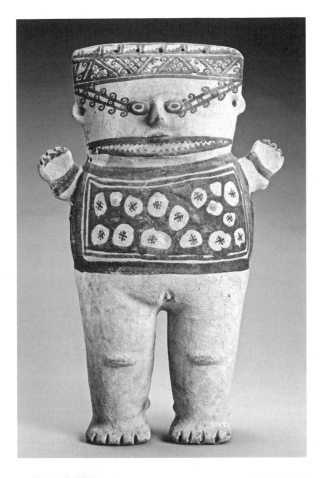

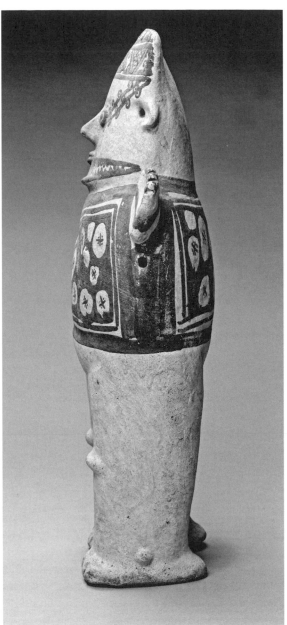

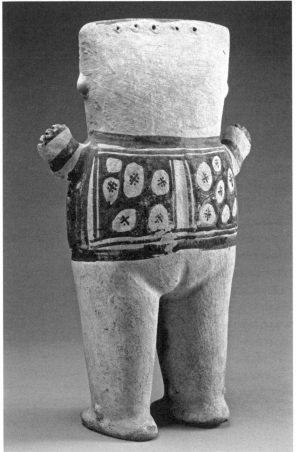

FIG. 7.10. (Top left) Front view of female whale shark shaman. Central Andes, Chancay, 1200–1450 CE. Michael C. Carlos Museum accession number 1988.12.12. Gift of William C. and Carol W. Thibadeau. Photo by Bruce M. White, 2008.

FIG. 7.11. (Right) Side view of effigy in figure 7.10. Photo by Bruce M. White, 2008.

FIG. 7.12. (Bottom left) Back view of effigy in figure 7.10. Photo by Bruce M. White, 2008.

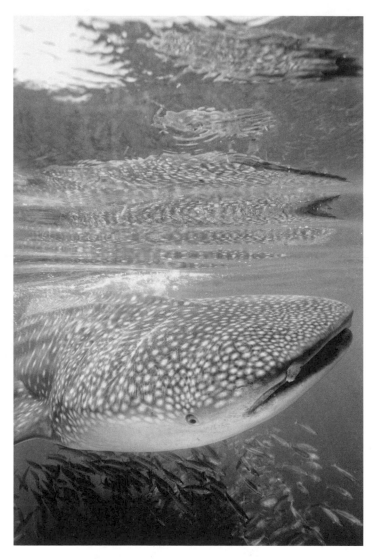

FIG. 7.13. Whale shark. Photograph by Andy Murch (http://elasmodiver.com).

appear shamanic and constitute another internal type of seeing.

These vision lines as well as the wide, painted mouth, help draw attention up to the head, as shamanic cephalocentrism dictates. The viewer's eye moves rather quickly up the large and emphatically columnar legs, since they are monochromatic, long, and smoothly tapered outward. The only captured negative space in the composition is located between the legs and unavoidably visually lightens this area. Although she physically stands on the feet—a technical feat in a large human effigy—and the legs are by no means spindly, the very vertical composition further subverts the message of unambiguous groundedness. These elongated bodily proportions are unusual in the corpus of Andean art but can be even more marked in other Chancay figures such as the Hearst pieces. Verticality works in favor of compromising gravity, privileging visionary experience. The viewer may note the protruding kneecaps and the female genitalia as the eye sweeps up the legs, but the patterns and shapes of the upper body and head demand more attention.

The upper areas are those with the animal references, while lower ones are unmistakably human. This creates a different sort of human-animal dichotomy than in other shaman effigies, a lower-upper contrast as opposed to a side-to-side (figs. 3.1–3.3, 7.14) or intermingled (figs. 5.18–5.20, 7.15) strategy for combining two states of being. The fully three-dimensional human legs and genitalia create the aspect of the shaman in trance that is Here physically. Although the shaman has an emphatically female human basis in the third dimension, that gives over to the flatter torso and head with their visually bold two-dimensional readings. Thus, a progression is set up from the more solid lower parts to the more dematerialized upper areas. Flux in state of being, and specifically the change from more human to less so, is thereby encoded as the viewer's eye moves upward, toward the Celestial. It is in the upper cosmic levels that the body loses volume and becomes more of a plane, a vehicle for the two-dimensional patterning. Likewise, it is in the upper body parts that animal selves (the torso spots and jaw) and geometry (the eye and headband/head patterns) take precedence in "one who has left." Yet the upper areas retain some volume, and so the

geometrical aspect of visions, particularly the spiral motion, and announce her role as a particularly powerful visionary. Someone with a giant shark alter ego would definitely be considered extraordinary in the hierarchy of shamans. The outlined eyes with the circular pupils not only represent mimetically the eyes of the whale shark but also constitute one of the main types of bulging, wide-open, staring trance eyes. Their distinctly oval shape serves to bridge effectively the human almond and the animal round eye shapes, creating deliberate and creative ambiguity in identity appropriate to the animal-transformed shaman. The bizarre ability of the whale shark to rotate and suck the eyes back into the head cannot help but

effigy as a whole carries a double message of both two- and three-dimensionality; this combination embraces the paradox of the shaman who exists in both realms during dual consciousness, who is both human and animal simultaneously.

The artist has cleverly interlocked human and animal content by conflating the painted and modeled information in several places. One of these is the chest, where the nipples are modeled but also function as two of the spots. This also underscores that the dark designs represent body painting or tattooing rather than a shirt, also proven by the textile imprint indicating she was originally covered in an actual dress (Stone-Miller 2002b: 247). The spots represent a part of her, not simply an overlay like clothing. They were originally hidden under her dress, and thus they represent her inner self. Following that line of reasoning, it is possible that the spots might not even represent her physical body's appearance at all but rather her interior animal self. Interestingly, the animal area again features the chest, where certain contemporary shamans locate their "defenders."

The face features another strongly interdigitated human-animal element, namely the mouth(s). The painted animal maw is superimposed on the lower lip of the three-dimensional human one, overlapping the two readings. However, the two-dimensional mouth takes visual precedence, being dark, much larger, and swallowing the lower lip of the modeled mouth. The human mouth is not only comparatively tiny but also closed, while the whale-shark mouth is open, succinctly communicating devouring capability. The feeding whale shark is an impressive sight in nature, the whole front of the fish a gaping opening (Taylor 1994: 25, 87). The effigy's dominant animal mouth signals the predator/ aggressor aspect of the shaman's animal self, a typical choice (figs. 3.1, 5.18–5.21, 6.10, 7.14, 7.15, 8.4–8.7) that shows the animal self's power to defeat rival shamans, take on malevolent spirits, traverse the land of the dead, and so on. The conflation of human mouth and animal maw aptly represent dual consciousness as well, plus the shaman as both gentle and ferocious. That in nature the whale shark appears fierce but is not reinforces this dynamic balance. The typical loss of the human ego's importance during the shamanic trance experience is played out here in that

the tiny, three-dimensional, closed mouth of the human aspect is self-contained and lesser, while the huge, two-dimensional, open mouth of the animal spirit looms large and dominant. They are not mutually exclusive states but rather aspects of a single whole that is simultaneously human and animal, as the two mouths overlap and contain parts of each other. The artist has successfully rendered two-as-one multiplicity, perhaps one of the most predominant messages of shamanic embodiments. For the dual messages to be located in the mouth reminds us of the importance of singing and chanting, ingestion/expulsion, and the internal as fundamental trance experiences.

Above the mouths, the most complex patterning occurs to further draw the viewers' attention to the eyes, other sensory organs, and the crown of the head, the inspirational centers during visions. (There is a discoloration on the central face that must be factored out as not original to the piece.) The intensely staring, riveting eyes emit detailed spiral patterns, strongly suggesting what she is seeing in her visions. The center of the lines of patterns is filled with concentric circles, suggesting multiplied small trance eyes.[13] Placing the patterns on diagonals that move outward and upward is dynamic visually, analogous with the character of visions. Diagonals inherently appear as more limitless perceptually than lines firmly planted on the vertical/horizontal axis. The role of the shaman to explore the unknown, the untapped Out There, is captured in this formal choice. Here, furthermore, the diagonals are not shown as ending but rather meeting—and so appearing to go on underneath—the bottom of the horizontal headband, that being the simplest perceptual resolution in the absence of any other visual cues. Thus, the artist arrayed the "vision lines" to help divert attention out from the body, beyond it, just as the visions do for the shaman herself as she looks Beyond with her trance/animal eyes. The vision lines echo the projecting arm position, the physical body doubly referencing the ecstatic out-of-body experience.

Another important function of the diagonals is to direct the viewer to notice the ears and top of the head. Though small, the ears nevertheless project out from the body as little else does. While previously I suggested gold earrings would have originally been placed in the ear holes (Stone-

Miller 2002b: 247), the openings do not actually go through lobes as they should for practical purposes and according to other effigies that wore real jewelry (fig. 4.3; ibid.: 186, catalogue no. 433). Instead, the ear holes penetrate her head and create dark, circular shadows, underscoring that she is hearing important spiritual information during trance, a multisensory experience. The ear circles are aligned with the eye circles, and perceptual similarity as dark-centered, concentric forms links them further. The fact that the whale shark's spiracles easily could be seen as ear holes and line up like the effigy's eyes and ears allows for a further interpretation that this shaman can magically hear underwater, or in the Underworld, during trance journeys.

The eye diagonals join their visionary geometry to that of the highly decorated crown of the head, which is also pierced by a series of five holes. What was threaded through these holes—feathers, ties for a wig, or a cloth headdress—remains unclear. If feathers, a widespread and high-status artistic medium throughout Andean history (Rowe 1984), then a bird may have been her second animal spirit.[14] Other Chancay fiber figures wear hair and openwork headscarves (Stone-Miller 2002a: 176, illustration 141; 177, illustration 142), and later Inka girls who were sacrificed wore feather headdresses (McEwan and Van de Guchte 1992: 362–365), suggesting various possibilities. In any case, the crown area would be even more striking, larger, expansive, and colorful, with something emanating out of the head in a typical shamanic manner. Of course this analysis is perforce based on what the figure looks like now, but in ancient times this figure was dressed, at least some of the time and for final interment, in a real textile garment and had attachments to her head. Thus, visual analysis must consider how her original appearance would affect the messages she was meant to convey. The dress would have covered much of the torso, which has several ramifications. The legs would therefore be more dematerialized and seem shorter. The obvious female genitalia and the emphatic torso painting would be hidden, present as her essence but withheld like other important shamanic information. There is also an element of flux possible in a figure that can change appearance by being dressed differently according to ritual purposes, making the whole enter-

prise more dynamic (Stone-Miller 2002b: 33, catalogue no. 43). Being dressed also would enhance cephalocentrism: the face would stand out even more as the uniquely patterned body part.

The three main visionary types of movement are certainly present in the composition, predictably in the head area. The spiral is represented most obviously above and below the diagonal lines that burst out of the trance eyes. They are organized in pairs that reflect each other as mirror images, although the small circles between the two straight lines complicate the reading. The headband pattern also features spirals as dark waves in the white-background diagonal. There is a more subtle idea of spiraling in the fact that the spiral diagonals and the triangles with white circles are organized in rotational symmetry: the triangle turns around on its axis to produce the next orientation, and so on. The second type of visionary movement, undulation, is found in the zigzags of the painted teeth and the headdress patterns. Radial movement is expressed in the concentric eyes and the manner in which the vision lines move out from them. The circles in the vision lines, the headband triangles, and the torso spots also qualify as radial patterns. In sum, there is an overall effect of movement and dynamism even in a relatively upright, oblong silhouette. The irregularity of the torso spots adds considerably to this activity since the figure is otherwise bilaterally symmetrical.

The sturdy, symmetrical, wide figure thus projects her authority, her arms-out posture quite arresting and commanding. The egalitarian shamanic approach to gender finds natural expression in such a strong female visionary, who is ascribed the capacity to become the formidable whale shark.

TOWARD THE CENTER OF THE FLUX CONTINUUM

CUPISNIQUE DUAL FELINE-TRANSFORMING PORTRAIT HEAD

While Chancay ceramic artists chose to combine the animal self by subtly bisecting the figure top to bottom, the earlier Cupisnique style features an iconic composition that frankly divides the face into two sides, a more and a less human (fig. 7.14). The Museo Larco Herrera's stirrup-spout

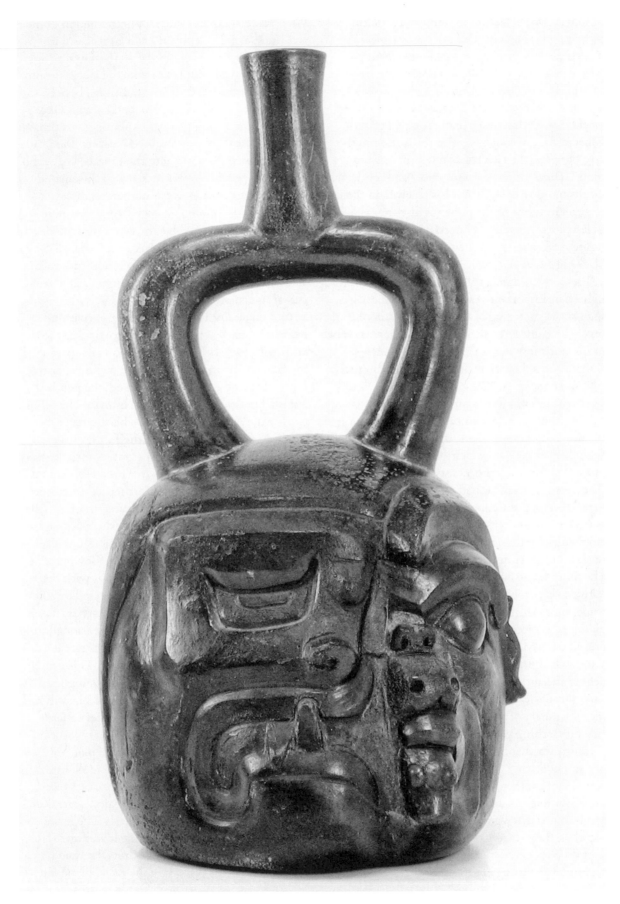

FIG. 7.14. Half-feline, half-human head stirrup-spout vessel. Cupisnique, site of Salamanca, Chicama Valley. 900–200 BCE. Museo Arqueológico Larco Herrera ML040218. Museo Larco–Lima, Peru.

blackware vessel (accession number 40218; Burger 1997: 74–75) is one of the most famous pieces in its extraordinary collection. Not only a sculptural masterpiece of planes complexly designed to achieve a richness of meaning, this vessel also is technically distinctive. It represents very fine blackware, with unusual matte textural effects generated from roughening of the surface in the area between the two faces and in the less human one's "white" of the eye. Both bold and subtle, it merits more analysis than it has received in the literature. In terms of the previous discussion of the Belen pieces, it is important to note that this dual figure references again the supreme power of the black jaguar in particular.

Previous commentary by Burger has highlighted its important general shamanic messages, such as the capturing of transformation in one image, in contrast to the Chavín de Huantar tenon heads that show stages in the process (1995: 158). Burger notes the two noses on the more human side and concludes, "Clearly neither side represents a straightforward feline or human" (1997: 75). He links the many contradictions inherent in the design to pervasive dualism in Andean art and thought. Yet such a necessarily brief entry may gloss over some significant aspects, such as the fact that the more transformed side physically dominates the composition rather than equally sharing space with the other. With the spout aligned perpendicular to the viewer, the more animal face is revealed to take up two-thirds of the vessel body. The more feline face takes visual priority no matter how one looks at it since even its profile protrudes more than the other. This animal-centered hierarchy is often encoded in dual shaman figures like the Maya piece in figures 3.1 through 3.4, in which the jaguar ears will always be visible behind the anthropomorphic deity but not vice versa (Stone-Miller 2002b: 4). While Burger notes the "imaginary vertical axis" across which the two faces, disturbingly, do not fully conjoin (1997: 74), I would aver that the axis is not a true, clean line but an undulating gap. Even their definite quality as two faces, rather than parts of one, can be questioned; ambiguity and flux hold sway once more. Moreover, rather than not completely coming together, they equally convey splitting apart, or at least do both perceptually. Selves emerging from within, in an analogy to molting or birthing, is a

widespread shamanic concept embodied in Olmec figurines (Reilly 1989) and Andean pieces with what look like tears or "rents" in the surface (figs. 7.14, 8.2, 8.3, 8.15, 8.16). The concept is still prominently described in modern traditional beliefs; for example, the Guajiro say "the person who takes tobacco 'opens himself up,' is 'split open,' as though a communication is established between the inside of the shaman's body where the tobacco is . . . and the [spirit] world" (Perrin 1992: 112). Fascinated and frustrated, the viewer's human tendency to want a face to "add up" is very strong, but here one simply cannot resolve the two differently shaped and sized eyes, mouths, and noses, all of which are also placed at slightly different levels. The composition constitutes ambiguity and paradox at its artistic best.

Not surprisingly, given the centrality of the eye in visionary art, the eyes are particularly at odds with each other and potentially disturbing for viewers. In an especially telling choice, two types of trance eyes are juxtaposed: the pendant-pupil feline and the wide-open human. The feline eye has the same matte-texture background as the "no man's land" between the faces; thus the eye appears somewhat transparent, as if the background is showing through it. This effect flattens and dematerializes the transformed side appropriately and is an artistic strategy found in other Chavín substyles. It increases the way the black jaguar side's gaze is detached and two-dimensional, aptly characterizing spiritual vision in the Beyond. The feline eye is in some sense continuous with the environment, a corporeal effect reported by some visionaries during trance state. By contrast, the more human eye is hyper-three-dimensional, fully conveying the eye-popping feeling of trance-induced exophthalmosis or proptosis. This eye remains clearly in the human realm, being level across rather than slanted as in felines, but still signals trance state. Its shiny texture differentiates it strongly from the feline eye and makes it seem more alive and engaged, more in this plane of existence, the "before" to the other side's "after" in the transformation process.

Many other features defy normalcy, several of them doubled and made into spirals. The more human face sports two noses, the lower one actually more that of an animal with its flat, wide shape and nostrils placed on the facial plane. There

is also an alternate reading of the upper nose as an outward double spiral, perhaps also constituting a furrowed brow that is a common Chavín element on supernatural beings (Stone 1983, Burger 1995). In any case, it is a highly ambiguous element and contains the curling motion ubiquitous in visions. The ear has been replaced with an equally enigmatic animal head, as has the tongue, although the latter is clearly a snake. Incised on the snake head are barely visible zigzag lines—three vertical ones above the eyes, one horizontal below, and circular ones around each eye—creating crackling radial energy concentrated at the snake's eyes. This is a mouth emanation but also references three common experiences during visions: regurgitating the inner snake self, a body part turning into a snake during visions, and/or speaking to or as a snake. Though the more human side may be smaller, it is more visually complex and has many embedded transformational aspects, especially in the sense organs. The image conveys heightened smell in two ways, from two noses and from an extended snake-tongue, as snakes smell with their tongues. The animal head's ear also conveys animal-keen hearing or listening to the wisdom of animals. Thus, the visionary experience is already fully in force on this side. There is, finally, an interestingly ambiguous way to "end" the face under the ear, with a cleft form more usually expected on the fontanel. It is a kind of ambiguous shape, a rending of the body, creating dents, peeling away surfaces, that at base works to qualify or contest their corporeal solidity in the terrestrial plane and reveal that which is hidden within. This rending is more often seen in later Moche visionary scenes (figs. 8.2, 8.15, 8.16).

The other side of the face furthers the process of dematerialization; everything about it retreats from the three-dimensional and the engaged. First, the human element is undermined by the archetypal crossed fangs, open, downturned aggressive mouth, and flat pendant–pupil eye of a cat. However, each feature is squared more than an actual animal's, and the unnatural angularity detaches this half of the face even from the animal world as well. This half of the being is an abstraction that goes several steps beyond either human or animal self. Its flatter planes are the sculptural equivalent of surface painting, like the two-dimensional spiritual messages in other pieces. The

feline face has two clear spirals, for the nose and the brow, elementally abstract shapes that allude to spirals seen during visions. The lower lid is likewise only a thick incised line so that the viewer is not as convinced of a seeing eye as on the more human side, where an eyeball is placed in a socket. Abstraction, replacing facial features with simple shapes and lines, is a conscious strategy for changing everyday anatomical parts into something much more far-reaching and less partaking of this terrestrial plane.

Neither half-face functions alone. Together, the two halves present the visionary state as transforming the eyes from a bulging and glassy human one to a matte, flat, and linear cat one. The viewer wants them to be the same but is forced to look back and forth between them and see the differences, the process of flux, the detachment from the human and even from the animal. This dual face embodies coming to a new synthesis: exactly what the shaman goes through in trance. The artistic juxtaposition of the two types of trance eyes makes one see that what is truly seen is the Beyond, not the dual either/or of human/animal but the transcendence of all that appears to occupy separate categories. The two half-faces, as jarring as they may be, do add up to a single frontal face, even if it splits apart easily. As a representation of the shaman who goes through the transformation to such transcendent wholeness, this work of art masterfully encodes the change in vision that takes place in visions as well as the revelation of underlying unity in all phenomena.

Yet it is not just the eyes that speak to this fluctuating gestalt. Both faces emerge and/or sink back into the undefined matte background between them, this area of purposeful liminality capturing the becoming that so deeply typifies the Other Side. This irregularly shaped middle ground cannot be grasped as a shape in itself but stands for the truly amorphous, nonmaterial bridging of the dialectic. It is the third element, full of visual tension yet almost not there, and it references the potential revelations once the either/or dichotomy is elided. It is the actual "ground" that makes the half-faces into "figure." The delicate but energy-charged synergy between the two, ultimately creating a third being state, truly represents the moment of balance at the very center of the transformational continuum.

Another piece that achieves this balance, though figured as a transforming head wearing its feline alter ego for a headband, is a Moche goblet held by the Carlos Museum (figs. 7.15, 7.16, accession no. 1989.8.159; Stone-Miller 2002b: 225–226, catalogue no. 515). I initially interpreted the obvious feline imagery as referring to a jaguar; however, it corresponds more convincingly to an ocelot (figs. 7.17, 7.18, as well as 8.1). A closely related stirrup-spout vessel at the Dumbarton Oaks Research Library and Collection in Washington, D.C., reinforces this identification (Donnan 1996: 127–128, plate 23).[15] Both are considered the Moche revival of the Chavín style, based on the prominent mouth baring fangs. Previously I stressed the object's ritual uses as both a goblet and a rattle, called attention to the winglike face paint as representing soul flight, and noted that "his bulging eyes, distinct from normal consciousness . . . are another sign of altered consciousness" (Stone-Miller 2002b: 225). However, there remains iconography to reattribute and a variety of issues to relate this piece to the visionary perceptual themes.

The ocelot (*Leopardis pardalis*) is an animal whose wide range includes the Peruvian North Coast and inland, and so it would have been familiar to the Moche. This spotted feline has many similarities to the jaguar, hence the confusion in the literature between it and the "king" of the jungle. The ocelot, however, would rank as "prince," only growing up to three feet in length and forty-five pounds in weight, compared to the jaguar's six-to-eight-foot span and up to three-hundred-pound bulk. Thus, sheer size and relative dominance in the natural hierarchy are good reasons to differentiate between the two when possible. The ocelot necessarily holds a lesser spot in the hierarchy yet closely resembles a jaguar; it is boldly spotted (figs. 7.17, 7.18), including a noticeable dorsal line of spots, has crossed canines and reflective eyes, and shares many of the same abilities of the larger cat, such as strong swimming, tree-climbing, diurnal and nocturnal hunting, and toleration of human proximity (Sunquist 2002: 121–122). The smaller cat produces a long, continuous, throaty growl,[16] related to the coughing, grumbling jaguar vocalization; both are distinct from the puma's shriek, for instance. The rattling

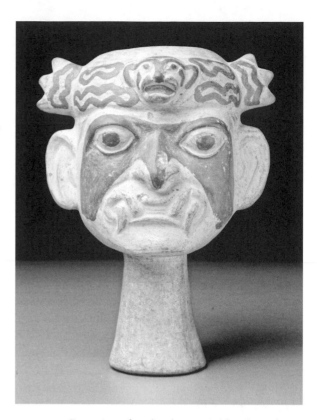

FIG. 7.15. Front view of ocelot shaman goblet. Central Andes, Moche, 200–600 CE. Michael C. Carlos Museum accession number 1989.8.159. Gift of William C. and Carol W. Thibadeau. Photo by Michael McKelvey.

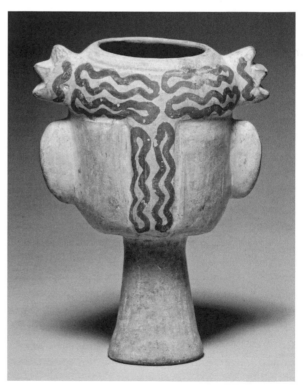

FIG. 7.16. Back view of vessel in figure 7.15. Photo by Bruce M. White, 2009.

FIG. 7.17. Head of an ocelot ("Alice"). Courtesy of the Oregon Zoo. Photograph by Michael Durham.

balls in the base of this goblet—and in that of the Dumbarton Oaks piece—would make this growling sound as one drank from them; doing so symbolically transferred the cat's aggressive voice with the contents of the container, perhaps an entheogenic beverage that catalyzed becoming the feline self.[17]

The important artistic clues that specify the ocelot include the sets of two stripes that go up the forehead and out from the eyes; the taller, rounder, white-interior ears (fig. 7.17); the open, wavy spots that differ from the familiar rounder rosettes of the jaguar; and the ocelot's markedly large and fluffy front paws (fig. 7.18). The spots pose a problem, however, because in some places an ocelot's are just like the jaguar's dots and dashes. However, an ocelot's markings have been described as "the most wonderful tangle of

stripes, bars, chains, spots, dots and smudges . . . which look as though they were put on as the animal ran by" (ibid.: 121). If an artist wants to create an unequivocal image of an ocelot, therefore, the long bars are definitive. It is this type of long, wavy, outlined marking that the goblet's headband cat displays, while a closed version of the same wavy line is found on the Dumbarton Oaks cognate piece. Like little snakes (probably not accidentally) and certainly participating in the importance of the visionary undulations as well, these long, serpentine markings cannot be mistaken for rosettes. The headpiece's exaggerated paws that flare out to either side also bespeak the ocelot, as do the lower, bigger ears and the lines on its face. The cognate piece has even more overt double lines from the ocelot headband figure's eyes and impressive paws, as well as snake-head earrings

FIG. 7.18. Ocelot ("Ralph"). Courtesy of the Oregon Zoo. Photograph by Michael Durham.

and geometric patterning on the neck/tunic to add to the visionary content.

Both ocelot shaman pieces are reduced to heads only, supporting the widespread visionary cephalocentrism, and the top of the head in each is accentuated as the animal transformation locus, following the alter ego's long association with the crown of the head. The ocelot's outstretched paws create the type of visual trajectory up and out that reinforces the theme of expanding consciousness. The paws on this goblet double as head emanations, flaring out in a strong three-dimensional zigzag accentuated in two dimensions with a wavy spot turned on it axis. The main face below the headband has taken on a feline mouth and exag-

geratedly open trance eyes with white showing all around the pupil, but it remains otherwise human, in the aquiline nose, for example. With the fully transformed feline self directly above in the head-band, it is as if the shamanic transformation into the alter ego is taking place as the eye moves up, as in the Chancay composition. The same is true of the Dumbarton Oaks piece, although a strict progression from one to the other is complicated by the fact that the main human face's trance eyes shade into the round animal type and the alter-ego ocelot's are quite almond shaped, so the selves are more interdigitated than sequential. Importantly, in the related Dumbarton Oaks composition, the eyebrows are the aforementioned type clearly

made up of individual hairs, found in a number of other Moche pieces with shamanic content, including effigies of shamans with anomalous bodies and pieces that illustrate the experience of visions directly (figs. 7.5, 7.9, 7.19, 7.21, 8.8, 8.10, 8.14). Hairs separated in this manner appear more like whiskers or fur. Both of the Moche Chavín-revival pieces are predominantly and starkly white, another trait that goes with the animal eyebrows.

Other features in the Carlos goblet mix animal and human in several ways. The mouth is overtly feline and the nose human, yet the ears, being noticeably large, rounded, and white like an ocelot's, blend the two. Thus some juxtaposition and some blending is the subtly complex artistic strategy for depicting a transformative state here. The overlay on the sculptural forms by a different two-dimensional scheme, the winglike pattern on the goblet and the vertical stripes on the stir-rup spout, creates the double message of corporeal person (the modeled forms) and dematerialized spirit self (the flat lines and color areas) we have seen before. The goblet face's nose is doubled visually: there is a modeled nose and a painted one, and their shapes do not correspond. Even more complicated, the stirrup-spout vessel's face patterning adds a thin line for a second nose and wide stripes that bisect the eyes and chin areas. In either composition, it becomes difficult for the viewer to hold onto the contradictory gestalt; the perusal goes back and forth between the "real" face and the patterned one, especially since the two slip colors—flat white and dark red—are highly contrastive. The pupils of the eyes partake more of the two-dimensional spirit world, appropriately enough since that is what is being seen in altered consciousness. Certainly this artistic confounding of clear categories by mixing animal, human, and two- and three-dimensional aspects represents a prime example of creative ambiguity, a shamanic expressive staple.

MOCHE SURVIVORS OF LEISHMANIASIS

Those with anomalous bodies, prime candidates for becoming shamans, take an important place at the middle of the transformational continuum. Here I would argue that a prevalent disease, namely leishmaniasis, known today in Peru as *uta*, rendered the human visage more like that of an

FIG. 7.19. Survivor of leishmaniasis in meditation pose. Central Andes, Moche, 200–600 CE. Michael C. Carlos Museum accession number 1989.8.72. Gift of William C. and Carol W. Thibadeau. Photo by Michael McKelvey.

animal, specifically a feline. As we have seen, in shamanism to become animal is a goal rather than a pejorative. Indeed, the Moche created hundreds of images (figs. 7.19–7.24 among them) of those who survived this horrible leprosy-like parasitic disease carried by sand flies from contaminated dog and rat hosts (Pearson and Queiroz Sousa 1992). When I first published the Carlos Museum example (Stone-Miller 2002b: 227–228, catalogue no. 518) I emphasized the survivor aspect, which remains key in that shamans are the wounded healers, believed to have already healed themselves and thus be able to do so for others. Conquest of

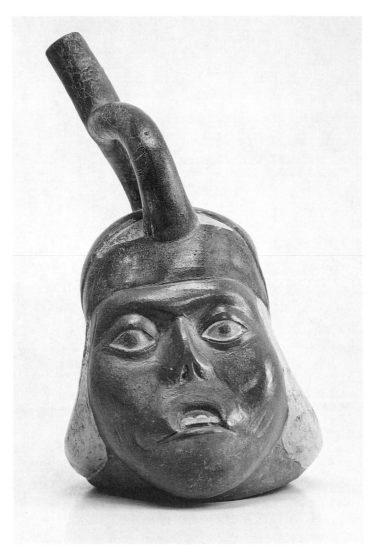

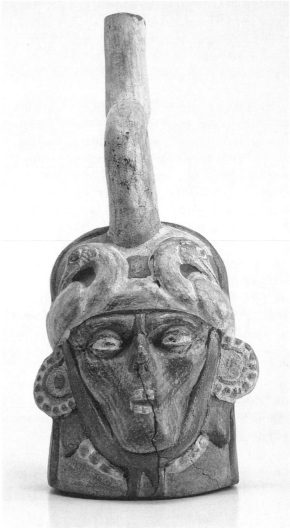

FIG. 7.20. Portrait head of a survivor of leishmaniasis (distortion due to firing). Central Andes, Moche, Santa Valley. 200–600 CE. Museo Arqueológico Larco Herrera ML001415. Museo Larco–Lima, Peru.

FIG. 7.21. Portrait head of a survivor of leishmaniasis wearing double bird headdress. Central Andes, Moche, site of Pur Pur, Virú Valley. 200–600 CE. Museo Arqueológico Larco Herrera ML001409. Museo Larco–Lima, Peru.

death as a shamanic prerequisite may explain the predominance of these images; most die from this horribly face-altering disease, but some do not,[18] which in shamanic thought would be attributed to superior healing powers. Disease survivors look like living skeletons and thus embody a shaman who walks in both the worlds of the living and of the dead. In the worst cases of advanced leishmaniasis, the skull can actually show through and begin to be eaten away, making this a very real visual connection (Robert Oster personal communication 1998). The idea of the interior of the shaman showing through may relate to the "rents"

in the Cupisnique face (fig. 7.14) and in visionary bodies and scenes (figs. 8.2, 8.3, 8.15, 8.16).

However, the visual repercussions of the disease are germane in other ways. I argue that the eyelid loss creates a permanent "trance" eye, wide open and staring in a way that echoes the visionary state and appearance. All the sensory organs are opened up, typically the end of the nose and the upper lip destroyed, which could be related to visionary intensification of the senses of smell and taste. Beyond this, the resemblance of a leishmaniasis survivor to a snarling cat is striking since this disease causes the face to have a flatter nose, wider

and rounder eyes, and permanently bared teeth. I am not alone in noting this: in his superb and deeply shamanic novel *The Storyteller*, Mario Vargas Llosa mentions a traditional Amazonian Matsigenka "boy whose mouth and nose had been eaten away by *uta* ulcers . . . that hole with teeth, palate, and tonsils *which gave him the appearance of some mysterious wild beast*" (1989: 5–6; my italics). It may be worth noting as well his later remark that on another occasion "the face of one of the children was eaten away by a form of leprosy [*sic*] known as *uta* . . . from the natural, uninhibited way in which the boy acted, running about among the other children, he did not seem, at first sight, to be the object of either discrimination or mockery because of his disfigurement" (ibid.: 168).

While granted this is an ethnographic novel, it nonetheless demonstrates the long Andean tradition of the positive reception of unusual physical form; generally, shamanic peoples still consider anomalous characteristics to elevate, not denigrate. We know this was true of the Inka as well, according to the Spanish chroniclers: "It was said that priests were not selected by chance nor without some mystery that marked them . . . [such as being] born as twins or triplets from the same womb, [or] . . . given by nature something out of the ordinary" (Cobo 1990: 159).

Effigies of individuals with leishmaniasis take several forms in Moche art: portrait heads (figs. 7.20, 7.21), full-body figures, many sitting upright in the hands-on-knees meditation pose (fig. 7.19, 7.22, 7.23; Scher 2010: figs. 6.25–6.27), and others lying on their stomachs apparently because their feet are missing (fig. 7.24; Scher 2010: figs. 5.166, 5.167). The prestigious portrait-head format includes the uta survivor right alongside the high-status individuals of "normal" appearance that epitomize Phase IV Moche ceramic artistry (Donnan 2004: figs. 1.9, 1.10). Because that is the part of the body affected by the disease, it makes sense to reduce a person to the head in this case, though it also reflects extreme cephalocentrism. One representative piece (fig. 7.21) shows the head of a man with the characteristic blunted nose that causes the nostrils to come straight out from the facial plane. His nose was painted black originally, emphasizing its triangular flat appearance and, more importantly, reflecting that jaguars' noses are actually black. Most of the faces of leishmaniasis survivors

that I have studied have a black nose or at least a black pattern on the nose, suggesting that this reference may be widespread. His eyes are somewhat wide, with white showing around the pupils, and his lips are eaten away in the center, exposing four teeth to view. His barely visible face paint is asymmetrical, a series of dark lines down his proper right cheek from temple to chin and from the edge of his mouth upward on the other side. The whiskerlike reference may be intentional. Although the black lines are faint, he also may have the individual hair eyebrows for his proper right eyebrow like those present in a number of visionary compositions (figs. 7.5, 7.9, 7.19, 7.21, 8.8, 8.10, 8.14). A further overt animal reference is the double bird headband he wears as an alter ego. Leishmaniasis survivors depicted in numerous works wear similarly prestigious animal headgear (Berrin 1997: 131, right; Lastres et al. 1943: plates IVb, Xb),[19] as does the Moche goblet (figs. 7.15, 7.16), along with a number of the portrait-head vessels of normative individuals (Duncan 2004: 59–63). The individual shown in figure 7.21 wears the fanciest type of Moche earspools with the encircling soldered-gold beads, only slightly less elaborate than those worn by the famous Lord of Sipán (Alva and Donnan 1993: 77–87; Stone-Miller 2002a: 100), and a bead necklace, again a simpler version of the most elite jewelry, since necklaces are relatively rare and high-status items among the Moche. The elevated social status of this person and the animal elements together suggest that he is a high-level shaman.

Prestigious garments and jewelry are found on the full-body effigies of leishmaniasis survivors as well. Most wear multilayer, tied, and decorated clothing; others sport earspools (fig. 7.19), an unusual type of animal headband, an iguana (figs. 7.22, 7.23), and the mushroomlike visionary head emanations (fig. 7.24). The iguana headband (figs. 7.22, 7.23) is an intriguing choice in that iguanas have a third eye that is barely covered by a thin membrane in their foreheads known as the pineal foramen (Rodríguez Schettino 1999: 22), making a powerful analogy with a visionary's enhanced internal, extra sight. The Carlos Museum example in figure 7.19 tilts his head as if listening intently and perhaps emphasizing enhanced trance hearing as well. The clothing of the prostrate person in figure 7.24 features zigzags and spirals, associ-

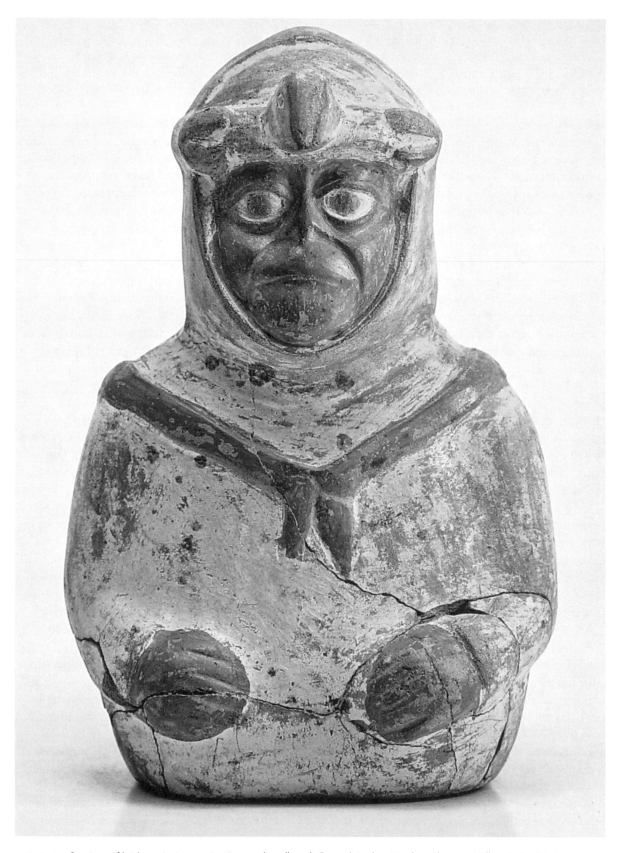

FIG. 7.22. Survivor of leishmaniasis wearing iguana headband. Central Andes, Moche, Chicama Valley. 200–600 CE. Museo Arqueológico Larco Herrera ML001505. Museo Larco–Lima, Peru.

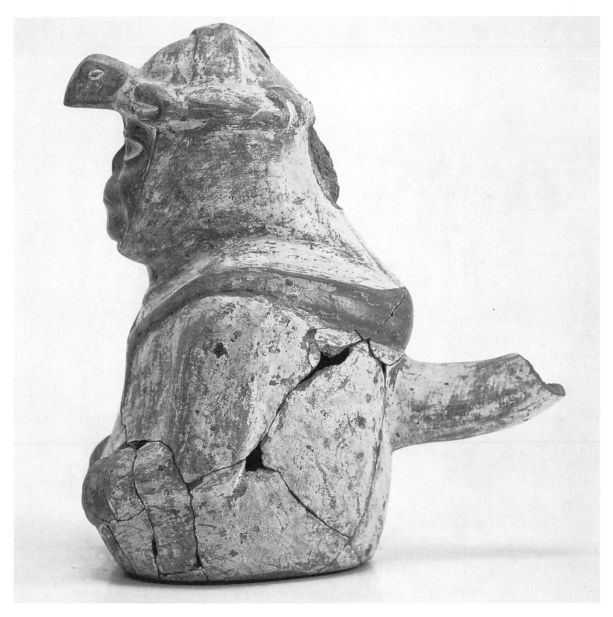

FIG. 7.23. Side view of effigy in figure 7.22. Museo Larco–Lima, Peru.

ating him with the undulating and spiral vision- ary movement types. This pose, which is found in a number of pieces, itself evokes the four-legged, horizontal position of a sea lion (Scher 2010: 226, fig. 5.171). We have seen sea animals as powerful shamanic animal selves, so this is not farfetched. The person lacks feet, and the protruding ends of the leg bones are modeled clearly. The Moche intentional mutilation of the limbs, especially the feet, is a far-reaching topic that I cannot consider at length here. I would only say that the result of whatever happened to this person is that he neces- sarily assumes a more animal pose.

Provocatively, Steve Bourget argues that what most call leishmaniasis could have been inten- tional facial mutilation (2006: 55–56; fig. 1.7). Even if true, the *imitation* of the disease's disfigurement shows that it was held in high esteem. Bourget suggests that the mutilation was "to transform the face of a living being into that of a skull, a sort of authentic living-dead" (ibid.), yet this is pre- cisely what a disease survivor embodies and a sha- man seeks to be. Making someone look like they had uta could carry a similar message to actually having it; the visual result of looking like a cat and surviving the loss of body parts remains in force.

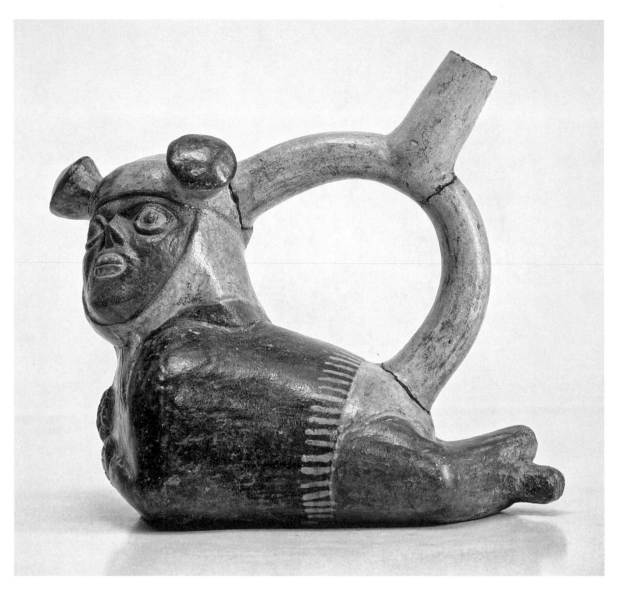

FIG. 7.24. Footless survivor of leishmaniasis with mushroom head emanations. Central Andes, Moche. 200–600 CE. Museo Arqueológico Larco Herrera ML001397. Museo Larco–Lima, Peru.

In any case, the high number of images that evoke leishmaniasis and the consistent inclusion of the full range of shamanic indicators underscore the spiritual and social status of anomalous physicality in Moche art.

WARI TRANSFORMING SHAMANS

In a completely different style and medium, Wari tapestry tunics contain images of half-animal, half-human beings that pertain to the center of the flux continuum. One fragment of a Wari tapestry tunic (figs. 7.25, 7.26, 7.26a), now

in the Peabody Museum of Archaeology and Ethnology at Harvard University (accession no. 1711), features a typical figure holding a staff, the body being human but the wings and head those of a condor. Despite a long engagement with this subject, I have yet to fully explore the now obvious point that these figures represent shamans in animal transformation and deserve to be renamed from "staff-bearers" to "transforming shamans." However, the formal analysis that dominated my previous considerations contributes to understanding how this distinctive Andean style and medium present the shaman in flux, recorporeal-

ized, suspended, and colorful.[20] Wari style basks in the illegible and the esoteric, its strong tendency toward abstraction appropriately removing the shaman from everyday naturalism. Other Wari tunics feature shamans betraying more animal characteristics (figs. 7.27, 7.27a, 7.28), and some go much further in abstraction, especially the "Lima Tapestry" (Stone-Miller 2002a: 148, illustration 119; 1992: 334, fig. 1), but this "middle of the road" piece well represents the Wari sensibility and allows shamanic messages to be interpreted.

Because of the level of abstraction and the number of shapes that make up each figure, such decoding is in order (fig. 7.26a). Beginning with the upward-facing head, it immediately lacks clear boundaries because it is assigned the same dark-blue color as the background of the figural column. The main eye of the figure is a typically

split rectangle inside a square outline (#1 in the drawing). Instead of having a human mouth, the hooked condor beak faces upward (#2). The ruff on condors appears as a notched element across the neck (the top part of #3).[21] The body consists of an arm (#4) and hand (#5), here disconnected due to the background color also matching that of the body, a bent front leg (#6) with foot facing forward (#7), and a rotated, bent back leg (#8) with foot facing downward (#9). Behind the back foot is a bird head (#10), two others of which appear on the top and bottom of the staff (#11, #12), the main body of which consists of nested squares and a sideways S pattern (#13). To the viewer's left of the main head is a headdress made up of bird heads (#14, #16), a spiral (#15), and an abstracted San Pedro cactus flower (#17). At the top left corner is the wing, made up of two

FIG. 7.25. Fragment of a Wari tunic featuring condor-transforming shamans. Central Andes, Wari, 600–800 CE. Peabody Museum of Archaeology and Ethnology, Harvard University, Copyright President and Fellows of Harvard College, 98540171 38–10–30/1711, Photo by Mark Craig.

FIG. 7.26. Detail of textile in figure 7.25. Photo by Mark Craig.

FIG. 7.26A. Drawing of one condor-transforming shaman from textile in figure 7.25. Drawing by Gabrielle Cooper and Nina West.

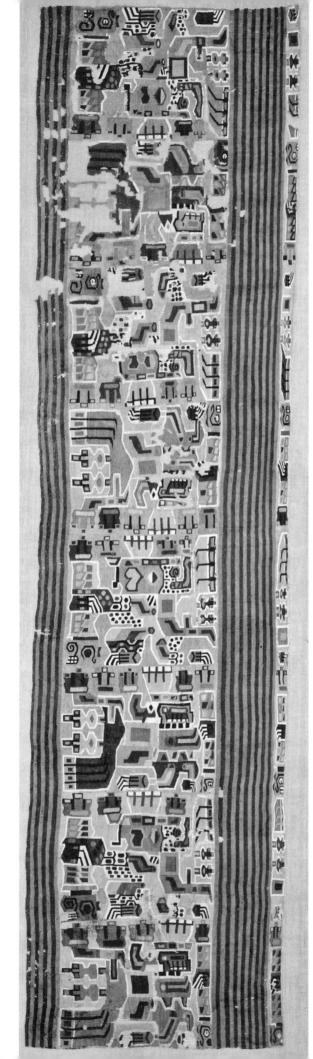

vertical feather elements forming a U ending in two squares (#18). There are additional shapes, but these take primacy.

These elements are understandably difficult to see and identify, particularly if one is unfamiliar with the abstraction process that leads from the readable figures on the Sun Gate at Tiwanaku to the Wari tunic versions (Stone-Miller 2002a: 146–147, illustration 118). I have repeatedly argued that the Wari premium placed on abstraction deliberately obscures the legibility of the figure. However, here I link this to the ways abstraction and illegibility help convey the shamanic visionary message. Certainly abstraction dissolves the coherent ego of the figure into extremely geometric patterning, which not only is an artistic process (Stone 1986: 140–143; 1987; Stone-Miller 1992) but also reflects the primacy of geometry in the experience of visions.

Another striking way to encode the dissolution of the transforming shaman as coherent "ego" has been mentioned: lack of distinction between the background color and some body parts. First and foremost, this makes the head float, boundaryless, in space. A head that is expanded, no longer part of the human body and no longer separate from the cosmos around it, perfectly encapsulates visionary consciousness. The head is predictably large and focuses attention on the transformation to bird taking place in the trance. By facing upward the head/beak helps create multiple orientations for the figure, which spins in space like Paracas-Nasca shamans.[22] The six other bird heads that make up and surround the figure and staff reiterate the role of animal spirits and auxiliary selves, underscoring the flying sensation and multiplicity itself.

The visual impression of a Wari transforming shaman is remarkably dynamic. At least 129 individual shapes, plus the background, make up this figure, and in other pieces there are often 180 or more (Stone 1987: 77). The atomized shapes—many of which are the same nested squares—

FIG. 7.27. Wari tunic fragment with condor- and jaguar-transforming shamans. Central Andes, Wari, 600–800 CE. Staatliches Museum fuer Voelkerkunde Muenchen, accession number 34-41-41. Courtesy of Staatliches Museum fuer Voelkerkunde Muenchen.

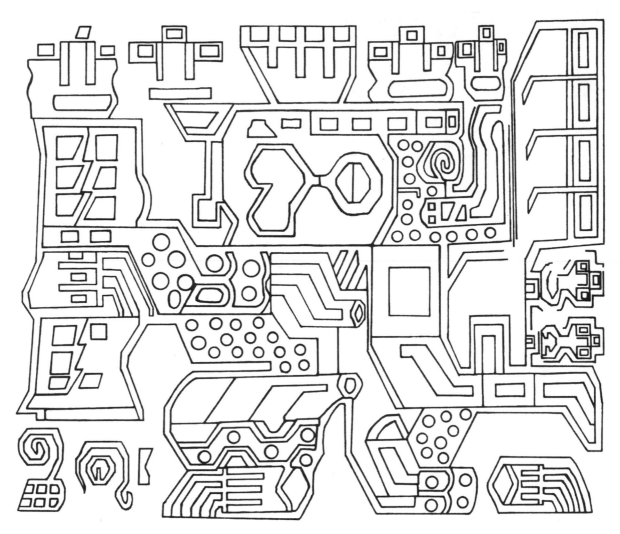

FIG. 7.27A. Drawing of one jaguar-transforming shaman in textile in figure 7.27. Drawing by Nina West.

have blasted apart a coherent, simple being and thus effectively dematerialized it as a figure and a human. The body, though outlined, remains difficult to grasp as "figure" because it swims in a sea of distracting elements and may also be the same color as the background. Granted, only one-fourth of the figures' bodies match the background color in the tunic as a whole, but those that do represent only a slightly more recorporealized version than the others; the Wari style calculatedly strips the figure of its perceptual unity.

This background-as-figure effect makes the already animalized being continuous with the environment in a manner eerily reminiscent of descriptions of perceived bodily distortions during trance ("the right half of [his] body was felt to be completely continuous with the outside surround-

ings"). The figure's thumb is likewise the color of the background, as is the connection between arm and hand, further severing the bodily gestalt and referencing another visionary effect ("with regard to his left hand, there was no 'feeling of continuity' with the rest of the body"). Thus, the transforming shaman is portrayed as more spiritual, essential, taking a form that relates to the human but that fundamentally has been altered. The body is not altogether there yet remains perceptible, as contemporary shamans like Doña Isabel describe themselves ("I touched the emptiness [of the sky] in spite of the fact that I was really sitting on the ground").

In fact, I argue that this shaman is identified as having taken San Pedro cactus in order to recorporealize himself. He wears a shorthand sym-

bol of a prime entheogenic substance as part of the headdress: element number 16, what I am proposing to be an abstracted San Pedro flower (fig. 7.29). The decoding begins, as before, with Tiwanaku sculpture, specifically the Bennett Monolith. On the back of this monumental figure are many incised images, including a realistic llama carrying on its back a branching plant with flowers on the top of each branch (fig. 7.30). I believe it represents the San Pedro cactus, as first suggested by Kolata (1996: 195–196, his fig. 7.27). The columnar, curving, then vertical, thick, branching elements, the position of the flowers, and their radial projections all visually echo the tall San Pedro cactus with its spectacular white flowers ten inches in diameter that indeed project from the tops of the branches (figs. 7.29, 7.30). The images essentialize the flower, since, as Knobloch has pointed out, "Wari depictions of plants were highly simplistic as two-dimensional flat shapes symmetrically positioned rather than naturally rendered" (2000: 390). The flower itself has a bulb with multiple long, white petals radiating outward, the lower range sometimes red-tipped, while the Wari version abstracts it into three top petals with different-colored tips coming up from a circular base (figs. 7.26a #17, 7.29).[23] On the Bennett Monolith, the same plant and flowers grow out of several motifs: disembodied heads (suggesting the spirit of the plant), the crown of a figure like the Sun Gate's central Puma Shaman and out from his feet, and the tails of bird-headed headbands on numerous figures. The flower overlaps with feather imagery, not surprisingly since the San Pedro cactus gives the sensation of flying during altered consciousness. Knobloch notes that the *Anadenanthera* plant icon likewise may be appended to the winged eyepiece common in Wari figures (2000: 394);[24] conflating wings, plants, and eyes is a wonderfully succinct code for visionary experience. In Wari textile versions of the San Pedro flower motif, the parts may be squared off and the number of tipped petals reduced to two, as here; however, they almost universally bloom on the branch tips and are nearly always white. Again, this echoes how the *Anadenanthera* can be shown with the circular flowers as squares in more abstract versions (ibid.). Consistent placement of the San Pedro flower in the headdress restates its natural position on the top of the cactus and locates the entheogen and

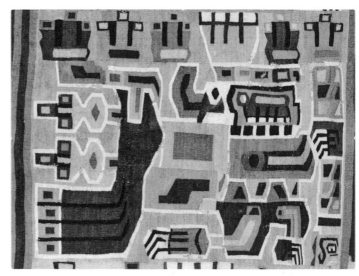

FIG. 7.28. Detail of condor-transforming shaman in textile in figure 7.27. Courtesy of Staatliches Museum fuer Voelkerkunde Muenchen.

FIG. 7.29. San Pedro cactus flower in bloom. Courtesy of Chaskes and Corral.

FIG. 7.30. Drawing of llama carrying a flowering San Pedro cactus (*Trichocereus pachanoi*) from the back of the Bennett Monolith. Drawing by Nina West (after Posnansky 1945: fig. 113a).

figure is calling the San Pedro spirit, announcing its presence, vomiting, or all of the above. Such "speech scrolls" are almost nonexistent in ancient Andean art, though they are typical of Meso-american art (Houston and Taube 2000). This rarity makes such a detail important, showing how the artist seeking to convey the vision state generates novel devices. This wavy scroll reiterates the ubiquity of undulation as well. The proliferation of San Pedro flowers in these figures seems to correlate with their being more jaguar-transformed shamans, shown as exuberantly spotted on the muzzle and limbs, having clawed hands and feet, and displaying an unabashed visionary spiral for a nose (fig. 7.27a). In another example of shamans being depicted as different, the condor-transforming figures' wings are shown upside down, an inversion perhaps referring to his being in the Underworld and certainly disorienting and creating spinning motion. In this figure (7.28) the eyepiece is an inverted San Pedro flower motif, suggesting the message that the plant takes the eye to the opposite reality of the Other Side. Finally, one of the spotted figures has a color anomaly,[26] a single bright-blue jaguar spot, indigo being the transformational dye. The jaguar-transforming shaman is perfectly represented by such an anomalous blue spot; it is his jaguar self that is equally prestigious, distinctive, and shape-shifting as the unpredictable indigo dye (Stone n.d.b).

Fully tracing the San Pedro flower motif throughout Wari art remains for a future study, but it marks the shaman and the trance wherever it appears, and it is indeed ubiquitous. Wari abstraction may obscure it to a degree, as it does all elements, yet the presence of the Other Side is invoked continuously in this style, reminding us of the absolute centrality of trance consciousness in Andean art.

We can now turn to the animal-dominant and overtly visionary Andean works to complete these case studies of images of shamans in trance.

its visionary effect in/on the head, especially the crown, where spiritual interchange takes place.

Other Wari tunics include many repeats of the San Pedro flower motif (figs. 7.27, 7.27a, 7.28; Staatliches Museum fuer Voelkerkunde Muen-chen, accession no. 34.41.41).[25] There are between six and nine San Pedro flowers per figure in this tunic fragment, each one in the center of the headband, on the top of the staff, or—remark-ably—coming out of an undulating emanation from the mouth (figs. 7.27a, 7.28). The latter element is rare and significant and may signal that the

SHAMANIC EMBODIMENT IN ANCIENT CENTRAL ANDEAN ART II

TOWARD THE ANIMAL END AND BEYOND THE FLUX CONTINUUM

Andean cultures seem to favor representing the middle of the human-to-animal continuum; however, artistic exploration of the nonhuman extreme was also important. Moche art in particular traces a path from the mimetic to the frankly abstract, ultimately celebrating the dynamically chaotic experience of visions.

TOWARD THE ANIMAL END OF THE FLUX CONTINUUM

MOCHE OCELOT SHAMAN

A seated cat-human effigy was previously identified as a jaguar wearing a scarf to indicate its human self (fig. 8.1; Carlos Museum, accession no. 1989.8.164; Stone-Miller 2002b: 232–235). However, currently I believe it represents a transformed ocelot shaman shown as a potential victim by a rope around its neck. Nevertheless, the dress element and the recognizably level, almond-shaped human eyes helped me conclude that, "like the goblet . . . this is a human gone feline, a feline going human, or both" (ibid.: 235). The human in the feline is found in the eyes that tend toward the human side. The feline is clearly dominant elsewhere in the effigy, and while it does not change the basic dynamic of transformation, *which* feline alter ego is important as regards the relative position in the hierarchy of shamanic prestige. Being an ocelot helps explain the presence of the rope, seen on Moche images of human prisoners, often of previously high rank (Donnan 2004: 120–123; Scher 2010: figs. 2.4, 5.44, 5.46–5.54, 5.56, 5.57, 5.75), and on human-deer figures, expressing the analogy of the hunt with warfare and sacrifice (Donnan 1997). As previously discussed, ocelots as smaller versions of jaguars can well represent a

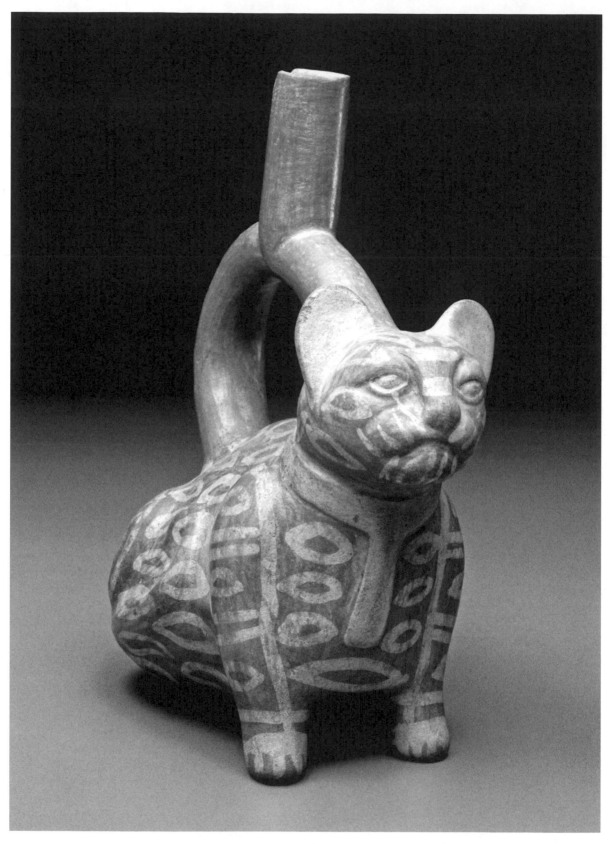

FIG. 8.1. Seated Moche ocelot shaman effigy stirrup-spout vessel. Central Andes, Moche, 200–600 CE. Michael C. Carlos Museum accession number 1989.8.164. Gift of William C. and Carol W. Thibadeau. Photo by Michael McKelvey.

shaman of slightly lesser status, one that might be metaphorically captured by a top jaguar-shaman during trance-state spiritual warfare.

A number of features reinforce the ocelot reading, from markings to ears, tail, paws, whiskers, and the seated position. First, the markings being open almonds rather than circular rosettes and the strong lines on the face and legs are telltale indications of an ocelot (figs. 7.17, 7.18) and not a jaguar (figs. 4.19, 5.22), as we have seen. Rather than depicting these mimetically in long, wavy shapes as in the Moche goblet (figs. 7.15, 7.16), the artist here chose almond-shaped spots that mimic the shape of the figure's humanoid eyes. That the English word for ocelot derives from a root that means "spots like eyes" may well reflect a resemblance the Moche also noted. The visionary implications are clear: an animal that looks like it is covered with eyes forms a natural shamanic alter ego that can see more in visions and specifically see with the body in a synaesthetic manner. Earlier Chavín felines shown with matching eyes and spots come to mind (Stone-Miller 2002a: 32, illustration 21). Like the Pataky jaguar (figs. 5.18–5.21), however, the artist has reversed the natural color of the markings, making them light on dark. Looking at a number of images of actual ocelots allows one to see that the relatively large, long, closely spaced spots make it possible to read the light, plain areas of the background almost as "figure," and so in an odd way, the coat itself may visually reverse. But it is not necessary to claim that ancient peoples saw it this way, given the strong tendency for spiritual imagery to invert key aspects of terrestrial reality, appearances, and images. The light spots can serve again as an artistic strategy to place the effigy double on the Other Side and provide the proper recorporealizing distance from normalcy.

Two marking details likewise point to an ocelot. First, while jaguars are spotted on the feet as well, most ocelots have fewer, smaller, or no spots on their feet, another realistic aspect captured here. Attention is drawn to this characteristic by making the feet white, in fact. Second, although the actual animals do not have stripes on their noses as in this rendition, they have vertical stripes above the nose and strong horizontal ones sideways from the outer edges of the eyes. The artist took some license, evidently, but related the markings to those of ocelots and not jaguars, since jaguars definitely lack facial striping.

Several aspects of body treatment indicate that the smaller feline is portrayed in this piece. Ocelots' relatively larger, whiter, and more oval-shaped ears relative to those of jaguars are clearly illustrated here (figs. 7.17, 7.18). So, too, the smaller cat's significantly shorter tail, curled up the proper left back leg, is not painted separately and remains underplayed. The body's spots traverse it as if it were not there, in another instance of the two-dimensional and three-dimensional messages being at odds in visionary imagery. Furthermore, ocelots nowadays are nicknamed "fat hands" in South America for their outsized, puffy forepaws (visible in fig. 7.18; Sunquist 2002: 121), and here the artist did not even model any back paws, emphasizing the front ones, which are completely white and have deep triangles for the toes. Finally, ocelots have long, white whiskers, here painted all around the mouth relatively naturalistically.

Perhaps most provocative in regard to reidentifying the species, one of the main ways ocelots hunt is the "move and sit" method. The animal sits for thirty to sixty minutes, then changes locations by moving faster than usual (ibid.: 122). This is the opposite strategy of jaguars, which move almost continuously as they hunt. Thus, the sitting pose in this effigy supports reattribution. Ocelots stay quiet when sitting so game will not be scared off by their presence; perhaps this suggests why the cat's mouth is closed here. An ocelot, while wild, is not inherently as dangerous as its larger counterpart the jaguar and may appropriately be shown in a less aggressive manner here.

Another nonaggressive aspect of the effigy is certainly the rope around the neck. Moche depictions of such ropes often have diagonal black lines to realistically represent spin or ply (Donnan 2004: 129, fig. 7.32). Tied around naked captives prepared for sacrifice, the end usually dangles down the front as here. Since some of these captives are shown as composites of humans and animals, specifically deer, this roped effigy being similarly human-ocelot has a precedent. By similar implication, this ocelot has been vanquished, and if it does represent a shaman in his ocelot self, then the struggle implied here was a spiritual one. It makes sense as well to show a defeated rival shaman as an ocelot, lessening his or her power and hierarchical

standing in an analogy with the animal kingdom pecking order.

In sum, in the eyes and the rope is a hint of the human shaman within his ocelot self, which has taken over in all other aspects. These details warn us to look very closely at what seem to be animal figures and to correlate social context and the natural appearance of specific species carefully in our search for the meanings behind shamanic effigies at all locations along the continuum.

BEYOND THE CONTINUUM

MOCHE PARASITIC TWIN SHAMAN EFFIGY

Not only the blind and those who have lost limbs (figs. 7.3, 7.5–7.9) as well as the survivors of disfiguring disease (figs. 7.19–7.24) but profoundly anomalous bodies also are commemorated in Moche art and suggest that such individuals probably played a shamanic role. One unusual effigy (figs. 8.2, 8.3), now at the Phoebe A. Hearst Museum of Anthropology at the University of California at Berkeley (accession no. 4-2974), shows polycephaly, or two heads.[1] This may depict a set of asymmetrical conjoined twins who both physically function independently but more probably represents what is called a parasitic twin, one who is vestigial, unconscious, and externally attached to the functioning one (Anandakesavan 1998: 1027). Moche (and Costa Rican) depictions of equal conjoined twins exist, though not many, in keeping with the rarity of this condition among human populations.[2] In this effigy, however, the smaller head appears dead or semideveloped, shown lolling forward and lacking any real eyes or nose. The arm below this head is painted on, its two-dimensionality contrasting clearly with the modeled arm under the larger head, reinforcing a dichotomy of formed versus semiformed elements. Under the large head are two small, bent knees, but one bent knee appears under the small head. The two remaining feet are ambiguous regarding to which figure they belong. Since the bottom edge of the piece is somewhat broken, it is not possible to determine the exact original configuration, but the artist avoided clarification among three legs and at least two feet. A parasitic twin may not display the full complement of body parts, or parts may meld into the functioning twin's body, so this artistic ambiguity goes along with the physical realities of the condition.

No matter the modern diagnosis, the image effectively conveys a being with two heads, and such a condition fits with shamanic values by manifesting in this reality the two-headed imagery prevalent in expressions of the Other Side (figs. 4.2, 4.14, 4.15, 4.17, 8.4–8.7). It also provocatively dovetails with Cobo's comment mentioned earlier about Inka twins becoming shamans. In general, a person with the remains of a parasitic twin would naturally be seen as someone who is simultaneously alive and dead, who is frankly dual (huaca), who crosses physical/cosmic borders all the time, a shaman times two. Shamanic dual visionary consciousness would be embodied directly, one head with eyes that are active and the other the opposite. Both could be understood as seeing in a nonordinary way, the inert or less responsive head permanently in the Other Side and the live one a frequent visitor there, according to her entranced expression. If physical distinctiveness were seen as predisposing one to the role of shaman—showing that one was already a curer, in touch with the dead, seeing visions, and so forth—then a person born with two heads would exemplify such an already-shaman in the extreme.

On the larger head the facial expression with the lips exaggeratedly pursed but open is key to interpreting this as a spiritual practitioner. This mouth position is known as *much'ay* in Quechua (converted to *mocha* in Spanish), meaning to adore or revere, kiss, touch with the lips (Laime Ajacopa 2007). In Inka culture *much'ay* was a way to worship natural phenomena such as the sun, moon, and stars, the huacas, stones, and lagoons.[3] "Bending their backs and puffing out their cheeks, they blew their breath toward him, making the *mocha*, which is like paying obeisance" (Cieza de León 1959: 183). Since it was a gesture that existed in pre-Inka times, if it retained its same or a similar meaning of recognizing the spirits in natural phenomena, then this may be taken as a shamanic gesture in this piece. Certainly blowing in general constitutes a core shamanic act that continues to the present, and, being illustrated in Moche art (Scher 2010: figs. 5.94, 6.9–6.13), the *much'ay* gesture may be one of its most ancient Andean expressions. Significantly, another Moche piece

combines the much'ay mouth with round eyes and the animalistic eyebrows (ibid.: fig. 2.15).

The larger head has obvious wide-open trance eyes accentuated with red outlining on the upper lid and wears a red cowl, the well-known garb of female curers from ancient through colonial times (Sharon 2000: 9–11; figs. 41, 42, 46–92, 95–98). Here, however, there is an odd treatment of the cowl as more of a cape. It also comes to a blunt peak, and in places the white of the body seems to show through or split the garments, suggesting two interpretations, both transformational. From the back (fig. 8.3), the pointed cowl and the almond-shaped white opening on the larger head create a second reading of a bird beak and eye, a thin white-filled indention separating the two parts of the beak. The other side of the person's head being an abstract bird is yet another way to show the animal self and suggest the flying experience in visions. Quite a number of the cowled female healers have bird alter egos, with owl-transformed facial features and the cowl itself associated with the barn owl's head coloration (ibid.).

On the smaller head showing through the cowl is a white, upside-down, V-shaped depression that does not have as overt a reference as the bird. However, it relates to the other types of clefts, openings, or rents that I think signal internal but emergent selves in visionary compositions (figs. 7.14, 8.15, 8.16). These openings that disclose lower layers of the figure remain enigmatic, which in itself can be linked to the shamanic premium placed on ambiguity and mysterious corporeal effects. There is another diamond-shaped rent, this time in red and thus contradictory to the others, between the knees under the larger head. If it is meant to make spatial sense, which indeed it may not, then it implies that the body is red and wears first a white garment and then a red garment over the top. Yet, the feet and faces are white and only the arms are red, so the ambiguity remains as to what color the body is and indeed what is body and what clothing.

The mental gymnastics necessary to maintain the image of a red body with a white head and feet under two layers of clothing mean that the artist has successfully created a visually confusing configuration, in keeping with the anomalousness of this being and its ineffable location Elsewhere.

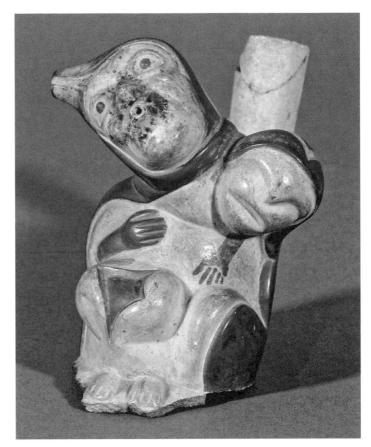

FIG. 8.2. Front view of parasitic twin effigy stirrup-spout vessel. Central Andes, Moche, 200–600 CE. Courtesy of Phoebe A. Hearst Museum of Anthropology and the Regents of the University of California, Photography by Alicja Egbert (Catalogue No. 4-2974).

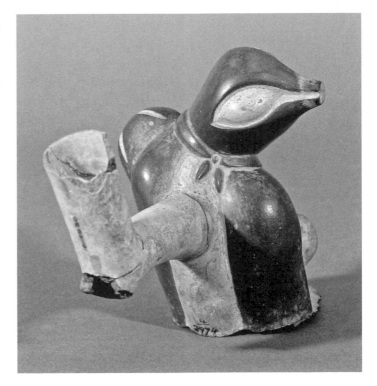

FIG. 8.3. Back view of effigy in figure 8.2. Photography by Alicja Egbert.

The rents and the layering promote the interiority, or internalism, central to the visionary aesthetic, in which the essence and the hidden selves revealed in trances reign supreme (Stone-Miller 2002b: xix-xxii). Simply perceiving some body parts as one color and some apparently as another creates a disturbing discontinuity in the gestalt and helps call into question corporeality itself. This profound ambiguity is epitomized in a body as patently unusual as this one, fully engaging the overall paradoxes inherent in the shaman's fundamentally contradictory Selves. One visible, living, bird-spirit self is Here, while the parasitic twin remains deeply liminal. Such a permanently dually conscious body encompasses the profound multiplicity of the shamanic being.

CHAVÍN DOUBLE FELINE-SNAKES

The ancient Andean artistic choice of the two-headed theme, played out in more abstract terms, continues further along the transformational continuum and in earlier times as well. Two Chavín-style vessels, a blackware in the Cupisnique style (figs. 8.4, 8.4a; Museo Larco Herrera, accession number 10863) and a slip-painted example of the Santa Ana substyle (figs. 8.5–8.7; Carlos Museum, accession number 1991.2.223; Stone-Miller 2002b, the Carlos Museum entry: 221, catalogue no. 505), represent highly abstracted encapsulations of the visionary mode. Both have potentially reduced the entranced shaman to two transformational heads connected by a snakelike body, examples of cephalocentrism in a radical form. The heads relate to the basic type that appears throughout Chavín-style art, especially on the sculptures at Chavín de Huantar, such as the famous relief of the shaman carrying the San Pedro cactus and becoming a winged jaguar being, with his transformed jaguar self below (Stone-Miller 2002a: 30–33, illustrations 20–22). Pendant-pupil eyes, fanged mouths, and spiral ears and/or noses are the common features that suggest that these very abstract versions are indeed renditions of shamans. The teeth on the Santa Ana piece are square and do not feature canines; thus they point to the human element. In both pieces the ears are set on the back of the head on the level of the eyes as in a human head and not on the top as in a feline one. Even if this enigmatic entity is not to be literally interpreted as the sha-man but rather what she or he sees—the Andean-style Vision Serpent—it epitomizes the beyond-the-continuum experience in which what the shaman experiences and "is" may no longer appropriately be teased apart. Having gone well past the limits of the human body and the terrestrial plane into some ambiguous zone of elemental beings, even these seemingly stable categories of seeing versus being seem to evaporate. The artists have created deeply essential expressions of interconnection, transmutation, and an almost entirely contested corporeality characteristic of the Other Side.

The double-headed entity found on each piece has definite snake characteristics, the "body" making the archetypal serpentine S curve that may be fully curvilinear (fig. 8.4) or unite a straight portion with a curved one (figs. 8.5–8.7). However, in neither composition does a snake end straightforwardly in one head as in a terrestrial snake or in two heads facing away from the body as in a Mesoamerican Vision Serpent. In the blackware, the serpentine forms the tongues of two heads, or at least connects them mouth to mouth; in the red and black piece it extends from the fontanel of one head into the mouth of the other. Despite the pointed snouts, none of the heads are completely snake, either, but add feline elements, especially by featuring trance eyes with the telltale pendant irises of cats. It is tempting to call the blackware a dark jaguar-snake and relate the bichrome piece to tawny or chocolate jaguar coloration. Be that as it may, the feline and the snake are often inextricably linked, not only in Chavín iconography but also in many Andean oeuvres.[4] They certainly are interrelated in visionary experience as well, the snakes introducing the feline transformation, among other ways of being intertwined, such as the person's experience of being a snake at one point in the vision and a jaguar in another. Thus, especially as the artist approaches the edge of the continuum, the strict identification of iconography becomes more of a Western than a shamanic preoccupation. The various swirls, teeth, and lines on the heads purposefully may not differentiate species, in keeping with communicating the fluidity of form and lack of boundaries that visions promote. How the snake elicits the jaguar in visions is better communicated visually by a being that shades from one into the other, not one that creates distinctions where they no longer apply.

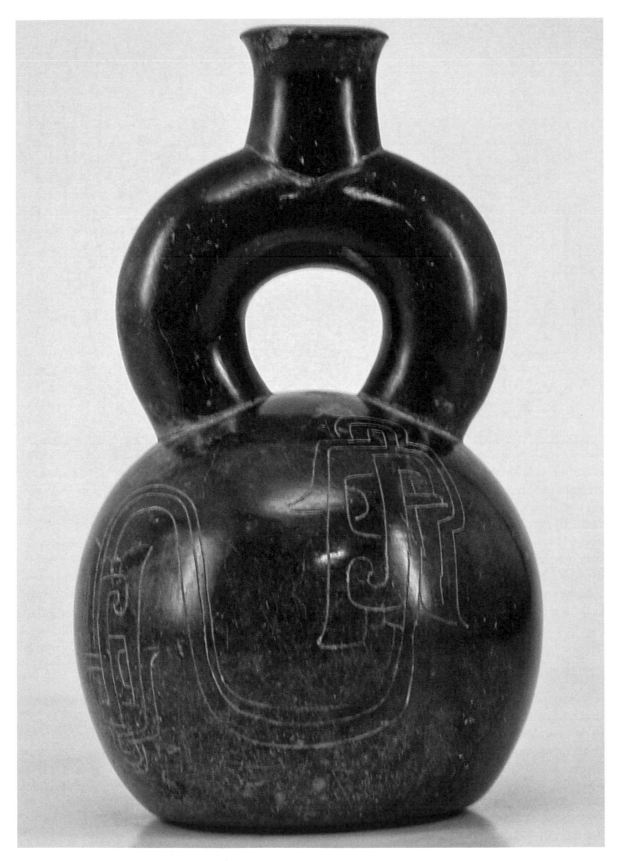

FIG. 8.4. Blackware two-headed snake-motif stirrup-spout vessel. Central Andes, Cupisnique, 900–200 BCE. Museo Arqueológico Larco Herrera ML010863. Museo Larco-Lima, Peru.

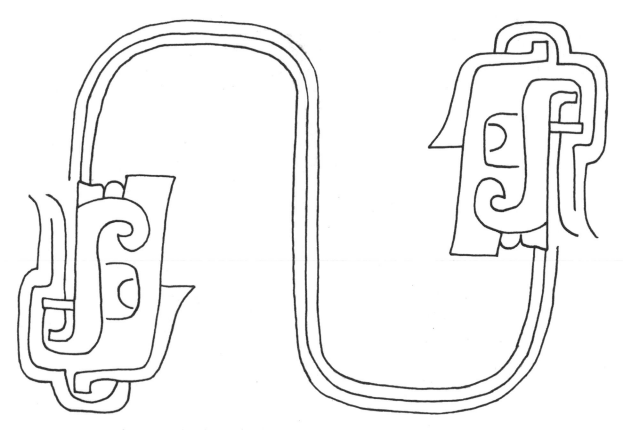

FIG. 8.4A. Drawing of two-headed snake motif on the vessel in figure 8.4. Drawing by Nina West.

Perceptual clarity also is subverted in various ways. In the blackware Cupisnique piece (fig. 8.4) the characteristic barely visible, postfired-incised lines of gray on black are all that constitute the figure. To attempt to read the imagery, one must turn the piece to encourage reflected light to catch the shadowy lines. This is considerably more difficult than with the Costa Rican blackwares, as the lines are even more delicate and shallow. The double-headed motif does not completely fit into the field of view when the stirrup spout is aligned parallel to the viewer; in other words, the "front" of the pot frustrates the desire to see the whole motif, as seen in figure 8.4, where the head to the left is almost out of view. Similarly, even in the Santa Ana example, with its color contrasts and the prefired-incised outlines accentuated with white kaolin, making the figures easy to differentiate from the ground, perceptibility is still withheld because one head is also always cut off in a single view. In both cases, therefore, the viewer must put the parts of the image together as much mentally as visually. That simple device makes a powerful statement about the inaccessibility of

the Other Side, the way everyday viewing must be adapted to the nonordinary, and how moving the image must somehow be induced to approximate the circular spinning of the supernatural realms.

Compromising the composition's symmetry in these ways adds visual tension, and by moving the piece to resolve it the viewer experiences the transformation of the serpentine form. In the case of the Cupisnique vessel, the snake form that acts as the tongue of one head becomes the tongue of another head, which is morphologically similar but facing a different direction (fig. 8.4a). The head on the viewer's right faces down, the one on the left up; perhaps this references the lower and upper cosmic levels a shaman traverses, as in other Chavín works.[5] By contrast, in the Santa Ana piece the snake emanation goes from the fontanel of one head to become the tongue of the other, though both heads keep the same upright orientation.

Thus, each artist has kept one formal aspect constant and changed another, successfully establishing dynamic flux. Both schemes are prime examples of contour rivalry employed as the

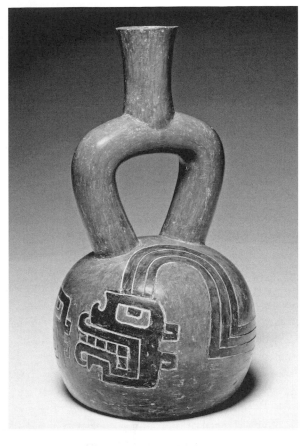

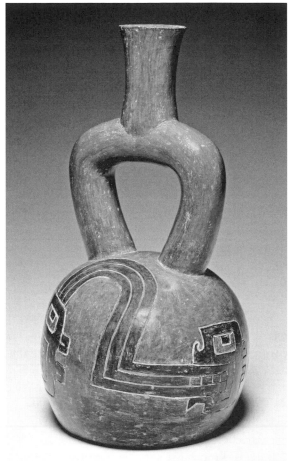

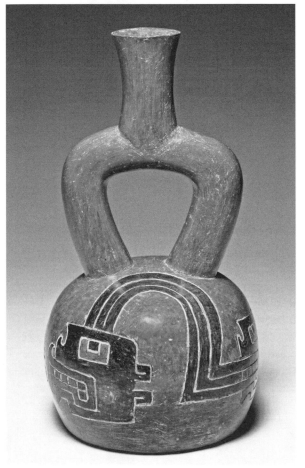

FIG. 8.5. (Top left) Side of polychrome vessel featuring two-headed snake-motifs, one head with fontanel emanation. Central Andes, Chavín, Santa Ana substyle, 900–200 BCE. Michael C. Carlos Museum accession number 1991.2.223. Gift of William C. and Carol W. Thibadeau. Photo by Bruce M. White, 2009.

FIG. 8.6. (Right) Side of vessel in figure 8.5, head with tongue emanation, connected to head in figure 8.5. Photo by Bruce M. White, 2009.

FIG. 8.7. (Bottom left) Side of vessel in figure 8.5, other head with fontanel emanation. Photo by Bruce M. White, 2008.

artistic strategy to bind two images into one that changes, a typical choice in Chavín art (Stone 1983: 68–70; Stone-Miller 2002a: 36). The serpentine lines are the same throughout their span, but somewhere in the middle—fully exploiting the productive "between" of liminality—one head flips over or a tongue becomes a head emanation, so that when the eye arrives at the other end the lines have magically assumed a different role. The angle change in the serpentine of the red and black example almost marks this change point, but the viewer still does not fully discover what the lines have changed into until the eye reaches the other head. This is a very effective way to convey the essential multiplicity of one being, a recurring theme in Chavín art (Stone-Miller 2002a: 36, 39, 40, 46) as well as other Andean styles (Stone-Miller 1994: 153–154).

Both pieces mutate but also markedly dematerialize the dual being. The blackware linear entity is almost completely "transparent" since the background black and the figural black are one and the same, as in the Belen examples from Costa Rica. The lines are sufficiently complex and closely spaced to cohere but not in a forceful or stable way, also because they are shallow and elusive. Thus, it is as much the *idea* of a two-headed feline snake as it is an image of one. In this way the artist has conveyed the reality—yet the deeply ephemeral nature—of phenomena on the Other Side. The Santa Ana snake-feline creates a more palpable figure on ground reading—black coheres on top of red—yet it qualifies that spatial relationship in one important place. The eyes have black pendant pupils, but the background of the eye is the same red as the background of the composition, so the eye becomes partially transparent. Likewise, the black head is revealed as thin and permeable. This choice of a transparent feline trance eye makes a wonderfully apt shamanic statement about seeing, and being one with, the rest of the cosmos, which is captured as part of the seer. By creating an overarching unity of seer and seen, the shaman as fundamentally Beyond is conveyed. Once again, the bodily experience of the visionary as physically continuous with the environment is applicable, too, as is the perspective of X-ray vision that is possible during trance. Furthermore, transparency that comes and goes, applying only

to the eye, very creatively communicates flux as a function of visionary seeing.

The treatment of the eye can be taken a few steps further. The head emanation is subdivided into three sections by the white-filled incised lines. In either of the left-hand heads (featured in figures 8.5 and 8.7), the white-outlined pupil spans the same width as the central third of the fontanel emanation and is positioned directly below it. Perceptually, the viewer wants to make the two continuous, as if the pupil is really also the beginning of a part of the emanation that runs behind the thin plane of the head. In a right-hand head (seen in figure 8.6), that same central section of the fontanel emanation turns into the first tooth of the mouth emanation, a square just like the pupil but now a completely different body part. More flux occurs at a subliminal level. There is a unity, the square shape, that nevertheless changes its character depending on where it occurs; likewise, the shaman never stops being the shaman, yet she constantly changes. Thus, the innovative artist has subtly manipulated the connecting serpent element to send a complex message: the act of seeing through the eyes of one's animal self, here represented by the pendant pupil in a transparent eye, seamlessly entails the serpentine fontanel emanation, that is, visions that are introduced by snakes. This connection communicates that visions are what give the self another "head," a new, doubled consciousness, an expanded self. The visioning self (the head with the fontanel emanation) leads to and from the self that speaks, chants, vomits/ingests (the head with the "tongue"), illustrating that both the centripetal and centrifugal are inextricable aspects of the shaman. The tongued head that chants is perhaps more Here and "before" (one vomits early in the process and sings to bring on the animal spirits), but since they are interconnected and have the same cosmically transparent eyes, they are clearly presented as parts of the same being. The shamanic corporeal paradox has been presented and bridged with aplomb in a spectacularly bodiless image of recorporealization at its most reductively expressive.

In the blackware version, the two heads more equally sing/vomit/ingest one another into existence, but the idea at base remains the same. The viewer swings back and forth along the serpen-

tine path from one head to the other and irrevocably understands their unity, spinning change, and unity again. These two masterful compositions, perhaps deceptively simple at first, nevertheless embody the complexities of visionary-realm liminality. They demonstrate the creative role of ambiguity that is achieved through abstraction and especially how well contour rivalry conveys shamanic flux. That ancient American artists developed many creative ways to represent this ambiguity of shaman and animal spirit, from fully volumetric back-to-back bodies (figs. 3.1–3.3) to this, becomes manifestly obvious.

MOCHE VISIONARY PORTRAIT HEADS AND SCENES

Flux and multiplicity come to the fore in the most Beyond of the Moche ceramics, perhaps of all Andean art: those that I call simply Visionary Scenes, meaning they directly illustrate what was seen in a vision and how trance kinesthetically feels (figs. 8.8–8.17). A relatively large number of examples exist—the Museo Larco Herrera has sixty-nine—yet few have been published (Berrin 1997: 116–117). No doubt this is partly because it seems daunting to find a name for them, given the apparently unrelated, fantastical, and partial beings they celebrate. Attempts range from "relief fantasy scene" (ibid.) to "horrifying world" (the Museo Larco Herrera's category) to "abstract supernatural collage" (Donnan 1978: 100). While all these terms capture something of the character of such anomalous compositions, they avoid the crux of the matter: What is being depicted? The compositions display motifs that usually can be identified individually but that collectively represent a level of visual chaos unprecedented elsewhere in the corpus. While there may be connections among the animals, skeletons, faces, shells, fruits, flowers, knives, and more in stories now lost to us, elsewhere in Moche art narratives of stories or actual rituals are unquestionably presented in a much more standardized and coherent fashion, even when we have yet to decode the referent. For instance, the Sacrifice Ceremony is organized along two registers, with the prisoners of war being ritually bled from the neck below the procession of officials bringing the goblet of blood

to the Lord of Sipán above (Berrin 1997: 164–165). Curing scenes clearly organize the tools and the patient around the healer (ibid.: 136). Sea lion hunts logically unfold around the body of a vessel, and so on (ibid.: 113).

Because these Visionary Scene compositions are unabashedly asymmetrical and barely legible piles of often partial images, I argue that they step entirely outside narrative in the everyday world and depict the later stages of visions in which frankly bizarre, fast-moving, and changing imagery occurs. They are images whose disorderly reversal of the expected has a strong place in the Andean worldview: the later Inka refer to cataclysmic, chaotic events as *pachakuti*, and they serve as a necessary periodic restructuring of the social, political, and I would add spiritual order (Babcock 1978; Classen 1993: 50, 109–110; Stone 2007a: 406–408). Setting up and breaking down order is an Andean predilection in the artistic realm, as the key role of the formal anomaly in Wari and later textiles attests (Stone 1987, 2007a; Stone-Miller 1994: 165–167, 174–175). Closer to home, the Moche theme called "The Revolt of the Objects" shows animated spears and various implements attacking their owners (Quilter 1990); this is so pervasive that in modern times the same theme occurs, according to ethnographers (Allen 1998). Yet the Moche Visionary Scene vessels' brand of disorder is more extreme and pervasive still; there is not an orderliness periodically challenged by anomalies as in Wari art or a coherent side and an illegible one as in the Carrillo head (figs. 6.19–6.22), for instance. The scenes of objects revolting are frenzied, but they remain readable in the same way that battles do elsewhere in the Moche corpus. The Visionary Scenes are artistic tours-de-force, breaking all the rules to promote full-scale ambiguity, and thus they reflect the experience of trance uniquely and directly.

Visionary Scenes feature head effigies, thus including visions and visionaries in the prestigious portrait-head format alongside those of leishmaniasis survivors (figs. 7.20, 7.21). One piece features a relatively normal head in which multiple eyes appear in places where eyes do not usually occur (figs. 8.8, 8.9). Another distorts the head shape and pulls the facial features into a swirling composition, then adds other beings all over

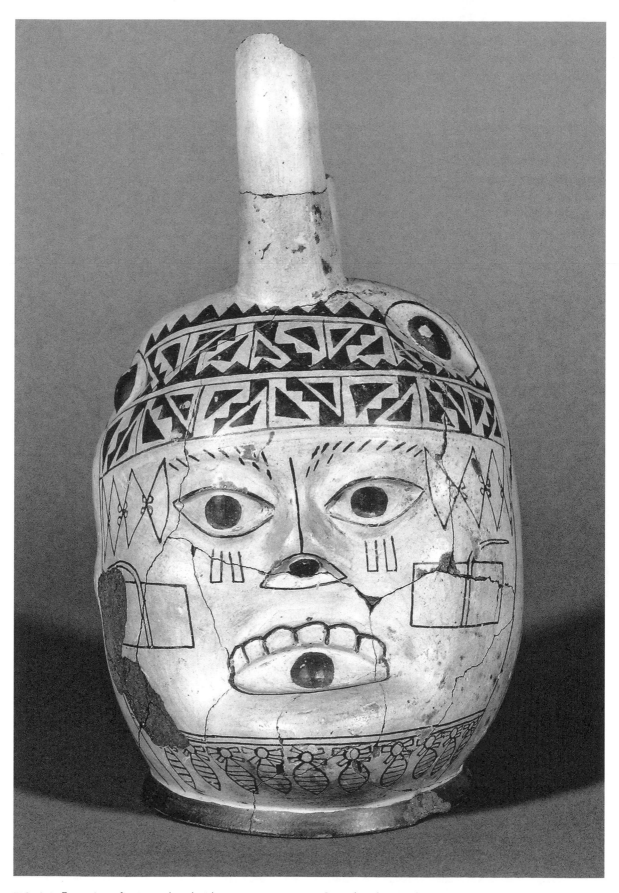

FIG. 8.8. Front view of visionary head with supernumerary eyes. Central Andes, Moche, 200–600 CE. Courtesy of Phoebe A. Hearst Museum of Anthropology and the Regents of the University of California, Photography by Alicja Egbert, (Catalogue No. 4-2814).

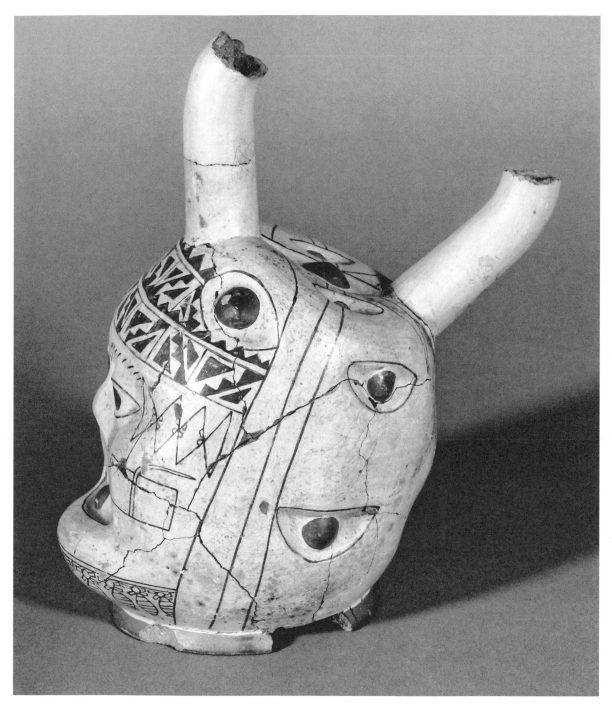

FIG. 8.9. Side view of effigy in figure 8.8. Photography by Alicja Egbert.

the remaining areas to create an image that likewise cannot depict an actual person in the everyday world (figs. 8.10–8.13). The heads, in keeping with the cephalocentrism of shamanic art, form a significant transition between the imagery of full-body shamans and that of the fully disembodied visionary scenes (figs. 8.14–8.17). The visionary heads once more stand for the entire shaman and

for the entire experience since the senses are clustered in that part of the body.

These visioning heads, like most of the latter scenes, are painted stark white with details picked out in red. This helps differentiate them at the outset from "normal" depictions that, choosing within the limited color palette of Moche ceramics, use the red-brown slip for realistic skin color.

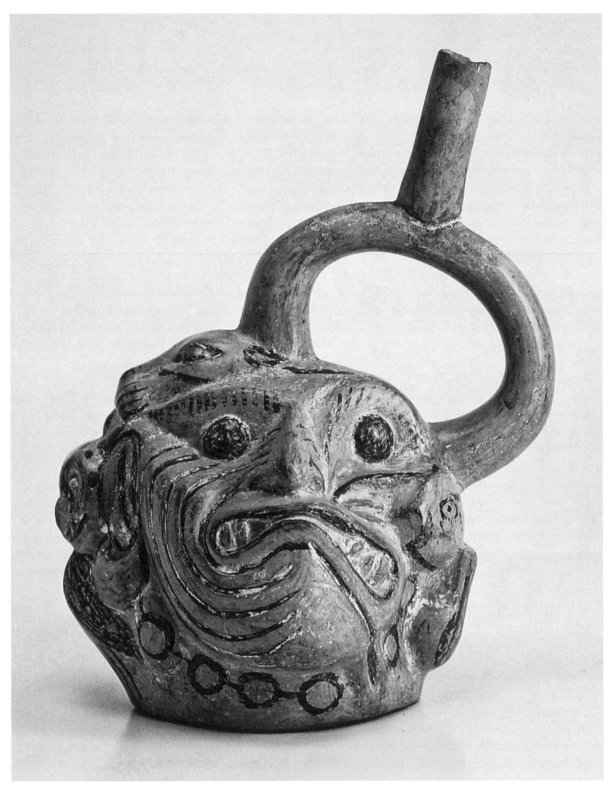

FIG. 8.10. Front view of visionary portrait head with facial contortion. Central Andes, Moche. 200–600 CE. Museo Arqueológico Larco Herrera ML007256. Museo Larco-Lima, Peru.

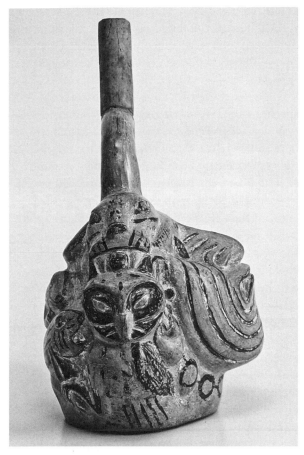

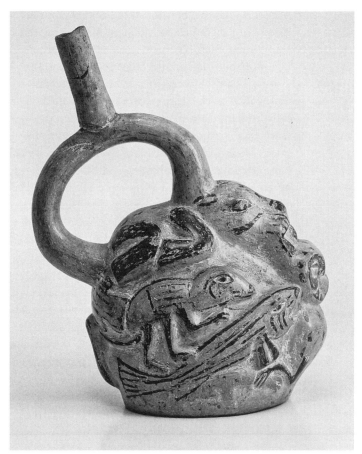

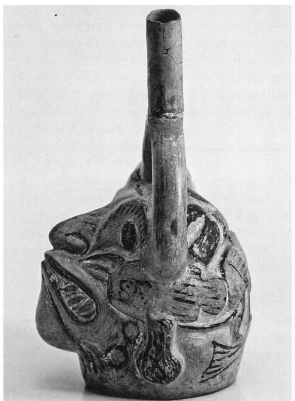

FIG. 8.11. (Top left) Side view (proper right) of vessel in figure 8.10. Museo Larco-Lima, Peru.

FIG. 8.12. (Right) Back view of vessel in figure 8.10. Museo Larco-Lima, Peru.

FIG. 8.13. (Bottom left) Side view (proper left) of vessel in figure 8.10. Museo Larco-Lima, Peru.

As mentioned earlier, the white background of the previously discussed Moche transforming shaman head goblet (figs. 7.15, 7.16) also fits within this reversed color palette. That shamans and the visions they experience should be rendered predominantly in the least colorful or naturalistically human color might be seen as allying them with such not-quite-there phenomena as incense smoke, spirits, and the dead, or even with anomalous individuals with albinism and those who have eluded death, such as the very aged. In any case, they are concertedly set apart by this formal choice.

At first glance, the white-faced example in figures 8.8 and 8.9 (Phoebe Hearst Museum of Anthropology, accession no. 4–2814) may appear almost ordinary, with the usual human facial features normally positioned. But one quickly notices that extra eyes are incorporated into the mouth and the nose areas, and many more pop out all over the head.[6] The one acting as the mouth may be the first to call into question the terrestrial nature of the rendition, noticeable due to its large size and central position as well as its protruding pupil. There are two readings of the mouth, the first featuring upper teeth holding something circular, which may reference the bezoars, a type of stone often included in Moche sea lion depictions and still used in modern shamanic healing.[7] However, there is no lower lip or set of teeth to finish out the mouth, making this reading less salient than one in which the circle forms the raised, red pupil of an almond-shaped, outlined eye like the other readable eyes all over the head. In the second take, the outlined "teeth" become eyelashes or eye emanations. Though the two readings do switch back and forth perceptually, I find that the mouth-as-eye reading prevails, its perceptual priority mainly due to its similarity to the eyes in the rest of the composition.

A second extra eye that becomes noticeable after some perusal is the nose-eye, less apparent because it is mostly two-dimensional and occurs mostly on the underside of the protruding portion. Its almond-shaped outline and round pupil are superimposed on the existing modeled nose, and its raised and painted pupil is positioned between two slightly indented nostrils. Thus, the nose and the eye coexist in a shared space, while the first eye takes over the mouth, superseding it.

While the nose-eye is smaller and more hidden, a vertical line on the nose ridge does draw attention down to it as well as up from it, helping to balance out how large and prominent the mouth-eye appears.

Together these two double sensory organs appear to communicate clearly the visionary experience of synaesthesia. Since humans both taste and vocalize with their mouths, a mouth-eye can communicate equally well seeing tastes and/or sounds and the reverse, hearing or tasting what is seen. In keeping with the mouth-eye's visual saliency, the interpenetration of sound and sight is in fact the most common synaesthetic experience. In turn, seeing smells or smelling sights could well be represented by the nose-eye. As throughout the shamanic expressive system, which favors dualism (based on the split consciousness of the trance state), the artist has created two readings to convey such overlapping sensory experiences: a mouth is also read as an eye, and a nose is also an eye. Yet the manner of conveying this double information differs: the mouth-eye relies on the same forms to encode two readings (contour rivalry), while the nose-eye employs the strategy of coexisting but distinct two- and three-dimensional messages, as the eye is modeled and drawn on the concave nostrils. The artist was not limited to one or the other method to convey visual/sensory conflation and creatively chose how to give precedence to the mouth and distinguish the two types of synaesthesia by degree and kind. The artist has come up with not one but two innovative and unusual aesthetic solutions to depicting synaesthesia, a creative doubling of doubling.

Extra trance eyes, independent of facial features, are scattered all over the vessel. They are painted into almond-shaped indentions in the vessel, but their pupils are consistently raised. Thus, they are both extraordinary (eyes are convex, not concave, in the regular body) and yet still eyes (normal pupils do bulge out, but here the bulging also represents trance consciousness). The artist has masterfully captured the paradox of visionary eyes, seeing within and yet beyond ordinary reality. They also function as head-eyes, like the Nasca navel-eye discussed earlier, and so could again refer to synaesthetic overlap of touch and sight.

These trance eyes overlay and take precedence

over any of the representational elements, such as the ties of the headdress. Thus, they are not presented as logically or normally "on" the head like decorations, but rather they are separate and dominant, insistently pushing aside and pressing into normal reality past the headband, the cowl, the head itself. Their insistence privileges the visionary mode and negates rational corporeal understanding. They are *interior* eyes nevertheless manifesting outwardly. Synaesthete and artist Marcia Smilack may provide further insight into the internal eye concept:

> One of the hardest things to explain to non-synesthetes . . . is how my "outer eyes" have nothing to do with what I "see." . . . Instead of asking me "what do you see" [interviewers] should ask me "where do I see it" because once people realize that the synesthetic visions are not seen with the outer eyes, they begin to understand a little about how it works internally. (Personal communication 2010)

Thus, here the head-eyes can be depicted like the rents or tears in the related anomalous twins and Visionary Scenes (figs. 8.2, 8.3, 8.15, 8.16) in their paradoxical inward and outward existence. They are ambiguous openings that problematize what is body and what is clothing and what may be neither, that is, the true or animal self emerging during transformation. The various eye choices in this piece aptly convey how visions from the Other Side relate to the head through the visual sense but are not simply products of it. Visionary eyes and seeing are not presented as limited to corporeal experience in a rational way but create an expanded reality.

Expansion is also represented through enlarging these extra eyes and placing them at strategic locations. The two largest supernumerary eyes interrupt or crowd the headband at its upper edges (fig. 8.8). They look outward from the temples like widely spaced animal eyes such as those of deer, snakes, birds, and crocodilians, typical animal alter egos. Another outsized and elongated trance eye caps the crown of the head, not surprisingly marking the fontanel with the largest eye of all (slightly visible in figure 8.9 as a large, protruding, dark pupil between the two spouts). Accentuating the key visionary area, this outsized trance eye is flanked by two smaller ones. The shamanic

power of this prime location is thereby tripled in a wonderful example of multiplicity; three eyes represent seeing many things at once, as reported to occur widely during trance. The most concentrated zone of eyes is toward the top of the head, again predictably given the upward sweep of visionary art away from the body and into the cosmos.

Certainly adding all these extra eyes is a perfect way to signal very elevated abilities to See, in all directions, connoting prescience and multiple ways of supernatural knowing in general. With two of them communicating crossing over from seeing to the other enhanced senses, vision is expanded beyond usual boundaries. Thus, this head presents not random multiplication of eyes but steps outside representation of human facial features to deliver a subtle, powerful discourse on vision and visions, on shamanic consciousness itself.

However, there is also an iconographic referent for a head covered with eyes: the potato. In fact, Bourget calls this piece a "portrait head bottle in the shape of a potato" (2006: 85, fig. 2.21). Like a potato, this head with the extra eyes is painted stark white, and the indented eyes render it lumpy. Certainly the visual similarities between the buds of potatoes and eyes seem to be universally recognized, as in English the buds are indeed called the potato's "eyes." It is worth proposing that a visionary head could overlap with potato imagery because that family of plants (the *Solanaceae*) contains some of the most potent entheogens. Granted, Linnaean categories do not necessarily coincide with indigenous ones, but the visual similarity between the potato plant and datura include the telltale bell-shaped, flaring flowers, the basic plant form, and the type of leaves (Schultes and Hofmann 1992: 106–111).[8] So a visionary head strongly overlapping with potato imagery may betray a shamanic logic that, to my knowledge, has not been elucidated before. Datura is notoriously powerful and dangerous, giving intense visions that shade into unconsciousness and even death; even an indirect reference to it here may account for the unusual nature of the composition, the number of extra eyes, and the synaesthetic messages. The potato at least tangentially participates in entheogenic plant medicine imagery, and this links other aspects of this unusual composition to the visionary realm.

Several final features relate directly to visions as well. There are geometric patterns in the headband and beside the eyes, probably to signal the familiar experience of geometry at the outset of and during trance. Diamonds and zigzags are found in the phosphene tabulation (fig. 2.1), and the prevalence of undulating movement has been discussed throughout this consideration. The eyebrows are another telltale feature of a person in trance, according to other pieces in which they appear (figs. 7.5, 7.9, 7.19, 7.21; Berrin 1997: 150; Scher 2010: fig. 2.15). Another example of these eyebrows is on a strange, seated figure, also painted stark white, with round trance eyes and a grimacing mouth (fig. 8.14).[9] A more strictly potato-like head pot (Bourget 2006: 25, fig. 1.19) also has the individual-hair eyebrows that are associated with pieces I interpret as overtly visionary. Such eyebrows are definitely out of the ordinary (conveying shamans are anomalous), animalistic (hairy, whiskery), and very dynamic, radiating from the eye.

Certain other elements tie this extra-eyed head in figures 8.8 and 8.9 to the realm of the dead. The cheeks have rectangular objects with a cord across them, which Bourget proposes represents a copper sheet tied with string placed in the mouths of the deceased (2006: 83–91). Since it is not in the mouth here but repeated as body art, it could signal that the person deals with death, possibly preparing corpses, certainly a shamanic duty in the broad sense (Wingfield 2009: 141–142). Alternatively, it could show that the shaman is temporarily in the land of the dead during his trance. Another reference to death is the row of objects painted below the chin, identified by Bourget as the pupal cases of muscoid flies that emerge from corpses and that might have been seen as the souls escaping from the body (2006: 86). Again, this could symbolize an intermediary who interfaces between the living and the dead. Finally, another aspect of the hairy eyebrow might be to reference that after death human hair continues to grow, aptly linking the two states and underscoring rebirth potential. Whether these allusions to death are interpreted literally—that the subject portrayed is dead—or to show the shamanic bridging of the worlds, or both, depends on one's point of view. The main eyes are not closed, the usual indicator of death, however.

This head is wearing a cowl head wrap, visible in figure 8.9, the edges of it as vertical lines and the pointed ties barely visible in front of the rear spout. This type of headgear is often, though not exclusively, associated with healer images and the anomalous shaman effigies (figs. 7.5, 7.6, 7.19–7.22), and so its presence strengthens the visionary message. Certainly the synaesthetic substitutions fall on the side of a shamanic reading. Conceivably, adding my and Bourget's hypotheses together, this portrait head could be of a deceased shaman, seeing in extraordinary ways from the Other Side, perhaps even one who died from taking datura. Yet, because ingesting datura can make one feel and seem unconscious and thus overlaps more directly with a death state than other entheogens, the shaman under its influence need not actually die to appear as if he did (just as visionaries experience death but also do not physically perish). Wide-open trance eyes suggest his remaining alive, while the other imagery might indicate the opposite, in a suitably ambiguous composition. The prestige accorded a shaman courting death to achieve powerful visions with datura might correlate with the high-status portrait-head format and the innovative aesthetic treatment of a master artist.

The extra-eye piece lies on a continuum with other visionary portrait heads that proceed toward visual disorder with abandon. The "animal" eyebrow is found in a more transformed head (fig. 8.10; Museo Larco Herrera, accession no. ML007256),[10] surmounting wild, asymmetrical eyes (the proper left eye is lower than the other, though it appears higher due to the rest of the head falling away above it). The eyes are reduced to large modeled and painted round pupils. The many animals arrayed around the head (figs. 8.11–8.13) support this as the animal eye reading, but the grimace of the face suggests that extreme mydriasis conveys the intensity of the visionary experience. The deep facial lines around the lopsided, bowed mouth and bared, fanglike teeth have dual references, both of which implicate visionary experience. Simultaneously whisker-like and gill-like, these indented contour lines can be seen as an animalistic characteristic, and bared teeth typically connote displays of animal aggression (figs. 5.18, 6.1, 6.10, 7.15). The lines may denote the contortions that can affect the face

after ingesting entheogenic substances such as *Anadenanthera* (Schultes and Hofmann 1992: 119). There is no doubt that this is an image of a person deep in trance and transformation; therefore, the eyebrows on this piece serve as the key to those on effigies perhaps less obviously caught in the throes of the Other Side (as in figure 8.14).

The whole head in the stirrup-spout vessel is misshapen, evoking for the viewer a graphic, visceral sense of the bodily and sensory distortions experienced under trance. Even the stirrup spout is placed in an unusual, asymmetrical location, as if it is slipping off or counterbalancing the rest of the head, creating further visual discomfort and disorientation in the composition. This odd spout placement breaks with "normal" portrait heads also by being parallel to the face; the vast majority are perpendicular.[11] This choice constitutes another subtle artistic way to encode the shaman as anomaly. Yet the visioning shaman relates to the mainstream portrait heads in a key feature, namely the fancy necklace and dangling circular earrings, which send the familiar message of a person with middle to high social status.

This composition, however, is by no means just a head. Even viewed frontally (fig. 8.10), it is being invaded and qualified by parts of other beings: a sea lion head that juts in over the proper right eye, the profile of a horned owl behind the proper right ear, and the head of a knife-wielding fish on the proper left cheek. As one turns the piece to see the rest of these partially withheld figures (fig. 8.11), one discovers over the spotted horned owl the frontal head of the sea lion with a round bezoar in its mouth. Thus, two heads are stacked in an alter-ego arrangement, and the owl's ears can be read as the sea lion's lower teeth. Such linking of two distinct animals, one becoming part of the other, certainly echoes the morphing from one thing into the next during visions. Meanwhile, a fish head has begun veering in from the left. The artist has successfully created the sense that one thing actively displaces another, that the scene is shifting, that beings are colliding, as in the fast-paced panoply of trance.

The back differs again (fig. 8.12), showing a stack of three animals: the side of the sea lion over a very strange composite animal over a fish at the bottom. The sea lion is in swimming position, according to its two bent legs, which would put

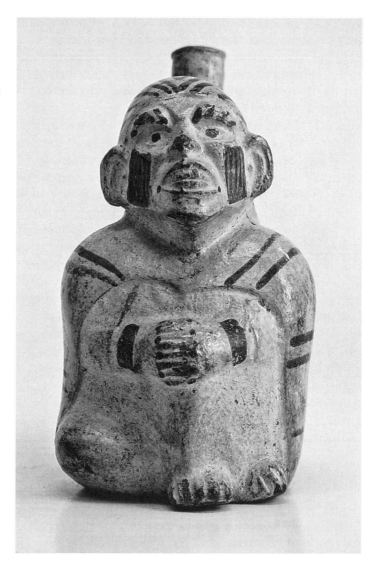

FIG. 8.14. Seated visionary with "animal" eyebrows. Central Andes, Moche, Chicama Valley. 200–600 CE. Museo Arqueológico Larco Herrera ML002738. Museo Larco-Lima, Peru.

the rest of the animals below under water—that is, if rational space applied, which it patently does not. Yet the watery Underworld is a place accessible by shamans in trance, so in a way this makes visionary sense. The composite animal below the sea lion is truly fantastical: it seems to have a rat's tail, insect legs, and an iguana head without ears but with the nose and whiskers of a rodent. These identifications are tentative; in any case, whatever it is certainly defies the coherence of a single, identifiable animal (as does the ineffable image in figure 4.1). Once more, resemblance to terrestrial reality is eschewed in a bizarre construct. Like visionary informants who find themselves at a loss

to describe their experiences, words "won't stick" to this creature. Likewise, the last side of the vessel (fig. 8.13) bears another fish, this one apparently holding a crescent knife or back-flap element, a gesture that propels it from pure fish to transformed human.

All these animals and beings take place "in" the head of the shaman, although—tellingly—one loses touch with the head as an organizing principle on these other sides. The visionary percepts take over and coherence is foregone, mimicking for the viewer what the person in trance is undergoing. Importantly, this means that each animal or object in the pile-up claims its own reality separate from the visionary, just as in visions there is a constancy of location for each bizarre entity so they do not seem to be products of the mind. The vessel is not really shaped like a human head, either, but is irregular, wide, lumpy, and twisted as well as populated with its own "horrifying world" of beings. This succinctly communicates that the trance has its own reality, ineffable as it may be, and that the shaman is the intermediary, not the creator, thereof.

Each Visionary Scene piece is comprised of as many or more contradictory and indecipherable elements. The other main type of Visionary Scene is not organized in relation to a head but is more like the nonface sides of this piece, a loose conglomeration of beings all mounded up, sometimes in a very asymmetrical fashion as in figure 8.15. This vessel is a technical tour-de-force, considering the extreme cantilevering of forms in space. Most Moche vessels do not even come close to such an uneven composition. Featuring a sideways monkey holding some kind of fruit(?), the composition also has an S-shaped snake, an upside-down face with open eyes, and a white, right-side-up head that seems dead and closely resembles the parasitic twin head in figure 8.2. The rest of the vessel is not simply the monkey's body but a molten mass of undifferentiated forms. This ambiguity of form, plus trance eyes, inversion, and the living-versus-dead dichotomy/unity constitute recurring themes in presenting the Other Side, as we have seen. There are several of the rents or molting marks mentioned above, triangular and lighter than the red. Again, it is as if the insides were being revealed by tearing through the outside self, recalling the importance of emer-

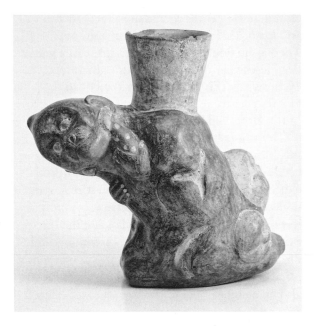

FIG. 8.15. Visionary scene featuring monkey. Central Andes, Moche. 200–600 CE. Museo Arqueológico Larco Herrera ML007265. Museo Larco–Lima, Peru.

gent internal selves and layers of consciousness of the body, mind, and soul during visionary states of consciousness. Anomalous and high-prestige individuals wear monkey headbands in Moche art, so the leaning monkey may represent a viable animal self like the ocelot, iguana, or bird, among others.

In another iteration, snakes wind through a maze of other beings in figure 8.16. Once more, the snake has a feline head and so belongs to the Andean Vision Serpent type. Similarly, the primary cat (toward the top of the pile) has human eyes and thus represents transformational state. But the small, white, disembodied head below the taloned paw on the front is of most interest. It is partial, like many elements on these pots, and mysteriously emerges out of the body of the vessel. It has a spiral for an eye that comes off a form that can be identified as the San Pedro backwards volute, probably referencing Chavín prototypes. On a series of earlier Cupisnique stirrup spouts there are felines, readable San Pedro cacti, and stepped frets with the frets turning the opposite direction from usual, as does the cat's head (Cordy-Collins 1998). This "jaguar of the backward glance" is a key shamanic alter ego, its presence explained by the taking of the entheogenic cactus and accompanied by the usual spiral geo-

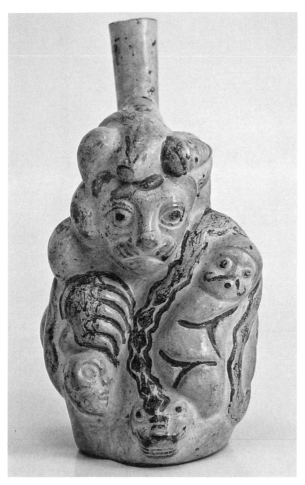

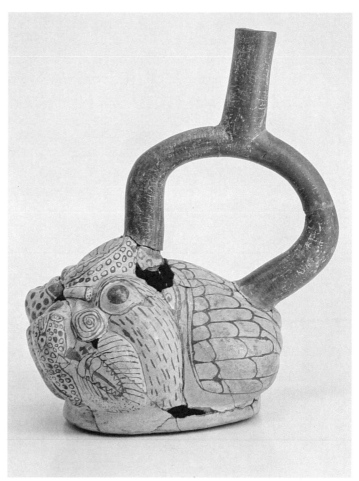

FIG. 8.16. Visionary scene featuring feline-snake. Central Andes, Moche. 200–600 CE. Museo Arqueológico Larco Herrera ML007229. Museo Larco-Lima, Peru.

FIG. 8.17. Visionary scene featuring sea lion with spiral nose. Central Andes, Moche. 200–600 CE. Museo Arqueológico Larco Herrera ML007292. Museo Larco-Lima, Peru.

metric visionary percepts. The Moche revived Chavín style, as in figures 7.15 and 7.16, so they were almost certainly aware of this iconographic staple from earlier times. In this Moche piece there is also a funeral procession, triangular rents (this time in red), a fetal body, and another head with face painting that includes spirals. The sheer number of visionary clues found throughout these compositions remains hard to discount.

Finally, among the many examples, fine-line Visionary Scenes exist as well (fig. 8.17). This supremely complex composition includes an owl with half a head, *strombus* shells, sea lions that shade into felines (one with a spiral nose and the other with a pointed feline trance eye),

wings, snakes, a figure in a fancy tunic and turban with painted lines radiating from the eyes, and a ceramic vessel with a rope around it. While many elements such as felines and skulls are common to a number of pieces, each Visionary Scene is a unique composition. This in itself parallels trance experience with its universal images creatively combined in endless, rich, and odd profusion. It is easy to conclude that the panoply of visionary experience was the subject of these fantastical, horrifying, and collage-like compositions. At this far extreme of the continuum, the Moche have left us with remarkable attempts to capture the only barely controllable and explainable phenomena beyond the terrestrial plane.

CONCLUSION

Given the foregoing case studies it may be safely concluded that the visionary aesthetic proposed at the outset applies across a wide spectrum of the ancient cultures of Costa Rica and the Central Andes, if not the ancient Americas as a whole, a topic for another study. Works of art in disparate media, times, and locales bear witness that the complex yet highly memorable trance experience illuminates widespread patterns of artistic choice, such as emphasis on the head and various kinds of nonhuman eyes, a plethora of combinations of animal with human features, subtle references to entheogens, celebration of those with unusual bodies, and even the explicit communication of the chaotic, emergent, and shifting conglomerations that typify visions. The shamanic experience serves as a telling locus for the celebration of ambiguity, the body in flux, and dual consciousness. Since the shaman's role as spiritual intermediary naturally entails a profound embrace of paradox, depicting such a being challenges artists to fabricate a body that nevertheless communicates outside-the-body journeying, including sensory enhancement without corporeal engagement, and the identification of the self with outside objects rather than with the expected ego or body, among other effects. This daunting artistic task preoccupies shamanic cultures because they value the extraordinary over the quotidian, cosmic realms over the terrestrial, and distinct ways of knowing beyond "normal" circumstances. Yet, artists still must create these embodiments in this world, using materials such as clay, stone, and thread to make a static double of someone who is anything but. Finally, in the visionary aesthetic the work of art functions as a vehicle rather than an image in the Western sense. When a wide range of "vehicle-images" is surveyed with trance experience as a guide, some perhaps surprising

creative strategies emerge, like the promotion of the generic, the illegible, or the torn-apart in widely divergent styles.

In concluding this consideration, it is important to relate the material from Costa Rica and the Andes to see what they may share as "shamanic" artistic systems and what makes each of them distinct. In this way the "common denominator" of shamanic visionary experience may be suggested. The art of these two areas makes a particularly good test case since lower Central America and the Central Andes were not directly tied to one another by trade or conquest and were not analogous in terms of political organization. In design, subject matter, and artistry it goes without saying that Costa Rican and Andean art cannot be confused, interchanged, or reduced to products of some sort of overarching shamanic determinism. Yet the strength with which both areas reflect the themes generated from trance consciousness shows once again that in the Americas shamanism, though typically elsewhere in the world a village-level phenomenon, characterizes not only chiefdoms but also the more highly organized civilizations. That the state-level Moche actually explored the most overtly shamanic visionary experiential imagery indicates that the importance of the vision and the role of the shaman did not necessarily diminish as political organizational complexity increased. On the contrary, the vision forms an underpinning of the Amerindian worldview itself, and shamanism on this continent clearly accommodates different political systems rather than being snuffed out at a certain point. Its inherent flexibility, one of shamanism's diagnostic features, has allowed it to remain powerful in a wide variety of contexts, as the existence of modern Catholic shamans in the Andes attests.

Thus, a brief art historical comparison of the two case study area's aesthetic choices underscores a twofold conclusion. First, striking commonalities do exist between cultures not in direct contact with one another and differing in political organization, suggesting that valuing the shamanic visionary experience leads to certain shared artistic choices across the ancient Americas. Second, the solutions to the problems inherent in depicting shamans in trance are many, such that specific cultures and culture areas maintain distinctive expressive systems and cannot be collapsed into a metaphenomenon. I offer a necessarily brief comparison of certain focal objects from the two case studies to demonstrate that subject matter, technique, and style reflect the dialectic of a shared visionary foundation and unmistakable individual cultural expression.

Artistic subject matter, particularly the transformation of the human into the animal self, might seem to be the most obvious way visionary content is expressed in any culture in which shamanic trance is esteemed. Here contrasting the Moche ocelot shaman goblet (figs. 7.15, 7.16) with the Pataky jaguar shaman (figs. 5.18–5.21) serves to show how the iconography of the feline alter ego may be embodied in the Andes and Costa Rica. Technical choices are equally fundamental to visionary artistic expression, as comparing representative blackware ceramics created in the Chavín style (fig. 7.14) and the Belen style (figs. 6.7, 6.7a) demonstrates. Finally, on a stylistic level, the intentionally chaotic, illegible imagery of the Moche, Wari (figs. 8.10–8.13, 7.25–7.26a), and Altiplano (fig. 6.25) examples epitomizes how different yet how allied are various Amerindian cultures' impulses to communicate the truly bizarre characteristics of trance perceptions. Naturally the iconography, technique, and style work together to create meaning in each piece, so the comparisons will encompass all three aspects together.

Shamans with feline alter egos represent perhaps the most ubiquitous and prestigious combination throughout the Americas, so it is no surprise that both Andean and Costa Rican cultures celebrate this subject matter. The Moche goblet (figs. 7.15, 7.16) and the Greater Nicoyan Pataky vessel (figs. 5.18–5.21) feature ocelot and jaguar components, respectively; however, for present purposes, this will not constitute a major distinction. Both pieces emphasize the aggressive qualities and body parts of felines by including a jutting animal head, prominent canine teeth, and pointed paws with deadly claws. Each embeds rattles inside hollow portions to evoke the animal's threatening audible presence, as well. Yet it is not the exact perceptible qualities of the animal that governs the artistic characterizations. In both cream-background pieces the continuous dark markings of the feline coat are evoked but not naturalistically depicted, I argue since it is not an animal in the terrestrial world but an animal spirit that is

at issue. Interestingly, the creators of both works chose to disengage from the actual animal by featuring segregated areas of spotting, even including a prominent spotted stripe down the back that delineates the tail and/or the dorsal stripe (figs. 5.20, 7.16). Further artistic license is taken in relation to markings: spots are rendered as exaggeratedly large and elongated forms in one piece and as tiny felines in the other. The micropsia and macropsia characteristic of visions could well have influenced these complementary variations.

Significantly, both present spots as layered over the shaman's body, whether as roller-stamped body art in the Pataky example or as a worn headpiece in the Moche one. Body painting and clothing alike overlay the shaman's corporeal presence, different from but closely identified with the human body underneath. Yet, in both examples the message is more complex and subtle than simply a human wearing an animal layer to represent the animal self, since both pieces feature feline fangs combined with an upright human pose. The bodies are already three-dimensionally both animal and human, and then more animal messages are added as two-dimensional layers. This additive approach bespeaks a common desire to communicate the multiplicity of the transforming shaman's body/bodies by showing that the animal self is at once a fundamental part of the shaman (connoted by fangs) but also, paradoxically, separable (connoted by a spotted garment or areas of body paint).

During daily life the shaman is wholly human but during trance becomes much more: inner animal body parts emerge and, as easily as a regular person dons a hat or marks her body, a shaman takes on another state of being. The creative ambiguity of such embodiments is further in keeping with the trance in which a perceived nesting of selves profoundly reconfigures notions of what is outside and inside, what is unified and what is removable in body, soul, and mind: "I was realizing that my body and my mind were such autonomous forces that if they ever had converged in me it seemed pure chance" (Naranjo 1973: 179). Thus, in each of these cases a shaman's sense of Self is presented as deeply stratified, featuring concurrent identification with a true transformed animal self and detachment from a ritualized role that comes and goes.

Yet, to draw attention to important cultural values that differ, one may argue that the Moche piece frames the interchangeable animal self as a more literal garment, reflective of the longstanding and widespread Andean preoccupation with textiles and garments and more specifically with layering, wrapping, dressing, and bundling objects and people, living and dead, a focus I have called "textile primacy" (Stone-Miller 1994: 13–18). By contrast, dress was less key in Costa Rican culture, since the forgiving and often steamy climate did not encourage textile elaboration to such a degree as did the forbidding Andes. In lower Central American art, body ornamentation—whether painting, stamping, or tattooing—is extensively catalogued in effigies, and roller stamps and seals are ubiquitous and act as works of art and items of wear themselves (figs. 5.1, 5.24–5.33). This is not to say that Andeans did not paint their skin (indeed the goblet shows face paint) or that Costa Ricans did not wear clothing, but certainly the relative weight given to the two modes of ornamentation differs markedly between the two cultural areas. Thus, artists seeking to imbue their shamanic embodiments with suitably ambiguous strata of human and animal selves would naturally choose distinct types of overlays favored by their own particular cultural matrix.

A second comparison, between Belen and Cupisnique pieces (figs. 6.7 and 7.14), still engages the crucial issue of feline animal selves but couches it in a specific technical choice: blackware ceramics. It is important to note that blackware, while found in a number of Amerindian cultures, is by no means widespread or always explored even in societies with prodigious clay traditions. Thus, finding the technique in both culture areas is itself significant. Its rarity is partly due to the extreme technical challenge of achieving the anoxic firing climate that produces blackware, which inevitably plays into its meaning when it is undertaken. Applying to both works, an obvious analogy can be drawn between shamanic visionary experience and an arduous, color-transforming firing, necessitating opposite conditions from usual, taking place in darkness and without others being able to see the process.

When subject matter is added to the equation, certainly the black-on-black melanistic jaguar animal self is directly and appropriately repre-

sented by this technique. In the Belen example (and related ones, particularly figures. 6.1, 6.2), the shadowy, dark jaguar aptly appears (and disappears) through the strategy of "transparency," in which the figure's outlining captures the color of the vessel so that the feline body is rendered essentially see-through. Notably, incised Cupisnique pieces (fig. 8.4, for example) utilize transparency toward the same ends. In the modeled half-face composition in figure 7.14, a similar effect allows the matte black "background" to show through the shiny black mouth and eyes of the feline half-face on the viewer's left. Because there is only one color and very little separable background, the intentional confusion of figure and ground is equally marked. A visionary whose body may feel as if it is part of the outside nighttime world can be invoked here, as well as the simple observation that an actual black jaguar seen in the darkness would be nearly indistinguishable from the surroundings. Thus, even far-flung shamanic cultures predictably favor monochromatic media and design strategies that interweave beings with the black void.

More provocatively, the design choices of both the Costa Rican and the Andean pieces split open the shamanic being in analogously and profoundly disorienting ways. In the third dimension, the Belen jaguar is hollowed out, its body the vessel itself, while the second dimension arrays the front half of the body above the opening and the back half below. If the jaguar were simply resolvable as lying on its back, then the legs would not be shown, only the paws reaching up. The vine-filled sections arching around the rim and over the half-bodies add double messages as to what is back or belly, dissecting the body further. The Cupisnique work has equally paradoxical split and unified aspects, two profiles almost forming a frontal whole but mainly juxtaposing uncomfortably ambiguous dual stages of transformation. Thus, there is a lack of possible perceptual resolution in the forms and coloration of both blackware examples, bearing witness to a deeply shamanic value on the hidden and the unknowable, a quality taken even further in the more extreme images of the final comparison I will discuss.

In accounting for the differences between the Costa Rican and Andean blackwares, as in the previous Moche-Pataky discussion, the Andean choices favor a clearer juxtaposition of two entities, whether a person and his headwear or a side-by-side more-human and more-transformed being. Reciprocal relationships between often opposing entities, typically subsumed under the Quechua term *ayni*, are extremely dominant in the greater Andean worldview (Stone n.d.b.). The highly influential environment again bears on this, the contrasts of desert, mountain, and jungle highlighting strategies of interdependence to ensure survival. Chavín art as a whole celebrates two-as-one messages in a number of ways (Stone-Miller 2002a: 33–44). By contrast, it may be argued that the Pataky and Belen examples similarly embed vessel and image, vine and body, human and cat with less emphasis on juxtaposition and more on conflation or blending. Costa Rican microenvironments differ but not to the Andean extreme, and they did not inspire social organization to the state level in which such pronounced social distinctions and reciprocal obligations hold sway. Chiefdom organization in lower Central America may encourage art to bring together different elements in a more equal, integrated mode in keeping with an easier natural context and less emphasis on strict political hierarchy. In general, the natural and social worlds are less predicated on sharp differences between one thing and another, perhaps informing the aesthetic choices likewise. While this cannot be argued across all of Andean or all of Costa Rican art, as a general hypothesis it may have some value.

A final set of comparisons highlights how divergent styles take positions on the edge of their cultural matrices to characterize the shamanic visionary experience through ultimate essentializing abstraction, intentional illegibility, and swirling chaos. A mixture of recognizable and obscure elements arrayed in a purposefully disorienting manner describes the Andean Wari style as a whole (figs. 7.25–7.28) and a notable subset of Moche depictions (figs. 8.10–8.17), as well as the Costa Rican Carrillo, Galo, and Altiplano styles (figs. 5.35, 6.19–6.24). These styles could scarcely be more visually different: Wari is rectilinear and coloristic, Moche naturalistically modeled but bichromatic, while Galo and Carrillo densely combine rectilinear and curvilinear elements, and

Altiplano is calligraphic and sketchy. Yet, they all take an extreme stance so as to directly embody important qualities of trance consciousness, particularly the constantly moving and changing percepts consistently reported by visionaries. Everyday seeing is clearly not predominant in any of these styles, considering that visual wholes are irreparably broken into parts or individual entities, some of which may be inverted and most of which spin around, encapsulating the familiar spiraling form of visionary movement detailed in many instances throughout this study. Readability, clear narrative, boundaries between discrete forms, all these are eschewed in various ways. Wari figures drop the distinction between body parts and the background, and the former are exploded into repeated shapes that drain the specific meaning from a foot, a segment of staff, or a tassel. A play of color in dazzling detail replaces coherence and evokes trance consciousness with its brilliant parade of disembodied forms.

A representative of what I have termed the Moche Visionary Scenes, the vessel in figure 8.10 piles up animals and implements into the actively distorting head with animalistic eyebrows. The perhaps terrifying corporeal feelings during trance are dramatically communicated: the mouth dragging down, the cheek corrugating, the mind bubbling with such incoherent beings as a fish wielding a knife. Though each entity may be clear, a sea lion versus an owl, the mandate of Moche naturalism does not here equal an interest in showing simply what things in the natural world look like, as the obvious subject is the Other Side invading this one. Thus, stylistic labels—Wari as "abstract" and Moche as "naturalistic"—do not override shamanic visionary experience as the ultimate referent in the two Andean examples.

The Costa Rican Carrillo and Galo styles take apart jaguars in various ways, boiling them down to spots, a curved haunch, and perhaps some red for a mouth (figs. 6.20–6.24). Body parts that would seem integral, like the canines or even eyes, are elided. Altiplano imagery patently spirals some possibly identifiable parts; the lower-right bowl in figure 6.25 has some eyes, beaks, and wings, for example. Altiplano's freeform calligraphic style captures the fast motion of visionary percepts in the artistic line itself, eluding readability but pro-

moting a sense of dizzying flux. While not as many Costa Rican examples throughout the entire tradition reach this level of abstraction, it is certainly an option.

In accounting for the two culture areas as they explore the Beyond of visionary encapsulation, it might be argued that abstraction as well as pitting the wildly disorderly against a predominantly regular backdrop are more Andean predilections than Costa Rican ones. Most of the major styles, the Wari and the Moche discussed here, plus the Nasca, Chimú, Inka, and others, have a strongly abstract side to their aesthetics (Stone-Miller 2002a: illustrations 51, 59, 135, 148–172). Many of them will set up a visual order and then intentionally break it; color anomalies, for instance, appear as central in the Wari textiles but occur in Chimú and Inka works as well (Stone-Miller 1994: 174–175; Stone n.d.b). The whole idea of *pachakuti*, celebrating reversals of order, brought up in regard to the Moche Visionary Scenes, represents another overarching Andean concept like layering and ayni. The Andean environment, with its orderly cycles and yet its cataclysmic droughts, earthquakes, El Niño/La Niña events, and so on, again can be invoked as a deep level of inspiration for such an order/chaos preoccupation (Stone-Miller 1992).

Costa Rican cultures, organized as chiefdoms in a more benevolent environment, seem to have concerned themselves less with imposing order over large groups of people and trying to contain natural chaos. Hence relatively few forays into notable abstraction and illegibility can be pinpointed in the art. It may be argued that the importance of visions itself inspired these rare expressions in the face of an artistic system more preoccupied with the personal, whether figured as human, animal, or a shamanic combination of the two.

As well as suggesting these differences between the Andes and lower Central America, this last comparison underscores two larger points. First, in their respective culture areas, the Wari and the Altiplano styles are perhaps the most abstract and the Moche the most naturalistic, showing that no particular stylistic trajectory is more or less appropriate for characterizing the visionary experience directly. Within a category such as "abstraction"

no one type is chosen, either; certainly Wari and Altiplano versions are visually as distinct as possible from each other. So, too, Moche "naturalism" can be overstated since some of the figures in the Visionary Scenes defy identification. Thus, artistic creativity and exploration are paramount and no "trance experience determinism" can be postulated. In other words, artists seeking to convey fast-moving and changing visionary percepts do not necessarily choose reductive or mimetic forms, straight or curving lines, polychromy or monochromy. Second, the fact that the Andean examples come from political states of different magnitudes and the Costa Rican ones represent chiefdoms or subsets thereof shows that the impulse to follow visions out to their most elemental expression transcends human organizational structures as well. This unique feature of the indigenous Americas, the long-lasting relevance and power of the shamanic worldview and its aesthetic expression, is highly evident.

As a final word, these last, startling examples that illustrate the most intense experiential aspects of trance only slightly more actively bring the Other Side into this world than all the other works of art considered in this study. The visionary aesthetic of lower Central America and the Central Andes includes works of art that mark all different points along a continuum of human, animal, and Beyond. The dynamic interaction of unique styles, recognizable cultural matrices, and an overarching value on what the transforming entranced shaman senses make all these creative, purposefully ambiguous statements eminently worthy of our attention and appreciation.

NOTES

INTRODUCTION

1. Shreeve 2006. My thanks to Laura Wingfield for this reference. The Genographic Project has genetically linked Native Americans with the Altai regions of eastern Siberia, where the Tungusic word "shaman" originates. I feel the continuities and commonalities in the Siberian-Amerindian tradition allow me to retain the most familiar general term, "shaman," especially since there is no single general Native American name for this phenomenon, and to choose one culture and call shamans *payé*, *yachaj*, or *balam* would be as arbitrary. I will use the appropriate culture-specific terms in individual examples.

2. The brew known variously as ayahuasca (meaning "vine of the soul"), yagé, yajé, kahi, and other names is composed primarily of the giant liana *Banisteriopses caapi* or *inebrians*. Chopped into sections and boiled for several hours typically with the leaves of the *Psychotria viridis* plant, it becomes a thick, bitter, dark-brown drink. It is widespread throughout lower Central America and most areas of South America related to the Amazon. See Schultes and Hofmann 1992, especially 120–128.

3. If a scholar uses "hallucination" or "hallucinogen" in a quote, however, it will be retained.

4. Arnheim (1974) sets out how humans see shape, color, line, and space, resolve figure and ground relationships, and so forth. I will rely on perceptual principles such as similarity, simultaneous contrast, and contour rivalry to suggest how human viewers generally resolve what artists compose. Jules Prown's explication of material culture studies (1980, 1982) provides a useful method for mining visual objects for cultural information by engaging all the senses and forming hypotheses without recourse to written sources, which rarely were germane to most ancient American cultures. George Kubler's 1962 classic yet still innovative approach to formal analysis, *The Shape of Time: Remarks on a History of Things*, informs my analysis of art according to both intrinsic and conventional meanings. Michael Coe and Richard Diehl (1980), among many other anthropologists, explore and compare modern traditional cultures with their ancestral traditions in search of ongoing ancient expressive values. None of these approaches claims specific interpretative links between past and present, but all of them assume that art inevitably expresses culture and offer ways to generate relevant information from the artwork in context.

5. For example, a famous Chavín relief is usually called the Smiling God; Burger 1995: 174, fig. 175. Paracas shamans are described as smiling; Paul and Turpin 1986: 23. However, drawn-back lips signal aggression in felines; Wolfe and Sleeper 1995: 47, 76–77, 103. "Coffee bean eyes" has been a common descriptor, although coffee is not native to the continent; Kubler 1975: 116.

6. "And God said, Let us make man in our image, after our likeness, and let them have dominion over the fish of the sea, and over the fowl of the air, and over the cattle, and over all the earth, and over every creeping thing that creepeth upon the earth. So God created man in his own image, in the image of God created he him, male and female created he them. And God blessed them, and God said unto them, Be fruitful, and multiply, and replenish the earth and subdue it: and have dominion over the fish of the sea, and over the fowl of the air, and over every living thing that moveth upon the earth"; Authorized King James Version.

7. The Linnaean family is *crocodylidae*, the subfamily *alligatorinae*, and alligator and caiman are separate genera; Ross 1989: 58. Although this may not reflect indigenous natural categories, when using species names, I suggest we should be accurate.

8. For instance, Legast writes that some Colombian bat figures seem to wear masks, but she gives no visual criteria to distinguish them; 1998: 131.

9. Various cultural, historical, and scholarly stances doubtless account for antishamanic academic sentiment. Grob suggests that rational science is uncomfortable with "an experience that moves beyond the realm of rational, linear thought," and thus native cultures' ritual plant technology has been pathologized or ignored; 2002b: 185. Narby concurs that visions are by their nature emotional, subjective, and irreproducible, so studying them opposes the tenets of the scientific method; 2002: 162. Wasson contends that "an imperative though unconscious inhibition seems to grip scholars when their natural instincts would lead them into the Paradise—the Tlalocan—of the entheogens. . . . [Thus] for going on five centuries those interested in Mesoamerica have ignored the entheogens"; 1980: 59–72. He reviews how the Spanish grafted witchcraft onto shamanism; ibid.: 108–109. The implication is that modern prejudices continue this disdainful European tradition.

10. See Furst's distinction between the sacred uses of entheogens and "drugs"; 1990: vii–xxviii. See also Metzner with Darling on the Harvard Project, the Good Friday Experiment, and "hybrid neo-shamanic rituals"; 2005: 29–46. To some, the experience of pharmahuasca, a synthesized ayahuasca, "'felt like a drug. I felt intoxicated as opposed to enlightened, inebriated instead of connected . . . there is a huge difference between taking this drug and ingesting the plant material'"; in Metzner 2006: 131.

11. I thank Gary Laderman for pointing out this source.

12. Arrévalo describes "folkloric shamanism" or "drug tourism" as opportunistic and based on an insincere corps of individuals anxious to gain economic benefits from "borrowed mysticism" and thus fundamentally different from "traditional shamanism"; 2005: 203. In "commercial shamanism," a patient can take ayahuasca without experiencing "the

force or energy that comes from the plant," thereby missing the key respectful interaction; ibid.: 204. Don José Campos likewise bemoans the bags of ayahuasca for sale in markets whose ingestion lack the true essence of the respectful relationship between taker and plant teacher; Wiese 2010: minute 52.

13. Peyote, from the Nahuatl *peyotl*, is the woolly cactus *Lophophora williamsi* that grows in the northern and western desert areas of Mexico. Its use has spread throughout North America in recent times via the Native American Church. See Schultes and Hofmann 1992, specifically 132–143.

CHAPTER 1

1. In a late-nineteenth-century study, 10 percent of the population reported experiencing spontaneous visions; 25 percent did in 1957 and 79 percent in 1988; Siegel 1992: 7.

2. The so-called San Pedro cactus (*Trichocereus pachanoi*) is a columnar cactus that grows on the foothills in Peru and the high plains, or *altiplano*, of Bolivia. It reaches thirty feet in height and bears ten-inch-wide white flowers that bloom at night. *Achuma* is the Quechua name for it. The reference to Saint Peter is a prime example of syncretism, in that in Catholicism this saint holds the keys to heaven, while in the shamanic tradition the cactus opens the portal to the Other Side.

3. This does not just apply to the Americas. William Blake asserted that "the Prophets describe what they saw in Vision as real"; 1893: 228.

4. Interestingly, traditional Quichua shaman Don Agustín Grefa discussed the placebo effect and shamanic curing. He pointed out a sacred rock that too much Western development and casual treatment had "killed," saying it no longer held a spirit capable of curing. However, he mentioned that people did still consult it and receive miraculous cures simply because they still believed it was alive.

5. Datura is a plant with long, bell-shaped flowers and is found throughout South and Central America. It is the most powerful and dangerous of the entheogenic substances in the Americas, causing unconsciousness and even death; Schultes 1990: 47; Schultes and Hofmann 1992: 128–131.

6. Sixty species of *Virola* are spread throughout the forests of the tropical Americas but especially the northern Amazon region. It is known as *epená* and may be mixed with the leaves of *Justicia pectoralis* or the burned bark of the *Elizabetha princeps* tree to improve its taste and/or effect. It is a snuff pulverized from the dried, blood-red resin collected from the bark of the tree. See Schultes and Hofmann 1992, especially 164–171.

7. Shamanic societies would not use the word "distortion," given the reality value accorded the experience; however, Klüver's work began in the 1920s, and his terminology is understandably biased.

8. These artists presented talks at the College Art Association annual conference in 2005 during a session titled "Synesthesia and Perception" chaired by Greta Berman and Carol Steen.

9. The artist requested that this statement be included

with his drawing: "Yando is the son of a Peruvian Amazon healer, Don Hilde. He grew up witnessing healing practices (see [Dobkin de Rios] 1992) and also participated in these practices with his father, but he chose art, not healing, as his own profession. He experimented with various plants and their effects, particularly in the context of their effects on art. In his early work, he painted while under their influence and also to recreate those states without the need to continue their use. All this was for the purpose of exploring the boundaries of art, its expressive and formal possibilities. Yando refused in the late 1960s and 1970s to be part of the art current titled 'psychedelic art.'"

10. Two of innumerable examples are a Huaca Prieta twined textile of a condor with a snake in its belly (Stone-Miller 2002a: 19, illustration 6) and a Wari pregnant llama shown with her unborn baby inside; Stone-Miller 1992: 342, fig. 12.

CHAPTER 2

1. A *New Yorker* cartoon played on the variety of possible spirit animals by showing a dispirited, drab businessman looking down at a snail who informs him, "I'm your spirit animal"; Sam Means, December 11, 2006.

2. Narby reports on the "primordial psychological sensitivities rooted in the evolution of primates; that unlike almost all other animals, serpents, in varying degree, provoke certain characteristically intuitive, irrational, phobic responses in human and nonhuman primates alike . . . a type of response that may have been reinforced by memories of venomous attacks during anthropogenesis and the differentiation of human societies"; 1998: 114–115. In note 17 on page 195 he cites snakes' "ability to remain hidden, the power in their sinuous limbless bodies, and the threat from venom injected hypodermically through sharp hollow teeth. It pays in elementary survival to be interested in snakes and to respond emotionally to their generalized image, to go beyond ordinary caution and fear. The rule built into the brain in the form of a learning bias is: become alert quickly to any object with a serpentine gestalt. Overlearn this particular response in order to keep safe (Wilson 1984: 92–93)." See also the discussion of overcoming fear in chapter 3 of the present volume.

3. In the Carlos Museum collection, for instance, snakes are found in pieces shown and/or discussed throughout Stone-Miller 2002b.

4. Glass-Coffin (1998) and Tedlock (2005) have made good cases for less aggressive, feminine styles of shamanic healing, but most male practice remains bellicose.

5. For some images of these among the contemporary Yanomami see Lizot, Curling, and Jillings 1996: minutes 10:25, 12:20, 33–34; and Mann 1999: minute 18.

CHAPTER 3

1. Nonshamans who treat plants as sacred aver that "the entheogens are Teachers who have no time for students who wish only to fool around at the back of the classroom"; Metzner with Darling 2005: 257.

2. Power objects are called *artes* in Peru and can include items in the shaman's mesa and anything material he or she manipulates to cure.

3. The deep and potentially life-threatening connection between mesa vehicles and shaman also was underscored when Doña Clorinda allowed Glass-Coffin to photograph her mesa and one of the artes (ritual implements) spontaneously broke; Glass-Coffin was told that as a consequence Doña Clorinda's life had been shortened by one-third; Glass-Coffin 1998: 137.

4. Don Guillermo claims to be one of four traditional healers in his region; Arrévalo 2005: 205. Some communities have proportionately more shamans; about 25 percent of adult male Shuar take that role; Harner 1973d: 17. Archaeologists have found snuffers in about one out of ten graves in San Pedro de Atacama, Chile, suggesting that shamans may have comprised about 10 percent of the population; Llagostera 1995: 52.

5. I thank Randy Hall for drawing my attention to these primate fears.

6. The recognition of women in shamanism has grown slowly; Tedlock 2005: 60–75. Roland Dixon in 1908 presented men as more predominant but admitted that women shamans and cross-dressing male shamans existed; see Narby and Huxley 2001: 65. Métraux in 1944 wrote, "Shamanism is a profession that is almost essentially masculine; it is not closed to women but the latter only play an important role in a very small number of tribes"; ibid.: 98. Tedlock's and Glass-Coffin's work has done much to redress the scholarly biases by reporting on female healers, consciously engaging the issue of gendered curing styles, and exposing our androcentric view; Glass-Coffin 1998: 139–140, 171–203; Tedlock 2005.

7. An exception, Glass-Coffin illustrates Doña Vicky curing while visibly pregnant; 1998, thirteenth photograph between pages 138 and 139.

8. "The wounded surgeon plies the steel / That questions the distempered part; / Beneath the bleeding hands we feel / The sharp compassion of the healer's art / Resolving the enigma of the fever chart"; Eliot 1944: 20.

9. As a personal note, in 1993 when Earle gave a lecture in which he unexpectedly revealed that he had been trained as a Maya shaman, the "nonlinear" aspects of shamanism became apparent to me. Earle visited my home after the lecture and my then three-year-old son, Dylan, was listening to Earle's account of his dream. Dylan became excited when Earle mentioned the skeletons and interrupted him, pointing upward and saying, "and then there was a big, big star!" Dylan had no prior knowledge of the dream.

10. At the 2005 College Art Association session on synaesthesia in Atlanta about 10 percent of the audience reported synaesthetic experiences, but that may partially represent preselection.

11. This was an unusually open attitude toward foreigners. However, in the early 1990s multiple Ecuadorian shamans had visions of a condor flying with an eagle, interpreted as a mandate for South Americans to include North Americans in their shamanic practice; Stone 2007b: 6.

12. Luna reports that Amaringo's shaman father, Don Ezequías Amaringo Mendoza, was killed by sorcerers during an ayahuasca session; Luna and Amaringo 1999: 21. Doña Isabel was told she could not die by taking San Pedro, but if she took too much and did not defend herself, evil shamans could kill her nonetheless; Glass-Coffin 1998: 66.

13. The grumble of the jaguar sounds like thunder; *National Geographic*, http://animals.nationalgeographic.com/animals/mammals/jaguar.html.

14. The work of Sharon on Don Eduardo serves as a good introduction, as do Glass-Coffin 1998, Joralemon and Sharon 1993, and Wiese 2010.

CHAPTER 4

1. There are a number of indications that they were in trance: Gose discusses (1996: 10) Polo de Ondegardo's remarks that the Inka put the entheogenic substance *vilca* (*Anadenanthera colubrina*) in their corn beer and used it as an enema; see also Cobo 1990: 169.

2. My thanks to Ricardo Gutierrez-Mouat for this translation.

3. I thank Sarahh Scher for her input on this point.

4. "Diviners of this kind [who used fire to decide the most important questions] were called *yacarca* . . . They were greatly feared by the Inca as well as by the rest of the people and wherever he went the [Sapa] Inca took them with him" (Cobo 1990: 170).

5. Others have commented on cephalocentrism but without using the term or directly associating it to trance experience. In Nasca art "there is a focus on an enormous head and ornaments, with the body and feet relegated to lesser importance"; Dobkin de Rios and Cardenas 1980: 241.

6. I conducted a post-dissertation study of a group of Wari tunics that alternate profile heads with stepped fret motifs. In these examples, any given individual feature may be omitted, but the face is never blank.

7. Anther instance of this substitution is found in Labbé et al. 1998: 175, catalogue no. 144. The snake may be substituted for almost any sinuous body part or object in many ancient American styles.

8. See, for example, Broude and Garrard 1992. I thank James Meyer for pointing out this source to me.

9. My thanks to Laurie Patton and Flavia Mercado for these medical terms.

10. Don Eduardo, inspired by a dream, killed a cat, drank its blood, and made it into a "spiritual savage cat" by tying its right paw and two eyeballs to an ancient arrowhead placed inside a perfume container. He put it on top of a block of crystal that he said acted like a mirror so the cat could see the movement of disturbances, making its eyes light up like light bulbs, and it could go "out to the hills screaming and screeching"; Sharon 1978: 55. While this creation is patently idiosyncratic, it epitomizes the shamanic desire to access the superior sight of the nocturnal predators. Sharon also reports that Eduardo said this helped him visualize attacks by evil spirits and sorcerers, that is, gave him the cat's ability to see in the dark; ibid.: 70.

11. Previously this was known as the pendant iris, an error that, among many others, I perpetuated in Stone-Miller 2002a: 35 and 2002b: 221.

12. See http://animalphotos.info/a/2008/01/01/zoo-jaguar-with-pretty-blye-eyes [*sic*].

13. For examples of inlaid eyes in Olmec figures see Reilly 1989; for Sicán *tumi* knives see Stone-Miller 2002a: 160, illustration 127. For Tiwanaku wooden snuff tablets see Llagostera 1995: 56, fig. 2d. For Moche effigies see Lavalle 1989: figs. 124, 174, 180, 183, 190, 225, 227, 230–234, 239, 244–247; Berrin 1997: 102–103, 137; Scher 2010: figs. 5.67, 5.142.

CHAPTER 5

1. I am indebted to Kent Brintnall for pointing out this reading.

2. This figure was destined to be on the cover of the 2004 *RES*, but the editor found her too shiny. For the cover of *Seeing with New Eyes*, the graphic designer had to edit out a lot of shine in order for the title to be readable. The new photos also necessitated editing out the hot spots.

3. The figure's proper left foot is partially repainted in modern times, having five toes, which the other foot does not have and which are rare in ancient American art. Its telltale matte finish betrays a lack of burnishing as well.

4. Barbara Tedlock writes of this effect, brought up by her master shamans as they were interpreting her dream: "'The lightning moved and the blood spoke here, on the back of my thigh,' he [Andrés] whispered, lifting his pant leg and pointing to the very center of his thigh. He was referring to 'the speaking of the blood,' caused by rapid movements of subtle energy. Andrés and Talín said these bodily sensations felt like an icy wind within their arteries and veins"; 2005: 123. While the connection may seem tenuous, in ancient times the Maya certainly were in contact with inhabitants of what is now Costa Rica, as exchange of artwork and a later influx of people indicate, and it is possible that they shared some shamanic beliefs such as this one.

5. My thanks go to Laura Wingfield for bringing seven of these to my attention.

6. I saw these as toad glands in my previous discussion but was not attuned to the issue of the anomalous body; in this case I would see the bumps on the head as the glands and these circles as breasts.

7. This is seen in a figurine in the Arthur M. Sackler Collection, accession no. AMSN-1129; Clifford 1985: 80. Again, thanks are due to Laura Wingfield for this find.

8. This is not how they were created, however, since all the painting is positive (the black was painted directly on the white). Yet it remains quite difficult to paint so that what reads as figure is the space where the artist did *not* paint.

CHAPTER 6

1. Black ocelots also exist but are rare (Eizirik et al. 2003). Only in figure 6.10, the large head with the lines

coming out from the eyes, may conceivably represent an ocelot. The other pieces feature circular rather than elongated spots and thus support only the jaguar identification.

2. See also Big Cat Rescue.

3. I appreciate the input of Dorie Reents-Budet on this issue. The piece in question (fig. 6.5) has been reconstructed, making it difficult to ascertain whether the color variations, thickness of surface, and other characteristics are indicative of one technique or the other. I think the surface looks more like reduced-firing brownware in this case, though I cannot be certain.

4. In the early Marbella style, brown animals are depicted in brownware, including the vampire bat, brown caiman, and three-banded armadillo, as are the brown caiman, monkeys, owls, and toads in later El Río, Ticaban, and Africa styles; Stone-Miller 2002b: 80–82, 121–127.

5. I may have overstated their rarity in a former publication (2002: 94). I am indebted to Dr. John Polisar for bringing the brown jaguar more to my attention; personal communication and joint lecture 2009.

6. The highest number of black jaguars is reported from the Brazilian rainforest, probably because of how adaptive their coloring is in denser forest and darker night conditions but also because there are simply more wild habitats remaining; Meyer 1994.

7. I am very grateful to Eduardo Eizirik for sharing his expert opinion on jaguar-coat genetics.

8. Today there are more dark jaguars in the dense rainforests in Brazil, and in the past there were vast such environments conducive to the better-hidden felines. In lower Central America and southward, the ancient cultures did not seem to hunt or sacrifice jaguars extensively, according to the lack of their skeletons in caches or graves, so the animal populations were naturally higher and thus the larger number of dark jaguars apparent to the indigenous peoples.

9. I am indebted to Amanda Rogers for this connection.

10. For instance, Berlo (1991: 443) draws attention to this connection among the modern traditional Maya, Klein (1982) for various ancient Mesoamerican peoples, and Reichel-Dolmatoff (1978) for the modern Kogi of Colombia.

11. A white dot on the upper front limb, upon examining the piece, is a chip.

12. Unfortunately, the photographs of this plant were stolen during fieldwork.

13. I want to thank Mike McQuaide for taking and sharing the photographs that brought this to my attention.

14. See Stone-Miller 2002b: 76, catalogue no. 133; 103, catalogue no. 214; 124–125, catalogue no. 262.

15. Scientific testing for the residues of entheogens has inherent problems; see Stone-Miller 2002b: 124–125.

16. A jaguar's vulva can be seen at http://www.flickr.com/search/?q=jaguar&w=75879414%40N00.

17. It is important to note, however, that this head pot may refer to a melanistic ocelot (see note 1) and have the characteristic linear markings out from their eyes. In the absence of other indications, however, it is not necessary to question the jaguar reading in the other pieces on the basis of this one possibility.

CHAPTER 7

1. Closely related pieces can be found in Kroeber 1956: 427–429; Sawyer 1962: 157 and 1997: 94, 161; Kroeber, Collier, and Carmichael 1998: plate 14 between pages 144 and 148, 160, 207; Rickenbach 1999: 347, 357, 363; Proulx 2006: 115. I am indebted to Sarahh Scher for pointing out this piece and to Meghan Tierney for finding similar works.

2. Paul and Turpin included forty in their corpus, and many more no doubt exist, especially since their definition was rather narrow as to what features constituted an image of a shaman versus a "ritual impersonator"; Stone-Miller 2004: 54, 56–58.

3. I am indebted to Amanda Rogers for making this connection.

4. My thanks to Meghan Tierney for bringing this to my attention.

5. I endeavor to use nonpejorative terminology and only use words such as "normal" in the statistical sense. "Different," "distinctive," and "anomalous" are to be understood favorably as well, in keeping with the values of the ancient cultures under consideration, as opposed to the mainstream ones in our own.

6. I studied thirty-three at the Museo Larco Herrera in Lima and one each at the Carlos and Hearst museums. With more than three hundred pieces coded as "pathological" in the Larco database, this is obviously not the definitive study but only a beginning.

7. Grefa cures women's infertility and other gynecological problems; Stone 2007b: 11–12.

8. Museo Arqueológico Larco Herrera ML002802.

9. A distribution map (United Nations, FAO 2009) shows them from California to northern Chile, while the one in Taylor 1994 (36) only south to Ecuador. The FAO website is an official fact sheet of the Food and Agriculture Organization of the United Nations that dates to 2009, and therefore I feel it is more reliable.

10. See Elasmodiver photos 203–206, among others.

11. I am indebted to Bruce Carlson, chief science officer of the Georgia Aquarium, for several of these connections, particularly regarding the white line and the side view, which he offered before and during a joint lecture we presented in April 2009 at the Carlos Museum.

12. There are many "modern manufactures" in this style, so it is important to use pieces with archaeological context information. The matched pair (Hearst 4–6451 and 4–6452) was found at the site Uhle called B, known locally as La Calera de Lauren, in Grave 2.

13. I am indebted to Ian Hennessee for this observation.

14. My thanks to Laura Kochman for this idea.

15. However, Donnan identifies the Dumbarton Oaks figure as a character called Wrinkle Face; he does not say this, but Wrinkle Face could well be a famous shaman or represent generically the role of a shaman.

16. The sound of the animal can be heard at http://animals.nationalgeographic.com/animals/mammals/ocelot.

17. The goblet tested negative for human blood; Stone-Miller 2002b: 226. However, it could have been cleaned

since ancient times. It is notoriously hard to test for entheogens; ibid.: 125.

18. In scientific terms, some individuals contract only the cutaneous type that scars, some the mucosal type that eats away at the face and may or may not result in death; others have the fatal visceral leishmaniasis. A person may have more than one type. Thus, all those whose faces were affected would not die, but the interpretation of why some survive depends on cultural explanations. See Pearson and Queiroz Sousa 1992, Stone-Miller 2002b: 227–228.

19. I also studied one at the Larco Herrera, accession number 1408, with a bird headdress very similar to that in figure 7.22; another with a monkey headband is at the Museo de America in Madrid, accession number 1418; Scher 2010: 602, catalogue no. CR406.

20. A similar piece—although it has gold plain stripes—appears in color in Boone 1996: 395, plate 110.

21. This element doubles as an unusual-shaped textile that hangs down from ties at the neck; see Conklin 1986.

22. In the previous literature these figures are consistently described as running or kneeling, and since they are arrayed in rows in tunics and on monuments such as the Sun Gate at Tiwanaku, the sense of a ground line may be (I think mistakenly) inferred.

23. Keeper of the Trout and friends 2005, cover. The plant can be seen in bloom in Mann 1999 at minute 19.

24. *Anadenanthera colubrina* of South America, also called vilca, *yopo*, and *cohoba* is made into an entheogenic snuff. It comes from the beans inside long pods hanging from a tree that grows in lowland, savannah areas; see Schultes and Hofmann 1992: 116–119.

25. Nearly every "staff-bearer" has one or more of these flowers; see Stone 1987. I plan an in-depth study of this phenomenon in the future.

26. The anomaly occurs as the bottom spot in the front arm of the fourth figure from the lower edge.

CHAPTER 8

1. I must again thank Sarahh Scher for finding this piece in storage while conducting her dissertation research and bringing it to my attention.

2. For more examples of Moche conjoined twins see Lastres et al. 1943: plate XLII; Museo Larco Herrera

ML002417. For Costa Rican examples see Wingfield 2009: 120–122, 208, 217–218, 235–237. The two Guinea Incised figures do not seem to depict parasitic twins but rather feature two equal, living heads. One of the two pieces (catalogue no. 86) is intersexed, however, so it evinces a strong shamanic potential. Wingfield points out that conjoined twinning occurs in about ten per million births; ibid.: 407.

3. Guaman Poma cites it in the entry "265 [267] VACAS, ÍDOLOS" in *Det Kongelige Bibliotek*. My thanks to Sarahh Scher for these references.

4. Composite cat-snakes abound in Chavín iconography; for example, see Donnan 1978: 109, 171; Berrin 1997: 76, catalogue no. 4; Sharon 2000: 49, figs. 31, 32. For a few of the many cats paired with snakes and San Pedro cacti see Cordy-Collins 1998: figs. 6.10, 6.16.

5. For example, the famous cult statue known as the Lanzón holds one hand up and one down to encompass and connect all realms; Stone-Miller 2002a: 34.

6. Bourget did not identify these features as eyes, saying the piece "depicts a mutilated being with his lips and nose excised"; 2006: 86.

7. Bezoars are masses of material caught in the stomach or intestines of an animal. In sea lions, they take the form of stones that are coughed up when the animals are hunted today. Bezoars are illustrated and the prevalent use of bezoars by modern healers is noted in Donnan 1978: 136–137.

8. Barbara Kerr (2007) identifies datura flowers as the catalyst for Lady Xoc's vision in the famous Yaxchilan Lintel 25.

9. This piece was catalogued by the Museo Larco Herrera staff as representing the pathology of "idiocy."

10. Another very similar piece is the Museo Larco Herrera's ML002971, which features the wild eyes, animal eyebrows, lumpy distortions, and modeled and painted sea lion, duck, fish, snake, iguana, and owl on the sides and back. It is not in good enough state of preservation to illustrate, however.

11. In Donnan's illustrations, all phase IV heads have perpendicular spouts, and only one phase III and one phase V example have the anomalous parallel ones; 2004: 17, fig. 2.11; 19, fig. 2.15. Spouts in other cases do meaningfully participate in the message, such as in the childbirth scenes in which the pressed-down and far-back spout seems to be pushing along with the mother; Stone-Miller 2002a: 115, illustration 92.

WORKS CITED

Abel-Vidor, Suzanne, Ronald L. Bishop, Warwick Bray, Elizabeth Kennedy Easby, Luis Ferrero A., Oscar Fonseca Zamora, Héctor Gamboa Paniagua, Luis Diego Gómez Pignataro, Mark M. Graham, Frederick W. Lange, Michael J. Snarskis, and Lambertus van Zelst. 1981. *Between continents/between seas: Precolumbian art of Costa Rica*. New York: H. N. Abrams in association with Detroit Institute of Arts.

Abram, David. 1996. *The spell of the sensuous: Perception and language in a more-than-human world*. New York: Pantheon Books.

Aldred, Lisa. 2000. Plastic shamans and Astroturf sun dances. *American Indian Quarterly* 24 (3): 329–352.

Allen, Catherine. 1998. When utensils revolt: Mind, matter, and modes of being in the pre-Columbian Andes. *RES: Journal of Anthropology and Aesthetics* 33 (Spring): 18–27.

Alva, Walter. 2000. Sacerdotes, shamanes y curanderos en la cultura mochica. In *Shamán: La búsqueda*, ed. W. Alva, M. Polía, F. Chávez, and L. Hurtado, 23–43. Cordoba, Spain: Imprenta San Pablo.

Alva, Walter, and Christopher B. Donnan. 1993. *Royal tombs of Sipán*. Los Angeles: Fowler Museum of Cultural History, University of California.

Anandakesavan, T. M. 1998. Craniopharyngeal parasitic twin. *Indian Pediatrics* 35 (10): 1027.

Animal Photos! Pictures of jaguars. http://animalphotos .info/a/2008/01/01/zoo-jaguar-with-pretty-blye-eyes [sic].

Arnheim, Rudolf. 1974. *Art and visual perception: A psychology of the creative eye*. Berkeley: University of California Press.

Arrévalo, Guillermo. 2005. Interview with Guillermo Arrévalo, a Shipibo urban shaman, by Roger Rumrrill. *Journal of Psychoactive Drugs* 37, no. 2 (June): 203–207.

Association for Psychological Science. 2008. Evolution of aversion: Why even children are fearful of snakes. *Science Daily*, February 28.

Babcock, Barbara, ed. 1978. *The reversible world: Symbolic inversion in art and society*. Ithaca, NY: Cornell University Press.

Balzer, Marjorie Mandelstam. 2003. Sacred genders in Siberia: Shamans, bear festivals, and androgyny. In Harvey 2003, 242–261.

Benson, Elizabeth. 1997. *Birds and beasts of ancient Latin America*. Gainesville: University Press of Florida.

Benson, Elizabeth P., and Anita Gwynn Cook. 2001. *Ritual sacrifice in ancient Peru*. Austin: University of Texas Press.

Berlo, Janet Catherine. 1991. Beyond bricolage: Women and aesthetic strategies in Latin American textiles. In *Textile traditions of Mesoamerica and the Andes: An anthology*, ed. M. Schevill, J. Berlo, and E. Dwyer, 437–479. New York: Garland.

Berrin, Kathleen, ed. 1997. *The spirit of ancient Peru: Treasures from the Museo Arqueológico Rafael Larco Herrera*. New York: Thames and Hudson.

Big Cat Rescue. Jaguar facts and jaguar photos. http://www .bigcatrescue.org/cats/wild/jaguar.htm.

Blake, William. 1893. *The poems of William Blake*. Ed. W. B. Yeats. New York: Charles Scribner's Sons.

Boaz, Noel Thomas. 2002. *Evolving health: The origins of illness and how the modern world is making us sick*. New York: Wiley.

Boone, Elizabeth Hill, ed. 1996. Andean art at Dumbarton Oaks. *Pre-Columbian art at Dumbarton Oaks*, vol. 1. Washington, DC: Dumbarton Oaks Research Library and Collection.

Bourget, Steve. 2006. *Sex, death, and sacrifice in Moche religion and visual culture*. Austin: University of Texas Press.

Bracewell, Amy. 2001. Creation and termination of ceramic objects in ancient America. Master's thesis, University of Texas.

Brannen, Laura. 2006. An approach to the study of unprovenienced objects: Nicoyan shoe pots/womb urns. Paper presented at the 39th annual Chacmool Archaeological Conference, November 12, University of Calgary, Alberta, Canada.

Bray, Warwick. 1981. Gold work. In Abel-Vidor et al. 1981, 153–166.

Broude, Norma, and Mary D. Garrard. 1992. *The expanding discourse: Feminism and art history*. Boulder, CO: Westview Press.

Buchillet, Dominique. 1992. Nobody is there to hear: Desana therapeutic incantations. In Langdon and Baer 1992, 211–230.

Burger, Richard L. 1995. *Chavín and the origins of Andean civilization*. New York: Thames and Hudson.

———. 1997. Life and afterlife in pre-Hispanic Peru: Contextualizing the masterworks of the Museo Arqueológico Rafael Larco Herrera. In Berrin 1997, 21–32.

Calvo Mora, Marlin, Leidy Bonilla Vargas, and Julio Sánchez Pérez. 1995. *Gold, jade, forests: Costa Rica*. Washington DC: Trust for Museum Exhibitions, in association with the Museo Nacional de Costa Rica.

Cameron, Charles. 1985. Creature spirits everywhere about us: A voice of the Black Elk Nation. In *The human/animal connection*, ed. Randall L. Eaton, 30–41. Incline Village, NV: Carnivore Journal and Sierra Nevada College Press.

Campbell, Alan T. 2003. Submitting. In Harvey 2003, 123–144.

Carneiro, Robert L. 1964. The Amahuaca and the spirit world. *Ethnology* 3 (1) (Jan.): 6–11.

Chambers, Marlene, ed. 1990. *Little people of the earth: Ceramic figures from ancient America*. Denver: The Museum.

Churchill, Ward. 2003. Spiritual hucksterism: The rise of the plastic medicine man. In Harvey 2003, 324–333.

Cieza de León, Pedro de. 1959. *The Incas of Pedro de Cieza de León*. Trans. Harriet de Onis. Ed. Victor Wolfgang von Hagen. The Civilization of the American Indian series, 53. Norman: University of Oklahoma Press.

Classen, Constance. 1993. *Inca cosmology and the human body*. Salt Lake City: University of Utah Press.

Clifford, Paul. 1985. Catalogue. In *Art of Costa Rica from the Arthur M. Sackler Collections: Pre-Columbian painted and sculpted ceramics*, ed. Lois Katz, 50–291. Washington, DC: Arthur M. Sackler Foundation and AMS Foundation for the Arts, Sciences, and Humanities.

Cobo, Bernabé. 1990. *Inca religion and customs*. Trans. and ed. Roland Hamilton. Austin: University of Texas Press.

Coe, Michael D, and Richard A. Diehl. 1980. *In the land of the Olmec*. Austin: University of Texas Press.

Conklin, William. 1986. Pucara and Tiahuanaco tapestry: Time and style in a sierra weaving tradition. *Ñawpa Pacha* 21:1–44.

Cook, Anita. 1985. Art and time in the evolution of Andean state expansionism. Ph.D. diss., State University of New York, Binghamton.

Cordy-Collins, Alana. 1976. An iconographical study of Chavin textiles from the South Coast of Peru: The discovery of a pre-Columbian catechism. Ph.D. diss., University of California, Los Angeles.

———. 1979. Cotton and the staff god: Analysis of an ancient Chavín textile. In *The Junius B. Bird Pre-Columbian Textile Conference*, ed. A. P. Rowe, E. P. Benson, and A.-L. Schaffer, 51–60. Washington, DC: Textile Museum and Dumbarton Oaks Research Library and Collection.

———. 1980. An artistic record of the Chavin hallucinatory experience. *Masterkey* 54 (3): 84–93.

———. 1982. Psychoactive painted Peruvian plants: The shamanism textile. *Journal of Ethnobiology* 2 (2): 144–153.

———. 1989. The iconography of visionary experience: A resolve of the conflict between ordinary and nonordinary reality. In *Cultures in conflict: Current archaeological perspectives*, ed. D. C. Tkaczuk and B. C. Vivian, 34–43. Calgary, Canada: University of Calgary Archaeological Association.

———. 1998. The jaguar of the backward glance. In Saunders 1998b, 155–170.

The Corn Snakes Site. 2010. Information and corn snake pictures. http://www.snakepictures.co.uk/snake_picture_105.htm.

Cunningham, Bert. 1937. *Axial bifurcation in serpents: An historical survey of serpent monsters having part of the axial skeleton duplicated*. Durham, NC: Duke University Press.

D'Altroy, Terence N. 2002. *The Incas. The peoples of America*. Malden, MA: Blackwell.

d'Anglure, Bernard Saladin. 2003. Rethinking Inuit shamanism through the concept of "third gender." In Harvey 2003, 235–241.

David, Louis. 1991. Common vitamin D–deficiency rickets. In *Rickets*, ed. Francis H. Glorieux, 107–122. Nestlé Nutrition Workshop series, 21. New York: Raven Press.

Dobkin, Marlene. 1968/1969. Folk curing with a psychedelic cactus in the North Coast of Peru. *International Journal of Social Psychiatry* 15 (1): 23–31.

Dobkin de Rios, Marlene. 1992. *Amazon healer: The life and times of an urban shaman*. Dorset, England: Prism Press.

Dobkin de Rios, Marlene, and Mercedes Cardenas. 1980. Plant hallucinogens, shamanism and Nazca ceramics. *Journal of Ethnopharmacology* 2 (3): 233–46.

Dobkin de Rios, Marlene, and Fred Katz. 1975. Some relationships between music and hallucinogenic ritual: The "jungle gym" in consciousness. *Ethos* 3 (Spring): 64–76.

Donnan, Christopher. 1978. *Moche art of Peru: Pre-Columbian symbolic communication*. Los Angeles: Museum of Cultural History, University of California.

———. 1996. Stirrup spout bottle depicting a deity head. In *Andean art at Dumbarton Oaks*, ed. Elizabeth Hill Boone, Pre-Columbian Art at Dumbarton Oaks, vol. 1. Washington, DC: Dumbarton Oaks Research Library and Collection.

———. 1997. Deer hunting and combat: Parallel activities in the Moche world. In Berrin 1997, 50–59.

———. 2004. *Moche portraits from ancient Peru*. Austin: University of Texas Press.

Donnan, Christopher B., and Carol J. Mackey. 1978. *Ancient burial patterns of the Moche Valley*, Peru. Austin: University of Texas Press.

Dronamraju, Krishna R. 1986. *Cleft lip and palate: Aspects of reproductive biology*. Springfield, IL: C. C. Thomas.

Duffy, Patricia Lynne. 2001. *Blue cats and chartreuse kittens: How synesthetes color their worlds*. New York: Henry Holt.

Easby, Elizabeth Kennedy, and John F. Scott. 1970. *Before Cortés, sculpture of Middle America: A centennial exhibition at the Metropolitan Museum of Art from September 30, 1970 through January 3, 1971*. New York: Metropolitan Museum of Art.

Eizirik, Eduardo, Naoya Yuhki, Warren E. Johnson, Marilyn Menotti-Raymond, Steven S. Hannah, and Stephen J O'Brien. 2003. Molecular genetics and evolution of melanism in the cat family. *Current Biology* 13 (March): 448–453.

Elasmodiver. 2010. Whale shark pictures—Rhincodon typus images. http://www.elasmodiver.com/Whale%20 shark%20pictures.htm.

Eliade, Mircea. 1964. *Shamanism: Archaic techniques of ecstasy*. Trans. Willard R. Trask. Bollingen series, 76. New York: Bollingen Foundation, distributed by Pantheon Books.

Eliot, T. S. 1944. *Four quartets*. London: Faber and Faber.

Fash, William Leonard. 2001. *Scribes, warriors, and kings: The city of Copán and the ancient Maya*. New Aspects of Antiquity. New York: Thames and Hudson.

Fenton, M. Brock. 1983. *Just bats*. Toronto: University of Toronto Press.

Fikes, Jay. 1996. A brief history of the Native American Church. In *One nation under God: The triumph of the Native American Church*, ed. Huston Smith and Reuben Snake, 167–173. Santa Fe, NM: Clear Light.

Frame, Mary. 1986. The visual images of fabric structures in ancient Peruvian art. In *The Junius B. Bird Conference on Andean Textiles: April 7th and 8th, 1984*, ed. Ann P. Rowe, 47–80. Washington, DC: Textile Museum.

Furst, Peter T. 1968. *The Olmec Were-Jaguar motif in the light of ethnographic reality*. Los Angeles: University of California.

———, ed. 1990. *Flesh of the gods: The ritual use of hallucinogens*. Prospect Heights, IL: Waveland Press.

———. 2003. Visions of a Huichol shaman. Philadelphia: University of Pennsylvania Museum of Archaeology and Anthropology.

Gebhart-Sayer, Angelika. 1985. The geometric designs of the Shipibo-Conibo in ritual context. *Journal of Latin American Lore* 1 (2): 143–175.

Glass-Coffin, Bonnie. 1998. *The gift of life: Female spirituality and healing in northern Peru*. Albuquerque: University of New Mexico Press.

Gose, Peter. 1996. Oracles, divine kingship, and political representation in the Inka state. *Ethnohistory* 43 (Winter): 1–32.

Grob, Charles S., ed. 2002a. *Hallucinogens: A reader*. New York: Jeremy P. Tarcher/Putnam.

———. 2002b. The psychology of ayahuasca. In Grob 2002a, 185–216.

Halifax, Joan. 1982. *Shaman: The wounded healer*. New York: Thames and Hudson.

Harner, Michael J. 1973a. Common themes in South American Indian *yagé* experiences. In Harner 1973b, 155–175.

———, ed. 1973b. *Hallucinogens and shamanism*. New York: Oxford University Press.

———. 1973c. The role of hallucinogenic plants in European witchcraft. In Harner 1973b, 125–150.

———. 1973d. The sound of rushing water. In Harner 1973b, 15–27.

Harvey, Graham. 2003. *Shamanism: A reader*. London: Routledge.

Helms, Mary. 1981. Precious metals and politics: Style and ideology in the intermediate area and Peru. In *Journal of Latin American Lore* 7 (2): 215–238.

———. 1995. *Creations of the rainbow serpent: Polychrome ceramic designs from ancient Panama*. Albuquerque: University of New Mexico Press.

Herbas Sandoval, Angel. 1998. *Diccionario quichua a castellano (Qhishwasimimanta-kastillanuman rimayqillqa)*. Bolivia: Tunturi Qañiywa.

Hill, Jonathan. 1992. A musical aesthetic of ritual curing in the northwest Amazon. In Langdon and Baer 1992, 175–210.

Hiller, Ilo. 1996. *The white-tailed deer*. College Station: Texas A&M University Press.

Hoopes, John W., and Oscar M Fonseca Z. 2003. Goldwork and Chibchan identity: Endogenous change and diffuse unity in the Isthmo-Colombian Area. In *Gold and power in ancient Costa Rica, Panama, and Colombia: A symposium at Dumbarton Oaks, 9 and 10 October 1999*, ed. Jeffrey Quilter and John W. Hoopes, 49–89. Washington, DC: Dumbarton Oaks Research Library and Collection.

Houston, Stephen D., and David Stuart. 1989. The *way* glyph: Evidence for "co-essences" among the classic Maya. *Research Reports on Ancient Maya Writing* 30 (December): 1–16.

Houston, Stephen D., and Karl Taube. 2000. An archae-

ology of the senses: Perception and cultural expression in ancient Mesoamerica. *Cambridge Archaeological Journal* 10 (April): 261–294.

Howard, Rosaleen. 2006. *Rumi*: An ethnolinguistic approach to the symbolism of stone(s) in the Andes. In *Kay paccha: Cultivating earth and water in the Andes*, ed. Penelope Dransart, 233–245. BAR International Series, 1478. Oxford, England: Archaeopress.

Johnson, Paul C. 2003. Shamanism from Ecuador to Chicago: A case study in New Age ritual appropriation. In Harvey 2003, 334–354.

Jones, David E. 2002. *An instinct for dragons: Bio-cultural anthropology and myth*. New York: Routledge.

Joralemon, Donald, and Douglas Sharon. 1993. *Sorcery and shamanism*: *Curanderos and clients in northern Peru*. Salt Lake City: University of Utah Press.

Joyce, Rosemary. 1998. Performing the body in prehispanic Central America. *RES: Anthropology and Aesthetics* 33 (Spring): 147–165.

Keeper of the Trout and friends. 2005. *Trout's notes on San Pedro and related Trichocereus species: A guide to their visual recognition with notes on their botany, chemistry, and history*. 3rd edition. Sacred Cacti, Part B. Sedona, AZ: Mydriatic Productions.

Kerr, Barbara. 2007. Datura and the vision. http://www .mayavase.com/datura.pdf.

Klein, Cecelia F. 1982. Woven heaven, tangled earth: A weaver's paradigm of the Mesoamerican cosmos. In *Ethnoastronomy and archaeoastronomy in the American tropics*, ed. Anthony F. Aveni and Gary Urton. Annals of the New York Academy of Sciences 385:1–35.

Klüver, Heinrich. 1966. *Mescal and the mechanisms of hallucinations*. Chicago: University of Chicago Press.

Knobloch, Patricia J. 2000. Wari ritual power at Conchopata: An interpretation of *Anadenanthera colubrina* iconography. *Latin American Antiquity* 11 (4): 387–402.

Kolata, Alan L. 1996. Tiwanaku ceremonial architecture and urban organization. In *Tiwanaku and its hinterland: Archaeology and paleoecology of an Andean civilization*, ed. Alan L. Kolata, 175–201. Washington, DC: Smithsonian Institution Press.

Kongelige Bibliotek, Det. *Felipe Guaman Poma de Ayala: El primer nueva corónica y buen gobierno (1615/1616)*. http:// www.kb.dk/permalink/2006/poma/info/en/frontpage. htm.

König, Claus, Friedhelm Weick, and Michael Wink. 2008. *Owls of the world*. New Haven: Yale University Press.

Kracke, Waud. H. 1992. He who dreams: The nocturnal source of transforming power in Kagwahiv shamanism. In Langdon and Baer 1992, 127–148.

Kroeber, A. L. 1956. *Toward definition of the Nazca style*. Berkeley: University of California Press.

Kroeber, A. L., Donald Collier, and Patrick H. Carmichael. 1998. *The archaeology and pottery of Nazca, Peru: Alfred L. Kroeber's 1926 expedition*. Walnut Creek, CA: AltaMira Press.

Kubler, George. 1962. *The shape of time: Remarks on the history of things*. New Haven: Yale University Press.

———. 1975. *The art and architecture of ancient America: The Mexican, Maya, and Andean peoples*. The Pelican History of Art. Harmondsworth, England: Penguin.

Labbé, Armand J. 1986. *Colombia before Columbus: The people, culture, and ceramic art of prehispanic Colombia*. New York: Rizzoli.

———. 1998. Symbol, theme, context, and meaning in the art of prehispanic Colombia. In *Shamans, gods, and mythic beasts: Colombian gold and ceramics in antiquity*, Armand J. Labbé, 21–119. New York: American Federation of Arts.

Laime Ajacopa, Teofilo. 2007. *Diccionario bilingüe: Quechua-castellano, castellano-quechua*. http://issuu.com/ robertlangdon/docs/quechua.

Langdon, E. Jean Matteson. 1992a. *Dau*: Shamanic power in Siona religion and medicine. In Langdon and Baer 1992, 41–61.

———. 1992b. Shamanism and anthropology. In Langdon and Baer 1992, 1–21.

Langdon, E. Jean Matteson, and Gerhard Baer, eds. 1992. *Portals of power: Shamanism in South America*. Albuquerque: University of New Mexico Press.

Lastres, Juan B., Abraham Guillén, Jorge C. Muelle, and J. M. B. Tarfán. 1943. *Representaciones patológicas en la cerámica peruana: Texto médico*. Lima: Museo Nacional.

Lavalle, José Antonio de. 1989. *Moche*. Lima: Banco de Crédito del Perú.

Lechtman, Heather. 1984. Andean value systems and the development of prehistoric metallurgy. *Technology and Culture* 25 (1): 1–25.

Legast, Anne. 1998. Feline symbolism and material culture in prehistoric Colombia. In Saunders 1998b, 122–154.

Lewis, I. M. 2003. *Ecstatic religion: A study of shamanism and spirit possession*. 3rd edition. New York: Routledge.

Lewis-Williams, David. 2002. *The mind in the cave: Consciousness and the origins of art*. London: Thames and Hudson.

Lizot, Jacques, Chris Curling, and Andy Jillings. 1996. *Warriors of the Amazon*. VHS. Boston: WGBH Video.

Llagostera M., Agustín. 1995. Art in the snuff trays of San Pedro de Atacama (northern Chile). In *Andean art: Visual expression and its relation to Andean beliefs and values*, ed. Penny Dransart, 51–77. Worldwide Archaeology Series, 13. Aldershot, England: Avebury Press.

Luberth, Dirk. 2010. Personal webpage. www.luberth.com/ help/reflective_deer_eyes_in_the_dark.jpg.

Luna, Luis Eduardo. 1992. Icaros: Magic melodies among the mestizo shamans of the Peruvian Amazon. In Langdon and Baer, 1992, 231–256.

Luna, Luis Eduardo, and Pablo Amaringo. 1999. *Ayahuasca visions: The religious iconography of a Peruvian shaman*. Berkeley, CA: North Atlantic Books.

Mann, Christopher, prod. and dir. 1999. *Flightpaths to the gods*. VHS. Compass series. Sydney: ABC.

Mattison, Christopher. 1986. *Snakes of the world*. New York: Facts on File.

———. 1999. *Snake*. New York: DK.

McEwan, Colin, and Maarten van de Guchte. 1992. Ancestral time and sacred space in Inca state ritual. In *The*

ancient Americas: Art from sacred landscapes, ed. Richard F. Townsend, 359–371. Munich: Prestel Verlag.

Metzner, Ralph. 2002. Ritual approaches to working with sacred medicine plants: An interview with Ralph Metzner, Ph.D. In Grob 2002a, 164–184.

———, ed. 2006. *Sacred vine of the spirits*: Ayahuasca. Rochester, VT: Park Street Press.

Metzner, Ralph, ed., with Diane Conn Darling. 2005. *Sacred mushroom of visions* Teonanácatl: *A sourcebook on the psilocybin mushroom*. Rochester, VT: Park Street Press.

Meyer, John R. 1994. Black jaguars in Belize? A survey of melanism in the jaguar, Panthera onca. http://biological-diversity.info/Black_Jaguar.htm.

Miller, Mary Ellen, and Karl A. Taube. 1993. *The gods and symbols of ancient Mexico and the Maya: An illustrated dictionary of Mesoamerican religion*. New York: Thames and Hudson.

Mills, K. 1997. *Idolatry and its enemies: Colonial Andean religion and extirpation 1640–1750*. Princeton, NJ: Princeton University Press.

Munn, Henry. 1973. The mushrooms of language. In Harner 1973b, 86–122.

———. 2003. The uniqueness of María Sabina. In *Selections: María Sabina*, ed. Jerome Rothenberg, 140–163. Berkeley: University of California Press.

Naranjo, Claudio. 1973. Psychological aspects of the *yagé* experience in an experimental setting. In Harner 1973b, 176–190.

Narby, Jeremy. 1998. *The cosmic serpent: DNA and the origins of knowledge*. New York: Penguin.

———. 2002. Shamans and scientists. In Grob 2002a, 159–163.

Narby, Jeremy, and Francis Huxley. 2001. *Shamans through time: 500 years on the path to knowledge*. New York: Thames and Hudson.

National Geographic. 2010. Jaguar. http://animals.nationalgeographic.com/animals/mammals/jaguar.html.

Olsen, Dale. 1975. Music-induced altered states of consciousness among Warao shamans. *Journal of Latin American Lore* 1 (1): 19–33.

Ontaneda Luciano, Santiago. 2001. *Guia de la sala de arqueología*. Quito: Banco Central del Ecuador, Museo Nacional.

Oster, Gerald. 1966. Moiré patterns and visual hallucinations. *Psychedelic Review* (7): 33–40.

Pasztory, Esther. 1983. *Aztec art*. New York, H. N. Abrams.

Paul, Anne. 1990. *Paracas ritual attire: Symbols of authority in ancient Peru*. Norman: University of Oklahoma Press.

Paul, Anne, and Solveig A. Turpin. 1986. The ecstatic shaman theme of Paracas textiles. *Archaeology* 39 (5): 20–27.

Paulesu, E., J. Harrison, S. Baron-Cohen, J.D.G. Watson, L. Goldstein, J. Heather, R.S.J. Frackowiak, and C. D. Frith. 1995. The physiology of coloured hearing: A PET activation study of colour-word synaesthesia. *Brain* 118 (3): 661–676.

Pearson, Richard D., and Anastacio de Queiroz Sousa. 1992. Leishmania species: Visceral (Kala-Azar), cutaneous, and mucosal leishmaniasis. In *Principles and practice of infectious diseases*, 2428–2442. 4th edition. New York: Churchill Livingstone.

Perrin, Michael. 1992. The body of the Guajiro shaman: Symptoms or symbols? In Langdon and Baer 1992, 103–125.

Perry, Richard. 1970. *The world of the jaguar*. New York: Taplinger.

Polisar, John, and Rebecca R. Stone. 2009. Spotted and sacred: Jaguars in nature and art. Lecture, April 28, Michael C. Carlos Museum, Atlanta.

Posnansky, Arthur. 1945. *Tihuanacu, the cradle of American man*. New York: J. J. Augustin.

Proulx, Donald A. 2001. Ritual uses of trophy heads in ancient Nasca society. In Benson and Cook 2001, 119–136.

———. 2006. *A sourcebook of Nasca ceramic iconography: Reading a culture through its art*. Iowa City: University of Iowa Press.

Prown, Jules. 1980. Style as evidence. *Winterthur Portfolio* 15 (3): 197–210.

———. 1982. Mind in matter: An introduction to material culture theory and method. *Winterthur Portfolio* 17 (1): 1–19.

Quilter, Jeffrey. 1990. The Moche revolt of the objects. *Latin American Antiquity* 1 (1): 42–65.

Reiche, Maria. 1993. *Mysteries of Peru. The lines*. VHS. Bethesda, MD: Atlas Video.

Reichel-Dolmatoff, Gerardo. 1969. El contexto cultural de un alucinógeno aborigen: *Banisteriopsis Caapi*. Revista de la Academia Colombiana de Ciencias Exactas, Físicas y Naturales 13 (December): 327–345.

———. 1972. *San Agustín: A culture of Colombia*. New York: Praeger.

———. 1975. *The shaman and the jaguar: A study of narcotic drugs among the Indians of Colombia*. Philadelphia: Temple University Press.

———. 1978. *Beyond the Milky Way: Hallucinatory imagery of the Tukano Indians*. Los Angeles: Latin American Center, University of California, Los Angeles.

———. 1985. *Los Kogi: Una tribu de la Sierra Nevada de Santa Marta, Colombia*. Nueva Biblioteca Colombiana de Cultura. Bogota: Procultura.

Reilly, Kent. 1989. The shaman in transformation pose: A study of the theme of rulership in Olmec art. In *Record of the Art Museum, Princeton University* 48 (2): 4–21.

Rickenbach, Judith. 1999. *Nasca: Geheimnisvolle Zeichen im alten Peru*. Zürich: Museum Rietberg Zürich.

Rodríguez Schettino, Lourdes. 1999. Morphology. In *The iguanid lizards of Cuba*, ed. L. Rodríguez Schettino, 17–35. Gainesville: University Press of Florida.

Rose, Wendy. 1992. The great pretenders: Further reflections on whiteshamanism. In *The state of Native America: Genocide, colonization, and resistance*, ed. M. Annette Jaimes, 403–421. Boston: South End Press.

Ross, Charles. 1989. *Crocodiles and alligators*. New York: Facts on File.

Rothenberg, Jerome, ed. 2003. *Selections: María Sabina*. Berkeley: University of California Press.

Rowe, Ann P. 1984. *Costumes and featherwork of the lords of Chimor: Textiles from Peru's North Coast*. Washington, DC: Textile Museum.

Rowe, John H. 1962. *Chavin art, an inquiry into its form and meaning.* New York: Museum of Primitive Art.

Ruege, Ruth. 1991. *Cats of the ancient New World: The feline motif in Andean art.* Milwaukee: University of Wisconsin Press.

Ruiz de Alarcón, Hernando. 1984. *Treatise on the heathen superstitions that today live among the Indians native to this New Spain, 1629.* Trans. and ed. J. Richard Andrews and Ross Hassig. Norman: University of Oklahoma Press.

Ryan, Robert E. 1999. *The strong eye of shamanism: A journey into the caves of consciousness.* Rochester, VT: Inner Traditions.

Sabina, Mariá, with Álvaro Estrada. 2003. The life. In *Selections,* ed. Rothenberg, 1–79.

Salomon, Frank, and George Urioste, trans. 1991. *The Huarochirí Manuscript: A testament of ancient and colonial Andean religion.* Austin: University of Texas Press.

Saunders, Nicholas J. 1998a. Architecture of symbolism: The feline image. In Saunders 1998b, 12–52.

———, ed. 1998b. *Icons of power: Feline symbolism in the Americas.* London: Routledge.

———. 2003. "Catching the light": Technologies of power and enchantment in pre-Columbian goldworking. In *Gold and power in ancient Costa Rica, Panama, and Colombia: A symposium at Dumbarton Oaks, 9 and 10 October 1999,* ed. Jeffrey Quilter and John W. Hoopes, 15–47. Washington, DC: Dumbarton Oaks Research Library and Collection.

Sawyer, Alan R. 1962. A group of early Nazca sculptures in the Whyte Collection. *Archaeology* 15 (3): 152–159.

———. 1997. *Early Nasca needlework.* London: Laurence King in association with Alan Marcuson.

Schaefer, Stacy B., and Peter T. Furst. 1996. *People of the peyote: Huichol Indian history, religion, and survival.* Albuquerque: University of New Mexico Press.

Scher, Sarahh. 2007. Held in the balance: Shamanism and gender roles in ancient and modern practice. *Acta Americana* 15 (1): 28–46.

———. 2010. Clothing power: Hierarchies of gender difference and ambiguity in Moche ceramic representations of human dress, c.e. 1–850. Ph.D. diss., Emory University.

Schultes, Richard Evans. 1960. Pharmacognosy. The pharmaceutical sciences. Third lecture series.

———. 1990. An overview of hallucinogens in the Western Hemisphere. In Furst 1990, 3–54.

Schultes, Richard Evans, and Albert Hofmann. 1992. *Plants of the gods: Their sacred, healing, and hallucinogenic powers.* Rochester, VT: Healing Arts Press.

Schultes, Richard Evans, and Robert F. Raffauf. 1992. *Vine of the soul: Medicine men, their plants, and rituals in the Colombian Amazon.* Oracle, AZ: Synergetic Press.

Sharon, Douglas. 1972. Eduardo the healer. *Natural History* 81 (November): 32–47.

———. 1978. *Wizard of the four winds: A shaman's story.* New York: Free Press.

———. 2000. *Shamanism and the sacred cactus.* San Diego: Museum of Man.

Shreeve, James. 2006. The greatest journey. *National Geographic,* March, 60–69.

Siegel, Ronald. 1977. Hallucinations. *Scientific American,* October, 132–140.

———. 1992. *Fire in the brain: Clinical tales of hallucination.* New York: Dutton.

Siegel, Ronald K., and Murray E. Jarvik. 1975. Drug-induced hallucinations in animals and man. In *Hallucinations: Behavior, experience, and theory,* ed. Ronald K. Siegel and Louis Jolyon West, 81–161. New York: Wiley.

Silverman, Helaine, and Donald A. Proulx. 2002. *The Nasca: The peoples of America.* Malden, MA: Blackwell.

Siskind, Janet. 1973. Visions and cures among the Sharanahua. In Harner 1973b, 28–39. New York: Oxford University Press.

Smilack, Marcia R. 2005. The synesthetic sonar from artist to archetype: Photographic proof that the universe is dreaming. Paper presented at the annual conference of the College Art Association, February 17, Atlanta.

Smith, Michael E. 1998. *The Aztecs: The peoples of America.* Malden, MA: Blackwell.

Soham, Pablo. 2007. Let sleeping jaguars lie. Photo. http://www.flickr.com/search/?q=jaguar&w=75879414%4oNoo.

Stahl, Peter. 1986. Hallucinatory imagery and the origin of early South American figurine art. *World Archaeology* 18 (1): 134–150.

Staller, John E. 2001. Shamanic cosmology embodied in Valdivia VII-VIII mortuary contexts from the site of La Emerenciana, Ecuador. In *Mortuary practices and ritual associations,* ed. Staller and Currie, 19–36.

Staller, John E., and Elizabeth J. Currie. 2001. Introduction to *Mortuary practices and ritual associations,* ed. Staller and Currie.

———, eds. 2001. *Mortuary practices and ritual associations: Shamanic elements in prehistoric funerary contexts in South America.* BAR International Series, 982. Oxford, England: Archeopress.

Steen, Carol. 2005. In pursuit of the internal landscape: Visions shared. Paper presented at the Annual Conference of the College Art Association, February 17, Atlanta.

Stone, Rebecca R. 1983. Possible uses, roles, and meanings of Chavín-style painted textiles of South Coast Peru. In *Investigations of the Andean past: Papers from the first Annual Northeast Conference on Andean Archaeology and Ethnohistory,* ed. Daniel H. Sandweiss, 51–74. Ithaca, NY: Latin American Studies Program, Cornell University.

———. 1986. Color patterning and the Huari artist: The "Lima Tapestry" revisited. In *The Junius B. Bird Conference on Andean Textiles: April 7th and 8th, 1984,* ed. Ann P. Rowe, 137–149. Washington, DC: Textile Museum.

———. 1987. Technique and form in Huari-style tapestry tunics: The Andean artist, a.d. 500–800. Ph.D. diss., Yale University.

———. 2007a. "And all theirs different from his": The Inka royal tunic in context. In *Variability in the expression of Inka power: Proceedings of the 1997 Dumbarton Oaks Conference,* ed. Richard Burger, Craig Morris, and Ramiro Matos, 385–422. Washington, DC: Dumbarton Oaks Research Library and Collection.

———. 2007b. Using the past to heal the present: Rock art and curing in western Amazonia. *Acta Americana* 15 (1): 5–27.

———. n.d.a. Shamanic roles, practices, and beliefs during the Inca Empire according to Father Bernabé Cobo's "Inca Religion and Customs." Working paper, Art History Department, Emory University.

———. n.d.b. Thoughts on color use and visionary spirituality in Andean textile traditions. Working paper, Art History Department, Emory University.

Stone-Miller, Rebecca. 1992. Camelids and chaos in Wari and Tiwanaku textiles. In *The ancient Americas: Art from sacred landscapes*, ed. Richard F. Townsend, 334–345. Munich: Prestel Verlag.

———. 1994. *To weave for the sun: Ancient Andean textiles*. London: Thames and Hudson.

———. 2002a. *Art of the Andes from Chavín to Inca*. Rev. ed. World of Art series. London: Thames and Hudson.

———. 2002b. *Seeing with new eyes: Highlights of the Michael C. Carlos Museum Collection of Art of the Ancient Americas*. Atlanta: Michael C. Carlos Museum, University of Washington Press.

———. 2004. Human-animal imagery, shamanic visions, and the ancient American aesthetic. *RES: Journal of Anthropology and Aesthetics* 45 (Spring): 47–68.

———. 2006. Mimesis as participation: Imagery, style, and function of the Michael C. Carlos Museum paccha, an Inka ritual watering device. In *Kay paccha: Cultivating earth and water in the Andes*, ed. Penelope Dransart, 215–224. BAR International Series, 1478. Oxford, England: Archaeopress.

St. Pierre, Mark, and Tilda Long Soldier. 1995. *Walking in the sacred manner: Healers, dreamers, and pipe carriers—medicine women of the Plains Indians*. New York: Simon and Schuster.

Sunquist, Fiona. 2002. *Wild cats of the world*. Chicago: University of Chicago Press.

Tate, Carolyn E. 1992. *Yaxchilan: The design of a Maya ceremonial city*. Austin: University of Texas Press.

Taylor, Geoff. 1994. *Whale sharks: The giants of Ningaloo Reef*. New York: Angus and Robertson.

Taylor, Gérald. 2000. *Camac, camay y camasca y otros ensayos sobre Huarochirí y Yauyos*. *Archivos de Historia Andina* 35. Lima: Institut français d'études andines.

Tedlock, Barbara. 2003. The new anthropology of dreaming. In Harvey 2003, 103–122.

———. 2005. *The woman in the shaman's body: Reclaiming the feminine in religion and medicine*. New York: Bantam Dell.

Tierney, Meghan. n.d. Vessels of shamanic visions: Nasca "trophy head" imagery. Class paper, Emory University.

Tinsley, Jim Bob. 1987. *The puma: Legendary lion of the Americas*. El Paso: Texas Western Press.

Torres, Constantino M., and William J. Conklin. 1995.

Exploring the San Pedro de Atacama/Tiwanaku relationship. In *Andean art: Visual expression and its relation to Andean beliefs and values*, ed. Penny Dransart, 78–108. Worldwide Archaeology Series, 13. Aldershot, England: Avebury Press.

Townsend, Richard F. 1979. *State and cosmos in the art of Tenochtitlan*. Studies in Pre-Columbian Art and Archaeology series, 20. Washington, D.C.: Dumbarton Oaks Research Library and Collection.

———. 1985. Deciphering the Nazca world: Ceramic images from ancient Peru. *Art Institute of Chicago Museum Studies* 11 (2): 117–139.

Townsley, Graham. 1993. Song paths: The ways and means of Yaminahua shamanic knowledge. *L'Homme* 33 (126–128): 449–468.

———. 2001. "Twisted language," a technique for knowing. In Narby and Huxley 2001, 263–271.

Vargas Llosa, Mario. 1989. *The storyteller*. Trans. Helen Lane. New York: Farrar, Straus, and Giroux.

Verano, John W. 2001. The physical evidence of human sacrifice in ancient Peru. In Benson and Cook 2001, 165–184.

United Nations, Food and Agriculture Organization (FAO). 2010. Species fact sheets: Rhincodon typus (whale shark). http://www.fao.org/fishery/species/2801/en.

Wasson, R. Gordon. 1980. *The wondrous mushroom: Mycolatry in Mesoamerica*. New York: McGraw Hill.

Weiss, Gerald. 1973. Shamanism and priesthood in the light of the Campa *ayahuasca* ceremony. In Harner 1973b, 40–48.

———. 1975. Campa cosmology: The world of a forest tribe in South America. *Anthropological Papers of American Museum of Natural History* 52 (5): 217–588.

Wiese, Michael, dir. and prod. 2010. *The shaman and ayahuasca*. DVD. Michael Wiese Productions.

Wilbert, Johannes. 1987. *Tobacco and shamanism in South America. Psychoactive plants of the world*. New Haven: Yale University Press.

Wilson, Edward O. 1984. *Biophilia*. Cambridge: Harvard University Press.

Wingfield, Laura. 2009. Envisioning Greater Nicoya: Ceramic figural art of Costa Rica and Nicaragua, c. 800 BCE–1522 CE. Ph.D. diss., Emory University.

Wolfe, Art, and Barbara Sleeper. 1995. *Wild cats of the world*. New York: Crown.

Wright, Pablo G. 1992. Dream, shamanism, and power among the Toba of Formosa Province. In Langdon and Baer 1992, 149–172.

Zuidema, R. Tom, and Ulpiano Quispe. 1989. A visit to God: The account and interpretation of a religious experience in the Peruvian community of Choque-Huarcaya. In *Reyes y guerreros: Ensayos de cultura andina*, ed. Manuel Burga, 33–53. Lima: Fomciencias.

INDEX